MOVING PERFORMANCES

MOVING PERFORMANCES

Divas, Iconicity, and Remembering the Modern Stage

JEANNE SCHEPER

RUTGERS UNIVERSITY PRESS

New Brunswick, New Jersey, and London

Library of Congress Cataloging-in-Publication Data
Names: Scheper, Jeanne, 1967–author.
Title: Moving performances : divas, iconicity, and remembering the modern stage /
Jeanne Scheper.
Description: New Brunswick, N.J. : Rutgers University Press, 2016. | Includes
bibliographical references and index.
Identifiers: LCCN 2016003238| ISBN 9780813585451 (hardcover : alk. paper) | ISBN
9780813585444 (pbk. : alk. paper) | ISBN 9780813585468 (e-book (epub)) | ISBN
9780813585475 (e-book (web pdf))
Subjects: LCSH: African American women entertainers—History—20th century. |
Women entertainers—United States—History—20th century. | African Americans
in the performing arts. | Women in the performing arts—United States. | Performing
arts—Political aspects—United States—20th century. | Performing arts—Social
aspects—United States—20th century. | United States—Race relations—20th
century.
Classification: LCC PN1590.B53 S34 2016 | DDC 792.02/8082—dc23
LC record available at http://lccn.loc.gov/2016003238

A British Cataloging-in-Publication record for this book is available from the British
Library.

Visit our website: http://rutgerspress.rutgers.edu

Manufactured in the United States of America

For the Grandmothers
With love to Tiffany, and our children,
Salim and Solomon

CONTENTS

ACKNOWLEDGMENTS

This book is the result of many years and many hands. I give thanks for the artists, activists, and performers whose work and lives I write about and who inspired my thinking. I am grateful to the librarians and archivists who made this work possible and a pleasure, especially Antony M. Toussaint and Mary F. Yearwood of the Schomburg Center for Research in Black Culture; the Billy Rose Theater Division and Jerome Robbins Dance Division of the Library for the Performing Arts, New York Public Library; Madeline Matz of the Library of Congress; Margaret R. Goostray, Sean Noel, J. C. Johnson, and Jane Silva of the Howard Gotlieb Archival Research Center, Boston University Archives; the Libby Holman Foundation; the Pacific Film Archive at UCLA; the Association of Motion Picture Arts and Sciences; the Johns Hopkins University Sheridan Libraries; Sylvia Curtis and Sherri L. Barnes of Davidson Library at UC–Santa Barbara, as well as the Ethnic and Gender Studies Library, the Arts Library, and the Music Library there; and Pauline Manaka and Christina Woo of Langson Library, UC–Irvine. Final revisions were enhanced by an invitation to join the UC–Riverside summer faculty writing group at the Center for Ideas and Society (2014). The research for this book was made possible with financial support from a number of sources including a Hellman Fellowship (2013–2014), the Academic Senate Council on Research Computing and Libraries (UCI), a postdoctoral fellowship in women's studies at the University of Houston (2005–2007), graduate funding from UCSB, and a grant from UC–Irvine Humanities Commons. I am especially thankful to Professor Elliott Butler-Evans and family and honored to be the inaugural recipient of the Pearl Butler-Evans Award, UCSB.

While the entire manuscript has been heavily revised since they were originally published, sections of chapters have appeared in print. Portions of chapter 4 appeared in "'Of La Baker, I am a Disciple': The Diva Politics of Reception," *Camera Obscura* 65 (2007): 72–101; and sections of chapter 3 appeared in "'Take Black or White': Libby Holman's Sound," *Women & Performance: A Journal of Feminist Theory* 9, no. 2 (1998): 95–117.

Thank you to my astute and timely editors at Rutgers, especially Leslie Mitchner, India Cooper, and the generous anonymous readers who gave their time and insight. Without the invaluable comradeship and support of my friend of twenty years and now trusted editor, Laura Holliday, I could not have completed this book. My gratitude runs deep for my dissertation director, Maurizia Boscagli,

and committee: Fred Moten, H. Porter Abbott, and Constance Penley; as well as my many mentors and colleagues at UCSB, especially Eileen Boris, Julie Carlson, Catherine Cole, Anna Everett, Laury Oaks, Cedric Robinson, and Elizabeth Robinson. My thinking has been encouraged and inspired along the way by the scholars Jacqui Alexander, Pamela Caughie, Anne Anlin Cheng, Maryse Condé, Brenda Dixon Gottschild, and Mae Henderson. Thank you to the feminist editorial collective of *Camera Obscura*. At UC–Irvine, I have had the pleasure of working with intellectually inspiring colleagues in Gender and Sexuality Studies: Laura Kang, Jennifer Terry, Inderpal Grewal, Lilith Mahmud, Emily Thuma, and Catherine Sameh. For their generosity, I thank Vicki Ruiz, Jonathan Alexander, Susan Jarratt, Arlene Keizer, Christine Bacareza Balance, Jessica Millward, Jaye Austin Williams, Bridget Cooks, Alice Berghof, Sheron Wray, Denise Ferreira da Silva, Ann Cvetkovich, Andreana Clay, Deborah Vargas, Deborah Cohler, and Ernesto Martinez. I cherish my time at the University of Houston and thank Elizabeth Gregory, Margot Backus, Janice Blue, Sally Russ, Jay Mays, Natalie Gabiola, the Radical Womyn, the Gendermyn, and a memorable cohort of graduate students, especially the students in the Feminist Archives class. I also wish to thank the UH faculty writing group of Natalie Houston, Elizabeth Klett, and Karen Fang, and the UH and Rice Women's Studies feminist postdoc writing group: Kimberly Juanita Brown, Vochita Nachescu, and Mary Helen Dupree.

I am grateful for the circles of scholar-activist-artist friends who remain my interlocutors, especially Madelyn Detloff, for always reaching back and growing feminist connections, Geoffrey Bateman, Johanna Blakley, Beth Currans, Emily Davis, Kristin Koster, April Miller, Marisela Marquez, Susan Y. Najita, and Catherine Pancake.

This work is dedicated to my grandparents, especially my grandmother Marie Keane Lawler, who always corresponded and grew the archive; my grandma Anne Znojemské Scheper, who advised me to cherish the everyday connections formed on "the Avenue"; my grandpa George Scheper, whom she met while he was playing piano at a speakeasy and who later started a little lending library at the Brooklyn Union Gas Company; and my grandmother-in-law Frances Terry, who generously said, "Call me Grandma," and family. Thanks to my brother, steadfast friend and avid reader, collector, and maker of things, David Scheper; my mom, Nancy Lawler; and the Lawlers and Keanes of Chicago, all the aunties, uncles, and cousins, especially Megan Lizik. I am grateful for the unfailing support of my dad, George Scheper, and the family in New York, my stepmom Dianne Scheper and family, Nicole Ganz, Brian Ganz; sister-cousins Sarah Hughes and Jennifer Hughes, Santos Roman, Nate Hughes, tía Nancy Scheper-Hughes and uncle Michael Hughes, and the next generation: Santiago, Salvador, Dito, Nathanael Mandela, Ariella, and Aviana.

This work would not exist or be possible without those lovely circles of chosen family: You are my heart, Zia Isola, Karl Bryant, Mark Schuller, Dee-Dee Taylor and Chelsea, Jeremy Grainger, and David Smagalla. Thank you for sustaining and nourishing our family, Huda Jadallah, Deanna Karaa, and Hady, Omar, and Hind, Greg Simmons, Akel Robinson, Rachel Sarah O'Toole, Ann Kakaliouras, Tamara Austin, Jay L. Austin, Cody, and Sierra, LaShonda Carter and Jordan, Molly Talcott, Dana Collins, Najda Robinson and Jacob, H. T. L. Quan, and Crystal Griffith.

I am deeply grateful for the intellectual sustenance of former students at UMCP, MICA, MassArt, UCSB, UM–Flint, and UC–Irvine.

It's a heartbreaking lesson that there are people who didn't live to hold this in their hands. They live inside the project and joyfully inside my heart each day: Peter Pan Zahorecz, the earliest collaborator in this endeavor; brothers-in-law Tanji Willoughby and Robert Williams; and Orem "Jerry" Wahl. And as they say in my hometown, *"Please don't let my thanking stop"*—Lambs Eat Ivy, Baltimore.

MOVING PERFORMANCES

INTRODUCTION
Divas, Iconicity, Remembering

In the early twentieth century, two performers featured in this book—Aida Overton Walker and Loïe Fuller—rode the wave of Salomania, a transnational cultural craze with divergent genealogies that originated, first, from European high culture, beginning with Oscar Wilde's banned 1892 decadent symbolist play *Salomé* and Strauss's opera based on it, the US banning of which led the Met's prima ballerina to perform the Salome dance on the popular variety stage; and second, from a popular-culture myth of a colonial-folk-inspired "belly dancer" credited with saving the 1893 Chicago World's Fair from financial ruin—who in turn inspired a proliferation of imitators on the American popular stage. Onstage performances inspired offstage ones like orientalist-themed women-only dinner parties,[1] fashion harem pants, and Salome brand cigarettes. The Salomania craze was quickly considered a socially dangerous "contagion" whose scanty outfits and bare feet were manifestations of everything threatening about the New Woman.[2] But the same deviant self-fashioning and brazen sexuality that made Salome a symbol of cultural degeneration for some also made Salome a space for imagining modernity, and a role taken up enthusiastically by women artists who turned a predominantly misogynistic nineteenth-century trope into a defiant twentieth-century Bad Girl. Initially issued by Wilde as a queer provocation and later taken up in that spirit in a lineage that runs from Alla Nazimova to Ken Russell, Salome-as-cypher exposed faltering nineteenth-century colonial powers and patriarchy—even as it exhibited racialized and sexualized fantasies.

For Aida Overton Walker, an African American performer famous for her theatrical and often comedic work with the Williams & Walker Company and especially for her rendition of the cakewalk, performing the Salome dance bore particular significance. On the one hand, embracing a role associated with sexuality and scandal—especially given the racist equations of black women with hypersexuality, and the black middle class's understandable concern about that equation—was a risky move for someone wanting to be seen as a serious dancer.

1

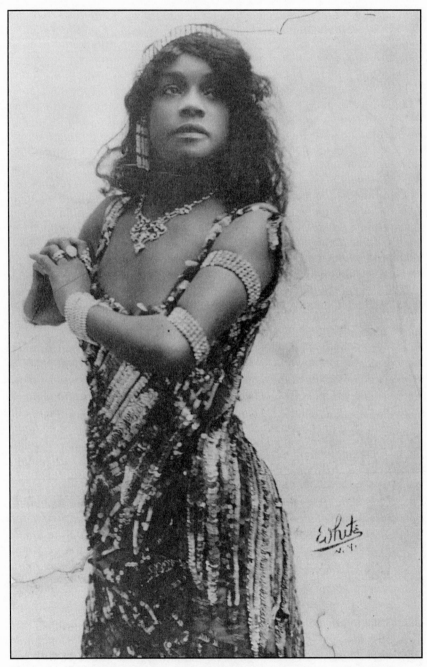

FIGURE 1. Portrait of Aida Overton Walker as Salome. E. White, New York, ca. 1911. Courtesy Schomburg Center for Research in Black Culture, The New York Public Library, Astor, Lenox, and Tilden Foundations.

On the other hand, it was a chance to demonstrate her talent as both solo artist and choreographer, and by extension to stage an intervention about attitudes and consumption practices related to black women's dancing bodies and public performances of race, gender, and sexuality, while forging new serious choreographic possibilities for the modern era. And so Overton Walker stepped into the fray, performing her version of a Salome dance at the height of its popularity in 1908 and again in 1912.

Critics writing for the mainstream white press generally reacted to Overton Walker's dance with none of the shock they reserved for other Salome dancers—but neither were they willing or able to recognize her as producing an intervention in the craze or even a serious contribution to the American art-dance. For one critic, for example, who observed that she "dances modestly in the bronze tights nature placed upon her," Overton Walker's dark skin managed to simultaneously signify "costume" (and therefore modesty, in contrast to the inappropriately bared skin of most Salome dancers) and "nature" (and therefore a kind of unstudied innocence, in contrast to the cunning artifice associated with Salome).[3] Overton Walker may have circumvented being seen in only sexualized terms, but the same racialized and gendered attitudes that defused the critic's reaction to her also rendered her skill as a dancer and choreographer illegible— suggesting that critics were ill equipped to understand the larger meaning and significance of Overton Walker's career as a whole, not just the Salome dance in particular.

This quick sketch of Overton Walker's Salomania performance and its reception highlights a number of the central themes of this book. *Moving Performances* takes up four early twentieth-century divas—Aida Overton Walker, Loïe Fuller, Libby Holman, and Josephine Baker—who sang and danced on popular stages, traveled along transnational circuits, and challenged existing prescriptions for women both onstage and off, as they performed their lives in the public eye. Yet the mainstream press in the United States and Europe relentlessly contained those challenges within prevailing discourses of race: Overton Walker's Salome dance or Loïe Fuller's Serpentine Dance through the lens of orientalism; or US performers working overseas, such as Overton Walker at Buckingham Palace or Josephine Baker at the Folies Bergère, through the lens of modern primitivism, keeping their bodies and movements locked into antiblack fantasies of savage otherness. ("She looks like some pretty savage and there is an unconventionality about her movements which suggest[s] the jungle"[4] was a sentence initially used to describe Overton Walker, but a sentiment echoed many times over in descriptions of Josephine Baker on the French stage.) Even as they moved from precarious working conditions in the United States to the exoticizing practices offered up globally at world's fairs and expositions, they engaged in multipronged challenges, onstage and off, to the representational, political, and economic

hostilities they faced, pushing past the constraints of prevailing cultural representations of race and ethnicity in different national contexts and the material limits and violence of the segregated US theater as a racist and sexist worksite. In turn, the meaning of their work changed as it became entangled within different national and colonial contexts.

MOVING PERFORMANCES

Overton Walker, Fuller, Holman, and Baker all built their careers in cacophonous, precarious, and competitive venues and circuits that provided potentially lucrative but also grindingly difficult employment. They traveled across state lines to perform along Jim Crow circuits that booked in the segregated South, and along transnational circuits that brought black and white performers from US Prohibition-era nightclubs to international venues such as world's fair stages that were designed to promote colonial enterprise and imperial progress. Mobility may have been a necessary means of pursing their livelihood, and could offer the potential for seeking new audiences or improved working conditions, but traveling and relocation also brought their own attendant hardships. Whether these performers sought to escape the sociopolitical and artistic limits of home and nation or to gain financial and artistic success overseas, they left behind the particular constraints of performing in the United States only to be relocated in other similarly intractable racial and gendered logics.

Despite all the ways in which the work of these performers was trivialized, dismissed, or made illegible by critics and audiences, they nonetheless forged solo careers through their dancing and singing that worked against those limits. Audiences' reception practices, as well as performers' repertoires, were saturated in raced and gendered ideologies produced out of histories of violence and social injustice. In particular, they were steeped in nineteenth-century ways of seeing, including the messy terrain of racial pseudoscience mixed with voyeuristic pleasures in the subjugation of racial others. The tropes that accompanied these ideologies were assigned to modernism's "others" in a representational economy organized in the service of social inequalities. That is, each of these performers, whether she wanted to be or not, was engaging with prevailing discourses of primitivism, orientalism, and exoticism; their choices were how and in what combination to engage them.

Tropes, and the spectacles through which they are performed, accumulate power over time by virtue of repetition, sedimentation, and naturalization: in this sense, they make up an archive of "performative effects."[5] The performative points not only to the power of language that *does* something as well as says something, in the J. L. Austin sense (which I expand upon in chapter 3),[6] but more expansively to the power of embodied practices as symbolic cultural

languages, which accumulate meaning over time and through the force of rep-
etition. Here I am connecting the sedimentation of meaning produced through
performance to the etymology of the word *trope* in Latin as "embellishment" and
in Greek as "style." If these definitions conjure images of popular music and fash-
ion, that reference point is valuable inasmuch as it points, first, to the role of style
in reproducing power and, second, to the tendency of tropes to produce excesses
of meaning, something more than the original signifier. These tropes, in other
words, are indeed "improper" to their subject.[7]

So these divas took up modernist tropes—even shaped as they were by racist
imaginaries that were the inheritances of slavery and Victorian empire—in part
because this was the inevitable and obligatory repertoire. But, I argue, as they
did so, they also aimed to animate new visions of gendered and raced modern
subjectivity, to move their bodies in forms of kinesthetic critique. These women
were modern innovators as well as cultural critics who reflected on their own
conditions of production and consumption. Each performer used a variety of
strategies to engage audiences and disrupt prevailing tropes, or "spectacles of
the other," and their attendant affective economies, through experiments with
and experiences of movement, relocation, and performance in the public sphere.
Viewed collectively, and then taken up within the play of geography and time,
these divas' performances and iconicity open a wide terrain of possibilities for
comparative study of feminist modernisms' capacities both to upend and to
entrench racial regimes.

One of the labors of mobility for these performers was the necessity of chal-
lenging the status quo of performance repertoires on an assortment of different
stages—from the variety stage to the world's fairs, from after-hours nightclubs to
Buckingham Palace. Across these different spaces, these performers confronted
audiences marked by changing demographics and dynamics of class, race, and
gender; each audience viewed their performances through its own set of con-
tested meanings, desires, and ways of seeing bodies onstage. White middle-class
women, for example, comprised a new type of audience in the early twentieth
century, working-class people had new discretionary forms of income and time
to spend on cheap amusements, and black audiences were seeking black theatri-
cal entertainments that spoke knowledgeably to their histories and lives. Audi-
ences' perspectives were additionally cultivated by various national and local
histories of racialized spectacle and colonialism, by ways of seeing further recon-
figured by new technologies of photography and film, by cultural forms high and
low, and by the visions of empire promoted at world's fairs and expositions and
through commodity advertising. Performers' labor of mobility was also shaped
by the need to contend with different conditions of social inequality that they
encountered offstage in these different locales, whether they were refused lodg-
ing on the road, could not perform as a racially integrated act, or were imagined

erroneously as colonial subjects. Yet all of these labors of mobility are not necessarily a part of how divas are remembered as performers on the modern stage, as popular icons, or as objects of scholarly study.

In fact, these myriad labors of mobility, limitations of repertoire, uneven working conditions, and differing audience consumption patterns are issues that the performers themselves went on to delineate and critique, including, for instance, Overton Walker, who (as I discuss in chapter 1) identified in public political statements the forces of antiblackness operating on black performers in this historical moment onstage and off. Employing critical archival practices that look at, for instance, the interplay of onstage and offstage performances, I argue, can reveal this aspect of the performer's labor: the labor of critique. Despite often expressing a critical standpoint, however, such performers did not always succeed in shifting the effects of power such that audiences or critics recognized the ways performers were not simply reproducing existing forms. The uneven success of staging challenges to the status quo of performance repertoires and prevailing tropes, including challenges to their misreception and other forms of illegibility, reveals the further powerful limitations placed on such performances in their moment and then in the archive. One question I take up in the present is how contemporary reiterations of their diva iconicity can illuminate rather than obfuscate the politics of these earlier innovators.

Taken together, the performers' life spans encompass more than a century, from Loïe Fuller's birth in 1862 to Josephine Baker's death in 1975, but all four women reached the height of their careers during an era running from the end of the late Victorian period, the fin de siècle, through modernism. *Moving Performances* traces how these performers navigated that transitional and transnational moment as well as how they have been remembered since then. These decades span the turn of the century, the interwar period bookended by World War I (1914–1918) and World War II (1939–1945), and the postwar or Cold War period that followed World War II. They are defined by global technological changes marked by speed and movement: in transportation (cars, flight, and rapid public transit trains); in communication (telephones, wireless telegraphs, phonographs, and other recording and sound technologies); in film (from the kinetoscope, cinematograph, and other early motion picture technologies, and the emergence of narrative film and sound, to classical Hollywood cinema); and in industry (mass production, the assembly line). They are also decades identified with enormous movement and upheaval in the economic and social order (stemming from the growth of cities, rising consumerism, the effects of Jim Crow, and the Cold War) and defined by social movements (anti-lynching campaigns, women's suffrage, civil rights, anticolonial movements) and movements of populations and goods (the Great Migration of blacks from the rural US South to the urban North, immigration, global migration, the opening of

Japan to trade with the West). The meanings attached to this transitional time, one of technological, social, and ideological change, are signified by how these decades have come to be understood as a time of negotiating modernity. Scholars in different fields variously refer to these decades, therefore, as those that produced "modernism," the "New Negro Renaissance," the birth of American art-dance, a "middle period" in African American theater, European Africanism in art, *la vogue nègre*; and other periodizations—often, as these examples show, accented by aesthetic innovations that challenged tradition and conceptions of civilization. Additionally, it is an era filled with "new figures" of the modern that challenged Eurocentric and patriarchal modes of thinking and constructing identities: the era of the New Woman, the New Negro, the pachuca, the flâneuse, the flapper, the chorus girl, the Gibson Girl—and the emergence of the female star on stage and screen.

It was, in fact, this nexus of larger cultural seismic shifts that initially drew me as a literary and cultural studies scholar out of the Victorian period, to look past fin-de-siècle decadence and symbolism and toward the transnational configuration of modernity, the modern, and modernism, a turn that accompanied larger scholarly shifts toward examining "new modernisms" and modernity from a multidisciplinary perspective in the 1990s. New modernisms recognized this as an era constituted by the increasing visibility of bodies of difference, a moment when the dissolution of normative social categories, developing technologies, rising consumer culture, and changing modes of entertainment resulted in a proliferation of new social identities that exceed existing social codes. And while all of the performers here began their professional lives during the earlier period, the long careers and life spans of two of them (Holman and Baker) and the contemporary visibility of some of their legacies but not others point to the ways that the contours of the "modern" linger on through the latter half of the twentieth century and continue to inform the present and shape the future.

The inventory of raced and gendered social and technological changes listed above—or at least a similar list—could be applied to almost any historical moment. I am not making yet another pitch for the exceptionalism of twentieth-century modernism; rather, I am emphasizing the need to take another look at these performances and their afterlives in a broad cultural context. All performance and reception practices are informed by distinct racial ideologies, which are then shaped by time and location, period and place. And these practices are further wrought by how racial logics inform each other, especially as performers travel across national and spatial boundaries. What does appear distinct about the nexus of performers embraced here is the way that these figures, their iconicity, and their era continue to hold out a particular scholarly and artistic and popular promise for reworking sexual, gender, and racial subjectivities in the present and for the future.

Because the archive of live performance is always tenuous and ephemeral, especially in a historical era of emergent recording technologies, and because the subjects of this book are in varying degrees marginal to dominant frameworks of history, these performers' substantive contributions have been obscured in a number of ways. The challenge of piecing together elusive information about them ultimately presented a methodological quandary for me as a researcher, one that in turn suggested an interesting solution. Performers, especially solo performers, who achieve a level of recognition and fame leave traces behind in the form of legacies, forms of fandom, and other remainders. I elaborate the meaning of the labor they performed onstage and off by first drawing a wider political context for these performances. I also take into account these remainders as sites for illuminating meaning: not only material traces and object artifacts, but ephemeral artifacts and affective histories, which make up the after-effects of these performances.

IN THE DIVA ARCHIVES

When I first requested access to the torch singer Libby Holman's sound recordings at Boston University Special Collections, the archivist casually remarked that no one had ever asked to listen to her recordings. Most visitors, he related, were looking for information on the notorious and sensational murder of her first husband and on Holman's role as murder suspect. The tapes, part of the hundreds of items gifted to Boston University by Holman herself, are labeled "Sonic Recording Products, inc. Test Pressing," and they are the "old" kind of reel-to-reel tapes. The archivist handed me a splicing kit, anticipating the difficulties ahead—"If the tapes aren't played, they disintegrate and the sound is lost forever," he warned me—and in fact, as I listened, the tapes began to snap every few rotations. As a last resort, another sound librarian was able to salvage them and create a cassette tape copy. While I listened to the recordings, the first time I had ever heard her voice, and then to Holman's radio interviews, accounts of Holman's personal magnetism became more dimensional, delivered through this precarious and intangible archived aurality.

The sound librarian's advice provided a cautionary object lesson. Originally proffered as practical wisdom, it took on new significance for me as I sorted through portraits, publicity photographs, newspaper and magazine clippings, fan scrapbooks, sheet music covers and lyrics, postcards, film clips, letters, and, in Holman's case, Elizabeth Taylor's gloves (which she wore on the evening Michael Todd proposed marriage, and which Taylor subsequently left in Holman's apartment). As anyone who has done archival research knows, working among all of these preserved and decaying, cataloged and uncataloged material artifacts creates a peculiar sense of dissonance: between permanence and

impermanence, preservation and deterioration; between the official endorse-ment of the institution holding the materials and the often ephemeral and ver-nacular qualities of what one holds in one's own gloved hands.

Performance studies captures a version of that dissonance with two terms—the *archive*, which is constituted by official records and institutional authority, with its attendant claims to reproducibility and endurance; and *repertoires*, which include living and embodied practices, oral traditions, and performance—in order to revalue the latter and critique the authority of the former.[8] And while Diana Taylor, in *The Archive and the Repertoire: Performing Cultural Memory in the Americas*, is careful to parse out the difference, I use the two terms less as oppo-sitional ways to delineate the power of official versus vernacular knowledge, and rather seek out the ways in which repertoires trouble and produce the possibility for a new conception of archives as spaces of critique. This is similar to how Ann Cvetkovich takes up the term *archive* in *An Archive of Feelings: Trauma, Sexual-ity, and Lesbian Public Cultures*, which delineates the political work of affective archives, making archives more akin than oppositional to Taylor's use of rep-ertoire. In other words, for fans and scholars to begin to understand the mean-ings that are generated in the complex exchanges of live theatrical and popular performances of the past, often in the absence of a moving record (though hav-ing such a record also risks fetishizing it and believing, from our contemporary perspective, that now we *do* see the performance), is to ask research questions about what any performance meant and did, and to run into perennial ontologi-cal and epistemological conundrums: *What counts as performance? How can we know about what a particular performance looked like, let alone what it conveyed, how it was received, and what it meant?* These questions are, of course, germane to my study of the onstage and offstage performances of Overton Walker, Fuller, Holman, and Baker, a point made viscerally clear when I listened to Holman's decaying tapes and realized how much knowledge they actually conveyed, yet how fragile access to them was, and how much more I still did not—and could not—know.

The pioneering US dance critic Marcia Siegel, in the introduction to her col-lected dance reviews of the late 1960s and early 1970s, articulates a theory of dance that persists to the present day, in which dance as an art form is ontologi-cally defined as a "disappearing" art. She writes: "Dance exists at a perpetual van-ishing point. At the moment of its creation it is gone. All of a dancer's years of training in the studio, all the choreographer's planning, the rehearsals, the coor-dination of designers, composers, and technicians, the raising of money and the gathering together of an audience, all these are only a preparation for an event that disappears in the very act of materializing. No other art is so hard to catch, so impossible to hold. Even in its earliest states as a theater form, dancers and audiences must have been aware of this ephemerality, and used it."[9] Performance

studies, ethnic studies, and queer and sexuality studies as interdisciplines have continued to take up this question of ephemerality, examining the ontology of performances and identities marked as "disappearances." Disappearance is a quality seen as inherent to live objects of study, including repertoires of embodied practices, oral histories, and sound performances, and also a condition shared by marginalized subjects.

If we accept that all dance, and performance, exists at this material vanishing point, then archival ephemera hold out the promise of a kind of ghostly evidence of performed materiality. The feminist performance studies scholar Peggy Phelan famously argues that performances become something else when they transfer into documentation. Yet this privileging of the work of performance as disappearance may not apply or be apt in every case.[10] In *Moving Performances*, I shift the emphasis to the importance of looking at the double movement of disappearance and impulses to visibility—of taking seriously, especially for marginalized subjects, those claims to appearance, to performing insubordinately into the record, to disrupting history.

For example, although during her lifetime Aida Overton Walker was an international star, performing onstage at Buckingham Palace alongside her husband, George Walker, and the famous comedian Bert Williams, her work has only relatively recently been recognized and restored to the annals of modern dance history and the genealogies of African American theater. But she has virtually no contemporary iconic visibility in mainstream popular culture compared with figures like Fuller and Baker. Suturing Overton Walker back into these histories as a restorative act is a necessary corrective but also entails an examination of how and why the critical terrain of the modern has been mapped in ways that echo the erasure of black bodies from the stage during this period. This disappearance isn't about the ontology of performance per se but is rather about the way the ontology of blackness is staged. To forget Overton Walker, as she was until recently forgotten, is only possible when the archive of modernism is conceived through the exclusion of modes of black cultural production—if the modern is understood without examining the black press, for instance, or the full repertoire of embodied practices that inform modern dance. And to forget Overton Walker, in turn, results in a flattening of how the origins of modern dance are conceived and how racialized embodied practices like primitivism and orientalism are understood. Further, such forgetting contributes to a failure to examine how whiteness is produced both as modern through popular performance practices, as defining the future by way of selective archiving and remembering. That forgetting is a political one with wide-ranging ramifications, one of which is to misrecognize or erase the effects of the "insurgency" and "radicalism" of these early black performers, and particularly, in this period, of what Cedric Robinson would proclaim these "audacious Black minstrels."[11]

Even when the when-and-where of a given performance can be reconstructed through a playbill or the personal scrapbooks of audience members, or when scholars can provide the historical context from an interdisciplinary perspective, there remains an uneven articulation of performers' or audiences' intentions. For instance, even when these artists left behind their own written or photographic record of events and articulated their ideas about intent, as Fuller and Baker both did in their autobiographies, their accounts may be self-interested as well as self-contradictory or otherwise not entirely trustworthy, and even, in some cases, intentionally manufactured to be ambiguous. These absences, multiplicities, and discrepancies raise methodological questions about how to engage with performers' own acts of history-making and self-articulation. From a performance studies perspective, these moments of absence, ephemera, and self-making are themselves supplementary performances to be interpreted in conversation with the partial record of actual stage performances. And "authorial intent," so to speak, does not become the driving force for understanding meaning or the political; rather, effects and aftereffects do.

Libby Holman, for instance, sought to craft the contours of her own iconicity and shape how it would be remembered—by archiving herself. But this effort, as it turns out, was no guarantor against loss, criticism, illegibility, or misrecognition. She literally produced her own archive by gifting her papers to Boston University's Howard Gotlieb Archival Research Center, but her impulses toward archiving can also be found in her radio interviews and in her narrative framing of her performances. Holman's two lauded careers (first as a torch singer in the 1920s and 1930s and later as a concert blues singer in the 1960s and 1970s) and her prominence as a wealthy white benefactor of the civil rights movement are ultimately overshadowed by a tabloid camp visibility, which began in the 1930s and has carried into the present. She self-identified as an antiracist throughout her life and worked hard to rescript the meaning of her first career in interviews and other autobiographical stories, and then produced her own archive, intentionally in the same repository as Martin Luther King Jr.'s papers. And yet her life is remembered predominantly, as the librarian observed when I went to listen to her recordings, in camp ways that make her a desirable subject for an episode of E!'s *Mysteries and Scandals* detailing the mysterious death of her first husband, heir to the R. J. Reynolds tobacco fortune.[12] That scandal earlier inspired three feature-length films[13] and the theatrical production *Play Murder* (1995), written by the Canadian professor, writer, gay activist, and drag performer Sky Gilbert. Persistently made, then, a worthy subject of a queer camp and popular theatrical, cinematic, televisual, and journalistic memory, Holman has stubbornly remained an improper object of scholarly attention, receiving virtually none. Yet her frustrated attempts to rescript the politics of her career, her archive, and her legacy offers a rich window into the political economies of her sound—marketed to

white audiences as a reconfigured black sound first through the queerly embod-
ied performance practices of the torch singer and then later as a kind of archi-
val restoration of American folk traditions—and, in turn, into the persistence of
racialized performance and consumption practices.

The sound-loop of Holman's case expresses the overall complexity of under-
standing the unevenness of the diva archive, which calls for a queer meth-
odology, one that can account for "innuendo, gossip, fleeting moments, and
performances"—or, in other words, "an object whose ontology, in its inability
to 'count' as a proper 'proof,' is profoundly queer."[14] Philip Brian Harper asks,
"How to consider the meaning of an experience no concrete evidence of which
exists, and of which we can therefore claim no positive knowledge?"[15] Such
subjects, as José Muñoz argues, require a turning to the "traces, glimmers, resi-
dues, and specks of things" that can expand our definition of materiality as per-
formance, producing "ephemera as evidence."[16] Ephemeral evidence, I argue,
in the case of the diva archive, provides a significant amount of retrospective
access to performance and reception history and the political meaning of the
diva's iconicity. Paying attention to the fragmentary, performed, material, and
affective traces of these diva histories aids not only in understanding what took
place on the stage long ago but in constructing the overall import, significance,
and efficacy of the dance or performance then, now, and in the future. Queer
of color critique has theorized around these methodological conundrums
through concepts such as Muñoz's "ephemeral as proof" and through Harper's
answer to his own question, by valuing "the evidence of felt intuition."[17] Schol-
ars argue that such illusive evidentiary truths constitute a significant, if more
immaterial, record of meaning, an "archive of feelings" made up of "residues,"
and truths constructed through the force of accumulated collective felt experi-
ence from the margins.[18]

The recognition of these ephemeral and affective archives does the critical
and ethical work of seeing in these performances impulses of appearance as well
as forces of disappearance. And by conjuring appearance, in this case, I point not
to the face of the other's hypervisibility but rather to a recognition of the impulse
toward political will. Especially for the subjugated, who often exist outside in the
peripheries or are misrepresented or evacuated from official histories, queered
archival methodology produces a challenge to overarching theories of perfor-
mance as ontologically a space of nonreproducibility and disappearance.[19] This
book, therefore, considers how, when marginal subjects insist on performing
presence within dominant structures of (often forced) disappearance, that insis-
tence can be more than a liberal assertion of citizen-subjectivity. Rather, carry-
ing the weight of an insurgent act, such refusals that challenge scopic regimes
and negative racialized tropes interrupt the interlocking and multiply sited
scripts of racial power.

In addition to presence, *persistence* is another key term both for this project and for performance studies. Scholars have examined the quality of persistence in performance, using a socioanthropological lens to understand performance as any "twice-repeated" gesture. Joseph Roach elaborates on this idea by foregrounding surrogation and the ways that history can be conceived as performances that "transform invented pasts into gloriously catastrophic futures."[20] Surrogation, in this instance, stands against the forgeries of memory produced by power.[21] In *Moving Performances*, I address the politics of performance by examining each impulse—disappearance/repetition and persistence/surrogation/citation—as well as recognizing the limits of focusing solely on one impulse.

This returns us to the problem that opened this section, "In the Diva Archives"—that is, the problem of archive and artefact, liveness and record, performance and reception, and the attending methodological questions of how we know and by what means, especially in the face of material loss, absence, and distortion. I shared the story from the Holman archives because it highlights the ontological and methodological conundrum of lost sound and how it helped to shape and inform the theoretical premises of this book. If, as scholars or as consumers, or as fans, we aren't listening to or playing in the archive, or if the archive (understood as tangible, material, or official traces) and the repertoire (understood as ephemeral, embodied, or cultural practices) are not heard together, or the repertoire is ignored, forgotten, or misidentified, then the meaning of these figures (and the tropes, histories, and performances that accrue to their iconicity) is distorted, misrecognized, made illegible, and can, indeed, be lost forever. The concept of the "uneven archive of the diva" emerges here at the beginning, then, as a way to open up a discussion of a) the complexity of understanding any history made up of "disappearing acts"[22] (as performance histories necessarily are); b) the politics of how and why some performers, celebrated in their day, become erased in popular and scholarly memory; and c) how the recitation and other forms of "afterlife" of such performances contribute to our understanding of the significance and meaning of these performers and their cultural work as diva icons.

RETROACTIVATION: THE ARCHIVE OF AFTEREFFECTS

An initial impetus for this project was to examine how women and other marginalized subjects author new spaces for identity, and how they survive when they exceed the limitations established by social norms and categories. As I continued researching popular performers of this era, however, it became clear that while it can be difficult to reconstruct such ephemeral histories, the significance of these performers and their work could in part be illuminated by considering the aftereffects of their performances. These aftereffects include later

interpretations, iterations, echoes, and absences that offer a view into the past but also the present—and future—significance of these performances. Indeed, as the project developed, it became clear that although my initial interest was in how performers' geographical mobility produced social mobilities (and intransigencies) related to categories such as race, class, and gender during the modern period, *Moving Performances* is as much about the movement of these performers and performances—or, more accurately, their diva iconicity—across time. Thus the *moving* of the title signals the significance of the geographic, affective, and temporal movement of these performances.

I contend in this book that the substance of the diva's work exists not only in the ephemera left in the wake of her live performance moment (historical photographs, reviews, sketches) but also in the ephemera produced much later, in retroactivated reception, citation, and reenactments, which carry affective traces of earlier performances. This is a way to consider how what was produced at Siegel's "vanishing point" (in social history as well as in dance) also continues to be produced. Therefore, I look at not only how Overton Walker, Fuller, Holman, and Baker are (or are not) forgotten and displaced, becoming unevenly archived histories, but also how they are consumed, reproduced, and remembered differently over the ensuing decades. Roach's "surrogation" describes a similar process in the structures of social memory and collective processes of remembering, where forgetting and then rescripting characterize not only stage performances but rituals of everyday life.[23] I argue that even as they shape something new, the aftereffects or afterlives of diva iconicity are their own form of evidence. The diva's iconicity is produced as well as made legible and illegible in a field of aftereffects. The method I employ, as a means to resist a certain kind of epistemological refusal to know in the presence of literal and manufactured absence, is to examine the political meaning and social effects of performances as *retroactivated*. These moments of retroactivation can be found as the diva's iconicity is received and taken up in its myriad afterlives. The aftereffects produced by the diva's iconicity can insist on the legibility of meanings that have been otherwise obscured by political amnesias, whose ideological force is that of disappearance, even as the diva's labor is often one of appearance.

Yet the practices of recitation, remembering, and forgetting that comprise retroactivation work together to structure the affective archive through which performers' movements can be understood backward through time as well as forward. This moving temporality shapes the diva's iconicity as a set of effects compounding the racial and gendered logics of her time, and these movements become traceable genealogies of limits and agency. Building on theories of critical cultural recycling, I examine first how the performances themselves take up existing tropes (such as exoticism, primitivism, and orientalism) and controlling images (such as the femme fatale, the mulatta, the primitive, and the geisha)

that reinforce dominant ideologies (such as white supremacy and the civilizing mission) and rework them in ways that produce new meanings and potentially push back against existing power relations. I am interested, further, in how performers and audiences enact modes of critique and oppositional politics that can potentially disrupt existing social geographies and tropes meant, foremost, to reinscribe them within structures of oppression. I see this complex set of negotiations of reception and consumption as a circuit within which the diva's iconicity is made and unmade—responding to a larger context of violent social mechanisms that are the technologies of manufacturing race and gender.

One way to illustrate the significance of retroactivation is by returning to Aida Overton Walker's Salome performance that opened this introduction. Overton Walker was taking a risk in part because the role of Salome (who as a historical figure was Middle Eastern and Jewish) had already been co-opted by European and white dancers for performing orientalism and, as I argue in this book, for producing whiteness. Indeed, critics seemed confused about whether to interpret Overton Walker as a black woman performing a "white role" or as more authentically racialized relative to the historical Salome and to tropes of oriental otherness. Yet Salomania, the cultural craze, emerged not from the biblical Salome but from what I called Wilde's queer provocation—his own retroactivation of the biblical Salome as queer diva icon. When white female performers took up the role, that is, it was already retroactivated, and they were extending or even appropriating Wilde's reworking to suit their own purposes in creating a new space for gendering the modern. Overton Walker was further engaged in taking up the Salome-cypher as a tool for black women as cultural producers of the modern and as serious choreographic innovators. Even as Overton Walker took up this charged image and deployed it for her own purposes, the cultural memory of her intervention is uneven at best. She's still primarily remembered as the wife of George Walker and as a cakewalk dancer. As I discuss in chapter 1, this is in part the effect of the misreception of her work in her own moment, as well as of a critical failure to later retroactively account for the politics of her performance—a failure *Moving Performances*, like other more recent scholarship, is trying to rectify.

In examining these geographic and temporal movements through this assortment of contemporaneous performers, I take as a premise the knowledge-value of the embodied practices of these early twentieth-century divas and their shared impulse toward appearing as performers rescripting and critiquing the modern. If we allow for the remains of their work to be only retrograde and fetishistic, signs that they were dupes of the racist gaze or prisoners of historical circumstance, or to be merely spectacularizing "snapshots" of their stage performances, then we may miss the actual labor they were enacting. At the same time, it is important to register the failures of these performances to enact critique or

to interrupt the circuits of retrograde consumption. These latter moments are equally telling—and, indeed, the effects of illegibility and misreception operate not only in their historical moment (a constraint often figured as the deadening weight of past tropes) but also in the present, in the ways these performers and their iconicity are remembered and consumed today, especially through the powerfully anachronistic themes at work in the exoticizing tropes they deployed. The images most frequently invoked of divas on the modern stage are those that frame them in these spectacular ways, emphasizing their visual iconic status as emblems of gendered modernism: their female star quality; their sexualized and racist fetishization. Baker's most circulated iconic image is one that freezes her forever in time at the Folies-Bergère in a banana skirt, while Holman, when she is remembered at all, is invoked in a limiting camp style as a headline-generating, torch-singing temptress-turned-murder-suspect. Such framing of their star quality often places them squarely back within the retrograde repertoires of their own moment, figures of the modern zeitgeist nostalgically imagined in a fashion that fetishizes a romance with ideas of "modern primitivism" and "modern orientalism."

Indeed, one site of reception considered in *Moving Performances* is what I call the "nostalgic grotesque." As Joseph Roach cautions, "The authors of eyewitness accounts and other documentary sources on which historians depend were distracted from the cultural productions they observed by the skins not only of the performers but also of the witnesses." He classifies this particular effect as "deep skin." "The malignancy of deep skin," he writes, "usually begins with a blank space or a kind of erasure, which empties out the possibility of empathetic response."[24] This blank space is one of the workings of ideology that Cedric Robinson names "forgeries of memory,"[25] or those persistent distortions in the production and reception circuits that structure both antiblackness and white supremacy. Attention to the negative ideological processes of forgetting, erasure, and absence builds on the earlier theoretical terrain of thinking through performances. This includes foregrounding how attention to reception through the skewed and racist lenses of the performers' contemporary audiences and the mainstream press can then be protracted in the further distortions produced by our present-day "remembering practices." The nostalgic grotesque captures the dynamic by which racist tropes and performance repertoires persist through time. Crucially, the nostalgic grotesque identifies contemporary desires to inhabit a fantasied past where there is an imagined and idealized easy traffic in racist and fetishistic forms of reception and consumption.

In order to read against the grain of either dismissing the popular as a site of nonexistent or retrograde politics or reading the retrieval of meaning as impossible at the site of the ephemerality of performance, then, I take up the idea of retroactivation as a method for examining the significance of the ways divas and

their iconicity are remembered—as well as forgotten and rescripted—both in their own moment and then in ours. This method also suggests a meta-attention to the critical impulses to adjudicate performances in binary terms: as retrograde or innovative, assimilationist or resistant, complicit or radical, having or lacking agency, good or bad. Taking seriously the ways that the afterlives of performances—in the form of citation, repetition, and affective investment—can illuminate meanings obfuscated by time and by archival practices becomes part of my method of investigation. This method of paying attention to the past and the present as mobile, mutually constituting genealogies is a way of looking back and understanding these pasts as temporally dynamic objects of study. Finally, this approach also entails critiquing those very contemporary investments in the past as potentially instructive yet limiting nostalgias. That is, the manufacturing of the star or diva as a representative figure of her own moment, and, in this case, as engaged in the making of the modern, is itself imbued with deep nostalgias, as these past figures, or figures of the past, become expressions of twentieth and twenty-first century desires—for both another era and the imagined futures those earlier moments promise to call forth.

DIVAS!

Imperious, impetuous, "bitchy," boss, or fierce—the use of the term *diva iconicity* in the title of this book is intended to embrace the commonsense, popular, instantly recognizable notion of a female celebrity marked by these charged, often negative descriptors of female power. It also situates the work within a theoretical cluster of literatures within which the diva can be understood as feminist precursor and queer camp idol, but also minstrel. Divas are paradoxical figures who can evoke powerful attachments: marginal figures who are larger than life, whose lives or art are only available in fragmentary yet legendary ways, and whose effects can be obscure but lasting. Such figures require scholars and fans to ask how one comes to know through a field staged as spectacle as well as absence and disappearance, or viewed as "close up" yet at a distance.

Divas are objects of intense devotional activity, objects of affection and adoration. This adoration comes from the cultural permission the diva confers on the devotee, a tacitly uncensored permission to inhabit and script his or her own passions. Divas imbue their fans with diva power; divas disseminate their ability to stage unashamed negotiations and contestations between convention and transgression through highly public performances. The devotional intensity of diva reception, then and now, ensures these figures a queer afterlife—in other words, a persistence that works against temporal norms and possibly enables those elements of the diva's performance history that are vulnerable to illegibility to be unpacked.

Not all the figures I examine can fit neatly into the category of the diva as conventionally understood. Some might argue that they do not all qualify for that designation. But it is exactly that policing and production of the category that leads me to examine each of these figures in relation to the status of the diva, and to examine the production and failure of diva iconicity. The divas considered in this project engage their audiences and devotees through their struggles, failures, and achievements—whether in the figure of Josephine Baker performing onstage until the week she died, an iconic survivor and global star; Loïe Fuller ironically seeking legal recognition of the intellectual property of her work while mapping the limiting frameworks of orientalism onto her contemporaries; Overton Walker producing serious choreography in the midst of the cacophony of minstrelsy; or Holman trying to sound out a space to be heard beyond the limiting persona of a torch singer. "Divas," writes Alexander Doty, "offer the world a compelling brass standard that has plenty to say to women, queer men, blacks, Latinos, and other marginalized groups about the costs and the rewards that can come when you decide both to live a conspicuous public life within white patriarchy and to try and live that life on your own terms."[26] Taking up these figures, it is clear that divas (and diva worship) are far more than the sum of their parts. By focusing, therefore, on iconicity rather than icon, on the movement rather than the moment, *Moving Performances* captures the creative possibilities of these performers and performances in the spaces and times of diva reception and diva remembering.

In chapter 1, "The Color Line Is Always Moving: Aida Overton Walker," I elaborate how the orientalism of the Salomania dance craze functioned within the context of US race relations at the beginning of the century. Aida Overton Walker (1870–1914), African American dancer and choreographer, was a singular star of the early twentieth-century stage, celebrated internationally for her renditions of the cakewalk, and an innovator of the emerging American art-dance. Despite her political contributions to resisting the antiblackness of American theater, she remains an underexamined figure, eclipsed and omitted in many regards in the archive of memory and specifically in dance histories. Overton Walker produced two versions of the Salomé dance, just as Salomania took hold of New York. She performed across the color line, dancing through orientalist tropes as a means of being taken seriously as a choreographer and classical dancer. Critically examining the racist reception of Overton Walker's work in the press reveals how white audiences and critics figured her use of orientalism in different terms than they did her white contemporaries'. Using newspaper editorials written by Overton Walker, this chapter shows that she theorized race and performance implicitly and explicitly through her choice of material, her decision to write as a public intellectual, and her role as a teacher.

In chapter 2, "Transnational Technologies of Orientalism: Loïe Fuller's Invented Repertoires," I examine how Loïe Fuller (1862–1928), a white US expatriate, became a fixture of Europe's popular stage by juxtaposing futuristic technological effects with an imagistic and atavistic orientalism to produce images of the modern gendered body in motion. At the 1900 Paris Exposition Universelle, Fuller appeared onstage in tandem with the renowned Japanese actress Kawakami Sadayakko (1871–1946), among the first women to play leading roles in the Japanese theater. Whereas in Japan the Salome theme (and Oscar Wilde's play) became key to producing the idea of a new modern drama and staking a claim for women as actresses, Fuller managed and marketed Sadayakko's performances in Europe as fantasies of the Orient, echoing themes of *japonisme*. Fuller deployed orientalism as a constraint within which to present and frame the Japanese performers whose careers she briefly managed in the West. Situating these performers within tropes of orientalism that drew on imagined pasts, Fuller sought to amplify her own visions of future-forward modernisms, for which she sought recognition as an innovator and inventor. While Fuller is remembered as "Fairy of Light" and muse of art nouveau, her uses of technologies of race are the ideological blind spot of her romance with technology and visual illusion.

Chapter 3, "'Voices within the Voice': Aural Passing and Libby Holman's Deracinated/Reracinated Sound," argues that the singer Libby Holman (1904–1971) sought to create disidentifications with whiteness by playing with the idea of visual and aural "passing" while seeking to cultivate racial unlocatability over her lifetime and in two distinct careers. A torch singer exemplar in the 1920s, Holman then generated scandalous headlines as an impetuous socialite diva in the 1930s. She enthusiastically retold stories of a career-launching incident in which she "passed as black passing as white," but she later distanced herself from her Tin Pan Alley sound and career, reconstructing herself as a concert singer of a blues and folk repertoire and as a civil rights benefactor in the 1950s and 1960s. Both of Holman's careers were based on white appropriation of "black sound"— and her ability to engage in "aural passing"—but she also attempted to address and mitigate the social violence of appropriation through self-conscious autobiographizing, including the idea of "racial mobility" through sound performance, for the purpose of disrupting fixed notions of racial and sexual identity.

Holman enters the repertoire of queer camp memory as a vehicle for Mae West–like biting humor and cocktail-fueled queer repartee. Holman in her lifetime had indeed circulated as part of a gay smart set of wealthy socialites, among them Louisa Carpenter, her lesbian lover and heiress to the Dupont fortune, the gay actors Clifton Webb and Montgomery Clift, and the notorious couple Jane and Paul Bowles. Holman's tragic marriage to the heir of the R. J. Reynolds tobacco fortune and subsequent murder charge has been the stuff of tabloid journalism, Hollywood film, and contemporary queer theater. But those

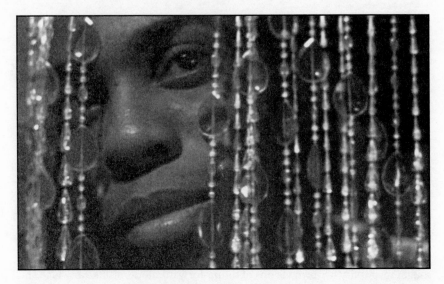

FIGURE 2. Lázaro Ramo as dos Santos in *Madam Satā*. Dir. Karim Aïnouz, Brazil, 2002.

particular remains of her diva iconicity have had limiting rather than liberatory possibilities and have deflected a more serious consideration and critique of the complex set of meanings generated by her onstage and offstage performances of race, gender, and sexuality.

Chapter 4, "'Much Too Busy to Die': Josephine Baker's Diva Iconicity," examines the complicated reception and retroactivation of the work of the African American US expatriate performer Josephine Baker (1906–1975), from her role as modernist muse to object of state surveillance to figure of contemporary nostalgia. Baker is best remembered for her risqué Parisian cabaret dances infused with primitivist themes, yet as a global star, she inhabited the roles of spy for the French Resistance, icon of transnational motherhood, and outspoken critic of US race relations. It was as a transnational antiracist activist that she became the object of FBI surveillance and US State Department regulation. Using the architect Darell Wayne Fields's graphic parody series "House for Josephine Baker" (2003), which deconstructs Adolf Loos's actual proposal for a "Josephine Baker House" (1928), the animated feature *Les Triplets de Belleville* (2003), which cites Baker's Parisian performances in its opening sequence, and the Brazilian filmmaker Karim Aïnouz's *Madame Satā* (2002), which treats Baker's *Princess Tam Tam* as it was screened in 1930s Rio de Janeiro, I show how contemporary points of remembering and reproducing Baker's image reveal the effects of the transnational circulation of her iconicity then and now, and further offer a means of understanding Baker's own critical practices as she reworked primitivism onstage and diva iconicity offstage. Geographic and bodily mobility both

succeeded and failed for Baker as strategies for performing against the negative tropes of black female subjectivity and creating antiracist discourses of the black body.

Finally, the conclusion of this investigation of diva iconicity offers a cautionary tale about the historical traumas that adhere in the traces of those performances. That caution or caveat is meant to be a productive way of moving forward by performing what Mae Henderson has called an "about face," a way to "bear critical witness and provide theoretical testimony to the historical trauma that is (re)enacted in the public (mis)performances [and] theorize a genealogy that will enable their transformation from voiceless objects of exchange and desire to speaking subjects."[27] The diva travels across borders and oceans, boundaries of space as well as time. The diva touches audiences and moves them in predictable as well as unexpected ways. The diva produces fans, imitators, and devotees. The divas I examine here traveled uncharted waters, forged new repertoires, and did so under enormous constraints that were material as well as representational and symbolic. They certainly also reproduced trite clichés, circulated within economies of imitation and repetition, and participated in sedimenting negative tropes and toxic archetypes.

For some, their work has remained center stage long after they died; for others, their contributions are oddly tenuous, yet nonetheless significant. Despite this uneven archive and the differing legibility of their contributions, the varying ways that their repertoires persist, as I argue here, indicate not just how an individual figure (a diva, a star) is remembered but also the myriad ways that the practices of performance, reception, and remembering compose the iconicity of the modern diva. Diva iconicity is a fulcrum, a point on to which to pivot, turning to forge a future while facing the forgeries of the past.

1 ⁑ THE COLOR LINE
IS ALWAYS MOVING
Aida Overton Walker

Aida Overton Walker (b. Ada Wilmore Overton, 1880–1914), African American vaudeville singer, dancer, and choreographer, was a celebrated star of the early twentieth-century transatlantic popular stage and a central figure in what James Weldon Johnson calls the "middle period" for African American theater in the United States, a time of resistance to minstrel forms and a period of growth and development of African American cultural production, writing, black theater management, and performance.[1] Overton Walker was an innovator in this scene, an originator of the American genre of art-dance, a developer of modern dance, and a teacher-mentor who sought to better working conditions and expand roles for black women on the stage. Photographs of Walker show a self-possessed international star seated at the threshold between the Victorian and the modern (figure 3). She was renowned in her day as a singer, dancer, choreographer, musical comedienne, and teacher, her name was a "household word" in the United States,[2] and she became internationally recognized for her renditions of the cakewalk. When she died at the age of thirty-four in New York City in 1914, her funeral was considered "the largest ever held for a woman of the race," and obituaries proclaimed her "the Dancer That Dignified the Profession."[3]

Overton Walker had contributed to building a performance repertoire for herself and other black female dancers that was original and produced a kinesthetic counterdiscourse to or critique of the comic, alternately hypersexual and asexual, degraded tropes that dominated representations of black women in the previous century and on the minstrel stage. Yet she remains an underexamined figure, overshadowed in scholarly and popular memory, in dance and social histories, by her white contemporaries, notably Isadora Duncan (1877–1927) and Ruth St. Denis (1879–1968), the "mothers of modern dance,"[4] but also by the groundbreaking black diasporic Caribbean- and African-inspired modern

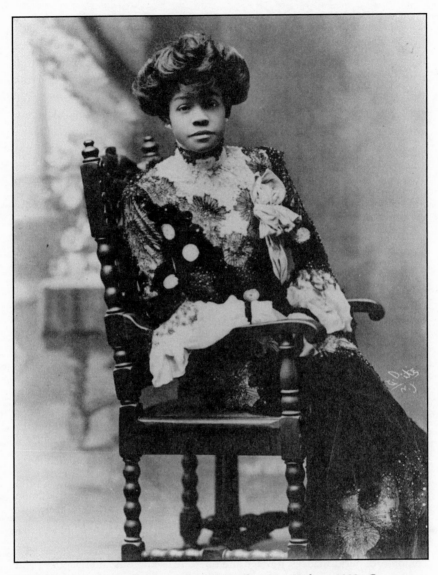

FIGURE 3. Portrait of Aida Overton Walker. E. White, New York, ca. 1900s. Courtesy Schomburg Center for Research in Black Culture, The New York Public Library, Astor, Lenox, and Tilden Foundations.

dancers and choreographers who emerged in the ensuing decades, such as Katherine Dunham (1909–2006) or the Trinidadian-born Pearl Primus (1919–1994), and, finally, by the more prominent careers of her husband, George Walker (1873–1911), and his renowned comedic stage partner Bert Williams (1874–1922), who were among the highest-paid black performers of their era.[5] Since the 1990s,

scholars have begun to recognize Overton Walker's important and lasting early contributions to transforming the American and international stage as a space for black women as cultural producers and innovators. David Krasner's work on African American theater during the Harlem Renaissance brought Overton Walker's career into visibility. Scholarship by Susan Curtis, Susan Glenn, and Cedric Robinson, as well as the earlier work of Jo A. Tanner, has enhanced our understanding of Overton Walker as a key contributor to black musical theater traditions and sociopolitical histories.[6] And as black feminist scholars such as Daphne Brooks and Jayna Brown began to seriously examine her contribution to both the cakewalk and the Salomania dance craze phenomenon, they brought her impact on black feminism and the gender and sexual politics of the modern era into greater focus.[7] Through this relatively recent nexus of scholarly work, Overton Walker has begun to receive well-deserved attention in the scholarly and historical archives of modern dance, choreography, theater, performance, and race and gender studies, though beyond specialists and the academy, she remains an unfamiliar figure. In her day, she was an iconic star, a diva of the international stage and a prominent leader in the community of Harlem. But in the twentieth- and twenty-first-century contemporary imagination, if she remains iconic, it is often in an anonymous way, frozen in time in a few photographic images of the cakewalk, emblematic of an era, but abstracted from the person.

With this absent presence as a crucial backdrop, in this chapter I foreground the significance of Aida Overton Walker's performative politics of race as an African American itinerant performer. She drew attention to the way Jim Crow and racism in the United States demanded particular embodiments of the black body—ways of moving and not moving, spaces to occupy and not occupy—and authorized which tropes were naturalized as "proper" to black bodies. Race, she understood, is constructed at the level of the body and geography; power demands that bodies perform according to certain social scripts, whether these are registered directly in and as rules, codes, and laws that enforce racial segregation, or in and as performative repertoires of expectations, social blueprints, cultural practices, and so forth that regulate social identities and bodies. These compulsory performances, onstage and off, were ubiquitous and relentless, and she directly addressed and protested them through her performances. Her cultural production onstage was augmented by the cultural critique she offered as a public thinker, in newspaper editorials that addressed racism and discrimination. Bringing the effects of racial power into view by responding to the injustice and social violence of these cultural mandates, she further articulated the added labor of critique required of black performers and of black people moving as social actors through the public sphere. She produced these critiques through her choice of theatrical material and in her own modes of embodied critical practice onstage, including teaching and making visible new approaches to dance,

movement, and political embodiment for black women. She thus resisted the limits placed on black bodies by producing a variety of public discourses that, in different registers, critically analyzed the impact of US racism on black people and black performers who labored on segregated, predominantly white-owned and white-managed national theater circuits. Aida Overton Walker's significant yet all-too-brief career demonstrates the political complexities embedded in popular dance performances. Popular dances like the Salomania dance craze and the cakewalk could easily be dismissed by her contemporaries and later by twentieth- and twenty-first-century critics as merely "cheap amusements" rather than political interventions.[8] The result is that black feminist thought, especially that conveyed through moving embodied practices, could be erased and hidden from view in the archive and in the myriad ways that the modern stage is remembered.

In the late nineteenth century, emerging as a popular routine on the blackface minstrel stage, the cakewalk became a fad onstage and off, on both sides of the Atlantic, among blacks but also among whites who imitated or wanted "to learn" what was seen as an exaggerated yet "authentic" black dance. The dance did in fact emerge from black slave dances, parodically imitating the pretentious manners of white plantation slaveholders.[9] When Carl Van Vechten, a white patron of the Harlem Renaissance and *New York Times* dance critic, recalled seeing Aida Overton Walker and George Walker dance the cakewalk, he described "the line, the grace, the assured ecstasy of these dancers, who bent over backward until their heads almost touched the floor, a feat demanding an incredible amount of strength, their enthusiastic prancing, almost in slow motion," and said that they "have never been equaled in this particular revel, let alone surpassed."[10] Aida Overton Walker became famous in her day for performing and teaching the cakewalk to white audiences, a fame that carried her to Buckingham Palace. White audiences enamored of Overton Walker's grace while dancing the cakewalk appeared not to register the parodic genealogy of the dances, nor the irony of whites adopting a popular "imitative" minstrel form and then promoting it as an imagined black "authenticity."

In addition to her renown for performing and teaching the cakewalk, a social dance, one of Overton Walker's most notable solo contributions to dance was her rendition of the Salome dance. The Salome dance was also a craze among white audiences, but read on a different register than the cakewalk. Overton Walker produced two versions of the popular Salome dance, just as the Salomania craze took hold of New York. Her renditions of this solo dance in 1908 and 1912 were patronizingly hailed in the press as "the first time . . . that a colored artist has ever attempted to execute classic dancing."[11] While only limited and grainy footage of her cakewalk performances exists, there is no moving record of her Salome dance. Instead, newspaper clippings from the US white mainstream press, black press, and popular theater journals,

as well as newspaper reviews from the United Kingdom, make up a print record that provides considerable insight into the critical and popular reception of Overton Walker's work in her day.

My analysis in this chapter of the critical reception of Overton Walker's Salome dance focuses on what that print history reveals about the contours of the color line that Overton Walker negotiated through her performances. W. E. B. Du Bois described the color line as a "prison-house" and "veil" of misperceptions, presciently declaring that "the problem of the Twentieth Century is the problem of the color-line."[12] And as Siobhan Somerville's work in *Queering the Colorline* elaborates, "Because existing cultural stereotypes of African Americans were largely sexualized, the new discourse of sexual pathology was intertwined with racialized images."[13] Examining the contours of this deeply raced and sexed color line is critical not only to understanding the sexual politics of the stage in 1908 but to recognizing the persistence of the color line in dance today, one of the factors contributing to the eclipse of Overton Walker's diva iconicity in the annals of dance history.

In the sections below, I outline two of the historical-cultural lineages that entwined when Overton Walker performed her Salome dance: first, the history of Salomania as a transnational cultural phenomenon, and then the black vaudeville context in which Overton Walker's performances occurred, and specifically her performances as part of the Williams and Walker team. I then turn to Overton Walker's Salome dance and its reception in the mainstream and black presses. The orientalism of the Salome dance triangulated the black-white binary of white supremacy because orientalism performed across the color line added layers of meaning to both Overton Walker's performances and the reception of those performances. Among other effects, it ultimately rendered Overton Walker's Salome dance illegible to white audiences and revealed the persistence of the power of whiteness at work in the orientalist fantasy of Salome and the Dance of the Seven Veils. These performances and their reception involved processes of racialization that, in turn, informed the afterlife of Salomania, reinforcing the persistence of its racialized effects.

"ALL SORTS AND KINDS OF SALOMES"

"All Sorts and Kinds of Salomes," announced the title of a 1909 illustrated article by Harriet E. Coffin in *Theatre Magazine,* which was accompanied by images of eight different Salome performers (absent Overton Walker).[14] Coffin's opening sentence added the caveat: "Salomania is not a new craze." The transhistorical Salomania craze offers a useful case study about how diva iconicities work within sedimented histories of racialized and gendered performance practices. These deposits mark the accumulation and persistence over time of certain visual and

performance tropes of representation and reception. But they can also reveal opportunities for critical reiterations that expose the various apparati producing this layered geography. For instance, the performance of orientalism through the figure of Salome, which was intimately tied to the cultivation of the emergent figure of the modern diva or female star, turns out to be a means of inhabiting and then upending raced and gendered femininities and sexual and social identities. Western women appropriated what had been a pervasive nineteenth-century patriarchal colonial fantasy of feminine evil, the racialized, sexualized figure of the femme fatale, activating the experimental display of their bodies. Their performances of Salome and her famous Dance of the Seven Veils were designed to create a new repertoire of gendered modern possibility. The space that created that possibility existed at the intersection of sexual scandal and racial otherness. However, for performers who were racialized others, that "new repertoire" of gendered modernity had to be produced by working through and against the racialized apparatus that shaped notions of the modern, both at the sites of performance and of reception.

Salome appears in the Bible, but her name is never mentioned, nor is her dance described. Clearly, however, the story of the stepdaughter who danced before King Herod and then demanded the head of John the Baptist was captivating enough to make both the figure and the dance she performed ubiquitous in Western art and literature, mythology, and poetry.[15] It was indeed, as Coffin noted, "not a new craze." By the later nineteenth century, the figure of Salome was firmly established, in predominantly misogynistic terms, as the femme fatale par excellence in a pantheon of images of evil, vengeful, devouring, phallic, and monstrous females that included Medusa, Pandora, and Judith.[16] The figure of Salome was made iconic as the static decadent muse of Gustave Moreau's *Salome Dancing before Herod* (1877), a painting in turn made famous by Joris-Karl Huysmans in the decadent novel *À rebours* (1884). But then, in 1891, Oscar Wilde wrote his symbolist drama, *Salomé: A Tragedy in One Act*, taking up the biblical narrative for his own queer purposes and making Salome's dance central within the otherwise repetitive inaction of the play. Wilde described Salome's dance only in parenthetical stage directions—"(Salomé dances the dance of the seven veils)"—but this very minimalism worked as a kind of queer provocation, creating a space implicitly intended to be filled with invention and daring.

Wilde's *Salomé* was notorious not just for its content but for the scandal with which it became associated. The piece was banned from the English stage in 1892 for its use of biblical material (considered taboo for the stage), even as it was in rehearsal with the famous actress Sarah Bernhardt (1845–1923) slated as the lead, and by the time it was first performed, in Paris in 1896, Wilde was in his ninth month of a prison sentence on charges of gross indecency.[17] The confluence of the play's banning and the publicity generated by Wilde's trial and imprisonment

sealed the indelible association of the Salome narrative with queer scandal, turn-ing a misogynistically charged biblical icon into an erotically charged icon of dec-adence and daring. Partly because of the notorious difficulty of staging Wilde's play, the most popular version of Wilde's *Salomé* was—and remains—Richard Strauss's operatic rendition, which premiered in Dresden in 1905.[18] Although widely performed in Europe, when the opera traveled to the United States to premiere in 1907 at New York's Metropolitan Opera, it was banned after a single performance.[19] In the wake of these scandals, Salome became part of an early twentieth-century popular repertoire of femme fatales, evil women, disobedi-ent daughters, and modern bad girls that proliferated as gendered and racialized specters of faltering nineteenth-century colonial powers and patriarchy.

As it was taken up by modern women performers, the figure of Salome and her signature dance was viewed alternately as "classical," a marker of high art aspiration, given the long-standing treatment of Salome as a theme in European high culture, and as "cheap," given its association with scandal and brazen sexual provocativeness (and indeed, it was later credited as the genesis of the American striptease genre). Salome began to become a signature piece for ingenues aspir-ing to become female stars. In 1906, inspired by Wilde's play, the Canadian-born dancer Maud Allan began performing an enormously popular European music-hall dance routine, "The Vision of Salomé." In the United States, the Met's prima ballerina, Bianca Froelich, slated to dance the Dance of the Seven Veils, reacted to the opera's banning by taking her dance to the Lincoln Square Variety Theater, while Mlle. Dazie capitalized on the publicity of that scandal by performing a satiric rendition of the Met fiasco for Florenz Ziegfeld's first show, *The Follies of 1907*.[20] Whether staged as a solo routine in the classic or concert tradition, or as the fodder for vaudeville or comedic sketches, stylized versions of the apocry-phal Dance of the Seven Veils were, by the time of Aida Overton Walker's 1908 performance, a transnational vehicle du jour for public expressions and staged performances of modern race, gender, and sexuality. The potentially polar-ized reception ("bad" or "good," cheaply imitative or original, daring or risqué, experimental or high art) becomes one of the "afterlives" of this era of burgeon-ing female stardom, constructing the field of reception as a dichotomous mode of critique for critics and audiences alike, operating as arbiters of female perfor-mance, a mode of entitlement to stand in judgment that continues to shape the reception of the diva.

Originating around the same time as the European version of Salomania, the version of the craze that took shape in the United States, and that Overton Walker ultimately engaged with, celebrated and generated new forms of US ori-entalism. Salomania as US orientalism wove together visual elements and perfor-mance practices derived, on the one hand, from nineteenth-century European painting, European literary high modernism, and opera—the Wildean lineage

outlined above—but also, on the other hand, from orientalist tropes honed in the United States. One key source of US Salomania was the 1893 Chicago World's Fair, which included traveling regional dance troupes from Turkey, Algeria, and other colonial regions who performed at least three dances that, according to the dance instructor and historian Donna Carlton, may have inspired the Salome dance.[21] The Midway Plaisance, where the dances took place, became one of the most popular attractions of the fair, drawing millions of visitors.[22] The apocryphal belly dances of the legendary performer "Little Egypt," who, rumor had it, had saved the fair from low attendance and bankruptcy by drawing crowds with her shocking rendition of a *danse du ventre*, or belly dance, are credited as originating both the American Salomania craze and the genre of striptease. Although some researchers have concluded that there is no evidence of an actual individual performing as "Little Egypt" at the fair, what is clear is that her effects were real—even if she was not.

As the fair closed, managers and performers seized upon the marketability and profitability of these international racialized entertainment spectacles. Taking these seemingly novel acts and imitations of them on tour in the United States, they contributed to the growth of the American sideshow, circus, and midway traditions. The dance, which varied from performer to performer, was described as combining the twirling of scarves or "veils" with sensuous hip-shaking that built to an energetic climax, ending in dramatic, spent collapse. Described in this way, it was clearly a metonymic staging of female sexual climax. Traditional dances, severed as they were from their social and cultural context, were displaced onto the entertainment stage and pooled into a single invented genre of so-called sensual dances, which were in turn entwined with African American traditions. The choreography of the Salome dance has, therefore, been seen by contemporary dance scholars and by dancers as a derivation of the both the *danse du ventre* and the "hootchy-cootchy" dance.[23] The *danse du ventre* was the French colonial name for Middle Eastern and North African sensual dances, but it was used in the United States to describe a whole range of "belly dances" only loosely derived from any of these dance traditions. The term *hootchy-cootchy* at the time referred both to orientalist dance forms and to African American social dances such as the hooch-ma-cooch popularized in New Orleans's Congo Square in the early 1900s, evidencing again how the two forms become mutually constitutive.[24]

As it evolved in its "homegrown" US form, the Salome theme, then, drew on international geographic circulations of meaning and performance as well as local practices and influences. Salomania meshed together the iconography and reception practices of American minstrelsy, vaudeville, and Jim Crow with those of European modern primitivism and orientalism, putting the imperial expositions to unusual effect on the domestic stage. In other words, the Salome dance

is expressive of an invented genealogy comprised from an invented archive. And audiences were invited to look under the guise of a lay ethnographic eye, cultivated by the fair, which laid claim to consuming sensuality through a pseudoscientific gaze, providing an alibi for the licentious and racist eye.

Passing themselves off as "Little Egypts" to eager consumers of exotic orientalist performances, women performers specifically capitalized on the legend.[25] While some of the women who adopted the pseudonym were traveling or immigrant performers (some of whom even performed at the original World's Fair), increasingly it became Anglo women who presented these dance routines— including many young women from the US Midwest looking for new economic and cultural opportunities along the thriving theater circuits. This was an era when performers literally substituted the white body for the bodies of traveling international women performers and colonial subjects. Therefore, the Salome dancers who continued to make the dance a recognizable fad were almost exclusively white dancers who presented themselves as objects of an occidental gaze educated by the World's Fair in the consumption of exotic bodies.

In this respect, Salome dancers were performers of "racechange" and worked in the long arc of other racialized entertainment traditions in the United States that both preceded and were contemporaneous with their own performances, namely blackface minstrelsy and yellowface.[26] In early twentieth-century Salomania, the coupling of the provocative representation of the oriental body with the image of the femme fatale—both signs of threatening, dangerous femininity—served to heighten the overall impression of sexual danger. At the same time, the figure of the femme fatale gave performers license to project a hyperfemininity imbued with power, indicating a certain control over the display of the body and over the consuming gaze directed toward it. The incitement of performing racial difference was in part the sense of proximity to hypersexuality that it brought. These racechange performances were an alibi to publicly perform an emboldened female sexuality, all the while maintaining and reinforcing racial hierarchies. This license to kinesthetically express gender and sexuality was imagined as authorized by the guise of racial and sexual otherness. In addition, this was tied to a more general "permission to experiment," comparable to the uses of primitivism by early twentieth-century high modernists, who, for instance, borrowed geometric lines from African sculpture, or organic design and color from Japanese printmaking, and used these cultural appropriations as signs of aesthetic experimentation, solidifying their purchase on both artistic authority and claims to innovation.[27]

Further, the racechange performer's perceived ability to move in and out of racial embodiments signaled a level of freedom and control over any dangerous proximity to being fixed in that racial category. The mobility of racechange allowed such performers to consolidate their whiteness while appropriating

the resources attributed to racial others, including choreography, movement, and proximity to sexuality and creative impulse. The marking of racial difference through racechange performance is meant as a sign of a kind of choice and agency in relation to the production of racialized sexuality, yet it functions ultimately to reinforce the conception of whiteness as a space of freedom from race.

To understand the significance of Overton Walker's Salome dance and its reception, it is important to recognize the ways in which white Salome dancers were reinforcing and generating the color line in dance, and specifically its gendered and sexualized manifestations, by evoking both orientalism and, to various degrees, primitivism. They engaged these racialized tropes as signifiers of social transgression and self-making. Ultimately, artists rendered the dancing Salome figure as a racialized sexual object—but they did so in order to enhance their own agency, authorship, and artistry as performers. For Overton Walker, making a similar claim to authority and artistry was likely a critical part of the Salome dance's appeal, especially because such a claim by an African American woman also constituted an intervention in both the racist and sexist politics of the stage. Overton Walker introduced her Salome dances at a moment when the figure of the female star consolidated as a recognizable and marketable category. Her performance would interrupt the proliferation and exclusivity of white dancers performing racialized otherness and disturb the histories of racial exclusion and distortion that monopoly signaled in defining the popular stage. Her Salome dance came at a time when black theater companies were mounting resistance to white management, racist performance circuits, and vulgar repertoires. In the next section, I consider the political work being done by black actors on the stage in the middle period of black theater and the social struggle within which they labored, as the context for understanding Overton Walker's work. I then return in the last section to Overton Walker's Salome performances, to consider how they were received and how they contributed to that black tradition of critique and resistance in theater.

IN THE COMPANY OF WILLIAMS & WALKER

The Salomania rage occurred at a time when the intense threat of violence to black people under slavery was directed, post-Reconstruction, at terrorizing black people, communities, and businesses through lynching and race riots. Lynching remained a prevalent mode of social control in the South, with at least eighty-nine black Americans lynched during the year of Aida Overton Walker's first Salome dance, in 1908. That same year, northern whites targeted black communities in escalated racial violence. In August, for example, there was a race riot in Springfield, Illinois, during which angry working-class white mobs, dominated by Irish immigrants, attacked black residents and destroyed black

businesses after hearing that a black man had been accused of sexually assaulting a white woman. The intensity of racial antagonism was rationalized in part by anxiety about miscegenation in the vice districts of the capital. Such projected anxieties were further fueled by Thomas Dixon's best-selling novel *The Clansman*, which became D. W. Griffith's *The Birth of a Nation*. A dramatic version of the novel had a successful national tour just a few years before the riot, proliferating the hateful image of black male danger and animality set against the specter of white female vulnerability, a cultural mythos that underlies Jim Crow segregation laws and flips the truth of the systemic rape by white masters of black female slaves under chattel slavery into reverse.

Dramatic economic shifts, the failures of Reconstruction in the South, and the rise of antiblackness contributed to the Great Migration of over two hundred thousand blacks from the rural South to northern industrial cities between 1890 and 1910. Urban employment for black women in the North was primarily in domestic service and low-paid industry jobs, with teaching emerging as another alternative. Given those limited employment possibilities, theater and performance became one potentially accessible, and potentially lucrative, source of work for African American women. Although still a suspect choice of occupation for aspiring middle-class women of any race—one viewed as dangerous to their reputations—the stage could also offer working-class women economic self-sufficiency. As Hazel Carby emphasizes, vaudeville not only was an important "avenue of geographic mobility for young black women" but also offered the "rare opportunity to do 'clean work' and to reject the life of a domestic servant."[28]

The migration also brought people north in search of a progressive political voice, black community formation, and cultural enterprise. Black migration and the establishment of new African American communities in northern cities contributed to the New Negro movement, a black cultural and political surge most commonly identified in terms of the literary and cultural production of the Harlem Renaissance of the 1920s. Although Harlem has come to stand in for a specific moment of black cultural productivity, including cultivation of black arts, black theater, and the black press, the renaissance flourished and expanded in many northern cities and was gaining momentum well before the 1920s. These cities, including Washington, Baltimore, Philadelphia, Detroit, St. Louis, and Chicago, were also the staple of the emerging black theater circuits in the North. In addition, while most African American performers were prohibited from touring on white vaudeville circuits, circuits like the white-organized Theater Owners Booking Association (TOBA, also known as the Chitlin Circuit) promoted black performers to black audiences. Through TOBA, black companies toured white- and black-owned theaters in the South, Southwest, and Midwest. But the circuit infamously mistreated its performers and only paid its top-billed acts well. Companies of about thirty-five people performed multiple

shows nightly; the theater conditions were often poor, and housing conditions were worse. In addition, the threat of racial violence, racism, and discrimination in the communities to which they traveled was unpredictable and ever present.[29] In the northern United States, a handful of white producers began to feature and capitalize on African American performers and companies in urban white venues, while some whites themselves began incursions into predominantly black social spaces, a practice referred to as *slumming*. However, the threat of antiblack violence persisted even as white audiences and critics were ostensibly becoming increasingly amenable to black cultural production.

Many African American companies augmented US tours with overseas engagements in Europe and Russia, where their working conditions and treatment were sometimes better. Overall, however, reception of black performers even when they moved across national borders and into different venues remained essentializing, primitivizing, or exoticizing, although channeled through discrete, but related, discourses of racial difference.[30] Geographic movement meant that performers were performing blackness in relation to specifically located histories of structural systems of racial power and the ways of seeing they produce—colonialism, slavery, empire, Jim Crow. Yet this experience of performances moving across, through, and away from these systems was cut through by the inescapable persistence and fixedness of tropes of antiblackness. The dissonance created by performing blackness across spaces where antiblackness was naturalized and universalized but also carried local specificities is captured in the literature of the era, which describes the very different, even conflicted, meanings attached by black and white audiences at home and abroad to performances by African Americans as these individuals and troupes traveled the world.

Vaudeville (1880s–1930s) was a genre that combined acts made up of earlier entertainment forms, including minstrelsy, variety traditions, road shows, circus acts, and dime shows. This "middle period" of black theater, as Johnson referred to it, marked a moment when black actors made "the first successful departure . . . from strict minstrelsy" and were able to form the first black repertory companies in New York, like the All Star Stock Company, where "a group of coloured performers were able to gain anything approaching dramatic training and experience on the strictly professional stage."[31] Bob Cole issued his famous "Colored Actors' Declaration of Independence of 1898" as a call for African Americans to write, produce, and perform for black audiences.

Until that call, from about 1879 to 1890, black women had been limited to stereotypical "Topsy" and so-called plantation roles, whose proliferation was heightened by the popularity of *Uncle Tom's Cabin*. The growth of black musicals in the 1890s represented a shift in the terrain of possibility, offering women more engaged stage roles (as well as positions as theatrical producers) outside of the limiting conventions of blackface minstrelsy. Troupes like the Whitman

Sisters were at the forefront of efforts to desegregate theaters, fight corruption in the entertainment industry, and promote black women.[32] This shift for women was decidedly marked by *The Creole Show*, whose famous rendition of the cakewalk is specifically credited with spurring the cakewalk dance craze—although, as Jo A. Tanner notes, *The Creole Show*'s legacy was also "a disservice to black women performers: It helped to foster and preserve the 'lightskinned' woman image over the years."[33]

Thus, new audiences and the rise of national management consortiums for both black and white performance circuits meant rapidly changing forms of entertainment and venues.[34] White attendance at black venues, as noted above, coincided with an era of ongoing white racial violence, and it is important to note that those changes were inflected by anxieties about gender and sexuality. Northern cities overall experienced the emergence of mixed-gender, working-class leisure practices that produced social spaces for racial mixing and the mixing of "normal" and "queer" communities, to use the language of the era.[35] Carby has argued that it was specifically "the movement of black women between rural and urban areas and between southern and northern cities [that] generated a series of moral panics." That is, white racism constructed moral panics around these mobile black women, who were characterized as "sexually degenerate" and "socially dangerous" and, therefore, in need of social regulation. This perceived need to "police" black women's bodies, to use Carby's word, was taken up by both white and black social reformers. And it was "the dance hall and the cabaret" that, according to Carby, were "the most frequently referenced landscapes in which black female promiscuity and sexual degeneracy were described."[36]

Into this complicated historical moment and cultural scene, Aida Overton Walker emerged as a young performer. She began her career performing with Sissieretta Jones, known as "the Black Patti," and the celebrated Black Patti Troubadours (formed in 1896). She met her future husband, George Walker, in 1898 when they both posed for a cigarette advertisement, and she went on to become the primary choreographer for the Williams and Walker revues. She was, therefore, not merely the partner of Walker but central in contributing to the company's collective efforts to move away from conventional comic and blackface-inflected routines and to produce original black-cast theater revues and dance numbers.

Pioneers of African American comedy and theater, Bert (Egbert) Austin Williams (1874–1922) and George Walker (1873–1911) had met in San Francisco in 1893 and were first employed by the Midwinter Exposition in Golden Gate Park at an exhibit of a Dahomeyan village. Reportedly, their "stage break" came when the scheduled African performers were late arriving and Walker and Williams went on in their place. After the Midwinter Exposition, they joined and were then quickly dropped from the African American company Isham's Octoroons,

who were also breaking away from the minstrel format. Walker and Williams then billed themselves as "the Two Real Coons," with Williams donning burnt-cork blackface, but the title's use of *real* was also designed to signal a move away from the degrading portrayals of minstrelsy produced by whites. They became regulars on the vaudeville circuit and continued to seek ways to move away from blackface constraints even though the genre proved lucrative for them, especially drawing white audiences.[37]

Williams and Walker's performances embody the contradictions of performing at the turn of the century when (white) blackface performance existed as the first national popular entertainment,[38] yet momentum was building toward the production of theater produced, written, and directed by black professionals. It was not uncommon for African American performers to use burnt cork to "black up" as minstrels in order to make a living in theater, as Williams and Walker did, but their work is important for the ways they negotiated and criticized the use of racist forms like blackface and sought to undo their oppressive hold on African American performers.[39] They performed a complicated dance with and against the toxic tropes trafficking on the American stage.

Among Bert Williams and George Walker's most popular and well-known vaudeville acts were *Clorindy, the Origin of the Cakewalk,* one of the first black shows to succeed with white audiences (1898),[40] *Sons of Ham* (1900), and a trilogy of shows that invoked "back to Africa" themes. Of the latter, two were set in Africa, *In Dahomey* (1902) and *Abyssinia* (1906), with a third, *Bandanna Land* (1908), set primarily in the United States but including themed numbers such as "Ballet, 'Ethiopia.'" A collaboration with Will Marion Cook (music), the poet Paul Lawrence Dunbar (lyrics), and Jesse Shipp, *In Dahomey*, which was funded by white investors, became the first full-length black musical comedy produced for Broadway. Playing to a black-and-white audience, albeit with blacks consigned to the three upper balconies, at the New York Theater in 1903, the production turned a huge 400 percent profit.[41] The company then traveled the United States by train "with a banner stretching the length of the car that read 'Williams and Walker Company.'"[42] With this success, the important black theater critic Sylvester Russell in the *Indianapolis Freeman* hailed Aida Overton Walker as the "greatest coming female comedy star of her race."[43]

It was *In Dahomey* that secured Overton Walker's status as a US and international star (figure 4). The domestic success of *In Dahomey*, which with over 1,100 performances was their longest-running show, meant that the company, including Aida Overton Walker, was able to sail on the Cunard line to tour England and Scotland. With a large cast, they toured for seven months in 1903, taking the show and their famous "cakewalk" to Buckingham Palace for the Prince of Wales's ninth birthday, generating some of the most enduring images and accounts of Overton Walker's dancing. Even before the company's arrival, the

FIGURE 4. Aida Overton Walker in *In Dahomey*. Cavendish Morton, platinotype print, 1903. Courtesy National Portrait Gallery, London.

cakewalk was a popular entertainment in England, and Overton Walker was already famous for her rendition of it in the United States. She had performed and taught the dance to white high society there, but this tour made her internationally famous for the cakewalk, which became a society craze in London and Paris, as, again, white audiences were excited by the prospect of consuming an "authentic" version.

Although *In Dahomey* was widely popular, and the cakewalk all the rage, the show was not received with the same enthusiasm in the black press. Featuring songs sung by Overton Walker such as "Evah Dahkey Is a King" and "I'd Like to Be a Real Lady," the show simultaneously reproduced racist tropes of black primitivism and imagistic stereotypes of black ignorance while invoking (albeit comically) discourses about pan-Africanism and diaspora.[44] Black reviewers took the playwright, Jesse Shipp, to task. For instance, in a review for the *Freeman*, Sylvester Russell wrote, "There is not a literary merit to be found in a band of American Negroes taking a trip to Dahomey merely to bluff the people around them after they get there. We must remember that we belong to an oppressed race ourselves and Jesse Shipp must scratch his head and write the third act over again."[45] These reviews highlight that although "Evah Dahkey Is a King" and "I'd Like to Be a Real Lady" spoke to the structural effects of discrimination in the United States, they did so while at the same time undercutting those very critiques by parodying their truth value, and perhaps at the expense of representations of Africans or blacks in the diaspora. For instance, "Evah Dahkey Is a King" spoke to how the slave trade stripped blacks of their kinship ties to communities, as well as taking wealth, property, citizenship rights, language, and personal and political sovereignty. However, the lyrics also functioned to make the audience laugh at the ludicrous possibility of any claim to African ancestry that would ever make "every" or even any black man a king.

Expanding the roles for women onstage, but still relying overall on controlling images of blackness, Williams and Walker's next show, *Abyssinia* (1906), also created by Jesse Shipp with music by Cook, had a cast of over twenty chorus girls and, importantly, principal parts for women, including Aida Overton Walker. It was the second Williams and Walker success and opened at the Majestic Theatre at Columbus Circle. One newspaper review, possibly even written by the influential black reviewer Lester A. Walton, notes that *Abyssinia* was "a product from beginning to end of Afro-American enterprise and ability, but unfortunately for the piece the inspiration was largely caucasian."[46] The reviewer in this instance is critiquing the show for being written and directed toward white consumption, even as it was produced by and for African Americans. These shows evidence that there was a market in vaudeville for African Americans performing blackface minstrelsy in juxtaposition with tropes of colonial primitivism through blackface. This reiteration or multiplied reproduction of racialized fantasies

produced strange effects: white atavistic fantasies of an imaginary "Africa" were satisfied by watching diasporic subjects who performed both "native informant" and race traitor. Yet George Walker made public the distinction and direction he desired for black theater and is quoted in a newspaper review as saying, "It's all rot, this slap-stick bandanna hand-kerchief-bladder in the face act, with which negro acting is associated. It ought to die out and we are trying hard to kill it."[47]

Bandanna Land, the third of Williams and Walker's "back to Africa"–themed productions, was also the theatrical setting for introducing Overton Walker's Salome dance.[48] It would be Williams and Walker's last show together: a year later, in 1909, George Walker collapsed onstage from paresis (advanced syphilis); in 1910, the Williams and Walker company disbanded; the following year, George Walker died. Bert Williams went on to become the first and only African American to be featured in the *Ziegfeld Follies*. Aida Overton Walker forged a solo career, and in this all-too-brief later career shifted her focus to choreography, mentorship, and teaching. She is listed in the *Bandanna Land* program as playing "Susie Simmons, Amos' daughter," her primary character role in the revue, as well as "Bon Bon Buddy," a part she took over from her husband and for which she dressed in male attire.[49] Her singing numbers included "Bon Bon Buddy: The Chocolate Drop" and "Kinky." In 1911, Overton Walker performed with the Smart Set, a black production and acting company, which opened with "His Honor the Barber." A review in the *New York Dramatic Mirror* still described Overton Walker as "the best Negro comedienne today," citing her "tomboy number, her Spanish song and dance, and her impersonation of a Negro 'chappie,' the last of which is the real hit of the play."[50] Another reviewer wrote, "Her male specialty, 'That's Why They Call Me Shine,' held the audiences spellbound. Mrs. Walker may as well assert herself and demand a company of her own" (figure 5).[51] At the time, many newspapers printed cartoons of her in male attire, an iconic image that holds the potential of contributing to a queer archive for twenty-first-century audiences interested not only in this theater history but in gender-transgressive, cross-dressing, and queer of color imaginaries, ephemera, and archiving. This is a bit of archival ephemera that is charged with the promise of future queer utopic diva iconicity for Overton Walker.

Interestingly, the lyrics for "Bon Bon Buddy: The Chocolate Drop," the song Overton Walker took over with great success, incorporate an account of the damaging effects of racist language, while at the same time functioning as a kind of nostalgic grotesque reproduction of that language. Such moments, in which black critical commentary can also be appropriated at sites of consumption to produce the opposite of its intended effects (a kind of production of illegibility or misreception), are pervasive in US popular cultural history and continue today—to the extent that they have come to be known colloquially as the "Dave Chappelle effect."[52] In this case, that moment is further complicated by the

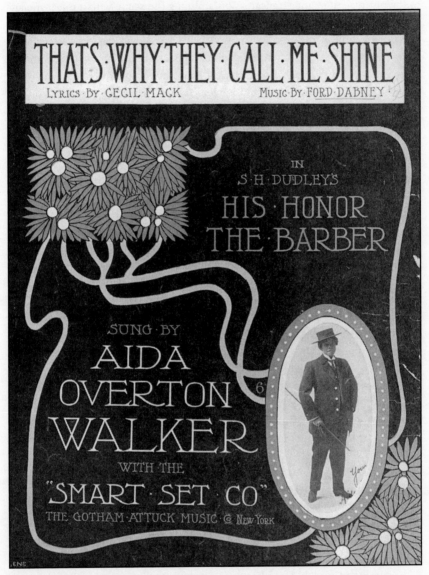

FIGURE 5. "That's Why They Call Me Shine," sheet music cover. Selection from S. H. Dudley's *His Honor the Barber*. Music by Ford Delaney, lyrics by Cecil Mack. As sung by Aida Overton Walker with the Smart Set Company. New York: Gotham-Attuck Music Co., 1910. Schomburg Center for Research in Black Culture, The New York Public Library, Astor, Lenox, and Tilden Foundations.

suturing of the ambivalent commentary on racist discourse of "Bon Bon Buddy" to the promise of gender transgression, imbuing the scene with a queer melancholy that haunts the queer present.

These reception misfires are an aspect of what I consider *the nostalgic grotesque*; in this instance, audience desires to consume racist and distorted images of blackness persist in a historic transitional moment even as such images are being publicly contested and new (queer) meanings are being generated. The images, lyrics, and embodiments of these shows clearly incorporate retrograde and crassly racist elements, and it is tempting—both for those contemporary reviewers of Williams and Walker's performances and for present-day cultural critics—to simply dismiss them as such. But doing so ignores their significance as part of the larger landscape and repertoire of black cultural critique. Moreover, such repertoires remain troubling ground to revisit for critics, fans, and audiences, especially as spaces of resistance, exactly *because* the language and imagery of minstrelsy have an active and persistent afterlife in the now. The genres of blackface minstrelsy and racial mimicry have been taken up in mass culture in the twenty-first-century genres of performing racechange and of "consuming the racist past"—as satirized vividly in Spike Lee's *Bamboozled* (2000). And troublingly, they are also taken up in queer-subcultural cultural spaces, where gender and sexuality are critiqued, but where racial ideologies often remain fixed. They persist in present-day popular consumption practices from ubiquitous college "ghetto fabulous" parties to the cheap commodity racisms of Halloween costume wigs and masks to debates over Internet memes, such as those where white bodies parodically embody black death through citations of high-profile racialized violence (for instance, the "Trayvoning" Internet meme in the wake of Trayvon Martin's murder).[53] These everyday (and every-night) practices are essential contributors to larger ideological processes that Cedric Robinson calls "forgeries of memory"—false historiographies that favor white supremacist ideology—or what Michael Rogin calls "political amnesia," or "motivated forgetting" in the interests of power.[54]

In opposition to such forgeries and distortions, black performers used a variety of strategies to convert the condition of black alterity into cultural expressiveness. In *Bodies in Dissent*, Daphne Brooks uses the term "Afro-alienation acts" to describe this work as a political performative.[55] Williams and Walker's performances engaged in such Afro-alienation acts by incorporating the toxic elements of antiblackness that made up many theatrical repertoires, but in doing so, they reworked them. The critic Maryse Condé captures the ideological work of this doubling-back movement with the critical term "cannibalizing" (a theoretical term that is itself lifted as a critical reappropriation from the racist repertoire of colonialism and the fantasy of the cannibal).[56] Even as Williams and Walker cannibalized and capitalized on racist theatrical forms for their own political aims

and profit, they were also eating them, digesting them,[57] and thus critically recycling concepts through the contours of current performance repertoires with the aim of developing altogether new forms that would radically depart from previous scripts.

Susan Curtis writes in *The First Great Black Actors on the Great White Way* that Williams's biography—born in the West Indies; raised in Riverside, California; a Stanford University student—undercuts the racialized stereotypes of plantation entertainment regularly echoed in his work.[58] His tragicomic performances (he was often considered a greater comic actor than his famous white contemporaries Eddie Cantor and Al Jolsen) represent African American performers' recognition of the commodity fetishism of performing race, and more particularly racechanges. Capitalizing on the popularity of consuming performances of race, African American performers "tapped into a desire by American audiences to laugh at performances of color and gender."[59] While audience laughter was often uncritical, Walker and Williams should also be recognized as critically resisting from within, especially when their stage performances are juxtaposed or offset with their sociopolitical organizing. By 1906, Williams and Walker had actively organized an African American actors union, the Negro's Society, to produce a space for rethinking the role and representation as well as working conditions of black actors. In 1908, they created another legendary group, the Frogs, a fraternal social and professional organization considered the first for theater professionals, although it was open to other professional elites. They undertook and won the legal battle to gain the right to incorporate, asserting their rights as "good citizens."[60]

The conditions both of restraint and possibility faced by Williams, Walker, and Overton Walker are captured well in the April 1908 edition of the *Theatre Magazine*, which featured two publicity stills for *Bandanna Land* incongruously set in an article about a production of Gabriele D'Annunzio's *La figlia di Jorio*.[61] Under the large caption "Principals in the Colored Show 'Bandanna Land' at the Majestic Theatre," the two photographs allegedly represent, according to the captions, "Bert A. Williams singing Late Hours" on the left and "Aida Overton Walker and George W. Walker dancing" on the right. In fact, Bert Williams is not singing, and his whole posture is at rest. He is seated, one arm draped casually over a table, a bottle and an empty glass at his side. The melancholy look on his face is an effrontery of the blackface makeup that exaggerates or produces his sad-clown look. The image is a racialized performance of despondency, a caricature that made him famous. The layout of the images makes it appear that Bert Williams's gaze falls out of the frame and onto the proud shoulders of Aida Overton Walker. She stands, poised formally in lace-up dance shoes and an elegant white dress, facing her tuxedo-clad husband (who cultivated his celebrity status as a well-dressed dandy). They are ready

to begin a dance, probably the cakewalk for which by now Overton Walker was celebrated, and they project an air of determined assertion of respectability. The juxtaposition between the formal and high-mannered image of the Walkers and the sad Williams in blackface forces the affect of the paired images to cut against each other. To some degree this manufactured contrast of racial tropes was one continuously capitalized on by Williams and Walker as a comic team. Carl Van Vechten recollected (in a quote that then circulated in other public commentary and reminiscence) how Williams "shuffled along in his hopeless way; always penniless, always the butt of fortune, and always human," in contrast to George Walker, the "spick and span Negro, the last word in tailoring, the highest stepper in the smart coon world."[62] Yet Van Vechten's description, which evokes the grotesque language of the minstrel stage, belies the work these performers themselves did to also cut against these very traditions. Likewise, *Theatre Magazine*'s images of Williams, Walker, and Overton Walker highlight the constant reframing of innovation and resistance through the constraints of the legible tropes of the racist past.

It is worth noting that the *Theatre Magazine* chose to promote *Bandanna Land* by reproducing this dichotomous formula juxtaposing the sad-clown persona of Williams and the high-stepping dandy image of George Walker and Overton Walker as cakewalk dancers, while specifically choosing not to feature Overton Walker's Salome dance, though she introduced it opportunely at the height of the craze. In fact, only two months later, in June 1908, the magazine would feature a gushing piece on the Toronto-born American music hall performer Maud Allan's barefoot rendition of the Salome dance.[63] Ironically, years later, Van Vechten, whose appointment as dance critic for the *New York Times* coincided with the Salomania dance craze, wrote with irony: "Perhaps Maud Allan was the Queen of Salome dancers. I saw her, but I have no remembrance of her at all."[64] In contrast, James Weldon Johnson would write about Overton Walker, "Ada Overton Walker (Mrs. George Walker) was beyond comparison the brightest star among women on the Negro stage of the period; and it is a question whether or not she has since been surpassed. She was an attraction in the company not many degrees less than the two principals."[65] He cut out a picture of her from the *Chicago Whip* and pasted it into one of his scrapbooks, which are now held at Beinecke Rare Book and Manuscript Library at Yale, adding the caption "GREATEST OF ALL, say oldtimers of Ada Overton Walker, world renown actress [sic]. We thought you might appreciate a glimpse of the star as she appeared in the heyday of her career."[66] The substance of Overton Walker's creation, which led to this assessment by Johnson, is to be gleaned from contextualizing her work within the formations of US orientalism, black minstrelsy, and black political organizing in the theater.

SKILL, NOT SCANDAL: "MISS WALKER'S OWN CREATION"

The image of the icon is one of the most powerful sites of locating diva power. Studio photographs and illustrations of Aida Overton Walker in Salome costume show her wearing a stylized "oriental" dress, a number of arm bracelets, and sometimes a small jeweled crown or beaded headband (see figure 1).[67] The posed studio portrait of her as Salome was the image chosen to accompany many of her obituaries, as it was seen to embody the zenith of her career: an image marked by dignity, seriousness, and iconicity. Here she stands as a diva crowned, both literally and in the sense of someone crowning her profession.

Yet, notably, in the very first place one might look to find a record of Aida Overton Walker's performance—the theater program for *Bandanna Land*—her Salome dance does not appear as such. One intermezzo lists a "MAORI, a Samoan Dance, by William H. Tyers," and in act 3, a segment is listed as "Ballet, 'Ethiopia' . . . Aida Overton Walker and Girls (Miss Walker's own creation.)"[68] In fact, as reviews of this show testify, there were actually two Salomes: in addition to Overton Walker performing her "Ballet, 'Ethiopia,'" Bert Williams appeared as Salome—in drag and blackface—burlesquing the Salome dance craze, wearing gauzy cheesecloth and going barefoot. Significantly, Bert Williams's appearance as Salome is also not listed in the program, but in addition to the testimony provided by reviewers, we have publicity stills showing Williams in blackface along with George Walker in a parodic pose with buckteeth.[69]

It is difficult to reconstruct what to make even of this piece of information about the competing Salomes. One clear implication of having two Salomes is that Overton Walker had to perform her Salome, a piece of earnest classical modern choreography billed as "Miss Walker's own creation," against the counterpoint of Williams's comic version in the same show. But the Williams parody of the craze, in keeping with the genre of vaudeville editorializing on theater currents, was likely directed at *other* Salome dancers, at dance trends more generally, and specifically at audiences themselves, whose fandom turned the dance into a craze to begin with. Therefore, this parodic doubling, it could be argued, served to reinforce Overton Walker's very seriousness and originality. For instance, one review emphasizes the fact of Overton Walker's seriousness by way of noting the juxtaposition of her performance with Williams's appearance in the show, which is described in this way: "As an additional feature, Bert Williams, in his inimitably funny and grotesque style of dancing, will do a burlesque of 'Salome.'"[70] Typically, Williams's characterizations were set against the dandyism of Overton Walker's husband. However, in this case, Overton Walker was the foil as Williams parodied both the race and gender performances of the Salomania craze with his blackface drag iteration, again signifying perhaps more on audiences

and their reception practices and desires than on the substance of "Miss Walker's own creation."

Situated onstage and off as a prominent figure of the middle class of Harlem, Overton Walker had to negotiate the skeptical disapproval of both black and white audiences. Her production was, as David Krasner has shown, a complicated combination of "resistance to and appropriation of racism,"[71] just as her husband, George Walker, and his partner, Bert Williams, similarly negotiated their use of blackface and minstrelsy. For black artists, the antiblack modernist tropes of primitivism and the comedic tropes of minstrelsy functioned both as predetermined cultural capital—a recognizable and marketable genre offering access to larger audiences, white "mainstream" cultural venues, and profitable markets—and as a persistent liability, a representational ground bent on reinforcing racist ideas of black atavism and inferiority. Performing in this mix risked alienating black critics and audiences alike who, during this middle period of theater, were intent on forging independent black arts or committed to broadcasting respectability politics. Overton Walker was part of a pioneering circle in theater, in ways that I believe remain to be fully documented, and certainly a central figure in the emergence of American art-dance and choreography. And, as she carved out a space onstage for these experiments, it was within a performance context that could easily have subsumed her into the echoes of a toxic past. Her proximity to minstrelsy may be one contributing factor in her absence from the pantheon of modern divas in popular memory, the result of contemporary hesitations to hold on to racist histories or theatrical modes. Ironically, her efforts to distance herself from such toxic forms also produced audience misrecognitions, further contributing to the effacing of the significance of her career.

Overton Walker staged her interventions for audiences, including critics, whose projections and ways of seeing served to make her performances effectively illegible; they could not see her Salome dance as an original contribution to American "classical" art-dance, nor even as a staged crossing of the color line of dance (rather than mere imitation), nor as an intervention in expanding the repertoire for black women dancers. For instance, in another image of Overton Walker in Salome costume, she is barefoot and wears toe rings.[72] The bare feet were considered audacious for the period and were a trademark of the Salome dancers' daring, signaling the "scandalous" risk-taking of their work. Yet reviewers were quick to remark that Overton Walker, in contrast to her (white) contemporaries, did not rely on skimpy costumes for her success, and one photo caption reads, "Dances better than some of the Salomes that wear fewer clothes."[73] This perceived modesty is significant to understanding the texture of her performances, for which there is neither significant film or sound documentation nor (multiple) autobiographies (unlike for Fuller or Baker) that elaborate on her work. And yet it would be wrong to assume that the lack of a moving

image record or of published autobiographical material necessarily erases the history or makes it impossible to discern the politics of her choreography, movement, live performance, or even self-fashioning. Even when and if the record of theatrical reviews is one that potentially misinscribes her and makes illegible the interventions she hoped to stage, it nonetheless inscribes a moment of reception and exchange that can be illuminating.

Reviews offer a powerful but limited window into the scene of reception, even as they contribute to the publicity apparatus that shapes a diva's iconicity. A Boston newspaper review of Overton Walker's dance performance in *Bandanna Land* at the Orpheum Theatre is subtitled "Aida Overton Walker, who interprets the dance, is styled the 'Mlle Genee' of her race." The favorable reference is not to a white Salomania dancer but to the ballet dancer Adeline Genée, who performed at the Empire Theatre of Varieties in London and was known for elevating the status of ballet. When she traveled in the United States in 1907–1908, she was billed by Florenz Ziegfeld as "the World's Greatest Dancer." Overton Walker's reviewer makes this comparison to Genée in order to take note of how Overton Walker's version of the Salome dance favorably contrasts in its artistic seriousness against other popular renditions:

> She gives an original conception to the role, which differs in many respects from that of the other dancers who are appearing in New York. She does not handle the gruesome head, she does not rely solely upon the movements of the body, and her dress is not quite so conspicuous by its absence.
>
> Miss Walker's costume will consist of a full covering for the body and limbs, except bare feet and shoulders. One phase of her art is notable in the fact that she acts the role of "Salome" as well as dances it. Her face is unusually mobile and she expresses through its muscles the emotions which the body is also interpreting, thus making the character of the biblical dancer lifelike. The poetry of motion is exemplified in this dance by Miss Walker, and she shows as well the passion and emotion which must have consumed 'Salome's' body and soul when she realized the awful price she demanded—the head of John the Baptist on a platter.[74]

Note how Overton Walker's performance is essentially read here as "proper," especially when contrasted to other Salome interpretations. This difference is something the comparison to Genée was intended to reinforce. Interestingly, this reading of Overton Walker's performance leads the reviewer to an interpretation of the biblical story that recasts Salome (and her body) as remorseful (a quality not foregrounded in the biblical narrative). So the passion expressed by Overton Walker's Salome, according to the review, is not the expression of unbridled lust typically associated with the figure of Salome but the passion of a sinner soon made aware of her transgression. For Overton Walker, performing

orientalism was in part a choice to participate in a major dance trend, yet she had to comingle the requirements of the trend with her desire to be recognized for the kind of propriety her repentant version of Salome signals, thus returning the scandalous popular Salome dance to its roots in serious or high art, with a repentant twist. Overton Walker—like Fuller and Sadayakko, discussed in the next chapter—recognized in the Salome theme an opportunity for lending seriousness to art, a site for modernist experimentation with innovative choreography, costume, and lighting and the adoption of a modern aesthetic that lent itself both to entrenching and to rescripting the cultural prescriptions for raced and gendered performances on the stage and off.

A survey of the newspaper reviews of Aida Overton Walker's performances preserved in the Locke Collection of the New York Public Library for the Performing Arts reveals this complexity. White critics myopically focused on her racial identity and were only able to read her Salome dance through the narrow framework of singularity, contrasting her performances against those of her white contemporaries. However, unlike the contrasting framework produced by Williams onstage (which emphasized the difference between the lascivious and cheap Salomes and Overton Walker's serious and classical version), the contrast on which the white press focused was produced through the lens of racist conceptions of what constituted the proper space of black performance. Seeing race trumped their ability to see her innovative choreography, rendering her artistry and modern innovation illegible. One headline for a review of *Bandanna Land* reads: "Different from the usual 'coon show.'"[75] She was viewed, therefore, as exceptional. But that noteworthiness was for crossing a color line (from black/comedy to white/artistry). Even as white reviewers made this difference the "news" in their headlines, they aimed to resituate her performances within the trope of the "coon show," exactly by invoking it—and thus shored up the color line in theater. Many reviews in the white press, while proffering limited praise, made baroque efforts to remind readers that she was nonetheless a primitive subject: "The dancing of Aida Overton Walker is a delight. She looks like some pretty savage and there is an unconventionality about her movements which suggests the jungle."[76] Recalling the force of the black/white binary model of the color line reveals how "classical" dance and orientalism were yoked and then mapped accordingly, and could then be seen as the exclusive preserve of white performers.

(Mis)reading Overton Walker as a mulatto, another critic writes, "In the last act the costumes are most picturesque. Some of them are oriental and they are the more striking because worn by the mulatto young woman with an effect that would be scarcely possible on the average white actress."[77] Here, the reviewer collapses racial and cultural identities into a homogenous otherness that equates Walker's complexion with access to racial authenticity: black skin is the more

suitable backdrop for the oriental costume, thus adding, for this reviewer, to the costume's exotic aesthetic effects or "picturesque quality." This aesthetic racial pseudoscience comes up again with another reviewer, who declares that "Miss Walker is the only colored artist who has ever been known to give this dance in public. This is strange though true, as the original Salome's skin may have been of a hue resembling that of Miss Walker's."[78] The racial otherness of the black body is more easily digested, for this reviewer, as a representation of the "oriental" body, producing effects that are satisfying to the occidental gaze in search of exotic spectacle or, as the review names it, "striking effects." The sense of her naturalized fit with the part is twofold: in one, a version of what today is called "traditional casting" or casting by color, in this case collapsing racial categories into an amalgamated otherness, she, as a black woman, is an appropriate metonymic substitute for the part of any racial other; and further, in the additional sense, which is seeking the "real," she stands as the authentic specimen of racial difference, rather than racial mimicry and imitation by white people. And finally, the review casts as "puzzling" the disappearance of the "original" Salome, making "strange" that which had become quite naturalized: the theft of cultural appropriation and the entitlement of whiteness to inhabit orientalism.

Again, reviews, and audience reception as it may be intuited from these reviews, tend to reveal more about the projections cast onto Overton Walker's body than they do about the performances themselves. This means that they do obscure what can be known about the kind of interventions she hoped to stage and what kind of agency we might presume she wished to enact. Yet, I will argue, by producing a picture of the resistance she met and how she chose to meet that resistance, we can glean something of her own politics of performance. For instance, Salome dances were considered scandalous or provocatively daring dances, associated with the revealing public performance of the female body, and one common sign of their daring, often remarked upon, was the dancer's lack of tights. However, when Walker danced she was again misread. In a striking reversal of the racist equation of black women with hypersexuality, critics read Overton Walker as modest: "Miss Walker's Salome is something like the others, being more modest, but quite as meaningless."[79] Overton Walker's skin becomes the sign of naturalized modesty, the critic imagining its tone as itself costume: "In 'Bandanna Land,'" the critic writes, "Aida Overton Walker . . . dances modestly in the bronze tights nature placed upon her."[80] This focus on Overton Walker's modesty in her Salome performance dramatically differentiates the reception of her work from that of the work of any of her white contemporaries. Yet the critic refused to allow that signature modesty to be read in a way that it likely would have been if Overton Walker had been white: as a signal of her seriousness of purpose. Rather, he misreads her actual choice—to dance without tights—thus refusing to engage her rather interesting choice to mesh that "nudity/scandal"

FIGURE 6. Hanes nylons magazine advertisement, illustrated by Vladimir Bobri, ca. 1960s. Collection of the author.

with serious choreography, a seriousness he rather displaces onto her body, as a naturalized state.

While the landscape of diva iconicity and its significations can be read through past photographs, newspaper accounts, and reviews such as this one, that landscape can also, I argue, be retroactivated by the echoes of the past found in popular culture. For example, this unusual suturing of Salome and the question of race through a discussion of tights and modesty makes an uncanny reappearance in a Hanes nylons print advertisement from the 1960s, shown in figure 6. So enduring is the association of the Dance of the Seven Veils with barefoot dancing and nudity (or the sequential unveiling of the body) that the Hanes ad was able to capitalize on the connection to make its own product, stockings, disappear. A line illustration shows a woman dancing on her toes and dropping the last veil. The caption reads: "More seductive than Salome's seventh veil. Seamless stockings by Hanes." The stockings are marketed as a kind of purchasable false modesty to the white consumer. This Hanes ad offers up the promise of white nudity for sale through the purchase of stockings that cannot be seen or distinguished on the light-skinned body. Promising an eighth veil, an invisible tease, as a tool of seduction to the white female consumer, the ad reinforces how whiteness mapped onto performing the orientalist Salome trope produces a space in which white female sexuality can appear. This ad, a late twentieth-century iteration of earlier commodity orientalism, produces white nudity for sale, paradoxically, through the promise of Salome's (always-nude) stockings.

From half a century earlier, reviews of Overton Walker's performances in the white press—which viewed her as crossing a color line (from black to white)—reveal how orientalism as a mainstream popular art form was already seen as the exclusive preserve of white performers. While Overton Walker's body performing Salome was still viewed by some critics as more closely approximating what was being represented on the stage (the racialized other), she, as a black performer, was seen as occupying a role reserved for the white performer (staging orientalism). As Linda Mizejewski similarly notes in her discussion of the racialized creation of the Ziegfeld Girl as an American icon at this time: "The circulated images of white women were dependent for their value on the presence and performance of other racial and ethnic identities. Beginning in the 1890s, the desirable African American female body 'on show' in a parallel theatrical venue heightened the stakes of the upscale chorus girl's whiteness."[81] When Overton Walker danced in the Salome style, she was conspicuous to critics and audiences alike not because she was producing another "hootchy-cootchy" dance, which would have been considered a recognizable and even acceptable performance of black femininity. Instead, her Salomania dance represented the "scandalous" (as in audacious) production of "classical" forms or modernist innovation by an African American choreographer. ("Classical" dance represented an aspiration

to high art rather than signaling participation in the "cheap entertainments" of vaudeville or social dance.) In the black press, Overton Walker was sometimes touted as being "further honored by being the only colored lady that has ever been accepted as a danseuse of the classics."[82] But that honor was an ambivalent production for the white press: one that meant that as she encroached on the repertoire of her white contemporaries and their claims as serious innovators, some critics took care to render her entire effort "meaningless."

Walker's Salome dances did produce scandal, as all Salome dances did, but her reception by black and white audiences and in the press figured that scandal in different terms. As the Salomania dance craze and its afterlives make evident, performances of Salome afforded opportunities for artists and audiences to produce scandal and therefore publicity, but at the same time accomplished, for some, the opportunity to perform value—in the form of a demonstrated artistry, including appreciation for or development of modern aesthetics and modern experimentation. Overton Walker's Salome produced scandal because it challenged the color line as it demarcated "serious" artistic production. White critics perceived Overton Walker's use of the Salome figure as the appropriation of material exclusively reserved for white performers, not just in terms of embodied practice but as material that specifically signaled intellectual and modern cultural production on the part of the dancer, of the sort that Loïe Fuller, subject of the next chapter, sought to have recognized in the courts as "intellectual property."

Finally, in contrast to the views iterated above that Overton Walker's Salome was relatively modest and proper, another reviewer of *Bandanna Land* did choose to view her version of Salome as a "cheap imitation" of the white Salome dancers. Implicitly the review polices the racial boundaries of the Salome dance; "her dances," the reviewer writes, "all except the cheap imitation of her least-to-be-imitated white sister dancers, are fine."[83] It is interesting to note that the reviewer does not even need to name the dance for the reader to infer which dance is being referenced. This review should also be construed as urging Aida Overton Walker to remain committed to developing black vernacular dance rather than taking up, chasing after, imitating, or assimilating to white genres.

"I'm Going to Get Myself a Black Salome." In the midst of the Salome craze, that possessive pronouncement graced an illustrated sheet music cover (see figure 7). Stanley Murphy wrote the lyrics, and the music was by Ed Wynn, whose feigning-airs mug appears in an oval inset on the cover. (Wynn, a vaudeville comedian, was beginning a long career in entertainment that stretched till his death in 1966; he appeared, for instance, as Uncle Albert in Walt Disney's *Mary Poppins*.) Here his image is juxtaposed with (but clearly also, by being set off in an inset, detached from) what is intended to convey the lascivious looks on the cover: a caricature of a young black man in the bottom left corner of the drawing

FIGURE 7. "I'm Going to Get Myself a Black Salome," sheet music cover. Levy Sheet Music Collection, Johns Hopkins University Sheridan Libraries.

is shown leering open-mouthed at a Salome dancer. The dancer's skin tone is light, but her race cannot be conclusively ascertained from the drawing; it is the lyrics that make a point of telling us what marks the difference between a white Salome and a black Salome. The lyrics tell the story of a "railroad man" who laments the cost of keeping his modern consumer girlfriend, for whom he has to buy "Brinkley hats and Gibson sacks": "Every single cent I earn she spends on clothes." The repeating chorus explains the solution to his bind: "I'm going to get myself a black 'Sal-om-ee.'"

> A Hootchie Kootchie dancer from Dahomey.
> All that she'll wear is a yard of lace.
> And some mosquito netting on her face.
> A whole new outfit costs about a cent.
> And then she can wiggle out of paying rent.

The dateline, New York City 1908, suggest this was a specific reference to the two black Salomes onstage that year: those performed in tandem by Bert Williams and Aida Overton Walker. The description of the cheap costume is, of course, a closer match to referencing Williams's own parody of the craze, performed in "burlap," but the real aim of the lyrics seems to be disparaging the other "Black Salome," a means of regulating Overton Walker's success and reattaching the idea of "cheap"—which was adhering to the white Salome dancers—back onto the African American Salome performer.

In figure 8, we see another and different example of how Overton Walker's success had to be repossessed under the sign of the white performer but to different effects.[84] The sheet music cover for "Lovie Dear" from 1911 makes apparent how Aida Overton Walker's song was marketed under her own name but through the image of a white woman. In this instance, the "good girl" of white femininity obscures the body of the black performer, assumed to be a marketing liability despite her success. In this familiar cycle of white cultural presumption, black female subjectivity and experience "circulate within the marketplace only when they can be packaged within a real or illusory white woman's body."[85]

A not-so-hidden identification exists in the practices of appropriation and inhabitation that present themselves in the guise of performances of differentiation. While white and black reviewers might label Overton Walker "imitative," it was in fact the white dancers themselves who were appropriative, using forms derived from dances originally presented at the world's fairs by performers from North Africa and the Middle East as well as from black vernacular traditions. The white orientalist femme fatale performer was also not so different from the Ziegfeld Girls in café au lait makeup, whom Mizejewski understands as "the apotheosis of the circular logic of blackface: representing "bad" sexuality, they also

FIGURE 8. "Lovie Dear," sheet music cover. Music by Tom Lemonier, lyrics by Fred Bonny. Introduced by Aida Overton Walker. New York: Roger Bros. Music Pub. Co., 1911. Schomburg Center for Research in Black Culture, The New York Public Library, Astor, Lenox, and Tilden Foundations.

remarkably imitated the light-skinned black chorus girl from the competing the-atrical tradition, who was in turn the 'bad' version of the white chorus girl. . . . Beneath the café au lait makeup was the American Girl who could safely act out the (bad) sexuality Ziegfeld Girls supposedly did not have. Nevertheless, for the Ziegfeld Girl to conjure up the black chorus girl was to acknowledge her, not as object to be imitated but as source and ground of identification."[86] This play-ing with racial identification by white performers in order to construct a space for bad-girl whiteness necessitated the imitation of—and then, importantly, the expulsion of—women of color from the site of performance. This is a descrip-tion of a technology of race that has become all too familiar, even defining of American popular culture.

As this archive of theatrical reviews of Overton Walker's performances in the white and black press reveals, orientalism proffered a space for performing bad-girl whiteness in popular culture. The constitution of this space as a white preserve or claim on orientalism—and by extension on the birth of American dance—was so established that Overton Walker's performance of orientalism was viewed as crossing a color line not from black to yellow but from black to white. Given this context, reviews focusing on propriety and authenticity as a form of scandal in Overton Walker's performances reveal her work as constitut-ing a daring political act of challenging the white hold over performance rep-ertoires. White and black critics alike at the time were critical of her choice to participate in the Salomania craze, which they saw in different ways and for dif-ferent reasons as reducible to acts of imitation. (And it should be clarified that even as those repertoires were themselves built on the reproduction of appropri-ative orientalist fantasies, they were critiqued in their time for imitation but not for appropriation.) The African American reviewer Lester A. Walton perceived Overton Walker's Salome as imitative of a white trend and therefore failing to invest in the racial project of black cultural expression. He negatively juxta-posed her Salome dance against her success with the cakewalk, which was in his view an essentially black form, rooted as it was in dances innovated by slaves as parodic send-ups of the plantation masters' manners and powers.[87] The charge to avoid imitation held a great deal of sway in this moment, as African Ameri-cans sought both to move away from the grotesque modes of mimicry presumed by minstrelsy and to promote vernacular forms. When she died, obituaries for Overton Walker took pains to recount that "her great maxim was that 'nothing was equal to originality.'"[88]

Aida Overton Walker was innovating modern dance at time when vibrant public conversations were taking place about what would constitute serious African American art, theater, and drama. Black theater companies were staging differently configured interventions into these debates, for instance, producing black-cast productions of modern European and Shakespearean plays while also

staging new black-authored dramas. In choosing the Salome material, Overton Walker was going to come under scrutiny about where she fell in these aesthetic-political debates about what constituted the ground of black performance, culture, and innovation.

Experimenting with modern dance—for all its associations with sexual excess and promiscuity—would appear to cast the art-dancer, like the figure of the blues singer, as necessarily flying in the face of black middle-class values and the black clubwomen's politics of uplift. But to *not* perform Salome meant to remain "Queen of the Cakewalk," a social dance that drew on black vernacular culture and highlighted Overton Walker's craft but not necessarily her originality as a solo dancer. Further, capitalizing on the vogue for the cakewalk among white audiences at home and abroad meant being confined to material that arguably delivered a kind of cultural slumming experience to white audiences, often safely ensconced in their homes—from the mansions of New York to Buckingham Palace—not to mention reproducing the nostalgic grotesque of minstrelsy for audiences seeking an entertainment space and genres that could enact affective ties to the imagined plantation past.

When Aida Overton Walker chose to perform the Salome dance as a serious piece of choreography on its own, removed from a revue context of blackface vaudeville productions like *Bandanna Land*, she was featured at the famous Hammerstein's Roof Garden theater in New York in 1912. William Hammerstein did not miss the opportunity to use the racial identity of the dancer as the key ingredient for a publicity stunt. We learn from a clipping, with its not so subtle word play, "Salome was a Dark Secret," that Hammerstein kept the identity of the new dancer undisclosed as a stunt to draw attention to his venue. "The identity of the Salome Dancer so carefully concealed for many weeks turns out to have been a dark secret which William Hammerstein decided yesterday he had kept long enough," the review reads.[89] According to another newspaper notice at the time, Overton Walker's performance of Salome was promoted as the "first" interpretation of the dance by an African American: "This will be the first time since the inception of this much talked of dance that it has ever been interpreted by a colored artist or that a colored artist has ever attempted to execute classic dancing."[90] In fact, as we know, Overton Walker herself had performed a Salome dance in 1908. But the publicity machine insisted on fetishizing the fact of her being "the first," a fetish that is carried into contemporary times, as critics still ignore the idea that Overton Walker might not have been the only black performer to create renditions of Salome.

Yet to search beyond this image or others like it for what Aida Overton Walker's performances of Salome looked like or meant for different audiences, or for what might be said to comprise the politics of those performances or the politics of diva iconicity itself, is to immediately confront archival conundrums such as

what is possible to reconstruct and what truth value one might claim through such necessarily fragmented remains. A picture of Aida Overton Walker's politics of performance only begins to materialize when the minimal and ephemeral archival record of those performance events (predominantly the static remains of photographs, news clippings, reviews, cartoons, obituaries, and brief remembrances by her contemporaries) is read within the larger complexity of its historical moment. The material archival record, in other words, can and should be read within the context of a larger repertoire of "ephemeral embodied practices" and black theater histories.[91] These contexts provide a window into what Overton Walker's Salome performances may have looked like, what movements and meanings they may have projected, and even what her choreography and appearances onstage may have meant for different audiences in different venues. Even with the aid of such contextualization, it is still an incomplete and ephemeral history: one additionally distorted by time, political amnesias, and forgeries of memory. And yet, if the alternative is simply to accept not knowing, or to accept the distortions built by absence, or to relinquish the demand for presence, it is imperative for feminist scholars and cultural studies scholars to do the opposite, to produce methodologies that can make something of what remains. I return to these methodological issues throughout the book, but they bear repeating here in that Overton Walker's Salome performances only survive in the form of scraps hidden away in archives and in subtle reiterations in the contemporary moment, and these scraps themselves appear to point more to the contours of her reception by various audiences than necessarily to Aida Overton Walker in general or even her Salome performances in particular. Initially appearing to trump attention to her actual dance and choreography, the dichotomies of propriety and scandal, the questions of originality and authenticity, and the ambiguities attributed to her racial identity are discourses that dominate the record of her work's reception. But that reception history is then critically useful in understanding what she herself called the "limitations others have made for us," limitations against which her performances can be read as embodied critique.

In order to come closer to understanding the full meaning of the politics of Overton Walker's performances, it is key to examine how she challenged the racial politics of the stage not only through the performance medium but also through other registers such as community and political organizing and the press. While George Walker has received recognition for founding the political organization the Frogs, no mention is made of Aida Overton Walker's potential contribution to this group. And yet it was founded in the summer of 1908 (the height of the Salome craze) and met at the Walkers' home, and it is likely she was involved. Although Williams and Walker are most often lauded as pioneers of black professional theater, Overton Walker clearly shared this commitment and desire, challenging the racial politics of the stage both in her performances and

through her community-minded pedagogy and activism. She should be recognized as a public critic of the racist imperatives imposed on African American performers. Reviews of the period demonstrate the consistent efforts of Williams, Walker, and Overton Walker to overcome racial barriers by performing for a variety of audiences and in black, white, and segregated venues. Onstage, Overton Walker also transformed her oeuvre by insisting on producing noncomic choreography, moving away from vaudeville forms toward producing the African American musical genre and choreographing serious dances for the company, training such important figures as Florence Mills. Offstage, in her later career, she managed and taught a younger generation of aspiring black female performers and dancers. She went on to produce and manage acts from 1912 to 1914 such as the Happy Girls and the Porto Rico Girls. When she died after an illness in 1914 at the age of thirty-four, her students were living in the house that she owned. In her day, her role as a manager could be framed as one of political organizing. Despite all these contributions, only recently has Overton Walker received attention as a pioneer of modern dance.

Aida Overton Walker's own writing is in keeping with the fighting spirit of the Frogs' efforts to professionalize and to organize aggressively on behalf of black performers. She wrote an outspoken newspaper editorial, "Color Line in Musical Comedy," which appeared in the *Chicago Herald* and other news sources, that challenged the racist reception of black performance, addressing the "policing of the black body" (to reinvoke Carby) and theorizing the performativity of race, or how racial ideology produces raced subjects. This is perhaps the most significant surviving piece of the archive because it contributes to understanding the political will that undergirds Overton Walker's overall artistic output. In this piece, Overton Walker directly addresses the mandate on the colored body to perform, and to perform in such a way as both not to offend white audiences and to fulfill racist fantasies of racialized others. She articulates the way racist white society expects black people to "always be on stage" whether in the theater or in the streets—performing certain recognizable tropes of blackness that will not offend or scare whites. I quote the piece in its entirety.

COLOR LINE IN MUSICAL COMEDY
BY AIDA OVERTON WALKER

You haven't the faintest conception of the difficulties which must be overcome, of the prejudices which must be soothed, of the things we must avoid whenever we write or sing a piece of music, put on a player sketch, walk out in the street or land in a new town. No white can understand these things. Every little thing we do must be thought out and arranged by negroes, because they alone know how easy it is for a colored show to offend a white audience.

Let me give you an example. In all the ten years that I have appeared in and helped to produce a great many plays of a musical nature, there has never been even the remotest suspicion of a love story in any form. During those ten years I don't think there has been a single white company which has produced any kind of musical play in which a love story was not the central motive.

Now why is this? It is not accident or because we don't want to put on plays as beautiful and as artistic in every way as do white actors, but because there is a popular prejudice against love scenes enacted by negroes.

That's just one of the many things we must think of every time we make a [illegible].

The public does not appreciate our limitations, or, rather, the limitations other persons have made for us.[92]

With this editorial and others,[93] Aida Overton Walker affirms her identity as an activist and political essayist as well as a performer. "Color Line in Musical Comedy" was reprinted in full in other mainstream national papers such as the *Pittsburgh Leader* and appeared in at least two other news sources in the form of quotes as though taken from a personal interview with the author.

In her editorial, Overton Walker points to how African Americans moving on the stage *and* moving in the public sphere are scrutinized and policed by both blacks (through the ideology of racial uplift) and whites (through the ideology of white supremacy). Moreover, Overton Walker lays out an intersectional analysis of how the regulation of race, gender, and sexuality disproportionately impacted black women's performances onstage and in the public sphere.[94] By indicating her awareness that there are "things we must avoid," she partly aligns herself with the politics of social reformers and uplift ideologies that would regulate sexual expression as strategy of survival and a form of reversing the culturally pervasive negative views toward black women and sexuality. But in highlighting "prejudice against love scenes enacted by negroes," and calling attention to how glaring the difference in imperatives is for black and white companies within the genre of musical theater, she critiques this censorship as a practice of regulating black women's sexuality perpetuated by white audiences. This double move demonstrates her desire to represent the complexity of black women's sexual identity onstage.

When Overton Walker died, obituaries in the black press repeatedly recognized her as both an advocate ("She fought for right and justice to her sex and received the same") and a lady ("She was the lady of the stage, the one woman whose every-day life was the exemplification of the fact that good women follow the footlights. She lent dignity to the profession") who "proved to the world that you can be a lady on and off the stage."[95] Given her recognized commitment to performing dignity, respect, and gendered political subjectivity for and as a

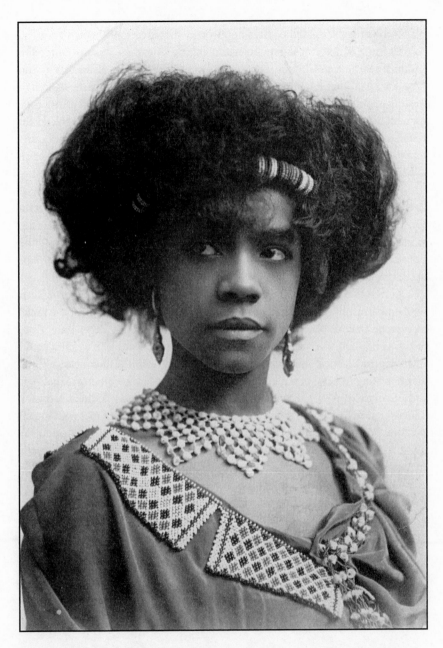

FIGURE 9. Portrait of Aida Overton Walker. Artist unknown, ca. 1910s. Schomburg Center for Research in Black Culture, The New York Public Library, Astor, Lenox, and Tilden Foundations.

black woman, onstage and off, it is noteworthy that Overton Walker chose also to perform a dance that was popularized exactly because it was guaranteed to produce sexual scandal. This would seem to belie the image of the "lady" and "good woman" that she projected and that the community of Harlem wanted to bestow upon her. As Hazel Carby, Angela Davis, and black feminist critics have argued, black women performers of this period should also be recognized for their social refusal to be policed. In Salome, public expression of sexuality came in a package that could also signify classical dance, allowing Overton Walker an alibi for performing sexuality while simultaneously cultivating dignity (see figure 9). By taking the twofold risk of performing sexuality and presenting herself as a serious choreographer and classical dancer, Walker negotiated a new terrain for imagining black female subjectivity as modern, one that falls between the strategies of the black clubwomen (that would police sexual expression) and the politics of the blues singer (that openly embraced a ribald sexuality, but perhaps at the risk of spectacularization).[96]

Overton Walker was not just refusing to be policed by the prohibition against women performing sexually explicit material but was fighting against the racial stereotype that all black women's performances are sexually degenerate. And, at the same time, she was countering the prohibition that black women could not perform "classical" material professionally. In Overton Walker's case, we see an interesting reversal of the cultural imperative that black women's sexuality is presumed excessive and scandalous. Instead, it was Overton Walker's modesty and aspiration to classical forms that read as "scandal" and were met with mixed reviews. For Aida Overton Walker, Salome represented a theater of opportunity for gendering modernism and assigning value to her art. Salome, as it turns out, represented an "uplift aesthetic" rather than cheap entertainment (as it is sometimes viewed), and it offered a chance to be taken seriously on the stage performing modernism. However, the adoption of "orientalist feminism" came with hidden costs, as it meant the production of modern black female sexuality through racialized performance practices. Unlike other divas of the modern era who experienced her magnitude of success, she apparently did not (yet) earn an iconic afterlife by virtue of her fame—which is striking given the significance of these contributions.

2 ⁑ TRANSNATIONAL TECHNOLOGIES OF ORIENTALISM

Loïe Fuller's Invented Repertoires

"The Harem 'Baby'" (figure 10), a period postcard I found while rummaging in a secondhand shop, neatly illustrates how fashion around the turn of the twentieth century could perfectly fuse fantasies of the East with the recommendations of dress reform to produce a modern commodity orientalism. A young woman stands poised in a split skirt, an innovation designed to allow women greater freedom of movement, including the ability to bicycle, while wearing (at least a semblance of) the full skirts associated with the proper femininity of the Victorian era. In this studio photograph, the split skirt is conjoined with the concept of "harem pants," offering a fashionable merger of substance and style. While practical dress reforms of the period were ridiculed as "mannish," in this postcard they are reworked as appealingly feminine through sexy infantilism, rendering the independent New Woman as, in the lexicon of the postcard, a Harem Baby.

The Harem Baby postcard is in one sense a campy recitation of the ubiquitous exotic colonial postcards that circulated liberally throughout Europe and the United States and functioned, as the scholar Malek Alloula puts it, as "the poor Man's phantasm: for a few pennies, display racks full of dreams. The postcard is everywhere, covering all colonial space, immediately available to the tourist, the soldier, the colonist. [It is] their pseudoknowledge of the colony."[1] However, in the case of the Harem Baby postcard, it is the dress and social reforms of the late nineteenth-century New Woman that are circulating in orientalist drag. In this "poor woman's phantasm," another shift is enacted, one taking place again and again, as illustrated in the previous chapter, on the US popular stage: a scenario in which the white woman substitutes her body for the body of the racialized

The Harem "Baby"

FIGURE 10. "The Harem 'Baby'" postcard. Collection of the author.

other in a pitch to claim modern gender and sexual subjectivity through the vehicle of orientalist fantasies. Images of this masquerading colonial subjectivity circulated as objects of the occidental and colonial gaze and were figured as an object of desire for both male admirers and female fans.

In place of the exotic racialized colonial subject, of the kind Alloula documents in *The Colonial Harem*, in the Harem Baby postcard it is rather a young white woman that becomes the display ground for orientalist accessories. The image could almost double as an ad for a music hall revue, as she holds a dapper cane, presenting the impression that she could momentarily break out into a dance routine. From the cane hangs a coordinating purse, so that she appears to be holding out the pleasurable promises of commodity fetishism to other women. The postcard is selling this idea of the stylish orientalist New Woman—a "femme" foil to the mannish New Woman, a disparaging image invented in newspaper articles and cartoons of the era in an attempt to deride, trivialize, and marginalize the political power of suffragists and other advocates of women's rights. In contrast, this Harem Baby is one who discovers, in the trappings of a seductive orientalist fantasy, the promise of freedom of movement—and without paying the price of her femininity. Her coquettish allure, it seems to say, will not be compromised by the adoption of pants. Breaking from the Victorian conventions of gender ideology, it tells modern young women, need not be equated with mannish gender nonnormativity, and in fact will be rewarded with the spoils of consumerism. This card is a penny souvenir, an accidental tourist from the ephemeral archive of gendered modernisms. Yet it perfectly captures how orientalism demarcated larger cultural shifts that opened up societal spaces for white women. Broadly, fashion orientalism was deployed as a tool for allowing white middle-class women to experiment with public displays of the female body by circulating as consumers and audiences of new goods and entertainment, by participating in physical movement culture, and, overall, by moving in a variety of newly available venues and public spaces.

Just as the Harem Baby postcard uses orientalism as an anachronistic alibi, standing for an always already past tense that sets off the modern, for the dancer Loïe Fuller, transnational forms of orientalism were coded as imaginary pasts from which to launch herself into the future as a modern gendered subject. Orientalism was an instrument for gendering modernism and assigning value to her art. For Fuller, as for Aida Overton Walker in the preceding chapter, the Salome repertoire represented a means for distancing herself from notions of women's performance as cheap entertainment and enhanced the possibility of being taken seriously as a woman cultural producer on the popular stage performing modernism. However, this adoption of orientalism and the production of female sexuality through racialized performance came with different hidden costs for different performers. For Aida Overton Walker, performing orientalism

FIGURE 11. "Loie Fuller 22." Jerome Robbins Dance Division, The New York Public Library, Astor, Lenox, and Tilden Foundations, New York Public Library Digital Collections. Accessed December 11, 2015. http://digitalcollections.nypl.org/items/71bdc090-6b3b-0131-de7f-58d385a7bbd0.

variously produced forms of "uplift aesthetics" as well as conditions of illegibility. Chapter 1 explored these associations and dissociations of oriental otherness from black otherness in Salome performances as these movements can be traced through critical and popular reception of Overton Walker. Alternatively, for her white contemporaries, as a technology of performing difference, orientalist performances contributed to entrenching the color line in dance and theater. The Salome repertoire functioned as a trope for the consolidation of white femininity and aesthetics. And as we saw, beneath the veil of performing gendered modernism lies the persistent deployment of orientalism, and beneath the veil of performing orientalism lies a recurrent investment in whiteness, haunting the afterlives of these diva iconicities.

Unlike Overton Walker, Loïe Fuller has a very visible afterlife—one in which she is remembered primarily as an icon of light-color-motion, the muse of the symbolist movement and art nouveau, and the inspiration for hundreds of decorative items like lamps and vases with her likeness swirling in her signature moving-fabric costumes (see figure 11). Through commercial reproduction (and the continued circulation) of these objects and also of the prints that were used to promote her performances, Fuller has a signature iconicity that continues to signify the fin de siècle, primarily in a decorative register. In this chapter, I examine a different aspect of Loïe Fuller's reproduction, one that is lost if we only remember her as art-nouveau muse and "Fairy of Light." I look specifically at her production of futuristic transporting modernist visions out of notions of anachronistic static orientalisms. I begin by considering the taxonomy of popular orientalisms, including the marketing of fashion and domestic commodities, that fed and cultivated audiences' tastes for inhabiting and performing orientalism. Audiences fashioned themselves as modern subjects through practices of consuming orientalisms—and performers such as Fuller, for their part, were both engaging in their own consumption of orientalism and producing it for themselves and their audiences. In the next section, "Performing Fashion Orientalism," I look at how fashion orientalism and its audiences set the stage on which Fuller then built her repertoire as a moving performer on the stages of America, the Caribbean, London, and Paris.

PERFORMING FASHION ORIENTALISM

According to the implied contract of the Harem Baby postcard, adopting the new social persona of the orientalist modern girl brings with it the promise of luxurious things and daring sex appeal. Fashion orientalism sutured ideas of sexual expression, public legibility, and physical exercise to luxury. And it sutured gendered mobility to notions of upward class mobility. Fascination with orientalism was directed toward the "appeal of luxurious consumables" as well as the

"search for intensified experience."[2] Popular manifestations of this fashion orientalism included myriad cigarette brands (among them Egyptian Deities and Salome cigarettes),[3] "Turkish trousers" (such as the ones featured in the Harem Baby postcard) and other publicly daring fashion statements, and conspicuous makeup (such as heavy kohl eye makeup), all of which were similarly marketed as products, designs, and leisure practices of a fantasied "East." One magazine ad for silk fabrics describes the Orient as a place "where richness, luxury, and elegance are demanded of everything worn by woman."[4] Fashion orientalism promised the modern middle-class white woman that she could have forms of feminist liberation that Victorian patriarchy otherwise imagined would desexualize, degender, and masculinize women—particularly sexual embodiment and freedom of movement—while maintaining aspects of traditional gender roles. Whereas Victorian patriarchy imagined the dissolution of gender roles that accompanied the figure of the New Woman as threatening women's and men's social and economic well-being, fashion orientalism reframed these changes by promising that New Womanhood would be accompanied by material wealth and access to commodities.

In the opening example of the postcard, this suturing of orientalism and modern gender expression through fashion is realized in the figure of the everyday woman as Harem Baby. This equation of the Orient with readily available or purchasable luxury goods, and the pleasure and leisure lifestyle that went with them, was being conspicuously marketed in the same era as the Chicago Columbian Exposition was cultivating popular audiences for exotic dance performances, as discussed in chapter 1. The modern style of orientalism moved between exotic spectacle of the other on the public stage and orientalism as privatized domestic luxury that fashionable middle-class women could emulate, for instance, by creating "Turkish corners" in their homes featuring ornamentation such as "tasseled cushions, potted palms, and ostrich plumes in big vases or majolica jars."[5] This replication of luxury through affordable consumer domestic goods made class as well as race aspiration symbolically attainable through the purchase of decorative objects and clothing items.

This makes fashion orientalism symptomatic of and complicit in the larger circulation of "commodity racism" that Ann McClintock identifies in *Imperial Leather*. Using the example of Pear's soap, she memorably shows how everyday products bearing images of imperialism enabled the quotidian circulation of the ideology of the civilizing mission.[6] Domestic orientalism similarly circulated through everyday objects; cultural masquerade became a sign of cultivated taste that ultimately served to reinforce white norms and, ironically, to domesticate women's daring uses of orientalism to perform a new gendered modernism in the public sphere.

The dancers—Loïe Fuller and Aida Overton Walker among them—who performed Salome and similar dances circulated as traveling commodities, and as

such capitalized on the popularity of fashion orientalism to promote their own work as the spectacular embodiment of these tropes. Situating their work as contemporaneous with fashion orientalism helps track the material culture and popular consumption practices that undergirded audience reception of these dancers. It marks how these performers successfully capitalized on, but also shaped the contours of, this new modern gendered orientalism. They shaped the meaning of modern orientalism when they converted their own consumption into production in the form of public spectacle—which inspired at least some female fans in turn to create their own public and domestic performances of orientalism. Audiences had been educated to see and consume orientalist feminisms in particular ways—as racialized spectacle that offered access to sexual expression and attainable luxury. Fuller and Walker constructed their diva personae within these logics, but also against them. They did so by both inhabiting existing idealized visions of the oriental while distinguishing themselves from each other and their competitors. In the next section, I examine how Fuller constructed this difference in relation to another performer: her contemporary Kawakami Sadayakko (who later became famous for her version of Oscar Wilde's *Salomé* on the Japanese stage). Fuller used the juxtaposition of their work to stage the cultural anachronisms of orientalism as diva gestures toward a gendering of the modern future.

A STUDY IN CONTRASTS: COMPETING ORIENTALISMS

In 1900, two very different divas took to the transnational performance circuits, eventually appearing in tandem while sharing their theatrical innovations at the Paris Exposition Universelle: the Chicago-born Loïe Fuller (1862–1928) and the Tokyo-born Kawakami Sadayakko (b. Koyama Sada, 1871–1946).[7] Fuller was scheduled to perform in her own pavilion—Le Théâtre de la Loïe Fuller—designed by Henri Sauvage and Pierre Roche to echo her famous moving-fabric images. Known as the "Fairy of Light" ("La Fée Lumineuse") for her experiments with lighting and special effects for the theater, she was the perfect icon for the exposition, which sought to celebrate new technologies, in particular electricity, but also sound and film recording.[8] Her diva iconicity became the living enactment of technological change at an exposition that celebrated new technologies as indexes of national progress and colonial expansion.[9] Fuller invited Sadayakko to join her as an accompanying act in her pavilion: the Japanese acting troupe of which Sadayakko was a part had been receiving significant media attention in New York and London, and Fuller, a savvy self-promoter, knew that Sadayakko would draw additional audiences to Fuller's own pavilion. Significantly, the troupe's appearance would also shape how Fuller's own work was perceived. Fuller's invitation, as I discuss in more detail below, was a means of promoting Sadayakko but

also functioned to recontain the Japanese actress's performances firmly within tropes of orientalism. This recontainment foreclosed the possibility, at least in this context, of Sadayakko and the Kawakami troupe performing the modern theatrical techniques and styles of acting for which they were renowned in Japan.

Fuller and Sadayakko took to the popular stage together within the throes of early twentieth-century fashion orientalism, a trend that, as outlined above, expressed the competing impulses of daring and domestication. At the Paris Exposition, they were also doing so within a sea of *japonisme*, a particular subset of orientalism that had been gaining momentum since the 1853 opening of Japanese trade with the West. This taste craze was marked, like orientalism more generally, by a romantic tension in which Western modernism's turn to the East was also coded temporally as a turning to the past in the service of forging Western futures. The fabrics, woodblock prints, vases, screens, fans, hair combs, and kimonos adorning Victorian domestic spaces were valued as precious by collectors in part for their imagined contrast to the aesthetics of industrial modernity. Ideologically suturing the Orient to romantic notions of a preindustrial past, these objects seemingly contained within them the fantasy of unalienated life and labor. Similarly, European and American artists seeking a countertradition to what they perceived as the vulgar modern styles inspired by industrial and mass production, mass consumption, and the overall commercialization of culture saw an alternative in the floral ornamentalism of Japanese design, with its fluid, organic lines and botanical themes. Borrowing these techniques of using natural forms as a foundation for abstracted design, the ensuing style became a hallmark of art nouveau, of which the Paris Metro stations designed by Hector Guimard are perhaps the most famous example.

As divas of the turn-of-the-century popular stage, Fuller and Sadayakko were each made famous as representative figures of their era: they widely inspired the arts, from literature to painting to the decorative arts. Sadayakko's and Fuller's likenesses were reproduced and marketed in the form of perfumes, magazine covers, and lamps. They became iconic figures whose ways of performing gender in the public sphere symbolized the social shifts and movements that accompanied the modern. On the one hand, they were symbolic muses, captivating spectacles that were source material and inspiration for male modernists; on the other hand, they were producers of diva iconicity, carving out a space for remaking gender and for innovating and interrupting the circuits between performers and audience reception. Each sought to capitalize on popular audiences' desires for new forms and iterations of female spectacle, yet they differently reconfigured that vision of what the female body performing the modern would look like on the transnational stage. Orientalism, as expressed in the Paris Exposition's emphasis on decorative art nouveau, fused the static decorative object (the lamp, the chair, the vase) with fluidity and movement (and sometimes

FIGURE 12. Loie Fuller. Glasier, photograph, 1902. Courtesy Library of Congress Prints and Photographs Division, Washington, DC (ref. LC-USZ62–90931).

electricity) through design. And yet in some sense that fluidity or movement remained a referent that was paradoxically locked into such domestic objects. This paradox is one that I see enacted again in the reception of their work, which seeks to transform mobility and live performance into a recognizable, identifiable form or literally into a decorative object, even when audiences were being drawn initially to their experimentation and the unexpected effects of live moving performances.

Nicknamed "La Loïe Fuller," Fuller was an innovator of modern dance who is noteworthy for not having classical training in ballet. Rather, like many other US Salome dancers, she emerged out of the vaudeville and popular stage traditions. Her work (unlike that of other Salome dancers) was both spectacular and apparitional, featuring effects that demonstrate how deeply inflected her performances were with themes of moving-image technologies. Perhaps because of the pervasiveness of fashion orientalism and her savvy deployment of it, Loïe Fuller's contemporaries saw her work as a Western embodiment of Japanese organicism.[10] In contrast, contemporary scholarship tends to focus on the technological innovation in her work, a move that can distract from the orientalist foundations upon which these inventions were built. I am arguing that any focus on her technological futurism should also recognize the extent to which it was entwined with, and even made possible by, her uses of orientalism. It is the double move of her appropriation of Japanese organicism juxtaposed against a kind

of atavistic orientalism (making it a symbolically temporal move as well) that launches her capacity to be seen as producing new desirable technologies for the future.

Fuller's dances were ethereal projections of otherworldly technological dreamscapes, whose prosthetic devices and lighting effects seemed to thrust the body beyond its own reach, into space and time—and into magical futures created out of the past tense of orientalism. And yet they presented such techno-visions on a palatable human scale (see figure 12). Although her work is most remembered as the embodiment of art nouveau and *symbolisme*, the figure of a woman decoratively metamorphosing into a butterfly or becoming a Georgia O'Keeffe–esque flower-shape, F. T. Marinetti would claim Fuller's dances for futurism, declaring her the ideal modernist for his vision of a "multiplied body of the motor" and what he saw as "metallicity."[11] Marinetti's remarks are a reminder that because Fuller's work offered a vision of the "pleasing effects" of technology, it could become a tool both for and against state and industry.

At the Paris Exposition, with its themes of industrial progress and colonialism, two of the four dances Fuller presented were drawn from her 1895 full-length production of *Salomé*. Colonialism was represented by pavilions promoting Java, Senegal, Madagascar, Algeria, Cambodia, and Dahomey, each colony experienced through performances, food, rides, simulated villages, dioramas, and other ethnographic spectacles and mechanical illusions that transported imperial visitors to these faraway places. Fuller's pavilion similarly transported visitors; she was a figure who made electricity magical, "the electric fairy"—and who also "refined" the colonial veil dance, making it wholesome fare for women and children.[12] Rhonda Garelick has persuasively argued that Fuller "laid bare the trappings of colonial spectacle" as she "literalized and played with the sci-entific voyeurism" of the colonial objectifying gaze through her use of mirrors and other stage devices.[13] But Fuller also, I argue, reproduced and cultivated the orientalist gaze, including generating extra publicity by inviting Japanese actress Kawakami Sadayakko to perform on the same stage as spectacle.

Kawakami Sadayakko and her husband, Kawakami Otojiro, were pioneers of the modern theater in Japan. Sadayakko was considered the first cisgen-dered woman to perform in modern Japanese theater, replacing the *onnagata*, or male performers of female roles (see figure 13).[14] Otojiro began his career in Japan performing satirical, antigovernmental skits and later became known abroad for his "war plays" and new genres combining Kabuki and Western conventions, melodrama and realism. The troupe built a European-style the-ater in Japan, the Kawakami Theater, and a new school for actors. They would adapt Western plays such as Shakespeare's *The Merchant of Venice* or Alexandre Dumas's *The Three Musketeers*, rescripting them as commentaries on local and national politics and using them as vehicles for developing a more "natural" or

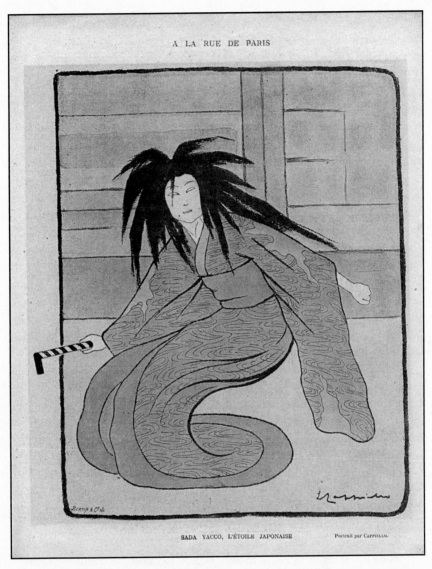

A LA RUE DE PARIS

SADA YACCO, L'ÉTOILE JAPONAISE Portrait par CAPPIELLO.

FIGURE 13. Kawakami Sadayakko, print from *Le Rire* (satirical weekly) by Leonetto Cappiello, lithographer, 1899. Collection of the author.

realistic style of acting, in contrast to the stylized conventions of traditional Japanese theater.[15] When the experimental Kawakami Theater became a financial liability, they planned to tour Europe and the United States with Kabuki adaptations. Ironically, despite being considered radical antitraditionalists at home, pioneers of *soshi shibai*, or "new theater," while abroad they were compelled to adapt to American and European tastes by performing material that

occidental audiences would embrace as quintessentially or imagine as "traditionally" oriental.[16]

Sadayakko toured with the troupe in the West only briefly, from 1899 to 1900 (the United States, London, and Paris) and 1901 to 1902 (Europe, arranged with Loïe Fuller), and again in 1907 and 1908 (France). During these tours Sadayakko employed the movement of transnational performance and capitalized in each location on performing difference. This meant essentially performing contrasting material for Western versus Japanese audiences. In Japan she advocated for the new theater, breaking from tradition as the first female actress and trying out new forms (styles of acting) and content (Western dramas adapted as commentaries on local and national politics) for the stage. In addition, she displayed her departure from tradition by dressing in Western attire for publicity stills in Japan. In stark contrast, while traveling internationally, she embodied for Western audiences what were perceived as the traditional conventions of being a Japanese woman. As Ayako Kano argues in her study of the first generation of women to act on the Japanese theatrical stage, *Acting like a Woman in Modern Japan*, "While she may have presented herself as the essence of the Orient to Western eyes, once back in Japan she presented herself as the perfect Western lady. And while she may have seduced the Western audience with her exotic dances, her compatriots at home looked at her askance, with more than a little ambivalence."[17]

When Fuller invited Sadayakko to join her for a tandem appearance at the 1900 Paris Exposition Universelle, it was for a collaboration in publicity, with each capitalizing on the other's status as a modern diva. The juxtaposition of their work served several purposes. Placing the two back-to-back—stylistically different, yet similarly skilled and lauded as stellar performers—could potentially boost the perceived value of each performer as a diva of the modern stage. It also served to reinforce the uses of orientalism by each, but to distinct effects. Much of the Western critical and popular response to Sadayakko understood her comparatively, as the "Japanese Sarah Bernhardt" or the "Japanese Ellen Terry"; reviews in particular celebrated her success as a tragedienne. Her dramatic death scenes and the realism of the troupe's war plays were amplified when set against the cinematic experiments and visual effects of Fuller. In turn, Fuller's eschewing of traditional scenery and props in favor of darkness and dramatic lighting projections was well received as contrasting theatrical experimentation. Prior to her inviting Sadayakko to share the stage in 1900, Fuller's work had come under scrutiny, in particular over its originality (or, as critics charged, a lack thereof). When Fuller's bid to win legal recognition of her work as intellectual property in the United States failed, success in Europe as an inventor and modern innovator offered the potential to imbue her work with artistic and authorial value. The juxtaposition, then, of the two performers and their respective uses of orientalism served to articulate what kind of theatrical authorship and originality was attributed to each.

AN ARCHIVE OF SPECIAL EFFECTS

Loïe Fuller is often understood by cultural historians through a lens of abstract invention and experimentation; however, her work rests on an armature of orientalist visions, an invented archive that is in many ways obscured by her successful bid for being recognized as an innovator, but upon which her work is nonetheless built. Before exploring the ways this hidden archive can be read symptomatically in her work, in particular leading up to her 1900 collaboration with Kawakami Sadayakko, in this section I first look at those aspects of her work for which she is most celebrated and remembered. Loïe Fuller had arrived in Paris in 1892, the year that Oscar Wilde's iconic queer decadent play *Salomé* was refused license by the Lord Chamberlain's Office in London while in rehearsal with Sarah Bernhardt. With that scandal fomenting, Fuller performed with the Folies-Bergère, bringing her innovative Serpentine Dance (*Danse serpentine*) to the stage.[18] This term came to refer to her signature method of dancing using large bamboo or aluminum wands, yards of diaphanous material, and lighting effects—including the projection of colored lights and the strategic use of darkness and shadows—to sculpt magical moving images in fabric (see figure 14).

In the Serpentine Dance, Fuller perfected a genre of dance that might be understood as a modern, even avant-garde, articulation of the vaudeville genre

FIGURE 14. "La Danse Blanche." Jerome Robbins Dance Division, The New York Public Library, Astor, Lenox, and Tilden Foundations, New York Public Library Digital Collections. Accessed December 11, 2015. http://digitalcollections.nypl.org/items/8653bb60–3046–0131–31b9–58d385a7b928.

of "skirt dancing": a future-forward iteration of Salome's Dance of the Seven Veils. As with Aida Overton Walker and other women performers onstage at the cultural turn from the nineteenth to the twentieth century, performing this apocryphal piece of choreography came to symbolize the creative possibility for a new gendering of modernism—through orientalism. Over the course of her career Fuller only built two productions explicitly around the interpretation of the Salome theme (in 1895 and again in 1907), and she therefore is not primarily remembered as a "Salome dancer."

Yet her entire oeuvre might be thought of as a modernist vision of veil danc- ing. Fuller, along with the new cohort of art-dancers, fused gender to ideas of motion and the modern, creating a new somatechnological aesthetic through dance. They staged the possibility of a public, mobile, and, in Fuller's case, sci- entific modern female subject. Fuller was more than a muse or art-nouveau object; she was an inventor and a scientist—and it is important to recognize her as such in order to understand the gendering of modernity by women cul- tural producers. However, it is also important to recognize that that ground of scientific invention was produced by the social exclusion and circumscription of other women and feminized subjects around the world. The scholarship on gendered modernism has accumulated as a white female archive with flashes of dissonance like Kawakami Sadayakko, Aida Overton Walker, and Oscar Wilde. To understand how that configuration of modernism takes place, we can also look at how a figure like Fuller produces modernism through the discourse of scientific experimentation but how, at the same time, her inventions rely on the exclusion of raced modernisms.

Theatricality was critical to producing the illusion of scientific expertise throughout the nineteenth century. Fuller's performances of technological mas- tery positioned her not only as an innovator but as a middle manager of race, producing female modernisms through racial difference. Fuller's illusionism, innovation, and experimentation, and her overall aesthetic science, were bol- stered by shifting explanations for race and colonialism, which themselves relied on the blurred territory of illusion and science. Audiences were taken by the pos- sibility that there could be a ringmaster in charge of these blurred lines and that this theatrically extended far beyond the stage and the cult of female celebrity.

Embracing electricity, carbon arc lights, hand-painted gels, radium, and chemical effects in her performances, Fuller became an early scientific inventor of stage and film technologies. Modifying the body and challenging prescribed gendered roles, Fuller, through dance, was also an early experimenter with a modern vision for a new "technology of gender"[19]—to borrow Teresa de Laure- tis's term—by defining gender as a set of effects produced by various social tech- nologies such as cinema and institutional discourses such as law. Fuller invested the feminine with science and embedded science in the figure of the woman's

dancing body in ways that anticipate twentieth- and twenty-first-century feminist performance art that engages technologies of the body. She is also a touchstone in early dance for a genealogy for contemporary choreographers working with differently configured bodies, disability, prosthesis, and dance. But Fuller is no Maria/Hel, that other famous machinic dancing femme fatale of modernism from Fritz Lang's *Metropolis*. In contrast to Hel's embodiment of a male fantasy of technological modernism imagined as woman, which encompassed all the fears of the deadly seduction of the cyborg, and whereas Hel danced the Dance of the Seven Veils in the form of a robotic whore of Babylon imagined through vaudeville spectacle, Fuller's machinic femme fatale was woman-made. Fuller's work resonates with the late twentieth-century feminist revolutionary myth of "cyborg consciousness" formulated by Donna Haraway in "A Cyborg Manifesto": "A cyborg is a cybernetic organism, a hybrid of machine and organism, a creature of social reality as well as a creature of science fiction.... The cyborg is a matter of fiction and lived experience that changes what counts as women's experience in the late twentieth century. This is a struggle over life and death, but the boundary between science fiction and social reality is an optical illusion."[20] Haraway's call for feminists to embrace technology echoes Fuller's welding of the modern woman with science and new technologies. Breaking the gendered distinctions between organism and machine, Fuller's investment in movement and hybridity not only extended the reach of the performer onstage but extended the reach of her own work across space and time. Her choreography was a form of feminist critique, speaking to the social construction of gender and changing what counted as women's embodied experience in the late nineteenth century. Yet the optical illusion she created was one that distracted from the ways that she inhabited race in her performances. Fuller, "seizing the tools to mark the world that marked [her] as other,"[21] transformed and dissolved the gendered polarities of art/science, nature/machine, and body/mind but did so through her own version of a new racial science.

Fuller produced this newly reconfigured gendered modernism as a space that she could occupy as both inventor and experimental object. Fuller's science-infused imagistic veil dances were spectacles that transformed the live experience of the theater by shunning the use of theatrical scenery conventionally used to replicate a "realistic" setting. Rather, she draped the walls and floor of the stage completely in black velvet and enveloped the theater in complete darkness before a dance began, making the stage a terra incognita. This technique had been utilized earlier in operatic productions, but Fuller was among the first to make use of it on the popular stage.[22] Into this theatrical night, Fuller projected effects using Thomas Edison's newly invented (1879) incandescent lamps. Fuller emerged in her performances from total darkness, a solitary illuminated figure slowly revolving to musical accompaniment. This careful staging

of transformation from dark to light and her performance of metamorphosis would have resonated profoundly with audiences familiar with popular, racialized explanations of science and progress. While analyses of women modernists are directed toward seeking out performers' agency, that gendered agency needs to be examined simultaneously in light of its complicity with other social structures besides gender, such as race and colonialism.

Fuller's aesthetic experiments with the metamorphosis of the female body through fabric, light illusionism, and movement held a special appeal for early experimenters in the new medium of moving pictures. Fuller also brought her special effects expertise to film as a producer and director, not merely as muse, for Léon Gaumont in France. Together with her life partner, Gabrielle Bloch, she produced and planned several of her own film projects, hoping to expand on her special effects inventions by creating illusion pieces that combined her stage effects with the new film-editing technologies.[23] She worked with the Lumière brothers, Georges Méliès, and Gaumont on experiments with the new medium. Because her Serpentine Dance performance was filmed in 1896 by the Lumière brothers,[24] who hand-tinted each frame to capture the lighting effects of her live performance, and because she (and her imitators) became a favorite subject for film experimenters and for Thomas Edison and the Edison Company, there exists a unique, if fragmentary, archival record of her work (as well as the work of her imitators such as Annabelle Moore, whose 1865 performance of the Serpentine Dance Edison also filmed and enhanced with hand-tinting). Yet just as the iconicity of Edison's persona as inventor obscured numerous other scientists and film experimenters from these histories of invention, Loïe Fuller's appearance in the archive in some respects disappears her nonwhite contemporaries who were similarly experimenting with performances and technologies of race and gender on screen and stage. For instance, Jayna Brown's work in *Babylon Girls* draws attention to performers such as the team Johnson and Dean, who presented their dances "using a system of lights that gave their bodies a kinescopic effect."[25]

An example of Fuller's convergence of technique and editing is a short film in which she transforms from a bat into a dancer.[26] A black bat puppet flutters haltingly down until it is flying near a garden wall; suddenly Fuller appears from her hiding place behind the wall, creating the illusion that she has metamorphosed from the form of a bat into a human dancer. She begins to dance in her trademark style, with movement almost exclusively in the arms, using her batons to manipulate the fabric—which in this case becomes swirling bat wings. Fuller is able to sustain the vigorous movement of her arms with their long extensions while executing a backbend, literally and figuratively conducting a symphony of fabric upside down. At the end of the film, editing creates a sudden very special effect not possible in her live stage performances: she vanishes entirely from the scene.

In this short piece, film effects and Fuller as a vamp are sutured in such a way that woman is not only the object of disappearance but the magician, too. The metamorphosis of the bat followed by the disappearance of the female body from the scene is the product of female mastery of technology and the stage. Technology affords woman a kind of power over both representation and the spectator. Editing to produce disappearance makes the screen perform as a veil drawn over the promise of the image. Loïe Fuller is a diva appearing in the shape of a master technological trickster.[27] The appearance/disappearance effect in this moment takes on new significance read in concert with other moments of appearance and disappearance that Fuller orchestrated in her work: where Kawakami Sadayakko's own experimentalism is foreclosed, her role as modern actress erased or replaced by more digestible fantasies, or where the roots of Fuller's work in cultural appropriation of traditional dances is rescripted by her in fantastical narratives about the genealogy of her work.

At the same time that Fuller's oeuvre both lent itself to and inspired the genre of trick films, her work shares qualities with what Tom Gunning calls the "cinema of attraction," or the exhibitionist impulses of early cinema, invested in the ability to make images seen rather than in creating a self-sufficient narrative or in imitating nature or the theater.[28] Although Fuller's work never fully adopted the stance of exhibitionist confrontation with the spectator associated with the cinema of attraction, neither did her work rest easily on the spectator's diegetic absorption. Fuller's work, like many other films of this early cinematic period, emerged in a historically liminal space of performance, a period of transition for audiences and performers alike, between changing technologies and the social practices of being-an-audience associated with different venues and media, and between the appearance of bodies of difference on the colonial stage as mere spectacle and the possibility of forging new raced and gendered visions that challenged staid consumption practices.

Temporally, technologically, and spatially, Fuller existed between the old and the new: between colonial ethnographic exhibition forms and the emergence of modern technologically inspired dance performance, between the vaudeville stage and the birth of film, between her manufacture of orientalism's past tense and her manufacture of modernism's orientalist techno-futures. The short films of her work, with their mixed messages, traveled internationally. Julio Arce and Yolanda Acker describe how her work functioned in the context of Spain's early years of cinema, when theater owners initially viewed cinema as a way of attracting audiences. An 1896 Teatro Apolo screening, for example, included a hand-tinted film print of *La serpentine*, which was screened along with six other short films including "panoramas, current affairs and short comic sketches . . . forming part of a vaudeville show that was not good enough to stand on its own."[29] Fuller was an emergent diva, yet still one attraction among many.

How she then chose four years later to be framed—as a solo performer sharing the stage with another prominent emergent diva—changed how her own performances would be received. This auteur image of a single moving figure, which she carefully crafted, represents both the emergence of art-dance as a serious genre and the rise at the turn of the century of the figure of the modernist female solo performer as choreographer and director and dancer. This image of the solo artist was critical also as a counterargument to the sea of imitators that came to define popular performance in this era. Ironically, although Fuller's work is deeply associated with motion or moving images, Fuller's body hardly moved during her performances. While she dispensed with the restrictive corset of the Victorian era, almost all the effort of her dances remained concentrated in the movement of her arms as she controlled the long batons attached to lengths of fabric. As she performed, she turned slowly, executing backbends and broad gestures, keeping the skirts twirling in ever-changing shapes. Her movements were restricted to what one reviewer called "graceful rotary movements."[30] Fuller's body was the source of the kinetic energy; that is, it was not her body that was set in motion onstage as a dancer, but rather the fabric that was literally set in motion by Fuller and could be manipulated into the illusion of mutating and dancing shapes. If Fuller was often read by her audiences via the comforting image of a "good fairy" or "Fairy of Light," it should also be remembered that the technologies that went into producing this feminist cyborg good fairy were not simply scientific, chemical, and cinematographic, but were also those visual technologies informed by racial science and mastery over the technologies of orientalism.

Audiences initially delighted in attempting to identify a shape in all that sinuous motion. According to one account by Fuller, she discovered the new art form in an accidental moment during a stage play, when her handling of an oversize costume elicited cries of "It's a butterfly! A butterfly!" from the audience.[31] Audiences saw her as sculpting silk into recognizable moving images that suggested flames, flowers, butterflies, bats, and other organic forms. One skeptical critic concluded that her pieces were "reminiscent of everything and convincing of nothing," while another marveled, "She is a spectacle that is scarcely equaled by rainbows, torchlight processions, Niagara Falls, or military parades."[32] The former critic takes a frustrated, skeptical stance as a result of wanting Fuller to *be* something, rather than trying to invoke many things. The latter's praise involves repeatedly searching for the perfect spectacular comparison, only to end up with a string of failed metaphors. Although it might not be immediately apparent, her critics were describing her in terms commonly deployed by colonial frameworks. Drawing on discourses of the sublime, they situated her movements within the world of natural phenomena, thereby naturalizing her special effects; or, drawing on touristic and militaristic examples, they situated her within nationalistic or

colonial pageantry. It seems focusing on Fuller as an innovator and director and scientist helps escape one level of colonial discourse, only to find it replaced by another.

Spectators' desire to capture Fuller, to pin her down like the proverbial butterfly in a collection, cuts against the grain of her own endeavor to project a modern vision of woman-in-motion that is unlocatable. But that pinning down reveals an impulse related to orientalism. Although not explicitly invoked, orientalism is at work in the logic of reception as an act of collecting and possessing the female body as a natural wonder. Her 1913 autobiography, *Fifteen Years of a Dancer's Life*, is an artist's treatise on motion, revealing how preoccupied Fuller was with lighting and movement effects even as her audiences ironically remained preoccupied with solving the Rorschach-like mysteries of her performances. The difference in the preoccupation between artist and audience is noteworthy because both equally remain firmly entrenched within Western appropriation and control of the naturalized aesthetic effects of the Orient.

These dynamics have been further reinforced in the archival practices of Fuller herself. Fuller's *Fifteen Years of a Dancer's Life* is an autobiography that defies easy description yet becomes a central way that her work is preserved: part celebrity memoir, part artist's treatise, and part lay inventor's manual, it contains short treatises on "Colour and Light," "The Harmony of Motion," "The Music of Dance," and "The Expression of Sensation," but nothing on shape, form, or image as might be expected. These headings reveal that for Fuller, her work was an exploration of the phenomenology of motion, not objects. This attention to movement would seem to belie an investment in objects and objectification, in contradistinction to the impulses of her audiences, as I show above. Yet Fuller is not only reduced to an object or identifiable thing by her contemporary audiences; she again appears literally objectified in the archive of aftereffects. She has become most enduringly known and made visible as the muse of art nouveau and, hence, inspiration for literally hundreds of actual objects: bronze lamps, sculptures, and vases made with her likeness. This material and commodity culture dominates the scene and goes on to deeply shape the afterlife of her iconicity.

Several major museum exhibitions that feature Fuller are devoted primarily to the decorative and fine arts inspired by her work. When the Virginia Museum held the first of these blockbuster exhibitions in 1979, *Loïe Fuller: Magician of Light*, the director of the museum noted that "although Fuller was the toast of Paris at the turn of the century, the fifty-one years since her death in 1928 have left her an almost forgotten figure, shrouded in misinformation and obscurity."[33] This exhibit was followed by others at the Museum Villa Stuck in Munich and the Musée d'Orsay, both of which held exhibitions solely devoted to Fuller's performances and works inspired by them. The materials then gathered to

restore Fuller to prominence—including Jules Chéret's and Henri de Toulouse-Lautrec's famous 1893 series of sixty color lithographs, *Miss Loie Fuller*; Agathon Léonard's table setting *Jeu de l'écharpe* (France, 1898), a series of porcelain figurines, some performing with scarves; and Raoul-Françoise Larche's bronze lamps—demonstrate both how she became a popular cultural icon and how that iconicity endures through an image that was mass-producible, also circulating in postcards, prints, and posters.[34] Fuller's dances, as remembered in artefacts, are idealized images of her as a solo performer, an ethereal apparition who is then paradoxically frozen in bronze statues, paintings, and prints. In her day, the most prominent writers, scientists, musicians, artists, and performers came to her performances, including the poets Stéphane Mallarmé and Jean Lorrain, the novelist J. K. Huysmans, the musician A. Hamburg, the critic Roger Marx, the painter Henri de Toulouse-Lautrec, and the sculptor Auguste Rodin.[35] In addition, the Nobel-winning physicists Pierre and Marie Curie befriended Fuller. Her work was adopted as the corporeal expression of these artists' and scientists' own respective media: as symbolist poetry in motion, as the aural made visual, as the art of science, or as the ideal of *Gesamtkunstwerk*. And yet despite this wide and interdisciplinary influence, when condensed for contemporary audiences in American museums, Fuller tends to be framed narrowly within an archive of decorative objects, the legacy for which she is now most enduringly remembered.

With the publication in 1997 of an extensively researched biography by Richard Nelson Current and Marcia Ewing Current, *Loïe Fuller: Goddess of Light*, Fuller is certainly no longer a forgotten figure. When copies of surviving film footage of her dances were shown as part of another blockbuster exhibition, *Art Nouveau, 1890–1914*, which originated at the Victoria and Albert Museum in London in 2000 and went on to the National Gallery of Art in Washington, DC, the moving-performance and film-technology experimentalism of her work began to come to the fore for contemporary publics. And yet, because of the media in which her art is most visibly preserved and circulated, she continues to be better known as the feminine embodiment or muse of art nouveau than as a feminist modernist scientific experimenter. This is, of course, in part because of the apocryphal nature of choreography, but also because of the way her trace remains most prolifically preserved in the form of decorative objects. This objectification echoes the patriarchal effects of history, which relegate women artists to the status of muses and objects rather than subjects or producers of history, but it is also a reverberation or effect produced by the modern epoch of fashion orientalism and the turning of high art and aesthetics into everyday commodities.

In stark contrast to this literal and symbolic force of objectification—and often as a deliberate challenge to it—feminist dance and performance studies scholars have stressed, and even celebrated, that their "objects" of study are not

objects at all but moments definable by their very irreproducibility and ephemerality, or what Marcia Siegel calls "a perpetual vanishing point."[36] But the proliferation and repetition of Fuller's image, and the many traces from which we can read and interpret Fuller's performances in art objects and in the work of her imitators, can also be read as testament to a will to visibility that is gendered and raced and defines these early twentieth-century modern innovators. That will and purpose, and the force of citation and repetition that constitutes the diva afterlife, can be obscured by theories of performance that emphasize performance's ontological status as "disappearance."

Fuller's *Fifteen Years of a Dancer's Life* is an extension and expression of her engagement in self-authorship, and it is also a vehicle for self-archiving her cultural production and, in doing so, framing the stakes her own project. On page 62, Fuller apologetically breaks from a more standard account of life's progress to write what she calls a "theoretical 'essay'" explaining her "ideas relative to her art." She begins, "if I appear too serious I apologise in advance," signaling to the reader that she is an amateur and an American, one who "had never been inside an art museum" until she came to Europe. She then proceeds to articulate her phenomenology of motion. She writes, "To lead us to grasp the real and most extensive connotations of the word dance, let us try to forget what is implied by the choreographic art of our day. What is the dance? It is motion. What is motion? The expression of sensation. What is a sensation? The reaction in the human body produced by an impression or an idea perceived by the mind" (70). For Fuller, motion is the expression of an idea, not the expression of pure emotion. Fuller's work onstage and her writing about that work sought to change the terms of the nineteenth-century gendered equation of woman with emotion by turning to the idea of women in motion. The emotional woman of the Victorian period typified in the familiar figure of the pathologized hysteric had to be contained and subdued. The hysterical woman needed bed rest, a "cure" that represented the imposition of radical stasis. Fuller, in opposition, presented woman as motion, a shift that claimed not only the importance of physical culture but also the realm of ideas as a legitimate arena for women. Without simply being forced to expel (feminine) emotions from the scene to lay claim to (masculine) ideas, she instead made the body's gendered movement and the mind's abstract ideas about movement inseparable.

For groups marked—by nineteenth-century legacies of colonial and Freudian thinking and the prevailing popularization of scientific racism—as primitive and therefore anachronistic subjects of history, the constant rehearsal of the past performed as history was one way to undo occidental conceits of civilization. On the other hand, for Western modernity, the degenerative or romantic pulls of the past and the calls or impulses of historical progression and futurism saturated cultural obsessions. What I hope to draw attention to in the next section is how

Fuller chose as an inventor to amplify these modernist juxtapositions through the presence of the Kawakami troupe. The studied contrast of the Kawakami troupe's historical realism and performance of emotion provided Fuller with a counterpoint against which she constructed her modern, stark, abstracted, and electric performance. Ironically, while the Kawakami troupe sought to perfect a more realistic style of acting for the Japanese theater, staging its own revolution against tradition and its political uses on the stage, this modern realism was not the mode for which European and American audiences sought them out. Fuller's choice, therefore, was a studied performance, one that redeployed orientalism and framed Sadayakko's Japanese art as drawing on an anachronistic romantic past against which Fuller produced her future-directed, scientifically infused modern vision of the skirt dance and constructed herself as an inventor, thinker, and scientist.

©LOÏE FULLER: TECHNOLOGIES OF ORIENTALIST DRAG

Dance historians have challenged the absolute originality of Fuller's vision on the grounds that skirt dancing is a traditional dance appearing across cultures, and numerous other performers experimented with variations on skirt dancing during this period and even with the lighting technologies with which Fuller is strongly associated. Vaudeville could almost be said to operate on the principle of imitation among performers, since parody and referentiality were a staple of both comic and serious routines.[37] Perhaps because of these strong associations of unoriginality with the popular stage, Fuller was deeply invested, as we saw in the previous section, in claiming her work as inimitable and an arena of ideas, conceiving of herself as both a cultural and knowledge producer as well as a technological inventor, and not merely as a decorative object or muse. We know this not only because she took her own theories seriously enough to produce such treatises but because she took the unique steps of seeking patents and copyright for her technological and mechanical innovations (see figure 15).[38] Among the theatrical special effects Fuller eventually developed and patented (in the United States as well as Europe) were the long wands that enabled her to manipulate great quantities of fabric and to prosthetically extend her reach and enlarge her illusions (refer to figures 12, 14, and 15). However, when Fuller left the United States in 1892, it was out of artistic frustration: she experienced the failure of three separate lawsuits to protect her intellectual property against unfair competition by imitators. In an 1892 ruling, *Fuller v. Bemis*, the circuit judge held, "An examination of the description of the complainant's dance, as filed for copyright, shows that the end sought for and accomplished was solely the devising of a series of graceful movements, combined with an attractive arrangement of drapery, lights, and shadows, telling no story, portraying no character, depicting

FIGURE 15. "Garment for Dancing," M. L. Fuller, US Patent Drawing No. 518,347, April 17, 1894.

no emotion. The merely mechanical movements by which effects are produced on the stage are not subjects of copyright where they convey no ideas whose arrangement makes up a dramatic composition." The judge literally found that her performances had no ideas, and based on that finding he ruled that Fuller's modernist experiments with movement did not constitute intellectual property. "It is essential," he argued, "to such a composition that it should tell some story. The plot may be simple. It may be but the narrative or representation of a single transaction; but it must repeat or mimic some action, speech, emotion, passion, or character, real or imaginary. And when it does, it is the ideas thus expressed which become subject of copyright."[39] The equation of narrative and intellectual property by the judge meant that the absence of a dramatic narrative reduced her efforts to a mere expression of effects. According to the ruling, mechanical movements, technique, and technical devices cannot be copyrighted unless they are part of a dramatic composition. Perhaps here, too, Fuller was limited by the law trying to place her work in the realm of theater and, therefore, drama, rather than in the realm of technology and science. Fuller's focus on developing this genre as an art, and thinking through the phenomenology of movement and light and illusions as ideas, was an effort the judge failed to recognize. In reaction to what she saw as an anti-intellectual artistic climate in the United States (and perhaps to escape her competition), Fuller embarked on her European tour to Germany, France, and England.

Caroline Joan S. Picart and Anthea Kraut have recently applied a critical race theory framework to understanding the investment in whiteness as property that undergirds Fuller's lawsuit, marking an important turning point in Fuller scholarship.[40] They draw attention to Fuller's sense of entitlement to the protection of intellectual property. Kraut writes, "Fuller's invocation of property rights, made at a time when American women were not yet enfranchised citizens, was thus also an attempt to claim the white male privileges of possessive individualism. Aligning herself with the capital of the white propertied subject, Fuller sought to shore up her difference from the dancers that circulated as salable sexualized and/or racialized objects in the theatrical marketplace."[41] I see Kraut's observations played out as well in Fuller's use of mobility, both onstage and as a subject who could easily traverse national boundaries, which enabled the white female subject of modernism to exist within a certain set of social relations. In Fuller's work, the white feminine subject can come into modern subjecthood without sacrificing the feminine body (the scientist can be a woman) and without being reduced to the body (woman as only the object of science, of the male gaze). The feminine is not split off from science as its perfect opposite or as its desired object (Pygmalion's muse, the Bride of Frankenstein, or Metropolis's Hel); rather, Fuller's technologies of mobility facilitated her ability to inhabit the place of auteur, inventor, film editor, chemical scientist, and dancer at once. The

apartment Fuller occupied at the Folies-Bergère captures this perfectly. Filling it with miniature stage models that she used to design the staging and lighting of her projects, Fuller transformed her domestic space into a laboratory, a space of scientific enterprise.

The subject of feminism has been defined by its very impossibility, and by its necessary negotiation or movement between dominant ideologies and their unseen, unacknowledged, unrepresentable, and impossible-to-conceive-of-or-locate others. To describe this implied yet unseen space that is feminism's subject, and is outside the taken-for-granted system of gender ideology, Teresa de Lauretis borrows a term from film theory to describe the space outside the frame of the screen, or the "space-off." I am arguing that when Fuller invited Sadayakko to share the stage with her at the Paris Exposition Universelle in 1900, that moment seemed to be one in which each performer capitalized on the diva status of the other: Sadayakko's association with orientalism potentially functioned for Westerners as a backward historical gesture that offset Fuller's modern futurisms, a contrast available to be capitalized on by each performer. However, while Fuller's work can be seen as producing a modern gendered vision of dance and aesthetics and as representing feminist utopian possibility with its promise of free movement, gendered extension into space, queer subjectivity, and the image of woman as scientific innovator, at the same time, her work mobilizes this vision through technologies of orientalism that work to literally erase the innovations of women of color from the stage even as she is promoting them. This erasure of race becomes the space-off of Fuller's own ideological project.

This space-off can be read into three key moments in Fuller's career: first, the origins of her dances were fashioned through her narrating of their romanticized orientalist genealogies; second, she used her working relationship with Sadayakko and later with Hanako to activate an anachronistic orientalism as a tool to produce her vision of the modern; and third, orientalism as a racechange performance grounded Fuller's performances. All three moves contributed to Fuller's diva iconicity, as I discuss in the concluding section. Fuller's overall production and mastery of her art form are reproduced through these different orientalist impulses. In this section, I draw attention to the costs of performing orientalism as a means for generating gendered new modernisms. In the pursuit of occupying or copyrighting the position of authorial or liberal subject, Fuller produces the objectification and erasure of others from the scene of her creation.

The Salome dance was key to Fuller's narrative fashioning of the orientalist genealogies of her dance. It provided Fuller an artistic birthright for her work and served to legitimate her art. She wrote, "I have only revived a forgotten art, for I have been able to trace some of my dances back to four thousand years ago: the time when Miriam and the women of Israel . . . celebrated their release from

Egyptian captivity.'"[42] Through a logic of gender as culture, Fuller felt entitled to appropriate this legacy because it represented women's shared legacy. Over the years, Fuller gave multiple accounts of how she developed her techniques: she was inspired by the gift from an Indian officer of "an old Hindoo costume," or a "Nautch girl's dress" from Calcutta.[43] These romanticized colonial narratives, repeated in Fuller's autobiography, comprise an invented archive, specifically making the fabric, a technology essential to her art, a fetish through which Fuller can make sense of her own "discovery" of technique. And by imagining the origins of these fetish objects in India, she also reveals her resources as objects of British imperialism, exposing the European colonial themes at work in the imagined archive of her dance.

Her techniques secured in place through this narrative of technology as a gendered birthright, with the play of mythic and ancient origins swirling around them, Fuller then sought to produce out of that imperial archive a vision of her work as modern. Building on the ground of that British imperial archive, she went on to contrast her work against an entirely different set of oriental histories and identities. This effort to incrementally activate her work in contrast to a series of manufactured retrograde orientalisms can be seen played out in Fuller's working relationship with the Japanese performers Sadayakko and Hanako.

Even before she arrived in San Francisco in May of 1899, and a year before she joined Fuller onstage in Paris, Kawakami Sadayakko had been commodified and made the larger-than-life star of the Kawakami theater troupe as they traveled the United States. Sadayakko recalled, "One thing came as a surprise to me: on the way to the hotel, I could see photographs of myself blown up larger than life plastered at every street corner! . . . I argued that it was a big mistake, . . . that the play would be the Sino-Japanese War. But I was told, 'No, . . . Americans don't know the difference between Japan and China. . . . You've got to have an actress.'"[44] Sadayakko was told that to compensate for the audience's racist conflation of two Asian nations (which would make the war plot conflict between China and Japan supposedly incomprehensible, though the war broke out in 1894–1895), they had to substitute the body of the female star—which was easily consumable. During the US tour, Sadayakko was mostly received as a novelty and seen through the lens of American orientalism, where fascination with her Kabuki-inspired performances and dance was a central draw for American audiences. As Amy Sueyoshi explains, "Articles of Japanese femininity appealed to white San Franciscans at a time when the meaning of womanhood was changing. Japanese womanhood symbolized a 'lost' femininity in the shadow of the 'New Woman.'"[45]

After San Francisco, the troupe went on to perform in other cities with large Japanese populations, including Seattle, Portland, and Tacoma. They then traveled to Chicago and the Midwest before moving east to Boston, Washington,

and New York. Their presence in New York coincided with David Belasco's one-act play *Madame Butterfly: A Tragedy of Japan*, a coincidence that would reappear during their subsequent appearance in London. *Madame Butterfly*, which was also the basis of Giacomo Puccini's 1904 opera, was both a product of and a metaphor for the occidental fascination with Japan that would envelop the Kawakami troupe both in the United States and abroad.

In Boston, Sadayakko and the troupe of about twenty actors performed amid consumable goods that were marketed along with the performances. As described in the opening of this chapter, commodity orientalism in the United States and *japonisme* in France became spaces of reception in which audiences cultivated their own modern gendered self-definition. In the United States, the troupe's stage appearances were followed by pedagogical performances in which Sadayakko would ethnographically perform tea ceremonies. Educating her audience of aspiring art connoisseurs, Sadayakko performed in the guise of revealing "authenticity."[46] Shelley Berg describes Sadayakko's approach as "the unusual alliance of artifice and *verismo*," while Tara Rodman writes, "Audiences were not put off by the obvious commercialism of the arrangement" and, in fact, were in the habit of "objectifying troupe members as commodities available for purchase."[47] Rodman argues that the Boston audience had been cultivated to be able to—and desire to—recognize the troupe's "modernism," thus propping up their own sense of themselves as international connoisseurs of modernism. This transmogrifying of the performer into collectible is evidenced in the language of spectatorship captured in newspaper reviews of the era.

The troupe's dancing and their fighting scenes were also compelling to Western audiences, but the music, language, and plot were seen as barriers to Western enjoyment. As the first Japanese theatrical acting troupe to travel in Europe (earlier traveling performances from Japan consisted of juggling and acrobatics), and going on from London to Paris, Belgium, and Spain,[48] they met with mixed reviews. Although she was primarily renowned as an actress, Sadayakko's dances became popular and essential components of the troupe's theatrical productions. "Critics often wrote about her, especially her dancing," Berg notes, "as if she were alone on stage."[49] Her growing overall renown as compelling female figure and star of the troupe made Sadayakko an interesting choice for the invitation to perform in Fuller's own pavilion, which she did for four months. A second tour, under a yearlong contract with Fuller, took the Kawakami troupe to fourteen countries, including Russia, Italy, and Germany. And by the time of their third tour, which took place in 1907–1908 and was Sadayakko's last in the West, they were sometimes being billed as "la troupe Sada Yacco."

Berg explains that "comparison with the great divas of acting of the era" became the other mode of understanding Sadayakko's art. However, those reviews were laced with language that signaled racial distaste and even repulsion,

as when one critic described Sadayakko's dancing as "wonderful in skill, and at times very graceful, but unfortunately, occasionally grotesque from a Londoner's point of view." The contemporary reviewer Lady Colin Campbell wrote a column detailing Sadayakko's performances for readers that Berg argues provides a sense of how her "dual image—as fascinating actress and exotic geisha—and her successful manipulation and conflation of the realms of public performance and private occupation" produced her particular appeal.[50]

Fuller, in turn, used the particular appeal of the troupe and Sadayakko's personae specifically as a framing device to produce a dichotomy between Fuller's "new" theater of occidental modernism and technology and Sadayakko's "old" theater of the orient. She invited the Kawakami troupe to enact performances that would be perceived by Western audiences as "authentic" oriental dramas, such as *The Geisha and the Knight,* and encouraged the troupe to perform dramatic tragic death scenes, hara-kiri scenes that echoed a form of Grand Guignol to which French audiences were accustomed and for which the contemporary actress Sarah Bernhardt was famous.[51] The prominent European artists, dancers, and writers enthralled with Fuller were also captivated by Sadayakko, among them the writers Arthur Symons, Jean Lorrain, Max Beerbohm, and André Gide and the artists Pablo Picasso, Auguste Rodin, Edgar Degas, and Paul Klee. Women performers such as the actresses Ellen Terry and Sarah Bernhardt and the emerging dancers Ruth St. Denis and Isadora Duncan were inspired by Sadayakko's artistry, and Duncan even traveled with Fuller and Sadayakko in 1901–1902. This attention and excitement produced an archive of both performers' work and its reception that includes artists' sketches, posters, and prints, as well as interviews, reviews, staged photographs, sound recordings, and short film clips. A consequence, however, of Fuller's framing and the overall reception politics in this era, steeped in world's fair and colonial spectacle, which encouraged "orientalizing" of their repertoire, was to foreclose the possibility of the troupe performing the experiments in modernist theater for which they were renowned in Japan.[52] In Europe they came to be seen as part of the modernist enterprise, but as anachronistic modernist muses, not modernist performers in their own right.

In 1904–1905, shortly after a falling-out with Sadayakko, apparently over financial disagreements related to the costs associated with traveling with such a large company, Fuller engaged the Japanese actress Ota Hisa (1868–1945). Fuller introduced her to her friend Auguste Rodin, and the famous sculptor invited her to Paris, completing a famous series of masks studying her notably expressive death scenes. Also known as Hisako Hohta, she was encouraged by Loïe Fuller to use the name Hanako, or "little flower." Fuller had become fully attuned, after working with Sadayakko, to marketing traveling Japanese performers through an imagined lexicon of orientalism. Rather than inviting Hanako to share a venue

alongside her as a tandem solo performer, as she had with Sadayakko, Fuller now scripted orientalist dramas for her to perform, written in what one audience member described as "pidgin English."[53] Audiences assumed that the plays, with titles such as *Little Japanese Girl*, were translations of original Japanese dramas. British audiences had been primed in the consumption of a fantasied Japan by Arthur Sullivan and W. S. Gilbert's still-ubiquitous *The Mikado* (1885), which was ostensibly set in Japan. *The Mikado* saw one of the longest runs for a musical theatrical production of its era, and it remains one of the most frequently performed Savoy Theatre operettas in the present day.

In 1907, the Savoy produced *Little Japanese Girl* with an all-British cast. It is noteworthy that Fuller had herself photographed wearing Japanese clothing, including a kimono, as part of the promotion of the production. Fuller's increasing investment in, authorship of, and adoption of orientalist style can be traced from her management of what Kano calls the "pseudo *kabuki*" of Sadayakko to her authoring of faux Japanese dramas for Hanako to her use of Japanese clothing and fashion orientalism as a promotional gimmick for *Little Japanese Girl*. This (increasing) investment then extends into her own performances, as orientalism becomes an essential ingredient of her second version of Salome.

Ironically, and perhaps fittingly, only a few years later, after her return to Japan, Sadayakko became central to a Salomania craze in that country. In 1914, she staged Oscar Wilde's *Salomé* in a production that famously competed with another mounting of the same play, featuring the rising female star Matsui Sumako, a competition between divas that, significantly, announced the staying power of the figure of "the actress." As Kano argues, "*Salomé* marks a moment in Japanese history when the alignment between gender, sex, sexuality, and performance thus registered a recognizable shift: from gender defined as theatrical achievement, to gender defined as grounded in the visible body and as basis for theatrical expression." Productions of Salome-related performances in Japan over the next twelve years ranged from modernist renditions of Wilde's play to magical acts to geisha striptease routines in the late 1920s. In Japan, as in the West, Salome offered an opportunity for female performers to find new possibilities of gendered embodiment onstage and off. For Japanese actresses, Kano argues, the role opened up a new set of questions about gender and the body: "How can the body move differently when it is no longer encased in a long kimono? Even as the same body is being offered to the voyeuristic gaze of the spectators? Does it acquire an increased range of mobility, a new set of muscles, greater freedoms and powers?"[54] The role of Salome, situated at the intersection of the New Woman and the femme fatale in Europe and the United States, was popularized in Japan at a time of "straightening of theater," a time when gender, as Kano shows, was also being performed in dramatically new ways.

CONCLUSION: TECHNOLOGIES OF LIGHT AND DARK
ON THE TRANSNATIONAL STAGE

While Fuller's work is frequently discussed in terms of her use of technology, electricity, and cinematic theatrical special effects, critics make no mention of another technology of light and dark that Fuller mastered in her performances: technologies of orientalist drag. While racechange performances were common fare, and the donning of orientalia almost obligatory for early classical dancers, Fuller is not commonly associated with these tropes. Yet, as publicity photo spreads of Fuller posing in different theatrical wigs make apparent (see figure 16), in her 1907 production of *La tragedie de Salomé* at the Theatre des Arts in Paris, her manufacture of illusion extended to the fantasy of a racial masquerade. Fuller adopts stylized symbolic gestures and dramatic facial expressions to accompany each wig, appearing correspondingly as a smiling, subservient geisha, as an Egyptian queen, or as a "baby vamp." In figure 16, for example, Fuller appears in the upper right as a madwoman or Ophelia-like character who clutches her dress and whose face is barely visible beneath a sweep of unkempt hair. Just below this, in perhaps the least convincing of these images, Fuller's wig rests on her head like a box, forming a square that is drawn back by braids as if the hair is a stage curtain opening to reveal her face. She stares defiantly off into the distance. At the top left, Fuller evokes the trope of a smiling, subservient geisha by bowing forward with a deferential gesture. And at the bottom left, Fuller takes a quintessential "baby vamp" pose, hands curling into cat's paws, brushing invisible whiskers in a clawing gesture more childish than frightening—inhabiting a place between girlish and adult femininity, or rather bringing the two together as "sexy infantilism," like the Harem Baby postcard. At the bottom right of this collage of gestural orientalisms is Fuller in a traditional portrait pose as a Victorian lady whose performance of ethnicity is designed perhaps as unlocatable, as not-quite-white. Her hair has become a significant sculptural presence on her head, piled into a cluster of large stylized rolls.

In other publicity stills, Fuller's head is wrapped tightly in coils of braids, and we see simply a head rather than a full portrait torso. Fuller is shown with eyes shut, in a pose evoking a decapitated head, lifeless, without expression or gesture. In another image, apparently meant to evoke the trope of Egyptian queen, Fuller plays with a frozen and expressionless pose, making a two-dimensional hieroglyphic gesture, her hands posed with palms flat facing out.

None of these stylistically distinct wigs seems particular to the character or narrative of Salome, a role that more commonly evoked other required props such as jewelry or veils, or "un-props" in the form of degrees of undress. However, while none of these wigs directly signals the character of Salome, what they do reveal, both about Fuller's artistic vision and about the how the cultural trope

FIGURE 16. Publicity photograph for the 1907 production of Robert d'Humière's *Salome*. Fuller Clippings File, Jerome Robbins Dance Division, The New York Public Library, Astor, Lenox, and Tilden Foundations.

of Salome functioned, is an investment in deploying the body of the imagined other through a racialized grammar of hair and facial and hand gestures. This racial semiotics both produces distance from the anachronistically framed other and also builds on that difference to innovate new modernisms.

In some ways, this bit of ephemera from the publicity machine of Fuller shows a set of serial gestural images that resonates with Sadayakko's uses of Kabuki techniques. Sadyakko produced dances through "the visual effect of a progressive series of striking poses . . . The word *shosagoto* literally means 'posture business.'"[55] Fuller's appropriation of this "posture business" to produce racechange performance is an example of how international traveling performers might be invited onto the stage as spectacle but were then evacuated from the stage to make space for the retooled white femininities of gendered modernisms. This process of invitation, appropriation, and evacuation produced an imagined terrain that then could be occupied as a theater of possibility by the white American or European performer, who found in this space the potential to create multiple new modes of femininity.

As we saw in chapter 1, the fantasy of racechange itself appears to promise access not only to inhabitation and masquerade—to playing the other—but also to the privilege of mobility (moving between) and to transgression (overstepping limits). The imagined terrain was also that of the body of the other, which provided an alibi for improper inhabitations such as the ability to move the body in new (previously unsanctioned) ways, to express new or different emotions (considered improper to white femininity). That imagined terrain gave access to what Rebecca Schneider calls the "explicit body in performance," which "interrogates socio-cultural understandings of the 'appropriate' and/or the appropriately transgressive—particularly who gets to mark what (in)appropriate where, and, who has the right to appropriate what where," including public displays of sexuality.[56] These popular stage performances offered sites for the dislocation of the domesticated corseted Victorian woman, who was replaced on the stage and in public by the spectacle of the female star. In the racialized grammar of spectacle, bodies of color are under a mandate to perform.[57] Deemed primitive subjects, bodies of color are assumed to possess, along with women and children, a natural disposition to affectivity, a raw emotional talent, an inherent, inherited pathos. In colonial logics, that naturalized disposition becomes another raw commodity to be extracted. Racial drag, in the case of Fuller's Salome performance, is accomplished through changing wigs, mobile facial expressions, and frozen stylized gestures. Racial drag is used as a tool to provide imagined access to this mineable orientalist archive of affectivity, and, in this era particularly, this orientalism is mined to produce a new, modern gendered subjectivity for the white performer. What is lost in the annals of dance and performance of this era is a full account of the ground upon which this repertoire was built.

3 ⁝ "VOICES WITHIN THE VOICE"
Aural Passing and Libby Holman's Deracinated/Reracinated Sound

I always have to break a song over my back.... I just can't sing a song; it has to be part of my marrow and bones and everything.
—Libby Holman, Arlene Francis radio interview, WOR, New York, 1966

Libby Holman (1904–1971) carried one of the smokiest torches of the American music hall in the 1920s and 1930s. Celebrated as the inventor of the strapless evening dress and nicknamed the "Statue of Libby," she devoted her early torch-singing career to Tin Pan Alley heartbreak revue numbers, including popular renditions of "Moanin' Low" and "Can't We Be Friends." Entrenched in New York's bohemian Prohibition, dance, and bathtub-gin culture, Holman, like many of her white contemporaries, made regular late-night "slumming" excursions to Harlem's Cotton Club and Inferno. Holman was known not only for delivering blues-based material but for her fashionable deployment of racial indeterminacy. Through uninhibited swearing, drinking, and openly bisexual liaisons, she projected a bad-girl sexual appeal that attracted both genders. Holman's staging of an uncertain racial and sexual identity through sound and through practices of self-biographizing was amplified in the dramatic mininarratives that framed many of her early numbers as she performed mixed-raced characters in all-white revues. Those narratives, often deploying the genre of the tragic mulatta, can be read in concert with her own anecdotal stories about personal experiences with racial misidentification and passing. Together, they supply an ambivalent archive of competing narratives of racial ambiguity and

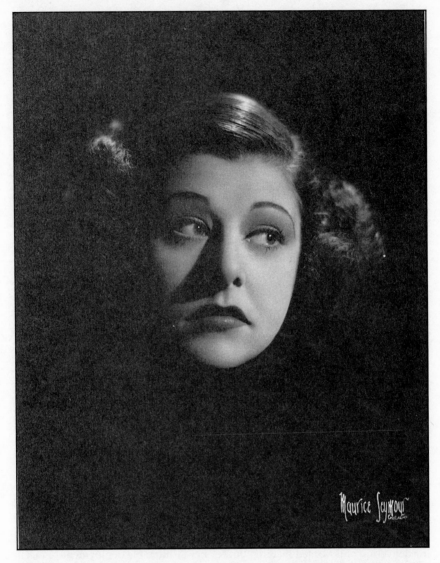

FIGURE 17. Libby Holman, Maurice Seymour portrait. Courtesy Howard Gotlieb Archival Research Center at Boston University and The Libby Holman Foundation

pretense that shaped the production, consumption, and ways of remembering this torch song diva.

Holman relished stories that she got her break because she "passed as black passing as white," but later, with some sense of ignominy, she repudiated her earlier sound and career. She went on to craft a second, ostensibly distinct career, almost as a counterpoint to the first, returning to the stage in the 1950s and 1960s

as a concert singer of a blues and folk repertoire and also taking on the role of civil rights benefactor, funding Dr. Martin Luther King Jr.'s visit to Mahatma Gandhi, Dr. Benjamin Spock's defense for taking part in antiwar demonstrations, and similar causes. At first listen, Holman sounds to be yet another straightforward example of white appropriation of the blues via the appropriative genre of torch songs, whose popularity capitalized on the 1920s vogue for black culture. Listening to her sound in the context of understanding the manufacturing of her diva iconicity over the decades, however, a more fraught portrait emerges, as she later attempted to address and mitigate her association with cultural appropriation by retrospectively narrating her own experiences with different modalities of racial passing.

In the 1960s, as Holman reflected on her first career, she attempted to retrospectively conceive of "aural passing" as the sound performance of "racial mobility." Playing with this idea of aural passing in both racial and sexual registers, Holman could be seen as producing forms of dissonance with heteronormative whiteness. Aural passing, that is, became a mechanism for cultivating racial unlocatability in an effort to disrupt fixed notions of both racial and sexual identity. Holman's diva persona and its visual and sonic associations with tropes of passing, deracination, and the tragic mulatta (including later iterations of the fashion orientalism explored in chapters 1 and 2) produced discourses that aimed at transforming the meaning of her whiteness. These forms of ambiguous racial embodiment contributed to the displacement of her Jewish identity and retroactively reframed the politics of her uses of African American material in her two distinct but related careers (as torch singer/socialite and as blues concert singer/civil rights benefactor). This chapter examines Holman's diva iconicity, focusing primarily on three perspectives: its articulation through sound and performances of racial and sexual identity onstage and off, particularly in her first career; the retroactive framing of her first career from the vantage point of her second, which constitutes both performance and archive; and the politics of Holman's diva afterlives as she becomes a camp figure taken up in film and onstage.

Holman was explicitly invested in her legacy not just as a serious chanteuse but also as a historical political actor, a purveyor of antiracist politics. More than any other performer featured in this book, Libby Holman self-consciously created her own official archive, gifting her papers, memorabilia, photographs, personal effects, and sound recordings to the same university archive that holds Martin Luther King Jr.'s papers. In doing so, she struggled to position herself in opposition to the larger cultural politics and history of cultural appropriation of black music within which both of her careers took place. Yet her own telling and then framing of her story continues to be eclipsed by other popular versions, including three biographies focusing on the sensational and tragic aspects of her

early life, especially her trial for the murder of her first husband, Zachary Smith Reynolds, heir to the R. J. Reynolds tobacco fortune, and numerous portraits in film and onstage that are loosely based on that scandal.[1] Moreover, Holman's diva iconicity continues to hover on the edges of queer camp memory. Comprising distinct afterlives of Holman's diva iconicity, these cultural texts work in service to the persistence of her image; however, their narrow vantage point underscores that Holman's sound and its significance have, to some degree, already been lost.

AURAL PASSING

Holman's recorded songs are not readily available, with the exception of the songs from the torch song era, available on Take Two Records: *Libby Holman: Moanin' Low (Early Recordings, 1927–1934)*. As I discuss in the introduction, before I played them, the sound recordings at Boston University Special Collections had not been listened to in years. The sound librarian cautioned, "If the tapes aren't played, they disintegrate and the sound is lost forever." Hearing Holman's voice for the first time in those archives, both singing and in radio interviews, gave me a much more tangible and immediate sense of how captivating Holman's raspy contralto sound could be. These recordings coupled with the recorded live radio interviews from the 1960s comprise the ephemeral sound archive in which Holman's voice can still be heard. While they produce a sonic record of the magnetism and verve of her racialized sound performance, they offer only a fragmented glimpse into what might have constituted her overall stage persona. Similarly, photographs, many of which are posed studio portraits and not candid shots, offer hints about the manufacture of her fascinating sexual allure but are inadequate corroboration of the numerous accounts of Holman's outrageous personality. The tabloid biographic record, the photographic archive, and the sonic recordings are amplified by descriptions of her performances in which her sound is documented through statements made both by Holman and by her musical and theatrical critics in the form of interviews and reviews covering the several decades of her two careers. These accounts are equally illusory, and often contradictory, ranging from descriptions of her voice as whiskey, graphite, or velvet, or as "bottled blue smoke" or as defined by a "grunting style."[2]

As Holman retroactively forged the meanings that she wanted attached to her torch songs, she emphasized the significance of racial passing. In her stage performances and her later anecdotal storytelling about racial misrecognitions, Holman foregrounded the implied transgression (from one clearly knowable racial category to another) implicit to racial passing. Passing as a visual trope turns the capacity for invisible transgression into the enactment of a spatial transgression. Because social space is demarcated by the visual politics of race, gender, sexuality, and class, the passing subject enters into the space of the other or threatens

those boundaries, both symbolically and literally. However, Holman hoped to deploy racial passing and sexual transgression as modes of moving between, of producing indeterminacy, not just having passed (or having "successfully" relocated from one category to another). And passing was not limited to the visual; it occurred significantly, even primarily, in the aural register. Holman's work explicitly takes up the racialization and sexualization of sonic space. Thinking about the meanings attached to the passing narratives she tells, and that people tell about her, within larger cultural practices of appropriation of the blues, I examine how she rescripted this "taking" as transposition and figured it as a mode of sonic mobility that was socially and artistically experimental. Holman's gestures are leading ones, raising the question of whether diva iconicity has the power to rescript the archive in search of a politics of sound.

In an essay theorizing vocal performance, "The Grain of the Voice," Roland Barthes points to the existence of infinite "space" in the voice, by asking, "Am I hearing voices within the voice?"[3] In negotiating the limits of the all-too-familiar ground of white appropriation of black sound, Holman sought to create, through sound performance, a race identity based on the textures of her own voice. This, she hoped, was an aural space where identity could resonate between otherwise rigidly fixed cultural notions of "whiteness" and "blackness," opening up a space of possibility akin to what Barthes heard as the voice's multivocal spatial infinity. Holman's desires gestured toward an aural production that modeled possibilities of a nonxenophobic locality of sound through oscillation and "moving between"—a desire for movement as freedom from the binary demarcation of the color line. The attempt to craft this new possibility, however, did not finally dislodge the voice from the implicit erasure of blackness often inherent in such projects.

According to several accounts, Holman's return to the stage for a second act to her earlier celebrated torch song career was inspired by a chance encounter with Leadbelly (Huddie Ledbetter) and Josh White at a Greenwich Village nightclub. An article in the *Chicago Defender* also describes a 1941 benefit for Ledbetter, indicating that "the now very wealthy Libby Holman" came out of retirement to participate, along with Josh White, Woody Guthrie, and others.[4] However, in this second, post-torch-singer incarnation, she took to the stage as a blues singer, joining the ranks of writers and singers promoting American folk traditions, often to predominantly white audiences through a middle- and upper-class appeal that drew on conventional concert forms—hence the name "concert blues." Accompanied first by Josh White, an African American singer, songwriter, and guitarist, and later by Gerald Cook, an African American composer and pianist, she often staged her concerts as civil rights benefits, touring them across the country and internationally.

With Holman's shift from her 1920s–1930s torch-singing career to her 1940s–1960s concert blues career, her self-biographizing of her relationship to

race and music changed as well. She sought to define herself in relation to the black cultural material that formed the ground of her performances in each distinct career and, by extension, was compelled to resituate herself within changing discourses around race in ensuing decades. In particular, she worked to dissociate herself from the earlier Tin Pan Alley genre, which came to be viewed as popular and trite, known for churning out "assembly-line musical products."[5] She also sought distance from associations with historical genealogies that might locate her oeuvre in closer proximity to blackface performance and the reception traditions of minstrelsy, as well as from the torch song itself as emblematic of an era of marketing African American blues sound and performance traditions for white audiences through white bodies. Angela Davis describes white Tin Pan Alley songs as "minstrel-like caricatures of the blues" that were later transformed by black performers like Billie Holiday—whose adoption of the lyrics was imposed by the market, but whose interpretation of that material Davis describes as "insinuating that battle into every musical phrase and making that battle the lyrical and dramatic core of her performances" as Holiday "relocated them in a specifically African-American cultural tradition."[6]

As Holman came to consciousness about the minstrel-like connotations of the torch song, she attempted to reframe her relationship to the Tin Pan Alley material as something other than minstrelsy or appropriation. Holman did this by retroactively producing a range of narratives of "authenticity" to alternatively describe her relationship to that material. In this self-biographizing, she expressed a desire to create for herself a liminal space from which to perform, a space within the color line that demarcated the African American sources of her music and her concert staging of them for predominantly white audiences. While she exhibited great relish in telling anecdotes about passing, the persistence of that narrativizing, primarily in later interviews, is symptomatic of her continued failure to produce an adequate account about her relationship to African American musical forms or her own participation in a racialized marketplace.

These stories were intended to become the ground of authenticity on which Holman was authorized to cultivate what was called by critics and herself a "grunting style," explicitly referencing the blues. It is in the sounds we can hear (in the limited recordings available), and in the sounds we can only imagine hearing (as described in textual accounts by critics and by Holman herself), and in those we never hear (which are displaced or erased or the stuff of impossible dreams) that the complicated *retroactivation* that Holman was trying to produce in the textures of her own voice becomes visible, if not audible.

In her early revue numbers, Holman was frequently cast in the role of a mixed-race character, the tragic mulatta, or as a prostitute. Her early sound, which accompanied these roles, was perceived as echoing the sounds of the blues women. Reproducing the tropes of racialized sound for predominantly white

audiences, Holman capitalized on the marketability of sound effects that were culturally coded as "black" but sung from a position of distance from actual black bodies, as a white singer in predominantly white venues. In addition to appropriating "black sound," Holman also deployed a fashionable and typically modernist fusion of orientalism, primitivism, and exoticism to market her torch songs. One publicity still, of Holman lounging in Chinese silk pajamas, exemplifies this melding and was chosen by Take Two Records as the cover art for the release of her early recordings. This visual fashion iconography was echoed in the musical orchestration of her numbers, which employed a range of instruments and effects intended to create a pastiche of supposedly primitive cultural sounds.[7] In addition, Holman capitalized on that racialized musical economy by performing (onstage and off) the possibility or insinuation of her own racial indeterminacy, her distance from whiteness. In the marketing drive to make blues more "palatable" (and Holman literally talked about her unusual palate) for white audiences, white singers often made use of forms of cultural appropriation, in which black female subjectivity and experience "circulate within the marketplace only when they can be packaged within a real or illusory white woman's body."[8]

Later, when looking back on this era, Holman attempted to retrospectively render an ethical relationship to her music by imagining herself, in a society built on racial hierarchy and exclusion, to have given expression onstage to marginalized voices, the voices of black people as well as of biracial subjects. Conveying the depth of her artistic passion in the conventional terms of an artist's hope to become one with her medium, Holman insisted that "I just can't sing a song; it has to be part of my marrow and bones and everything."[9] In radio interviews, she made clear that the staging of her material went beyond a desire to disseminate or mimic African American art forms. For Holman, singing and performing produced what she imagined as a space of "becoming black." That is, she imagined what she performed as exceeding theatrical performance, as something more akin to the *performative* as used in the field of performance studies, where words carry the power to *do* something—what Jacques Derrida and Judith Butler, building on the British language philosopher J. L. Austin's 1955 Harvard speeches, understand as "the ways in which identities are constructed iteratively through complex citational processes."[10] The performative utterance refers to that instance, as in an oath, when the force of repetition over time grants power, and "saying something," or singing something in Holman's case, is "doing" something.

Holman expressed a desire that singing yield such "performative" effects—constituting her identity as "black" in the very moment of utterance. Holman's imagined performative function of sound, *becoming black*, of course, is not new; it is, in fact, what we might call a "tired trope." It rests on an all-too-familiar, quintessentially American (but global as well) performance practice

of inhabiting blackness, one that can be understood as both the reproduction of antiblackness and ultimately an investment in whiteness that stretches from nineteenth-century minstrelsy to rock and roll to 1960s hipsters to the obligatory lauding of white people singing with "soul" on *America's Got Talent.* Yet the tiredness of such US racial tropes makes them all the more pressing to examine. In fact, it is not their existence but rather their persistence that warrants the most scrutiny.[11] Indeed, throughout her career Holman was identified in one way or another with "blackness," both by her own design and through market forces and audience tastes. Her vocal style produced the obvious opportunity for a "crossover" career. But in her vivid description of singing as becoming part of her "marrow and bones and everything," she conveys her conviction that the sonic could inhabit her body in ways that might somatechnically reconstitute her racial identity. Singing, therefore, was an act of transubstantiation for Holman: the transformation of that transient thing, "sound," into something material or corporeal.

The conceptual artist and philosopher Adrian Piper argues, "The ultimate test of a person's repudiation of racism is not what she can contemplate doing for or on behalf of black people, but whether she herself can contemplate calmly the likelihood of being black."[12] At least in relation to how Holman crafted herself as a chanteuse, she expressed a desire to do both—and engaged that contemplation of being black at the level of sound performance. She chose her words in such a way as to reanimate the politics of her participation in an earlier era of the segregated stage and appropriative sound of the torch singer. I am not arguing here that her biographizing narrative moves or her authenticating rationales for "sounding black" produced these desired effects, or did not erase the work of her black chanteuse counterparts; rather, I am interested in looking at the rhetorical convolutions and performance machinations that characterized her struggle to understand, rationalize, defend, justify, and explain her relationship to the material she performed through notions of incorporation of blackness at the level of sound and body.

Holman sought to convey sound's capacity to produce new and expansive spaces for rethinking racial identity and racial intersubjectivity. For Holman, the embodied act of singing was an Austinian "performative utterance,"[13] which involved "de-racinating" and "re-racinating" her own body, to borrow the words used in a newspaper review of one of Holman's last performances. Seeking to explain the results of Holman's concertized reworking of blues material, the author writes, "These songs are both de-racinating and re-racinating, de-rooting and re-rooting."[14] For the reviewer "de-racinating" and "re-racinating" referred to the process of cultural appropriation of the blues: pulling the music up from its African American roots and rerooting it elsewhere, in this case in the midst of a wealthy white East Hampton audience. Perhaps this critic was also

hearing Holman's attempt to deploy her sound toward a vision of a deracinated American culture, one that she hoped to understand in terms of civil rights and antiracism, but that critics today would more likely locate in the logics of the postracial. Linking deracination to relocation by conjuring the vivid metaphorical imagery of "de-rooting and re-rooting," this critic's words signal the forgery of memory surrounding the music's genealogy that such a performative would entail: a political erasure or amnesia about black labor and black bodies. But Holman, of course, hoped to imagine another possibility, a sonic space for developing a reverberating racial sound for a variety of audiences that would undo the entanglements of racism and performance.

Holman's second career in the 1950s and 1960s coincided with and was made possible by this era's interest in blues. The blues were being touted by the American folklorist and ethnographic musical archivist Alan Lomax and promoted by the emerging popular American folk music scene as an answer to America's search for an indigenous folk heritage, an original contribution to modern culture. Holman's second career as a concert blues singer, therefore, reframed her overall musical contribution as a part of a larger project of preserving blues as American folk heritage. Even while she was forthright in distancing herself from her earlier career, this new repertoire intentionally sutured her early torch song repertoire of "sin songs" to the new project of blues preservation—a move conveyed directly by the title of her program, *Blues, Ballads, and Sin Songs*. Holman and other white artists of the time granted themselves access to this American birthright material as self-appointed archivists of "Americana," as she puts it in materials promoting the program.

I read Holman's racialized performance and biographizing project as the product of a career that, in Langston Hughes's famous words, had "done taken my blues and gone," capitalizing on white fascination with a whitened form of the blues. What bears attention, however, is Holman's modes of "taking." For Holman, this taking involved a particular embodied enactment ostensibly aimed at troubling the color line: playing with the possibility of crafting a performed racial identity that she hoped resonated *between* culturally fixed notions of black and white.

"TO UNSCHOOLED WHITE EARS": CROSSOVER CAREERS

Holman's racial and ethnic identity was complex, obscured, and to some degree made illegible even before she moved to New York at the age of nineteen with dreams of Broadway. She was born on May 23, 1904, in Cincinnati, Ohio, to middle-class parents of German Jewish descent who, in response to anti-German public sentiment during World War I, changed the family name from Holzman to Holman and then converted to the Church of Christian Science.

Apparently inspired to pursue the theater by a local production of *Uncle Tom's Cabin*, she left Ohio after college to pursue acting in New York. While Holman reportedly denied (or perhaps elided) her Jewish heritage for many years, there is no evidence that her "whiteness" came under suspicion during her childhood and college years in Ohio. Later, however, when she was accused of murdering her first husband, the trial, the ensuing press, and its aftermath made visible the anti-Semitism that undergirded the Reynolds family's disapproval of Holman as an in-law and made it easy to cast suspicion upon her as a murder suspect.

Holman was a contemporary of Fanny Brice (1891–1951), Sophie Tucker (1887–1966), and a generation of white and ethnic European becoming-white women performers, including Jewish comedic stage performers, who were regularly characterized as "coon shouters." That designation (akin to Holman's voice being labeled "grunting") marks these performances as forms of minstrel afterlife. Michael Rogin's analysis of *The Jazz Singer* (1927) pertains here: "Blackface," he writes, "is the instrument that transfers identities from immigrant Jew to American. By taking on blackface the Jewish jazz singer acquires . . . first his own voice; then assimilation through upward mobility."[15] Blackface performances and acts of racial mimicry in the early twentieth century frequently functioned to secure Jewish and white ethnic European immigrant claims to whiteness. And, as Diane Negra's work argues, this was also an era of the emergence of com- modified forms of "off-whiteness."[16] It was in this historical context that Holman achieved success performing mulatta (that is, mixed-race) characters beginning shortly after her arrival in New York. Holman appears to have been typecast by directors and audiences, from early on, as racially indeterminate. According to some accounts, in the early years she performed in blackface for the part of the mulatta prostitute in "Moanin' Low," even being invited to perform this role for an NAACP fund-raiser "where her blackface was understood by some (such as Walter White, executive secretary of the NAACP) to be an act of solidarity rather than an insulting appropriation."[17]

It is unclear whether these early casting decisions were driven more by her visual appearance, her sound, a combination of the two, or merely the market. For instance, there were speculations about what meaning to attach to her phe- notype and physiognomy and what was perceived as her relatively dark skin tone and thick black hair—features that raised speculation about whether Holman was a "Negro" who had "passed" as white. Reviewers came to describe her using terms like "Creolesque" and "dusky,"[18] marking and capitalizing on her distance from whiteness and claiming for her the status of a mulatta. It is also possible that these initial casting decisions and critical responses to them then drove the later perceptions of Holman's racial indeterminacy and its marketability. In any case, this trend was established early on, and Holman's career was then built on the marketing of the visual and aural semiotics of racial difference and ambiguity.

Those qualities ultimately secured her status as a white performer of mixed-race characters.

Holman would later recount that as her career began to advance with racial ambiguity as a central theme, she also experienced instances *offstage* in which her race was misidentified and therefore made her subject to discrimination. In retrospective interviews about her career, for example, she recalled being harassed by the police while taking a walk one night on a pier in New York.[19] Seeing Holman accompanied by a white man, the police assumed they were encountering an interracial couple and aggressively questioned them. Over the years, she described the incident, imbuing the story with forceful righteous indignation, as the experience that enabled her to recognize and then communicate to white audiences the racial injustice of police harassment against African Americans and the effects of Jim Crow.

In another anecdote Holman told repeatedly, she delighted in the misidentification of her racial appearance by theater managers. The story went this way: *Rang Tang* was a successful all-Negro vaudeville revue that opened at the Royale Theatre on Forty-fifth Street west of Broadway on July 12, 1927.[20] Holman was performing across the street in a show that was not taking off. When one of the directors of *Rang Tang* approached her director and said, "Your show's a flop; ours is a hit. We are losing our leading lady—Can we have Libby Holman?" Holman's director responded skeptically, "Well, you don't want her. She's white." The *Rang Tang* director quipped, "Well, she may tell you that, but she's passed." When Holman told the story, she finished it off with the satisfied declaration, "Well, nothing could have pleased me more. In my whole life, nothing could have pleased me more."[21] The pleasure Holman took in telling the *Rang Tang* story came not simply from being able to pass as black but rather from realizing that the "truth" of her racial identity could so double back on itself as to become irretrievable. Would people imagine she was a white person passing as black? Or perhaps that she was a black person passing as a white person passing again as a black person?

Elaine Ginsberg, introducing the 1996 anthology *Passing and the Fictions of Identity*, defines passing as follows: "Passing is about identities: their creation or imposition, their adoption or rejection, their accompanying rewards or penalties. Passing is also about the boundaries established between identity categories and about the individual and cultural anxieties induced by boundary crossing. Finally, *passing is about specularity: the visible and the invisible, the seen and the unseen*."[22] Although passing has been generally defined in this way, ocularcentrically, I am interested in the way in which it might be seen as more than fundamentally an act of visual performativity. Libby Holman's reproduction of her own subjectivity through sound can be read against Ginsberg's definition of passing. Holman "passed" not only by the means usually assumed to constitute passing, specularity, but also, and perhaps primarily, by means of aurality—that

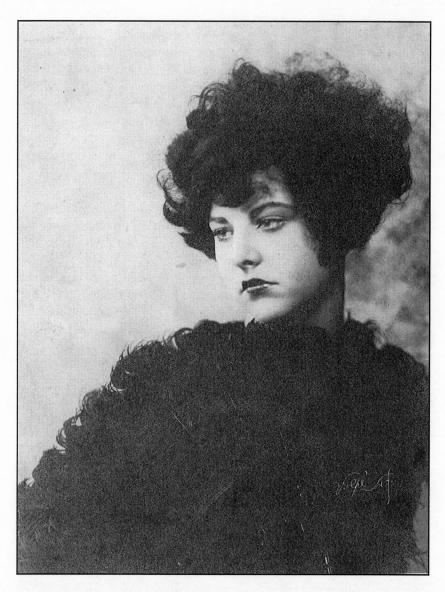

FIGURE 18: Libby Holman, Volpe silverprint. Courtesy Howard Gotlieb Archival Research Center at Boston University and The Libby Holman Foundation.

is, through a symbolic order of sound. The staging of Holman's sound was crafted to reproduce her racial indeterminacy and, by allusion, to reproduce ambiguity around her sexual identity.

During Holman's earlier torch song career, the *New York Times* critic Brooks Atkinson pointedly described Holman as the "dark purple menace," a label that would follow her throughout her career. Atkinson's use of *dark* and *purple* together intentionally marked her style as dangerous both for its "racial" deployments and its sexual ones, including embodying a queer, uninhibited bisexuality. Her unusual basso contralto (the lowest end of the "female" range, typically associated with black blues singers like Ma Rainey and Bessie Smith), combined with her dramatic gestures, "Betty Boop" lips,[23] and a nontraditional petite yet voluptuous figure, created an image of "raciness" in several senses of that word: the pushing of convention, the transgression of sexual boundaries, and the challenge to racial categorization (see figure 18). The iconic white torch singers, including Holman, Ruth Etting, and Helen Morgan, cultivated intimate modes of performance (songs directed to *you* in the second person) as they sang of unrequited love. Torch singers participated in an era that introduced new sounds and new intimacies to new venues for female audiences, producing new forms of female fandom. Holman's performances of unrequited love, performed in a queer female caliber as a basso contralto, cut against the ostensible obligatory heteronormativity of the torch song genre.

It is not clear whether Holman consciously chose to begin her career as a "crossover" performer, as a white woman who would sing black music for white audiences. In 1925, Holman landed her first significant role, in a play called *The Sapphire Ring* (staged at the Selwyn Theatre), and soon afterward, Richard Rodgers and Lorenz Hart's *The Garrick Gaieties* (1925) made her a minor celebrity. Apparently, one unexpected source of her alluring stage persona was her nearsightedness (or as she put it, "I can't see. I never could see"[24]). She allegedly appeared to be thoroughly vamping her musical numbers when in fact she was clasping at the curtains in order to maneuver across the stage. Additionally, her palate, purportedly an eighth of an inch askew, helped produce throaty laments and a grunting style.[25] The occasional attribution of her sound to a "congenital difference" lends another layer to the presumption of Holman's "embodiment" of black sound as an "authentic" embodiment, in this case as a "birthright," or an entitlement written into her body at birth.

While Holman's career began on Broadway, in Rodgers and Hart revues such as *The Garrick Gaieties* and Howard Dietz's *Merry-Go-Round* (1927) and *The Little Show* (1929), torch singers of this era took individual numbers from these revue shows directly into the after-hours clubs and cabarets and onto network radio. Performing for mostly white audiences and directing their songs to men and women, torch singers hailed their audiences with laments about lost and

unrequited love, inconstancy, and heartbreak. The Tin Pan Alley shows and the Broadway follies and revues of the twenties that gave Holman her start were constructed as musical and theatrical entertainments, framing these songs within dramatic mininarratives. "Tin Pan Alley" referred to New York's popular music, songwriting, and sheet music publishing industry, also known, as mentioned earlier, for producing "banal" "assembly-line musical products" and "minstrel-like caricatures of the blues."[26] Holman at first attributed her style to the hard-boiled nature of the characters she portrayed. In *Rainbow* (1928) she played a cigar-smoking, whiskey-drinking prostitute. Holman scoffed, "Where would she get a soprano voice?"[27] Although Holman provides this "bad girl" reading of her sound (a reading that later critics pick up on when describing her voice as "whiskey"), it is clear that Holman's "experience-hardened" voice was not just a sound that emanated from sinful habits of drinking and smoking but one meant to evoke the racialized space of the dance hall and the figure of the blues woman.

Holman's sound was considered scandalous both because she "dared" to "sound black" (some felt that she was too successful not to, in fact, be black passing as white) and because she chose numbers that, although tragic, were considered sympathetic portrayals of mulatta characters or stories of miscegenation. For Holman, the narrative of passing became an apparatus for both distancing herself from and bringing herself into whiteness at the same time. The mulatta figure seemed to offer an opportunity to create a space between or to destabilize rigid black/white racial binaries, neither of which Holman was seen as fitting into properly, but which nonetheless policed the stage.

The associations of her sound with blackness emerged in a theatrical, dramatic narrative context, produced in part by the roles in which she was cast. For example, Holman's earliest numbers included "Take Black or White," about miscegenation, and "Yaller," which includes the lament "I ain't even white, I ain't even black." Through such narrative and sound tropes, Holman succeeded in assimilating black sound for a white audience and, at the same time, presented for her white audience stories and characters that encroached on consolidated notions of whiteness. For Holman, this performance of racial indeterminacy was essential to her stage success and marketability in her early career, but it ultimately reveals the extent to which such roles were reserved for white performers, belying the overall narrative of being "not-white" that was used to market Holman. In her latter career, her enthusiastic self-narrativizing about racial passing then became an alibi for this earlier career and a way to frame her liberal political identity as a civil rights benefactor in order to assuage the past.

The Little Show, with Clifton Webb and Fred Allen, produced her first big hit, "Moanin' Low," a number created by Holman in collaboration with Webb and Howard Dietz. The song was known for its blues inflection and tonality. Originally "Moanin' Low" was part of a sketch set in a Harlem tenement in which

FIGURE 19. Libby Holman in *The Little Show*. Courtesy Howard Gotlieb Archival Research Center at Boston University and The Libby Holman Foundation.

Holman played a mulatta prostitute who comes home one night and hides her earnings from her pimp. During the violent sexual encounter that follows, he discovers the money, chokes her, and flees the apartment (see figure 19). The woman, who survives, crawls to the door while lamenting that she has lost her man. "He's a kind of man needs a kind of woman like me," she sings, never fully articulating what "kind" of man he is or what "kind" of woman she may be. She goes on to plead: "Don't know any reason why he treats me so poorly. / What have I gone and done? / Makes my trouble double / with his worries." The implication is that he rejects her not because she hid the money or because she is a prostitute, but rather for her color; her mixed-race status and her status as a prostitute are conflated as the double implied subject of the song lyrics. Having given voice to and staged the unjust plight of the mulatta prostitute, Holman must be silenced. The method—strangulation—is a literal representation of the cultural silencing around the issues and identities portrayed. The transgressive voice is cut off at its source: the throat.

In this instance, Holman was an actress playing the part of a mixed-race or light-skinned black character. And as she tells it, "That's when it got all around New York and the country I was a Negro, for which I was very pleased and happy because that's the way I always wanted to sing."[28] Holman assumes that the rumor

that she was black stemmed from her sound ("that's the way I always wanted to sing") and not from the characters she portrayed, as might have been the case. In fact, it does appear likely that Holman was cast in the "Moanin' Low" number not so much because of her racially ambiguous looks but because she was already cultivating a marketable racially inflected sound. Holman told Richard Lamparski in a radio interview in 1966, "My whole ambition was always to sound like Ethel Waters."[29] Specifically, Holman hoped to be recognized as the "white" Ethel Waters.

"OTHERS ARE ONLY PASSING FOR COLORED": SONIC BACKTRACKS

Ethel Waters (1896–1977), jazz and blues singer, dancer, and comedienne, described her own style as "refined" and "outrageous." Combining the two, Waters carved out a critical space within the black revues of the 1920s and 1930s where she got her start, cultivating herself as "Queen of the Double Entendre." Embracing the sexual politics of the blues women, she sang about and had a reputation for bawdy and irreverent humor, which lent queer meaning and style to her work and public persona. She had the "reputation of a bulldagger."[30] And along with the other black performers of her generation, she navigated the treacherous terrain of a historical moment steeped in working on and against Reconstruction- and post-Reconstruction-era conventions of blackface minstrelsy and "coon" performances. In other words, audiences (and directors, producers, writers, and circuit managers) still expected, desired, and demanded the replication and invocation of retrograde antiblack stereotypes onstage—from blacks and from whites. Waters, like her predecessors, attempted to undercut such compulsory inhabitations with satiric humor, distance, and intramural critique with her black audiences.

If Holman's "whole ambition was always to sound like Ethel Waters," it was more than just a sonic desire. Waters began her career performing for black audiences on the Theater Owners Booking Association vaudeville circuit, which was made up (with two exceptions) of white-owned theaters catering to black audiences.[31] Carby describes how blues women on the circuit challenged gender norms and how the circuit offered "an alternative way to achieve mobility for young women." "This increase in their physical mobility," she argues, "parallels their musical challenges to sexual conventions and gendered social roles."[32] In the 1920s Waters recorded for Black Swan, the first black-owned label, whose advertising slogan wryly declared: "The Only Genuine Colored Record—Others Are Only Passing for Colored." She recorded her songs for these so-called race records, producing recordings aimed specifically at working-class black audiences, until the Depression. As one of the central figures of the early blues-recording industry in the 1920s and 1930s, she produced hundreds of recordings.

An accomplished singer, dancer, and comedienne, she was featured in three black musical revues: *Africana* (1927), *Blackbirds of 1930* (1930), and *At Home Abroad* (1935). She became known for her ability to "cross over" between audiences, appealing to both black working-class and black middle-class audiences as well as to the white audience members coming to Harlem's clubs in those years. Her most famous songs are today archived and remembered through her films, such as the song "Am I Blue?" from her role as Hagar in *On with the Show* (1929).

The persistency of this celluloid archive, with its particular capture of Waters, has the effect of distorting our understanding of the meaning of her stage performances and would render a statement like Holman's claim that her "whole ambition was always to sound like Ethel Waters" illegible. As the film *Ethnic Notions*, Marlon Riggs's critical archive project on antiblack representations, powerfully illustrates, something happens to how Waters gets remembered when her performances are recorded and then made widely available through this visual medium. Waters gave a very particular kind of performance on film, one fixed within the Hollywood film industry's apparatus, a constraint that James Baldwin would say only allows for "hints of reality, smuggled like contraband into a maudlin tale."[33] In a famous *Ethnic Notions* segment, Waters is heard singing "Darkies never dream / They must laugh and sing all day." On the one hand, the film reminds the viewer of how Waters's film roles reduced her to a mammy figure. On the other hand, *Ethnic Notions* uses Waters as the transitional object between abjection and subjection, through enforced merriment ("never dream" / "must laugh and sing all day") to liberation and freedom-struggle ("I have a dream"). But this image of Waters has in many ways little to do with the Waters her earlier live audiences experienced and knew—and the diva persona Holman revered.

That potentiality was obscured—and, turning to Baldwin, again, he would say "misused"—and made illegible by the distorting lens of the "American looking-glass."[34] In her final years, Waters toured with the evangelist Billy Graham, singing the spiritual "His Eye Is on the Sparrow," which Baldwin characterizes as "painful." Yet, as the film scholar Patty White recognizes, even in this later career, "Waters forcefully conveys the compatibility of her sexual and religious subjectivities."[35] It is this complex figure that Holman wishes to evoke, while perhaps simultaneously not recognizing the costs that Waters bore and Holman's own role in the political economy of the early stage that they each inhabited in different ways.

Waters wrote two autobiographies, *His Eye Is on the Sparrow* (1951) and *To Me It's Wonderful* (1972), recounting how she grew up in the Philadelphia area and got her start developing an approach to the blues that distinguished her from famous contemporaries such as Bessie Smith and Ma Rainey, who were known for their "growling" style. As Angela Davis explains in *Blues Legacies*, "As music

entered its age of mechanical reproduction, blues were deemed reproducible only within the cultural borders of their site of origin. The racially segregationist distribution strategy of the recording industry implicitly instructed white ears to feel revolted by the blues, and moreover, to assume that this sense of revulsion was instinctive. Even those white Americans who wanted to break through barriers of racism, and who sincerely attempted to appreciate this music, tended to perceive it as primitive and exotic."[36] Waters, in fact, refused all offers from white shows during the early part of her career. Yet she also made the point of routinely introducing herself with the quip "Well, I'm not Bessie Smith." She elaborated, "I could always riff and jam and growl, but I never had that loud approach"[37]—an assessment with which Carl Van Vechten, white patron of the black literary renaissance, concurred. He presumptuously dubbed Bessie Smith "the true folk spirit of the race" while arguing for Waters's greater artistry: "In her singing she exercises . . . subtle skill. . . . Her methods are precisely opposed to those of the crude coon shouter, to those of the authentic Blues singer."[38] And, as Davis recounts, Black Swan rejected Bessie Smith in favor of Waters "because her style was more compatible with that of the popular white singers of the day." In a reversal of Van Vechten's assessment, Davis states, "To unschooled white ears as well as to successful black people who did not particularly relish musical reminders of their own social roots, Ethel Waters may have appeared to be the most accomplished blues singer of the period." Davis argues that Bessie Smith, however, "more accurately represented the sociohistorical patterns of black people's lives" and therefore was also a greater artist, an artistry to which white audiences were tone-deaf.[39]

Like Holman, then, Waters crafted herself in a "space between" racially and socially coded sonic hierarchies. For Waters, however, that *between* existed within black sound, a means of distancing herself from perceived "shouters" such as Smith while singing a "sophisticated" blues that could have been marketable to a white audience, but which she also refused to have commodified only for white listeners. Given the specific location that Waters occupied, Holman's desire to be identified with her is perhaps obvious, and yet it is not entirely aboveboard. It is obvious because Waters's stature and success were built on distancing her performances from the conditions of black people's lives, a distance that would facilitate the ease of Holman's identification. But it is also a discordant calculation, because Waters's sound was considered northern and urban, a refined and less "down-home" blues. To say she "never had that loud approach" was Waters's way of indicating that she refused to exaggerate the blackness of her sound. Her voice was described as "sweeter," "smoother," and "new." On the surface, these descriptors make her an incongruent choice for comparison with Holman, a basso contralto who was even described as a female baritone or bass-baritone and whose voice was described by critics as

"throaty," "whiskey," and "dark." Within this adjectival battleground over blues women's sound performance and race, Holman's and Waters's voices would appear incommensurable.

While Libby Holman insisted that "nothing could please me more" than to be compared to Ethel Waters, ironically, Ethel Waters was excited to be dubbed the "ebony Nora Bayes," referring to a popular white singer on the white vaudeville circuit. Holman's and Waters's performances of racial doubling and doubled-back doubling respectively echo and signify on earlier tools of mirroring, passing, and imitation central to the minstrel shows. Some critics of American popular culture have tended to read such tools simply as quintessential expressions of the American zeitgeist, a reading that troublingly naturalizes racial regimes of culture and its effects, thereby effacing the racialized social orders that undergird such forms. For instance, Ann Douglas in *Terrible Honesty* observes that "doubling" became the "*raison d'être*" not just of the minstrel shows but, from that moment forward, of American popular culture in general. She writes: "Blacks imitating and fooling whites, whites imitating and stealing from blacks, blacks reappropriating and transforming what has been stolen, whites making yet another foray on black styles, and on and on: this is American popular culture."[40] Similarly, Andrew Ross, discussing the history of appropriation in American music in *No Respect*, characterizes American music as a "miscegenated cultural production." His examples include "ragtime—a 'clean' black response to white imitations of the 'dirty' black versions of boogie-woogie piano blues; the cakewalk—a minstrel blackface imitation of blacks imitating highfalutin white manners[;] . . . Howlin' Wolf—an 'authentic' bluesman . . . whose name is taken from his failure to emulate the yodeling of Jimmie Rodgers . . . ; and Elvis's rockabilly hair, greased up with Royal Crown Pomade to emulate the black 'process' of straightening and curling, itself a black attempt to look 'white.'"[41] While Ross's examples completely elide the history of women's "miscegenated" production, Holman and Waters's relationship should be incorporated into such amalgamated popular culture trajectories as Douglas and Ross produce. Yet to do so could easily erase the ways that each was a product of and was reproducing existing hierarchal racial orders.

Waters eventually felt that white audiences accepted her on her own terms, but Douglas argues that it was Waters's self-imposed early "exile" that enabled her to create what Douglas labels a uniquely "bi-racial" approach, by which I assume she means performing for a crossover audience. Further, Douglas argues that performing for white audiences early on would never have allowed for the complexity of this sound. White audiences, like Van Vechten, preferred black performers to be "representative"—that is, to conform to the tropes of blackness recognizable to white audiences schooled on minstrel distortion and primitive fantasies of blackness.

Given this context, Holman's identification with Waters reflects specifically a choice to emulate a black singer who was herself working to cultivate a sound that had crossover appeal. Waters thought of herself as able to sing white or sing black and aimed to do both within a single song. Holman, in her decision to align herself with Waters, reveals a desire not only to sound black, to "pass," and claim some ground of blackness, but to achieve, as Waters aimed to, a new sound: one that resonated between notions of whiteness and blackness. The complex sound that Waters cultivated and the deracinated/reracinated sound that Holman was described as producing are further connected to each performer's reworking of notions of gender and sexual identity.

The opposition of white sound to black during this period represented and reinforced a predictably gendered opposition of white (femininized, refined, class-aspirational) sound as set against black (masculinized, sexualized, working-class) sound. In this gendered opposition, black sound was overdetermined as hypersexual, aggressive, and unruly. The use of growling and overtly sexual sounds by black women performers was, for white audiences, an "improper" expression of female sexuality (but one they also found seductive and sought access to). Libby Holman's use of a so-called grunting style represents a white woman's exercise of song as a theater of opportunity for the expression of this improper (black) sexuality. Operating in a performative mode akin to the Salome dance discussed in previous chapters, sonically crossing race for Holman was also a means to cross from a space of refined (repressed, class-aspirational) white female sexuality to a new "shameless" space for sexual expression. *Shameless* is the word Holman repeatedly delighted in using to describe her own sound performance throughout her life.

Waters, in her younger days, was openly bisexual, and her affairs with women were notorious for their public jealousies and physical arguments. Holman's deep admiration was for a woman whose sound attempted to elude rigid cultural racial categorization and whose sexuality, like her own, was not black-or-white either. When Waters, in her 1949 autobiography, *To Me It's Wonderful*, talked about her favorite song, "Sparrow," she exclaimed, "That song was the marrow in my bones."[42] It was these words of Ethel Waters's that I suggest Holman echoed repeatedly in describing her own sound, as she aimed to create an alternative space of identity through sound.

The shared ground of Holman and Waters is their way of imagining sound performance as a space for reconceiving and producing complex, non-normative or counterintuitive identities and histories. Deborah Vargas, writing on Mexican and Mexican American popular music at the borderlands in *Dissonant Divas*, describes such a space in Chicana music as the "sonic imaginaries" of borderlands music.[43] In "The Grain of the Voice," Roland Barthes identifies a space of contact between the musical object and discourse, or what he calls "the encounter

between language and a voice," and names this space "the *grain*." "The 'grain' of the voice is not—or it is not merely—its timbre," he writes. "The *significance* it opens cannot better be defined, indeed, than by the very friction between the music and something else, which something else is the particular language (and nowise the message)." And later, he elaborates a second definition: "The 'grain' is the body in the voice as it sings, the hand as it writes, the limb as it performs."[44] By drawing attention to Barthes's two elaborations of the "grain" and placing them next to Vargas's concept of "sonic imaginaries," I suggest that a new elaboration of the grain of the voice emerges that describes what Holman, indebted to Waters, hoped to produce. This grain is where the performing body and signification are at work together, as sound passes between voices, and where Barthes's "encounter" resides, in the friction between two racialized voices. The grain of Holman's voice is the space of friction between racialized sounds and identities. The loss of the subject in *significance* is substituted for in performance and in the repetition of performativity. Here the example of Holman challenges the conception of the ontology of performance as processes of loss/disappearance and nonreproductivity as articulated by Peggy Phelan.[45] In the early twentieth century, new radio broadcasting and recording technologies also functioned as ways of "passing on" sound material without bodies, immaterially, through the disembodied voice. Echoing the effects of this new technology, Holman's repertoire and her way of thinking about it prompt a consideration of what trace of race remains in sound as it is passed between iconicities such as Holman and Waters or via disembodying technologies. Fred Moten argues in *In the Break: The Aesthetics of the Black Radical Tradition*, "the *conjunction* of reproduction and disappearance" might be considered "performance's condition of possibility, its ontology and its mode of production."[46] The substitutions I have elaborated here, made in the passing of the torch between singers, in the entangled diva iconicities of the twentieth century, suggest that the movement of sound between bodies and across time is one melancholically mapped by failure. But that failure itself is perhaps more interesting and fraught than previously recognized.

If the "grain of the voice" is a process of performing subjectivity out of a loss; perhaps the grain here is the loss associated with the process of deracinating and reracinating the voice itself. For Barthes, there is no a priori politics to this process: it is not necessarily a good or a bad thing; for that matter, he is not concerned about the "racing" of anything, and that's his aporia. And it is not a process the subject is always in control of or even produces; in fact, it is a process by which subjects are produced. But if that is the case, this "passing" of the voice cannot be thoroughly delinked from the political significance of the act of appropriating sound within the context of slavery, US histories of racial exploitation, the color line, and the long history of cultural appropriation of which the torch singer is certainly an emblematic figure.

Holman's very desire and attempts to fashion an identity outside of "black or white" racist binaries and to get outside the system of racial capital had political costs. Her desire to perform outside the assigned boundaries of white femininity put her relentlessly back in a position of poaching black sound. She might not have been able to escape the meanings produced at the intersection of white bodies and black sound—one of which is exactly what might be called the "liberal humanist preference for a 'deracinated' body."[47] Holman's desire seems to have been to produce new sounds, subjectivities, and forms of relationality, and even a public conversation about what can be heard in the friction between the production of those discourses and desiring subjects. Yet that desire did not remove her from a position of privilege or exempt her from the exercise of power, or the reinforcing of existing racial regimes through her music and management.

DERACINATED AND RERACINATED: HOLMAN STAGES HER FINAL ACT

Holman consciously sought new ways of producing sound and imagining identity throughout her two careers. Her early career, as I described above and as she herself came to acknowledge, was steeped in the racist politics of Tin Pan Alley, the production of the Great White Way of Broadway, and the growth of racially segregationist recording industries. Holman's torch song materials were only one step away from an era of minstrelsy and coon shows that delivered racialized fantasies in a popular form that white audiences could digest and call their own. Holman's second career reworked blues material for the concert stage and for white audiences, often in the form of benefits for the civil rights movement. She sought, in this second act, to distance herself from associations with the retrograde racist politics of the first act by performing material that she saw as "authentically" African American and working toward desegregating the working conditions of the stage by collaborating with African American musicians. She chose to utilize her public persona toward political ends, as a citizen-diva, engaging in letter-writing campaigns to the White House, and the activities of her nonprofit foundation focused on antipoverty efforts and ending racial discrimination.[48] It was during this later career that she reanimated and put into circulation the self-biographizing narratives about her past in order to destabilize the earlier signifiers of her own racial identity and to dissociate herself from the now hackneyed torch song genre—but more than that, from being criticized as racist.

In 1941, when Holman performed to benefit Leadbelly and connected with Josh White in that Greenwich Village nightclub, White, who later reluctantly agreed to become her accompanist, piqued her interest in adapting African American songs.[49] Holman reportedly researched American folk and blues songs

at the Library of Congress, where she made use of the Lomax father-and-son field recordings of the Delta blues and other American song traditions. A news clipping from this era describes the collaboration between Holman and White as having "a more serious purpose, which is to present some of the earliest examples of this most interesting phase of Negro folk music, adding the better type of later blues. . . . Mr. White[,] who in addition to his singing is reputedly the greatest living Negro guitarist, taught Miss Holman how to sing these songs. At

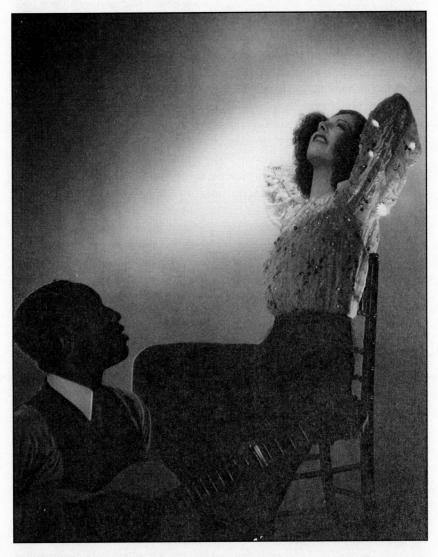

FIGURE 20. Libby Holman and Josh White. Courtesy Howard Gotlieb Archival Research Center at Boston University and The Libby Holman Foundation.

first he doubted that a white woman could ever get their 'feel,' but not now." In the same article, Holman described the transition between her two careers this way: "The blues I sing now are not sentimental; they're richer material than that. They're earth songs that have come out of the Library of Congress and from Carl Sandburg's 'American Song Bag' collection."[50] White and Holman toured the country with this national treasury comprising the material for their record *Blues Till Dawn*. They also appeared in an experimental film, *Dreams That Money Can Buy* (dir. Hans Richter, 1947). Together, they fought segregationist door policies at venues like the New York Club. When they were turned down for a USO appearance because they were a "mixed" act, they then played the black service-members' clubs, touring together until 1945 (see figure 20).

Holman later found it imperative to deemphasize Josh White's influence and insist that he had only been an accompanist, a denouncement undoubtedly in response to his decision to voluntarily testify before the House Committee on Un-American Activities.[51] Although he apparently did not target any individuals through his testimony, the American Left saw his voluntary participation as a betrayal. In response to a *Greenwich Times* article on December 23, 1965, which referred to White as her mentor, Holman wrote in a personal correspondence: "Bob—Never say Josh White was my mentor—I did no research until my real mentor—Gerald Cook and I did it together—Love, Libby."[52] However, Holman also framed her dismissiveness of White in terms of his being "not a trained musician"; this despite the fact that she prided herself on being seen as untrained. She is quoted in the press declaring, "I'm not a trained singer, any more than were the people who originated these songs. They came out of the throats of the common people—workers in the cotton fields, a girl in a New Orleans Bordello, ordinary people singing of work and love." [53] Yet this dismissiveness of White as untrained is echoed in a *Chicago Defender* review from 1944, "Josh White and Libby Holman Please Throng," which describes White as "a fine composer" but a "typical southern farmhand artist." White himself, then, was caught being accused, on the one hand, of "becoming white" in his style as he appealed to a crossover audience in his collaboration with Holman and, on the other hand and at the same time, of being "too unrefined," a black southerner.

Gerald Cook, a black composer and pianist, then became Holman's primary collaborator in the last successful round of her second career. Holman insisted that Cook be recognized as such in their productions and emphasized his role as mentor, co-artist, composer, and musician. He worked with her concert blues enterprise, and together in 1948 they began to compose and rearrange songs she now preferred to refer to as "earth songs." Holman recollected: "It was a whole new genre for me. . . . Right then I decided I didn't want to do Tin Pan Alley blues anymore, I wanted to sing *the real thing*. At first I thought I'ld [*sic*] sing folk songs from all over the world, until I discovered the wealth of material in America.

I don't like to call them folk songs, by the way—the connotation sounds precious. I prefer to call them 'earth songs.'"[54] In transitioning from White's guitar accompaniment to Cook's piano, Holman was enacting a shift that had already occurred in American popular music, a moving away from an emphasis on Delta and folk blues to jazz. But she was also continuing to participate in that other shift, one famously described by Langston Hughes when he writes, "You mixed 'em up with symphonies / And you fixed 'em / So they don't sound like me. / Yep, you done taken my blues and gone."[55]

The result was Holman and Cook's collaborative performance, *Blues, Ballads, and Sin Songs*, including contemporary lyrics by Tennessee Williams and Holman's friend the famous writer, composer, and quintessential homosexual modernist expatriate Paul Bowles (1910–1999). The show saw three continental tours, and among their last appearances were a UNICEF Concert (1965), a Georgetown University benefit concert for civil rights (1966), and a World Federation of United Nations Association Benefit (1968). For these concerts, carefully designed lighting and minimal, highly dramatic props became her trademarks. For a performance at the nightclub La Vie Parisienne, the well-known designer Mainbocher created an exaggeratedly long peasant skirt and a sparkling blouse for Holman. The costume became her uniform, sufficing as one of only two stage props. This infamous peasant-style evening gown, which the critic Brooks Atkinson cleverly called "Mainbocher in a democratic mood," typifies Holman's complicated and perhaps arch relationship to notions of authenticity. In a 1965 interview with Duncan McDonald, Holman explained that she saw these songs she sang as "not written, but com[ing] from the throats of the people as they sing them from one generation to another."[56]

This desire for authenticity often came into conflict with Holman's belief in being unabashedly dramatic—or perhaps this is precisely *how* Holman understood "authenticity." When asked by Arlene Francis in 1966 about her use of the Mainbocher skirt for flourish, she responded, "Shameless, I'm shameless."[57] Holman prided herself on existing in such spaces of contradiction; she took pleasure in occupying high and low, in bringing the folk and the concert, and by implication black and white, aesthetics together onstage through her diva persona. Although Holman made use of older, staged techniques, and her concert show stopped short of the minidramas that framed her Tin Pan Alley numbers in productions like *The Little Show*, she wanted the effect of her performances to be akin to modernist theater, where the barrier between artist and audience is collapsed. The other prop Holman relied on was a small chair with a slatted back, which she used for dramatic effect, to suggest prison bars one moment or an executioner's block the next, as she sang. Holman had a clear conception of what she considered to constitute effective performance, how the audience should engage with the work, and which techniques would achieve the desired effects. She thought of the microphone as an

intermediary that only served to distance her from the audience; she disdained its use. Holman insisted that entrances and exits were to be "natural" ones; in other words, there should be a narrative "reason" for them. Her stage directions called for a chair, a piano, lights, and black curtains, and she insisted (perhaps in contradiction to naturalness): "Have to have a proscenium. I've always leaned against something."[58] She called it a "fluid" show, which utilized dramatic gestures. She considered the audience an essential partner in these small dramas.

This second career brought Holman back to the stage and to blues material from a new perspective. Holman attempted a kind of artistic ethnography, approaching the material in a sociological, historical, and archival manner, while consciously promoting these popular songs as high art. Her approach was not entirely ruthlessly anthropological; she did attempt to approach the material as a living tradition and to collaborate with African American musicians rather than simply viewing the blues as raw material available for her excavation. And she prided herself in bringing a genuine affinity to the material despite her whiteness; she considered herself able to embody and perform the material authentically. To promote her work, playbills reproduced testimony such as this: "We never dreamed we'd hear any white person sing these songs in the electrifying way this new, this more dynamic Libby Holman sings them."[59] And a review from the *Detroit News* claims, "She can utter the sustained throb of loneliness more potently than any member of the white race now before the public."[60] The playbill goes on to call her "the only white woman capable of singing these songs in the authentic manner—a statement which she herself feels is the ultimate compliment, for singing blues is not entirely a matter of notes." The description continues by driving home the divergence between blues and torch singing that Holman herself wanted to enact in this second career: "There must be a basis of feeling and instinctive understanding that colors the renditions of these songs and makes them authentic blues as distinguished from the 'torch songs' for which Miss Holman became famous."[61]

Yet, in 1954, the *New York Herald Tribune* also reported, "Miss Holman has a ready answer for traditionalists who may say that she stylizes the folk (or earth) material to suit her own needs. 'In the introduction to "The American Song Bag," compiler Sandburg advises, "If you like a particular air, and would rather sing it in a way you have found or developed yourself, making such changes as pleases you, you have full historical authority to do so." So I keep each song as a modern, pertinent thing of today,' Miss Holman said."[62] In this instance, like Ethel Waters, Holman, as an artist, did not necessarily try to reproduce the material in a historical, reproductive fashion but rather sought to use traditional or cultural forms to create a new artistic vision.

Ironically, Holman's image became embroiled in an antiunion fiasco, when a photograph of Holman and Josh White was distributed as fearmongering

propaganda to produce racial animus toward the union. A 1947 piece in the *Chicago Defender* recounts how tobacco companies, angry about union organizing, noted "that colored and white workers were integrating in the budding locals." Seeking to provoke interracial hostility and thereby destroy the union's organizing efforts, they distributed a flier with what was intended to function as an "alarming" picture of an interracial couple, singing together arm in arm. The caption read: "This is what you'll get if you join the union" and "Would you want your sister to marry a Negro?" As it turned out, "the picture happened to be one you probably saw, of Libby Holman and Josh White. Well the race hate campaign was going great guns and the hand-bills were being handed out right and left, when someone remembered too late that Libby was married to one of the Reynolds. She is thus a member of one of the famed tobacco millionaire families. Brother you never in all your life saw white folks so busy scrambling around collecting pieces of paper."[63] This is precisely the kind of story of mistaken identity exposing the ignorance of racial hostility that Holman absolutely relished, especially as she became more committed to taking a public political stand against segregation and racial injustice during her second career, and as she became less invested in rationalizing the slipperiness of her own racial categorization onstage and in the public sphere.

Holman thus claimed the stage as a place for reproducing racial and sexual categories in unusual and occasionally resistant ways through sound performance and storytelling: she saw herself as cultural producer and cultural changemaker. Holman maintained that she possessed the deep identification that she viewed as necessary for her to perform the material "authentically." In both careers, Holman was aiming for ways of creating new sonic imaginaries, and embodying sound in order perhaps to imagine nonxenophobic possibilities through sound. Whether or not Holman was successful in realizing this imagined space, it is clear that she consciously sought new ways of trying to make it materialize. She deployed her voice to cut against the sonic grain of different racialized musical genres and sonic-somatechnic embodiments.

RETROACTIVATION: HOLMAN'S QUEER CAMP ARCHIVE

Holman's iconicity accrued status and then longevity as the affective attachment to her diva persona grew in the years after her death. She went from Depression-era tabloid fodder, wealthy suspected murderess, and femme fatale to representative figure in a larger pantheon of "notable women" from this turbulent era. Holman's life (and specifically her brief marriage to Zachary Smith Reynolds, his murder, and the subsequent murder changes brought against her, along with charges of infidelity with men and women) inspired two 1930s film musicals: *Sing, Sinner, Sing* (dir. Howard Christie, 1933) and *Reckless* (dir. Victor Fleming,

1935), with Jean Harlow. *Written on the Wind* (dir. Douglas Sirk, 1956), with Lauren Bacall and Rock Hudson, rewrote the Reynolds scandal as a murderous romantic melodrama set in Texas oil country. Holman was also apparently convinced that *Sunset Boulevard*'s (1950) film noir femme fatale Norma Desmond was a caricature of her.

Holman's life and diva iconicity also inspired at least two significant plays. The first, *Play Murder* (premiered in 1994 and published in 1995), written by the Canadian professor, writer, gay activist, and drag performer Sky Gilbert, was inspired by Jon Bradshaw's sensational biography *Dreams That Money Can Buy* and billed as a "postmodern bisexual thriller."[64] *Play Murder* was understood by the playwright and critics to be structured experimentally as a "metatheatrical historiographic exploration of 'the difference between an investigation and a play.'"[65] Then, in 1997, Holman was brought to life, along with Ethel Waters and several other "extraordinary women," in an experimental "interactive theater" play, *In Good Company*, written by Leslie Jacobson and directed by Jane Latman at the Horizons Theatre at Rosslyn Spectrum in Washington, DC. The play invited audience members to converse in real time with historical figures.[66]

Libby Holman and Ethel Waters are juxtaposed as lead characters in *In Good Company*. The contemporary drama was created as part of a series of the same name, developed at Horizons Theatre as an experimental interactive theater genre. In this iteration, referred to sometimes as *In Good Company: Sexual Icons*, the audience was briefed in the first half of the evening on five "pioneering women" through vignettes of their lives, and then encouraged in the second half to engage in conversation with them, with the aid of a hostess. The five well-versed actors who inhabited the personae of the different historical figures needed to improvise answers that credibly corresponded with their biographies. As one reviewer described it, the excitement of the evening emanated from the anticipation of interactivity with divas, but the conceit only worked once the audience had enough background information to be able to ask informed questions of the actors, such as "Who'll be cruel enough to raise the issue of Holman's black-widow touch and whether it has anything to do with the fading actress's fondness for drink?"[67]

The format and method of this contemporary play mirror the technologies of the diva put into play by Holman herself. The first half stages the work of dramatic self-biographizing that divas engage in as they craft the contours of their iconicity. The second half produces a particular renewed "afterlife" of the diva by offering a pedagogy of "conversancy" for those uninitiated in diva worship. The diva devotee should become expert or knowledgeable on the (sordid) details of the diva's life (the diva's repertoire), or at least take pleasure in gossip and innuendo, and in doing so cultivate a sense of personal connection, familiarity, even intimacy with the diva icon. The Horizons program included "a cheat sheet with

brief bios on the pioneering women" and "even a recommended reading list to take home: Do your homework, it seems to say, and you can come back next week and really make the cast earn its keep."[68] The diva devotee is just that, a student, an initiate: and it requires labor. The play then becomes a site of diva worship (it adores, celebrates, elevates, and studies its subject) and a pedagogical site, a space for educating audiences in diva worship (acquiring knowledge, collecting ephemera, engaging in gossip, inventing intimacy/proximity).

One reviewer, presuming to understand how "ultraserious feminists" might assess the play, claims that they "won't like the way the bickering reinforces stereotypes about backbiting women."[69] While this review may be a clue as to how tired tropes and gender stereotypes are reproduced in the play, this critic may also completely miss the mark. The interactive theater genre and the celebration of female figures with sharp tongues can be seen as precisely indebted to feminist impulses toward recording, staging, reinvigorating, and remembering improper female cultural producers as bad girls who upend patriarchal gender norms. And the review also completely misses queer camp identifications with acerbic wit, caustic humor, and nasty retorts as forms of social critique and tools of survival.

While the biographical details of Holman's life seem to have made her an almost inevitable subject for a burgeoning queer theater in the 1990s, contemporary renditions of her life tend to latch on to a narrow set of animating details. Gilbert wrote *Play Murder* as part of an experimental repertoire for Buddies in Bad Times Theatre, a thirty-five-year-old Toronto institution he cofounded that describes itself as "the world's longest-running and largest queer theatre."[70] In his memoir Gilbert states, "The cast knew that they were committing a political act even appearing."[71] Yet, when it was mounted as part of the theater's twenty-fifth anniversary, ten years after its premiere, the play was described paradoxically by one critic as "a wax museum of local gay theatre during its growing-pains years" and by another as "return[ing] . . . in the guise of respectably mainstream alternative theatre."[72] Ungenerously, perhaps toward both Gilbert and the historical figures that are his subjects, as well as the era's impulses towards gay history-making, the first critic describes Gilbert's method as "Googling": "Like a human Google, Gilbert scours historical data, searching for the gay subtext."

Yet Holman's sexuality has never been a subtext to be excavated, searched out, exhumed, or otherwise insinuated into the historical record. In the 1930s, she generated sensational headlines as an impetuous and queer socialite diva. In her social and sexual life she had publicly visible relationships with gay men, lesbian women, and bisexuals. And while Gilbert's play could be accused of camp fatigue (as the theatrical review headlined "Too Old for Camping" signals), it is not because Gilbert is "overreading" into his subject's sexual lives or sexual politics as the critic implies, but rather, perhaps, because he is reading queerness reductively, in an all-too-predictable vein.

Through racialized, sexualized soundscapes and practices of self-biographizing, Holman produced the conditions of possibility for her own queer diva iconicity, but those conditions were more interesting and complex than what has gained visibility through contemporary citation and performative forms of remembering. This is, in part, symptomatic of Holman's own inability to stage the retroactivation of her career by managing her own archive, or to influence the ways in which her diva iconicity is remembered or made legible. As that iconicity has played out in contemporary reiterations like *Play Murder*, the persistence and publicity of Holman's diva iconicity rest almost in their entirety on a particular originary set of circumstances: her brief, tragic, headline-generating marriage to Zachary Smith Reynolds; his ensuing suicide/murder; and her pregnancy with his heir, which came to light after his death. Her torch song career predated the marriage and perhaps came to an end because of it, yet it informed the femme fatale persona that made her an unsuitable spouse for the heir to the southern tobacco fortune and, therefore, a highly desirable prospect to the rebellious heir. Later, it made her an easy suspect for his murder, as the journalist Milt Machlin's investigative book on the case suggests, and, fueled by anti-Semitism, it fed the charges brought and then later dropped by the Reynolds family.

The tabloid sensationalism surrounding these events contributed to Holman's status as a "real-life" femme fatale. Her notoriety in the 1930s amplified the effect of her performances in her early revues as she deployed the worked-over tropes attached to mixed-race subjects, including the tragic mulatta and the "high yellow" prostitute. In her later career, Holman tried to reinvigorate the meaning attached to these theatrical vignettes by encouraging her audience to read them in conjunction with her offstage anecdotal storytelling practices. By emphasizing her personal experiences with racial misidentification and racial prejudice, she hoped to dislodge these minidramas from their clichéd status. Juxtaposed, the two narratives, as they were told by Holman in interviews in the 1960s, foreground questions of race alongside sexuality and "sin" or "vice." Holman's staging, therefore, of an uncertain sexual identity worked in tandem with her staging of racial indeterminacy, onstage and off.

This confluence of race and sexuality in the making of Holman's diva iconicity is flippantly alluded to by Gilbert. Holman began her career in an era of racially segregated theater circuits and debates about the arts and cultural assimilation for blacks (migrating to the North) and for Jews and other European and Asian immigrant communities coming to the United States. Yet, in Gilbert's play, rumors of Holman's racial ambiguity become merely an excuse to toss off the N-word onstage as the setup for a caustically camp remark about racialized sexuality: "The answer is maybe I am part negro . . . the question is which part!"[73] Such diminished and opportunistic uses of racist invectives aren't addressed by Gilbert's critics, but could substantiate their conclusion that the

play is "an exercise in pointlessness," or as one critics asks, "Are we having fun yet?"[74] Despite some bad reviews, Gilbert did successfully cultivate an audience for his work, and he saw the mission of queer theater in part as the "shameless" traffic in taboo language, including sexually graphic language and humor: "I had always thrown radical sexual politics—boys fucking boys, men fucking boys, fucking fucking fucking—right in the audience's face. No shame, no guilt. Just positive images of gay sexuality, frank and clear (but not clean)."[75] The writing in *Play Murder* casts the casual deployment of racist epithets as part and parcel of this stylized uncensored sexuality. We might have to answer the critic's question "Are we having fun yet?" by paying attention exactly to the fact that for some audiences, immersion in the graphic (whether critically or uncritically) was fun. While the retort from the Holman character in *Play Murder*, "Which part?," is designed as repartee to take the power out of the racist invective, the language also participates in the construction of blackness as a commodity, as fetishized, hypersexual, and appropriable fun.

Gilbert's play is referencing the ways that Holman herself took pleasure in narratives about the ambiguity of her racial and sexual identity and similarly relished being "shameless." But the camp invocation of Holman, while trying to evoke and perform her biting humor and critique, deploys that humor in the service of a retrograde racist queer politics, erasing exactly the kind of rescripting that Holman would have hoped could retroactivate her legacy. In our contemporary moment, Holman is part of a camp repertoire that hasn't found its full potential; she remains a B-list diva icon remembered for her "tragic" and scandalous marriage to Reynolds, or as part of the queer smart set including friendships and affairs with Clifton Webb, Montgomery Clift, Jane Bowles (wife of Paul Bowles), Jeanne Eagles, and her long-term lover Louisa Carpenter. These contemporary citations contribute to the persistence of another failure, the failure to produce a queer sexual politics that fully accounts for its uses of race in producing white non-normative gender and sexual subjectivities and, in turn, its erasure of queers of color from the scene of sexual and gender critique. This move has become a defining and troubling one for contemporary LGBTQ movement politics and formations, one crystallized in the post–Proposition 8 (California Gay Marriage Ban) political slogan "Gay Is the New Black," which analogizes gay rights struggles with black civil rights struggles.

So while Holman is an intriguing figure who invites attention by contemporary queer artists and scholars, she has yet to be taken up in a way that fully engages her repertoire, life story, and performance politics. She herself obfuscated uncomfortable truths by framing and later reframing her uses of African American material across her two careers. And yet she also earnestly tried to address them by aligning herself with antiracist politics, seeking ways to "undo" her earlier career, and contributing financially to the civil rights movement.

These are dimensions of her performance labor that get lost in the current contours of the queer camp afterlives of her diva iconicity. In the end, then, her own failure to redeem the appropriative politics of "embodying blackness" in her torch song career is amplified in the shortsightedness of contemporary citations and evocations of Holman.

"WELL, IF YOU LIKE IT"

Holman hoped to produce a sonic "racial mobility" that would undo the oppressive histories of the American sound archive. One *New York Times* critic seems to have at least heard this striving toward a new sound in Holman's voice during one of her last performances, even if he did not identify its aim or find her attempt successful:

> Miss Holman is intent on some special sounds that fascinate her, sounds that she seems to be tensely listening for and that we cannot quite hear. She lowers her eyes and strains for the piano. She fixes her glance on the second balcony, narrows her eyes to a slit, and fashions difficult phrases that remain merely difficult. She pursues a whispered inflection until it becomes prosaic and curiously unmusical. Whatever it is that the star earnestly has in mind just does not reach out to the back of the theater, not even to the back of the tiny Bijou.[76]

There is a kind of pathos to Holman's sound as it is described here: Is she striving for something we cannot hear? Or is the "special sound" the critic describes in fact the one that Holman has always intended? Are we hearing what Barthes called "voices in the voice"? When Holman went for voice training with Theresa Armitage, she said she did not want to change her voice, just stretch it. The teacher responded skeptically, "Well, if you like it."[77]

Her voice teacher may not have liked it, the critics may not have liked it, and we may not like it, but Libby Holman took up the tools of a trade, an early recording industry founded on musical appropriation, and at some point sought to bend it in a different direction. She took one moment of misidentification that made her the subject of police harassment and paired that story with another, in which she is reportedly sought out for casting in an all-black production and perceived as "black passing for white." Taken together, and repeated, these stories were used by Holman in the hopes of constructing a new relationship to her musical offerings. She takes these moments of racial ambiguity, even suspicion, and capitalizes on them to empower herself toward an entitlement to the genre. In one sense, she becomes the predictably appropriative voice for the torch song, a category invented for white singers to repackage the blues for a white audience. She becomes the person seen as

best suited to inhabit the mixed-race character onstage. And later, she counts herself among those artists best suited to cultural preservation and archiving of the blues. Yet Holman also desires to see in these moments of phenotypic ambivalence and misidentification an opening, a crack, in the ideology of race to exploit for the purposes of undoing. Despite the fact that her status as a 1920s torch singer inherently positioned her to capitalize on the vogue, Holman repeatedly indicated that she hoped to bend cultural appropriation in the direction of racial intersubjectivity and critique.

Holman liked to repeat the story that in her early career she "passed as black passing as white." Her work was associated with tropes of passing, deracination, the tragic mulatta, and ambiguous racial and sexual embodiment through sound, and produced discourses that sought to transform the meaning of her whiteness and of her gender and sexuality. In one sense, Holman contributed to the displacement of her ethnic identity, participating in a trend of Jewish assimilation in this period. However, Holman also tried to retroactivate racial passing into the notion of "racial mobility" through imagining forms of "aural passing." In doing so, she attempted a critique that was aimed at disrupting fixed notions of racial and sexual identity. This chapter has argued that Holman sought to create disidentifications with whiteness (and with white appropriation) by playing with the idea of aural passing and seeking to cultivate notions of racial unlocatability. Her retroactive and apocryphal narrativizing of her ambiguous racial identity reverberates against the politics of her performance of racialized sound. Nonetheless, looking back, it's apparent that she is constrained by the dissonance between what she was trying to do and its effects, particularly in its failure to be legible to audiences and critics. As a white blues singer, Holman appropriated an African American genre and archive, capitalizing on her predominantly white audience's ideas of "black sound" and their desire for that sound to be channeled by white bodies. In addition, by creating ways to disidentify with whiteness, and by playing with the idea of visual *and* aural "passing," she aimed to create a dichotomous appeal to both racial authenticity and racial unlocatability. Holman also made use of the conjunction between black sound and white performance to consider the instability of that racialized binary. She sought to reconceptualize racial passing not as crossing from one fixed category to another but as movement within a space between categories—even if she had to create that space herself—in hopes of dislodging their categorical hold. Libby Holman's experiments took place within what she conceived as the possibilities for mobile resonance within sound, the reverberation of "voices within the voice."

Although it is specifically the queer camp appreciation of her diva iconicity that has afforded her an enduring afterlife, ironically, Holman's queerness has perhaps become the most limiting aspect of her affective afterlife. Rather than

utilizing queer provocation productively, a narrow framing of scandal tends to deflect a more interesting consideration and critique of the complex set of meanings generated by her onstage and offstage performances at the intersection of race, gender, and sexuality. Onstage and off, she projected a sexual persona and sound that challenged heterosexual norms and cultivated queer attractions, but did so very much with race as the mobilizing technology of difference.

4 : "MUCH TOO BUSY TO DIE"
Josephine Baker's Diva Iconicity

It's Time (2003), a parody magazine cover from a graphic art series called "House for Josephine Baker (Parody Series)" by the contemporary architect Darell Wayne Fields, conveys how diva iconicity moves across time and place: captivating, yet captive (see figure 21). Appropriating the famous 1928 Adolf Loos architectural design for a house for Josephine Baker, Fields marks it with a large red X whose ink bleeds across a parodic *Time* magazine cover. The standard red frame of the magazine cover is echoed in the red of the X, referencing the May 7, 1945, cover of *Time* and its X over Adolf Hitler's face, announcing his death and becoming Time's X brand for marking the end of tyranny[1]—and here also invoking black militant resistance. The image of the house has been pasted over familiar line sketches of Baker dancing nude, topless, wearing the notorious banana skirt or Topsy overalls, and in other famous outfits. But instead of being erased or covered over, these sketched figures seem to break free from the page. Baker's dancing body-in-motion seeps through the image of the house, across time, across space. And, as multiple dancing Bakers surround and overwhelm the outer periphery framing the house, her mobility strikes a marked contrast with the solid and staid block of high-modernist architecture designed to captivate her.[2] The caption, "Notes on the Eviction of Josephine Baker," imposed below the Loos design, exposes the historical irony of a modern house designed but never built for Baker, reinforced by the reality of her later very public eviction from Les Milandes, the communal farm she envisioned and created in France, the site where she staged the creation of her ideal modern family, the "Rainbow Tribe." *It's Time* stands at the juncture of multiple and conflicting receptions of Baker and her legacy, marking her iconicity and its afterlives as a space of contestation of meaning and memory. The architect's (new) blueprint for Baker is a creative retrospection that illuminates the persistence and constraints of the racist/primitivist reception of Baker while imagining her own

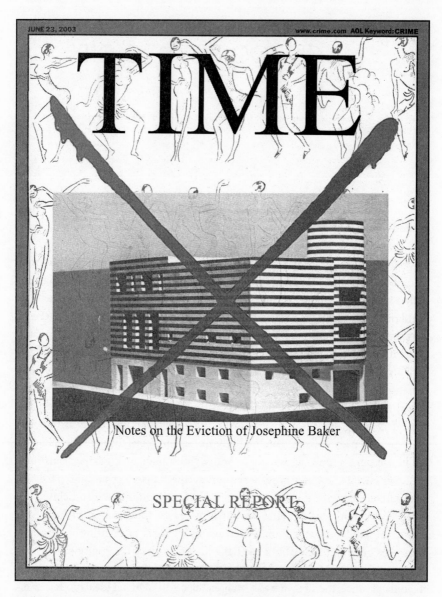

FIGURE 21. *It's Time* from "House for Josephine Baker (Parody Series)" by Darell Wayne
Fields, 2003. Originally published in *Harlemworld: Metropolis as Metaphor*. New York:
Studio Museum of Harlem, 2004. Courtesy of the artist.

mobile iconicity as a form of black resistance to capture. "There's been a slight exaggeration," in Baker's words; her iconicity has been "much too busy to die."[3]

In this chapter, I examine the diva iconography of Josephine Baker (1906–1975) by considering the politics of Baker's complicated staging of race, sexuality, and nationality—on and off stage and screen—alongside contemporary deployments of Baker's iconic status at three sites: the full-length animated feature Les Triplettes de Belleville (dir. Sylvain Chomet, France/Belgium/Canada/UK, 2003), in which Baker makes a brief appearance onstage as a cartoon figure; Fields's series "House for Josephine Baker"; and Madame Satā (dir. Karim Ainouz, Brazil, 2002), a film based on the memoirs of a legendary Brazilian drag performer, João Francisco dos Santos, which treats Baker's Princess Tam Tam (dir. Edmond T. Gréville, France, 1935) as it was screened in 1930s Rio de Janeiro.

These contemporary citations of Baker's iconicity contribute to a retrospective portfolio of Baker, an ephemeral yet persistent archive of the cultural icon and female star that sets her in motion rather than freezing her in the frame. This chapter examines how such citations can provide critical hindsight into the significations that Baker's performances produced onstage and off. By looking at the afterlives of the diva icon La Baker, I retrospectively consider Baker's multiple and often conflicting performative embodiments of her own iconicity as modern primitive. Focusing in particular on citations that move between modes of reception and modes of performance or cultural production, I consider how contemporary fandom acts productively through forms of affective agency. Taken together, these competing and very different citations reframe cultural nostalgia for Baker. They show how nostalgia itself can be a risky yet powerful affective structure for recycling the past in order to imagine a future through cultural materials that have an oppressive history. Yet at times these afterlives participate in retrograde oppressive circuits of voyeurism and spectacle, sometimes even under the guise of retroactivation.

Although Baker scholarship has effectively critiqued the colonizing ethnographic gaze and the racist male gaze that entrap Baker in a prison-house of primitivist discourse, like the melancholy birdcage from whose perch she sings in the film Zou Zou (dir. Marc Allégret, France, 1934), it has had less to say about Baker's other audiences, those who may have viewed her homesick birdcage lament for Haiti, for instance, from a transnational, black diasporic, black feminist, or queer perspective. Patricia Hill Collins sees Baker as part of a continuing genealogy of "distinctive sexualized spectacles" that mark "the contradictions of Western perceptions of African bodies and of black women's agency concerning the use of their bodies."[4]

As part of my discussion here, I want to consider a certain queer feminist nostalgia for Baker, whose bad-girl antics and daring performances of black femininity in the early part of the century anticipate high-profile self-marketers

of female trouble who follow in her wake, from the punk primitivism of Grace Jones or the quirky black dandyism of Janelle Monae to the diva performances of "Queen Bey," Beyoncé Knowles, who styled herself after Baker at the 2006 Fashion Rocks. In Beyoncé's tribute to Baker, produced in consultation with Baker's informally adopted son and promoter of her legacy, Jean-Claude Baker, Beyoncé appeared onstage in a sparkly version of Baker's famous banana skirt, surrounded by a chorus of similarly banana-skirted figures and incorporating some of Baker's signature choreographic moves. The tribute was orchestrated to signal Beyoncé's seriousness as a solo performer who was author of her own moves, reinforcing Baker's iconicity not only as a marker of success but as a sign of artistic authorship. Baker is the progenitor for the global mass marketability of the performances of these very differently raced and gendered black female megastars. In a different register, Baker is also the muse for performances that resist commercialization, such as the cross-race, cross-gender displays of the cult drag impresario Vaginal Davis. As one incarnation of a weekly cabaret night (2002–2005), Davis staged a cabaret tribute night devoted to Baker at a Los Angeles bar named for another famous twentieth-century transatlantic club diva, Bricktop.

Born Freda McDonald, Baker fled poverty, domestic labor, and traumatic memories of the violent 1917 East St. Louis race riots by seeking work in the theater. At times considered "too small, too thin, too dark" for chorus lines,[5] she left St. Louis to work as a dresser touring on the Theater Owners Booking Association segregated circuit for African American vaudeville companies. Eventually she worked her way into the chorus as a comic performer and ultimately landed a role in Nobel Sissle and Eubie Blake's already popular and groundbreaking *Shuffle Along* in 1921. Here Baker got her professional break and was quickly recruited for more principal roles, eventually being tapped to star in an "all-Negro" show, *La revue nègre* (1925–1927). Caroline Reagan, a liberal white New Yorker and socialite, conceived this show as a Harlem export for Europe. Arriving in Paris in 1925, at the height of *la vogue nègre*, Baker achieved a status, fandom, and recognition that she was never able to translate into commercial success in the United States.[6] Baker became an iconic international figure, La Joséphine or La Baker, moving through the transnational cultural circuits that helped define popular female stage and screen performers in the early twentieth century, a time when public performances of the "private" self coalesced as obligatory and defining elements of female stardom. Setting the stage for contemporary forms of celebrity, she famously staged her private life for public consumption, performing a vast array of personae in many different locations: as star of stage and film; as modernist muse, femme fatale, primitive savage, international spy, and transnational antiracist activist; and as an icon of motherhood.

Baker is frequently remembered for spectacles of modern primitivism, such as the costumed cabaret dances represented in films like *Princess Tam Tam* and

Zou Zou.[7] Baker the US expatriate performed primitivism in Europe through the foreignness of her American identity as much as through shifting notions of black otherness. Her transatlantic move from New York to Paris in 1925 became a permanent relocation, and she remained in France, an adored, adopted French citizen until she died in 1975. This national dislocation produced another dislocation, a kind of displacement and replacement of a range of signifiers attached to blackness whether read through European colonial frameworks of Africa or through a range of racialized modernities attached to American blackness that Baker insightfully recognized as at times producing a deracinating of her identity. The fetishization of race and racial difference remained at the core of how audiences read her at home and abroad, and the definition and meanings attached to her body as a black woman were among the repertoire of what Patricia Hill Collins calls "controlling images,"[8] their contour complicated by her expatriate national status and geographic mobility. Each location circumscribed and placed limits on the ways in which her performances, both onstage and off, were legible to different audiences as forms of spectacle shaped by social relations circumscribed variously by Jim Crow laws, colonial relations and practices, and their interconnections.

The centenary of Baker's birth in 2006 marked a significant renewed critical interest in her work among black studies, critical race theorists, and feminist scholars. In her birthplace of St. Louis, the Sheldon Art Galleries held a major exhibition, *Josephine Baker: Image and Icon*, which celebrated her contributions to the Jazz Age, while Barnard's Center for Research on Women brought together scholars, as well as one of Baker's adopted children, for "Josephine Baker: A Century in the Spotlight" (September 29–October 1, 2006). Her films *Zou Zou, Princess Tam Tam*, and the harder-to-find silent film *La sirène des tropiques* or *Siren of the Tropics* (dir. Mario Nalpas and Henri Étiévant, France, 1927) were rereleased as *The Josephine Baker Collection*, and the audio collection *Centenary Tribute: Songs from 1930–1953* brought Baker's diverse portfolio of work back into the public spotlight.

Black feminist scholarship in particular has pushed to move beyond the tendency to judge Baker's performances either on their political efficacy or on their aesthetic merits and rather to recognize and explore how performers convert the condition of black alterity into cultural expressiveness and insurgency.[9] Here I also seek to fashion a critical methodology that moves beyond the persistent dichotomy of asking whether Baker was exercising or lacking agency. (Is Baker a race woman or a race traitor? A pioneer of racial equality or a dupe of the racist colonial gaze? Does she deploy resistant feminist camp aesthetics or remain complicit as an objectified muse of the modernist male gaze?) Instead, by examining her performances as new and different audiences rework them, I construct a politics of performance in which Baker moves through various locations and

identities in order to carve out a habitable space for modernism's others, for those bodies classified and contained through scientific racism's pervasive and gendered ideology as "primitive" or "deviant" or "childlike" and then rigorously excluded, exploited, and spectacularized under European colonialism and Jim Crow segregation.

Such tropes of difference, essential to apartheid logics as well as to "civilizing missions," were taken up and redeployed during the cultural vogue in Europe between the world wars for *l'art nègre* by practitioners of modernism such as Jean Cocteau, Gertrude Stein, and Pablo Picasso. To this list I would add Paul Colin and Josephine Baker, emphasizing their collaboration in the production of some of the most famous primitivist images of Baker, namely a series of hand-colored lithographs included in *Le tumulte noir* (1927), later echoed in Fields's graphic piece *It's Time*. At times, avant-garde artists, such as the surrealists, sought to undermine colonial thinking by embracing the so-called primitive as an antidote to the repressive edicts of "civilization," seeing access to the creative unconscious in African sculpture and religious artifacts.[10] This revaluing, however, retained troubling and essentialist fantasies in the form of racialized exoticizing. Even when artists and writers attempted through their own modern experimentations to critique the logics of imperialism and the destructive consequences of imagining civilization and progress through the violence of colonialism, and to seek a counteraesthetic to the dehumanizing effects of industrialization, they often reinvested in the racist representational logics that deeply structured ideas of European progress and modern civilization in relation to an imagined atavistic African primitivism. Baker's body became exactly such an aesthetic site for exploring and expressing this fraught relationship of modernism and primitivism. Even Baker herself capitalized on such equations, refusing to be scripted in many ways, yet remaining captive in others.

Precisely because of Baker's contradictory and multilayered deployment of race, gender, and nationality, I argue that we can productively reframe our own nostalgia for her in the current moment, a time when a turn toward nostalgia might take its most conservative form as a turn away from current threats—imagined and otherwise—and toward an idealized ahistorical past, thus erasing any progressive politics of performance. Instead, turning our critical gaze farther afield to other kinds of sites where Baker's iconicity is consumed, cited, and redeployed allows us to remember the extent to which Baker produced complexity within the limits of historical spectacularization and commodification of the black female body.

Contemporary invocations of Baker, such as those I discuss here, criticize and rework her image through modes of retroactivation, even as they explore and embrace the nostalgias associated with it. Incorporating what Linda Hutcheon has termed "the necessary addition of irony to this nostalgic inheritance" of modernity,[11] such citations produce a reverence for the iconic subject, retaining

both an untempered enthusiasm *and* a certain critical incredulity. This reception space (whether occupied by fan, critic, or devotee) in turn is a reminder that Baker herself was capable of producing such ironies and did so when she produced a narrative of black womanhood that disrupted the limiting frameworks and tropes attached to the black female body in colonial and other contexts.

What happens if we refuse to remember only one Baker, be that Baker onstage, Baker in the banana skirt, Baker under FBI surveillance, or Baker very publicly evicted from her home in France in 1969, an image she ensured would saturate the global media? I want to suggest that the fullness of Baker's engagement can best be grasped by reading her performances together as intersecting and equally "staged" (whether onstage or off), and by reading them along with the intertext of contemporary afterlives. In doing so, we also refuse to assume that transhistorical exchanges are unilaterally interactions where the present imposes or fixes its own critical investments on the past, or where nostalgias for authenticity more often do the work of erasure. Rather, we can view these retroactivations as restorations that both make visible and produce Baker's own diva politics.

THE NOSTALGIC GROTESQUE

The 2004 exhibition *Harlemworld* at the Studio Museum in Harlem diminutized the name Harlem, relegating it to lowercase letters and collapsing neighborhood and planet into a single entity, harlemworld, as in SeaWorld or Disneyland. Honoring the neighborhood's cultural import while putting the spotlight on the manufacture of this global city as destination and export, the show invited eighteen architects and urban designers of African descent to envision not what Harlem had been but instead what it was in the present and might be in the future. Opening "in the midst of a struggle for the ownership of the legacy of Harlem" and battles over preservation that pit nostalgias against futurisms and people against competing notions of progress, this exhibition, subtitled "Metropolis as Metaphor," drives home a critique of nostalgia by exposing a variety of competing interests for a place that everyone wants to be able to call home, from Bill Clinton (who chose 125th Street as the site for his office after the end of his presidency) to over half a million visitors each year.[12] Like the imaginary place harlemworld, which offers up "the idea of Harlem as ghetto fabulous, presenting a stage of urban realness and authenticity,"[13] Josephine Baker, too, is an object of the global imaginary representing a nostalgic fantasy of a glamorous cultural past, modern cosmopolitanism, black female stardom, and the world of the twentieth-century diva.

Josephine Baker's *danse sauvage*, from *La revue nègre* (1925–1927) and her trademark tutu of stylized bananas—in which she first appeared in *danse des*

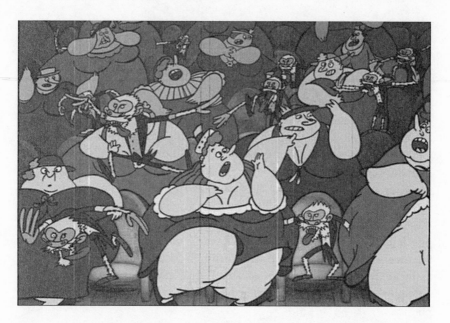

FIGURE 22. Josephine Baker's audience as represented in *Les Triplettes de Belleville* (dir. Sylvain Chomet, France/Belgium/Canada/UK, 2003).

bananas for *La folie du jour* at the Folies-Bergère (1926), deploying her other signature move, silly faces—present quintessential examples of the black female body functioning as an imaginary space in modernism for staging an encounter between the primitive savagery of the jungle and the civilized modernity of the cosmopolitan city. This encounter is parodically reversed in the opening scenes of the animated comedy feature *Les Triplettes de Belleville*. The film's reversal functions as a critique of this encounter as a trope and as a spectacular practice of modernism, but it also fails as a critique by perversely reproducing the primitive impulses of modernism through the pleasures of contemporary cinema, activating forms of nostalgic grotesque reception practices.

In a black-and-white retro toon-within-a-toon opening sequence, which pays homage to 1930s Disney animation, Baker makes a Betty Boop–like cameo dancing in her famous banana skirt to the musical accompaniment of Django Reinhardt. Her audience is represented as a theater filled with repetitions of the same white couple: a lecherous little old bearded man accompanied by an exaggeratedly fat society woman in a hat (figure 22). When Baker appears onstage to perform her banana dance—launching into another hallmark La Baker move where she imitates an animal by dancing on all fours—the crowd of identical geezers goes "bananas." They jump up from their seats, and, "going ape," literally turn into a pack of monkeys, rushing the stage in pursuit of, as it turns out, not Baker but her bananas (figure 23). White male desire to devour the staged spectacle

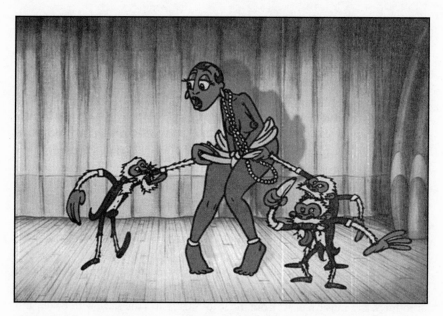

FIGURE 23. A retro-toon representation of Josephine Baker's banana dance in *Les Triplettes de Belleville* (dir. Sylvain Chomet, France/Belgium/Canada/UK, 2003).

of the black female body as primitive subject threatens to undo its own social performance of propriety. The scene reveals the infantile and sexual desires undergirding the civilizing mission: the drive for natural resources imagined as the drive for the female body through the feminization, possession, and rape of colonial lands and peoples.[14] Of course, the little old men are also stealing back Baker's parodic phallic signifiers. As this scene illustrates, the process of incorporating the other always threatens the coherence of the modern and the stability of white civilized masculinity it imagines, revealing the perversity of its desires.

In 1931, Baker was elected queen of the Colonial Exposition in Paris, an irony not missed by the French public, who decried her lack of claim to authentic colonial subjecthood. Celebrating the colonies of North Africa and their natural and cultural resources, the exposition was designed around dioramas that purported to display people in their native habitat. While Baker later had to relinquish her title, her music hall performances constituted a parallel world of display and commodification of the black body. However, as Mae G. Henderson argues, Baker's performances should perhaps be measured for their "distance from," rather than their repetition of, the ethnographic display of the black female body, epitomized by the historical exploitation of Sarah Baartman as "the Hottentot Venus," which I discuss in more detail below.[15] Baker stands onstage as a threshold figure, the gaze directed at her body simultaneously one cultivated through the old technologies of nineteenth-century colonial ethnographic displays of

racial difference and one in the process of "becoming modern"—a gaze hungry for burgeoning mass entertainment spectacles informed by new technologies, such as those shaping the iconicity of the modern female film star. The emergent diva iconicity of this period was composed of auras old and new, all the while continuing to project and absorb fantasies of imagined racial difference. Terri Francis has further shown how "Baker's popularity depended on the way Baker performed her own fame and 'freedom.'"[16] However, Baker's performance of freedom as an expatriate served to reinforce ideas of France as racially tolerant, suturing over the racial politics of French colonialism and assuaging colonial guilt, while at the same time exposing the practices of US racism.

On the stage and on film, Baker repeatedly functions as the primitive fetish, posing as a universalized colonial subject turned modernist muse. The aestheticized encounter of European modernism and its colonial other demands the other's incorporation into the modern as its object. *Les Triplettes de Belleville* imagines a scene that disrupts this process of incorporation by making it impossible to locate a coherently modern figure. The protagonists, the fictional "Triplettes," are cleverly introduced as a music hall act from the 1930s that shares the stage with Baker, and they represent the passing of vaudeville-era stage performance, presented here in the form I call the nostalgic grotesque. Whiteness is represented as degenerate in this opening scene, with the couples in the audience representing a comic trope about the degeneration of white bourgeois marriage: the "fat lady's" excessive body implies the couple's sexual dysfunction, while the small man represents impotence and submission. This couple figures European civilization itself as the progeny of excess and degeneration. The crisis of masculinity signaled by the wizened male body is essential to the modern, representing an anxiety over the waning status of patriarchal and colonial orders. As the film ironically returns the grotesque discourse of modern degeneration from the body of the other back onto the white male subject that produced it, it signals the inability of master narratives to contain the vitality of those subjects they attempt to control and their own instability. The historical Baker's dignity somehow remains intact in this scene, as the black-and-white retro-toon places white viewers uncomfortably in the vaudeville spectator's seat, forced to come to terms with their own nostalgia or desire for revisiting grotesque images of performing black bodies.[17] In *Les Triplettes de Belleville* it is clearly the white gaze that is primitivizing, not the performance that is primitive, as Baker's animated audience turns into the very thing it has fearfully projected onto her body. Even before the crowd of geezers' inner atavism is made manifest, the couple enters the theater as symbolic coupling of excess and degeneration. There is no imagined stability of white civilized masculinity to destabilize.

Nineteenth-century cultural obsessions with schematizing the civilized and primitive were tied to the emerging sciences of evolutionary biology and psychology, with their methods of classification and their use of layered evidence

and stratification. Whether on the dissection table, in geological strata, or in Freudian psychology, these modes of knowing lent themselves to what Ludmilla Jordanova identifies in *Sexual Visions* as a prevailing intellectual paradigm of "organic depth."[18] Such epistemologies of Victorian empire and patriarchy were intimately linked to the ideologies and logics of scientific racism and sexism. Truth and origin were imagined to be lying hidden beneath veils, waiting to be revealed by the scientist-explorer. The inextricable links between the desire to know, the establishment of various classification schemes, and practices of unveiling reveal how subjugation is enacted and envisioned along raced and gendered hierarchies of difference that are made available for scrutiny within visual regimes of expertise. Categories of subjectivity made available as objects of this gaze are fixed in such imagined strata (and therefore marked, knowable, and hierarchized), suspended in a stasis that becomes toxic for the subject of difference.[19]

In *Zou Zou*, echoing her famous Folies-Bergère routine, Baker descends from the ceiling, suspended as a gilded prisoner in a birdcage, offered up as an exotic pet, a primitive peacock. Baker's cage may be fanciful, but the moment is haunted by an earlier set of performances staging black femininity for French audiences: the life of Sarah Baartman (ca. 1778–1815).[20] Sarah Baartman, a young South African Khoikhoi woman, was brought to Europe in the very early nineteenth century as a pseudoscientific curiosity and displayed in Paris as a one-woman spectacle called "the Hottentot Venus." Baartman became a cultural obsession in France and the subject of a vaudeville theatrical production, *La Vénus Hottentot* (1814), as well as endless cartoons and other popular culture references. While Baartman's body was "on exhibition" during the run of the production, she did not appear as a performer; instead, she was caricatured by a white actress.[21] Baartman's exploitation has become emblematic of the spectacularization and fetishization of the black female body for entertainment as well as of its sacrifice in the name of scientific inquiry and the collusion between those two.[22] Even after she died in destitution, her body was dissected and her bones and genitals put on display at the Musee de l'Homme in Paris. While during her life her body was displayed for "cheap amusement," after death it was co-opted for "serious" anthropological display and scientific study, revealing the complicity of low and high culture in such practices.[23] It was not until 2002, after a long activist campaign and the African National Congress victory, that her remains were returned to South Africa and buried on National Women's Day, August 9.

Even if Baker's performances can be read as gestures of "distance from" the black female body on ethnographic display, as Henderson suggests, they remain haunted by the memory of Baartman, and Baker performs for audiences whose ways of looking were schooled through these earlier performance repertoires. Therefore, Baker both participates in and disrupts the primitive narrative of the Black Venus, a trope mapped out and critically examined by T. Denean

Sharpley-Whiting in *Black Venus: Sexualized Savages, Primal Fears, and Primitive Narratives in French*. Whether as star of the popular stage or as modernist muse and objet d'art, the framing of Baker persists through the lens of primitivism. Yet, as Sharpley-Whiting argues, "unlike Sarah Baartman, her nineteenth century in-the-flesh Venus predecessor who also captivated Paris, Baker found personal and economic validation in her constructed primitivity."[24]

Baker's body functioned, onstage and off, as an imaginary signifier of racial and colonial difference, the signs of which were produced in the complex interplay among the visual and performance tropes of nineteenth-century colonial spectacles, the signs of cosmopolitan modernism, and the meanings attached to black American modernism. This interplay itself often functioned to fix Baker as an emblem of primitivist modern subjectivity. But the interplay can also be read as producing the possibility of "give," or what Shane Vogel calls "loose pockets in tight spaces"—spaces of possibility within racialized performance venues.[25] Anne Anlin Cheng similarly speaks of the ethics of "looking for the possibility of the crevice," an imperative when examining orientalist and primitivist performances by women of color.[26] In such gives—the loose pockets and crevices— Baker's performances have the potential to interrupt the circuits of dominant systems of signification by which her performances were marked as "other."

Feminists have long argued for Baker's deliberate parodic deployment of primitivist tropes, finding resistance rather than acquiescence to exoticization in her use of comic faces, her intentional "forgetting" of dance steps, her insistence on performing "her own idiosyncratic moves," and her ability to "manipulat[e] the conventions of primitivism to gain a considerable amount of control over her audience."[27] For instance, Phyllis Rose argues that Baker's eye-crossing "functioned like a magical gesture of self-defense in a specifically erotic arena. It wards off the relentlessly erotic gaze of whoever might have been looking at her as, mythically, one warded off vampires by making the sign of the cross." Yet in the next sentence Rose's critical language notably maps the language of the grotesque back on to Baker: "Afraid in some way of evoking undiluted sexual excitement, she thwarts the deeply provocative contact of eye with eye not just by averting her own eyes but by jamming them grotesquely up against one another."[28]

Interrogations of Baker's agency continually return to such moments of comic interruption, of unscripted improvisation, or of feminist camp over-determination to question whether they produce new meanings and disrupt old paradigms. For Rose, the production of the grotesque is a self-consciously desexualizing move and therefore resistant, but the language for describing that resistance seems itself trapped within the prison-house of primitivism. Contemporary critics and artists must grapple with all the ways in which Baker and her oeuvre seem hopelessly constrained by racist US vaudeville performance

traditions, haunted by histories of ethnographic spectacle such as Baartman's, and circumscribed by the particular obsessions of US and European modernist aesthetic primitivism.

Baker herself capitalized on performing the uncanny juxtaposition of primitive and civilized through her body. An integral part of her star persona was staging her "primitive" iconicity, with its jungle-themed stage costumes, alongside her "cosmopolitan" diva iconicity, which dominated her offstage public appearances in haute couture eveningwear. Numerous publicity stills feature Baker in elegant silk dresses accompanied by a large wild cat. The uncanny and the ironic worked together to produce Baker's "unknowingness" (being childlike, playful, innocent, vulnerable) and her "knowingness" (having control, direction). On the one hand, the juxtaposition of primitive and civilized worked to further naturalize Baker's primitive status, making the jungle an apparently irrepressible element of her subjectivity—as when, playing Alwina, she cannot resist the call of the drums onstage in *Princess Tam Tam* and leaps from her black-tie dinner table onto the dance floor, throwing off her formal dress shoes to dance with barefoot abandon. On the other hand, the juxtaposition is revealed as available to be deliberately deployed by Baker, capitalized on to market herself as a global diva, something she could calculatingly domesticate—like the jungle animals she made her pets. As a politics of style, the juxtaposition tended to assert her mastery.

DOMESTICATING BAKER

The *House for Josephine Baker* that becomes the central image in Darell Wayne Fields's parodic piece *It's Time* was designed in 1928 by the Viennese architect Adolf Loos. A modern house designed to captivate Baker but never built as a home for her, it was imagined as a marble, zebra-print affair of black and white horizontal stripes. The striped surface, in conjunction with a structure made of simple geometric squares and rectangles, is intended as a meditation in modern form and reductionism. From an architectural point of view, it is a study in Loos's antiornamental modernist geometric abstraction, built on his idea of *Raumplan*, or planes of volume. From a critical perspective, it is a conceptual reduction of the idea of La Baker to race, and the reduction of race to a prison-house of competing visual grounds of black and white.

In the catalog commentary accompanying *It's Time*, Darell Wayne Fields asks rhetorically, " 'If architecture were black, how would it look, how would we recognize it anyway?" He continues, "The absence implied by the question assumes blackness and architecture exist solely on a visual plane of reference. . . . One might think of it as yet another *Negro problem*."[29] Fields is drawing attention to the problem of the supposed invisibility of "black architecture," by critiquing

the misrepresentation of blackness that is generated within an architectural context that presumes a neutral surface, which is in fact highly racialized. In order to challenge the presumption of an absence of blackness that informs (architectural) aesthetic regimes, he exposes their theoretical predicament: This lack is premised on an apparent invisibility that can only be rectified through a visual semiotics that correlates architecture directly to phenotypic conceptions of blackness as purely visual and specifically surface difference. By framing them in this way, Fields shows that (architectural) aesthetic regimes produce a dilemma that necessarily evacuates "blackness" of any content beyond a surface treatment of the visible/visual.

Loos, a white European architect apparently intending to render a "black building" for Baker, or at least one that reflects Baker's blackness, reproduces this *Negro problem* in his failure to incorporate the idea of race into space other than through a surface treatment of color. Ironically, this return to surface undermines Loos's own conception of antiornamentalism in modernism. The controlling metaphor in Loos's most famous essay, "Ornament and Crime," is the example of the tattoo.[30] For Loos, the tattoo stands in as the degenerative sign of primitivism, linking the desire for decoration to the primitive. He arrives in this essay, via the example of the tattoo, at his architectural axiom: "*The evolution of culture is synonymous with the removal of ornament from objects of daily use.*"[31] Strikingly, in the black and white stripes of his design, the forbidden tattoo reasserts itself.[32] In *House for Josephine Baker*, Loos commits a crime against his own prison-house rules of modern architecture.

The failure of the design either to create a home for Baker—in that the house was literally never built—or to represent Baker's "blackness" in architectural form is apparent in the result, a building that is inescapably a metaphorical prison in which the primitive subject Baker, who captivated the high-modernist practitioner Loos, can herself be captured. The house, that is, is captivating. The guise of serious architecture and the use of abstraction do not prevent Loos from insistently reproducing the controlling images of blackness that undergird modernist experiment.

Baker—who by running away as a child escaped the work most available to African American women, domestic labor—is conceptually resituated here within the sphere of domesticity, in an eviction of sorts from the public sphere. Fields's parody series exposes Loos's use of "an internalized ornamental strategy to shrink and domesticate Baker's public persona."[33] The design of the house is driven by a central pool—which Loos called a "bath," marking it as both a private space and a communal one, as in a "Turkish bath"—that was to be lit naturally from above by a skylight and surrounded by voyeuristic walkways with windows. Kurt Ungers, his collaborator, described the pool as serving as an "underwater revue" for Baker.[34] The feminist architectural critic Beatriz Colomina further

translations of items in the international press. They also include repor
anonymous informants and materials from Baker's public quarrel with th
dicated columnist and radio personality Walter Winchell.[42] In a famous incic
in 1951, Baker went into the popular Stork Club in New York and was seat
but her requests for service and food were refused and ignored until she place
two calls: to the police and a lawyer. She publicly condemned the club for its
treatment of her and called on Walter Winchell, who was there at the time of
the incident, to speak out about its practices of discrimination. He agreed to, in
exchange for a letter from Walter White of the NAACP exonerating him. But
when he went on the air it was with a weak statement of dismay, and he refused
to criticize the owners, instead chastising Baker for drawing him into the debate.
Walter White responded by organizing a picket of the Stork Club, after which
Winchell escalated his conflict with Baker. Winchell began compiling informa-
tion he perceived as potentially damaging to her reputation and forwarding it
to J. Edgar Hoover. Many of the documents held by the FBI are letters sent to
Winchell from listeners denouncing Baker, and one, for instance, by a person
who even claimed to have seen her in Leningrad as a guest of the Soviet Union
in 1936. Winchell forwarded these to the FBI with a note to J. Edgar Hoover:
"Hoover, can we check this please?"[43]

The clippings that comprise Baker's files are aimed at compiling an arsenal of
information that would implicate Baker on the wrong side of the Cold War.[44] As
a modernist archive made up of a pastiche of information intended to condemn
Baker as a communist and as anti-American by linking her to Paul Robeson and
other outspoken critics of American foreign policy, the FBI files are more suc-
cessful at exposing the Bureau's methods of producing subjects of suspicion
than they are at producing evidence of Baker's un-Americanness. The multi-
pronged attack on Baker by the FBI and State Department deployed strategies
that included condemning the sexual morality of her performances, establish-
ing guilt by association with suspected communists, and pandering to suspicions
that she was not loyal to the black community because of her interracial mar-
riages. The State Department disseminated information on Baker strategically to
foreign embassies and the US press, successfully interfering with her ability to
travel and speak out about racial discrimination in the United States, in a direct
attempt to contain her mobility and her message.

It seems that, like Loos, the government was engaged in the creation of a sys-
tematic architecture—in this case, a national security architecture—that would
entrap and domesticate Baker. The competing grounds of black and white that
dominate Loos's design of a house for Baker and turn it into a prison-house,
while also criminalizing blackness (as ornament), make a dramatic symbolic
reappearance in Baker's FBI files (see figure 24). Despite being available through
the Freedom of Information Act, Baker's files are, like most other FBI files,

connects the design of the pool to Christian Metz's description of the voyeur-
ism of the cinema screen as a window into "a kind of aquarium."[35] So, while the
house does not specifically relegate Baker to domestic labor, or to the sphere of
domestic chores, or to family life, it still domesticates her by privatizing her per-
formances, taking them offstage and shrinking them for private viewing. And it
takes the private act of bathing and makes it spectacle. The house collapses pub-
lic into private and private into public in a way that imagines Baker off the global
public stage while keeping her always onstage at home, in effect allowing her no
private space, and imagining the most private spaces—the home, the bath—as
spaces for public viewing and consumption. The *House for Josephine Baker* thus
represents a multifaceted, three-dimensional, interactive fantasy of the stage
actress as household curio on display for select visitors.

Another piece in Fields's series "House for Josephine Baker," *Black DNA*
(2003), is a semiotic diagram that deconstructs modernist white intellectual
and artistic appropriations of Baker and blackness. It makes visible the con-
ceptual frameworks, the DNA, upon which a project like Loos's *House for Jose-
phine Baker* builds and exposes the armature of signification that undergirds
Loos's attempt to collapse Baker and architecture into one mythic signifier.[36]
Fields pokes fun at Loos and exposes the savagery haunting Loos's own sur-
face project by parodying the clean logic of the imprisoning horizontal stripes
of his design. If we connect the dots along with Fields, we see how Loos par-
ticipates in a discourse of scientific racism in which the terms *Josephine* and
house are reduced to each other through lines of signification that link Baker
to woman to lady to gynecology to research to habitat to house. The chart
resembles a web trapping Baker in its tangle of meaning. Baker, it shows, can-
not be untangled from the signifiers attached to "Josephine," who is quickly
departicularized as "savage," "negress," "woman." It is these insistent categoriz-
ing impulses inherited from nineteenth-century epistemologies, identified by
Jordanova as impulses to "organic depth," that return here, relentlessly mark-
ing the surface of modernism. The modern imagined as neutral or abstract
surface is a sheen built on primitive depths and misrepresentations of black-
ness. The "meanings" attached to Baker through these chains of association
are the makeup of modernist fantasies of primitivism. Connecting the dots,
Black DNA finally resembles an African mask in its oval angularity, albeit one
stripped of color and form, a deracination that again suggests an eviction and
again, through its reduction to black-and-white geometry, parodies the crisp
logic of Loos's imprisoning horizontal stripes. Fields's piece implicates high
modernism in a web of significations that attempts to capture and domesticate
Baker—to fix her in the genealogies of scientific racism and narratives of the
Hottentot Venus, in an apparatus built on masked African genealogies.

As mentioned earlier, *It's Time* captions the Loos design with the words "Notes on the Eviction of Josephine Baker." Eviction, the act of taking possession of property *and* the act of dispossessing a person of property (or in older uses, the act of conquering), as Fields allows us to see, marks the status of blackness in modernism. Blackness inhabits modernism, serving as the ground of its imaginary, and blackness must also always stand evicted. Blackness, modernism's other, is excess, a refusal to incorporate; it is mobile, unfixed, persistent failure. Blackness stands as modernism's eviction, or in Saidiya Hartman's terms as "fungibility": "The figurative capacities of blackness enable white flights of fancy while increasing the likelihood of the captive's disappearance."[37]

Baker can be viewed as experiencing numerous evictions. First, we might see her as evicted from the United States, driven out by her experience of racism and the violent East St. Louis race riots that haunted memories of her childhood.[38] As Fields describes it, Baker is then evicted from the aesthetic and cultural legacy of Harlem: "The difference between Loos's house and Harlem is not one based on the obvious distinction between house and city. The difference lies in how the two deal with blackness. Harlem has, aesthetically speaking, moved on. It continues to manufacture and export blackness on an unprecedented scale and does so without Josephine's assistance. To put it another way, Harlem evicted Josephine long ago, while architecture continues to seek her audience."[39] And while Harlem may have evicted Baker, relegating her to a kind of shameful past of primitive spectacle, the fact that Baker herself participated in the staging of these evictions as well as in their archiving (as when she repeated the oral history of the St. Louis race riots) expands what we can examine as her repertoire of staged performances. Her final eviction takes place at her intentional community in Les Milandes. In this instance, moving beyond a simple notion of publicity stunt, Baker might also be seen as complicating her own iconicity.

In a photograph that received international circulation, we see Baker, at age sixty-two, sitting on the back steps of her Les Milandes château in the rain, surrounded by bottles of Perrier, wearing only her housecoat and cap, her feet bare and a blanket across her lap. Her home had been put up for auction; knowing that the new owner planned to forcibly remove her, she contacted the press, and the cameras rolled. But, unlike Norma Desmond (Gloria Swanson), the declining diva of *Sunset Boulevard* (dir. Billy Wilder, US, 1950), whose morbid exit from Hollywood is staged as a deluded grand entrance, Baker performs resistance to her eviction from the scene; she goes kicking and scratching. The year was 1969, and the image of Baker's eviction demands to be viewed in the context of the civil rights movement in the United States. Baker—whose political response to US racism had been a self-imposed exile that provoked criticism for her absence from US civil rights movements—stages a particular image of her forced eviction. While Harlem may have let go of Baker, here

Baker's staging of the eviction is designed to bring her closer to the quotidian experiences of Harlem.

What happened in the forty years between the 1929 design of a house for Baker and the 1969 eviction of Baker from her home? Like the growing lucrative real estate market in Harlem, and the growing lucrative nostalgia for Harlem, which is contested in the *Harlemworld* exhibition, investments in Baker multiplied over those years. Everyone, it seems, had an investment in La Baker.

CAPTIVATING BAKER

As a vocal critic of racial discrimination, Baker spoke out internationally about the lives of African Americans and other people of color in the United States. A former member of France's Foreign Service and a spy for the French Resistance against the Nazis, Baker deployed her diva status as a political weapon; it enabled her to have both a cover and the privilege of mobility. Later, in public speeches, she drew explicit connections for her international audiences between fascism, apartheid, and racism in different national contexts. She spoke passionately about the history of race riots in the United States and wrote a column for a French paper about her experiences of discrimination while traveling anonymously in the US South. Using the moral authority of a global perspective and the publicity machine of a star, Baker was able to shame America for its racism. The FBI and US State Department perceived any discourse other than one of "progress" on race relations as a threat to national security and a tool of anti-American propaganda. As Baker became more outspoken, the State Department became increasingly invested in domesticating her, in the sense of making her a good subject and holding her accountable to a citizenship that she had already rejected. But because they could not restrict her movements simply by revoking her passport—she held a French passport—they had to engage in more subtle campaigns to discredit her at home and abroad.

Baker's FBI files, along with those of other celebrated cultural producers of modernism such as Langston Hughes, James Baldwin, Claude McKay, Paul Robeson, and Richard Wright, are now available through the Freedom of Information Act, and many are easily accessible through the FBI's website.[40] These importantly, they offer an alternative archive of modernism understood through the state-sponsored gaze.[41] Their availability offers up a different space for the application of reception theory—creating a window into the world of government surveillance and the role of paid and unpaid informants as audience.

The US government did not simply engage in a passive spectatorship or one of "collecting" data; instead, its surveillance was aimed at *crafting* the identities of those it watched. As an archive, the 359 pages of FBI files on Baker draw heavily from clippings of the communist *Daily Worker* and the black press, as well

FIGURE 24. Federal Bureau of Investigation, Freedom of Information Act Files, "Josephine Baker."

redacted, or "blacked out." A modernist visual aesthetic is produced by these official gestures of censorship—neat black lines minimize the space of "freedom" of information while creating a montage of (mis)information fragments. The FBI files resonate with modern aesthetic forms, from minimalism and montage to stream of consciousness, all produced by the ephemera of surveillance. Their uncanny aesthetic resemblance to Loos's design similarly produces a sense of the powerful forces working to lock down Baker, to produce her containment and domestication and reduce race to a visual mark of suspicion—and, by extension, map whiteness as the abstract space of freedom and neutrality.

Ultimately, however, the FBI files on Baker serve as an ironic archive. Despite obviously attempting to create a portrait of extremism, what they achieve instead is a portrait of a moderate, thoughtful, and politically engaged Baker who, as an expatriate, claimed license to critique US race relations through a transnational lens. Exercising moral authority on the global stage, Baker, as a transnational subject, was distinctively able to "sunshine" American racism, to expose it to the light of day. Furthermore, they reveal the extent to which the Bureau's surveillance architecture itself contained Baker despite the lack of real evidence it produced. Baker, that is, was the captive of a surveillance architecture that attempted to defuse her political critique by framing her as an un-American provocateur and propagandist. In that capacity, she was scrutinized by everyone from other cultural icons to anonymous citizens to paid informants. After her speeches in Argentina on US racism were widely quoted in the international and US press, her tours to Lima, Peru, and Bogotá, Colombia, in the early 1950s were canceled; and in 1953, she was taken into custody in Havana, Cuba, by military police as a suspected communist.

But the files simultaneously document all the ways that she effectively escaped the bounds of US government cultural and political control. Through these files, we can construct another set of performances that Baker enacted and for which she is less often remembered, as a social justice activist. In addition, the FBI files on Baker serve for contemporary critics as an important corrective to assessments of the Harlem Renaissance and of Baker's performances as apolitical. In the end, the FBI could not erase her mobility or her critique of US racism on the international stage. In fact, the FBI archives contribute to the preservation of this other set of performances.

Tellingly, until 2004 the subtitle given to Baker's files on the FBI website read: "The famous nightclub entertainer was thought to be involved in communist activities, however, no evidence was ever found that proved otherwise." The doublespeak of that sentence, "no evidence was ever found that proved otherwise," reveals the FBI's ongoing defensive posture toward its initial suspicions, as well as its continued attempt to script Baker as ceaselessly under suspicion. By 2006, the FBI records preamble had been edited to say that "this

famous African-American nightclub entertainer was accused of communistic affiliations," and as of late 2014 it was further amended to call Baker simply a "singer, dancer, actress, and civil rights advocate," with the caveat explaining, "This release contains FBI documents from 1951 to 1966, largely concerning immigration and security issues related to Baker's association with communist proponents and related groups."[45]

Despite the fact that the FBI files actually provided more evidence that she was anticommunist than that she was a communist sympathizer, the Bureau's subtitles continue to actively seek to discredit her and have remained at best ambivalent over the years about the subject of the investigation, even while a certain defensiveness has crept into the public description of the agency's own activities. The McCarran Committee explicitly requested "a summary of any derogatory information in the Bureau's files on Josephine Baker, the Colored chanteuse, who it will be recalled recently was involved in an incident at the Stork Club in New York City in which she alleged that she had been discriminated against." The director of the FBI responded "that there was no derogatory information identifiable with the subject of their inquiry."[46] Nevertheless, the State Department successfully curtailed her movements and blocked her reentry into the United States. I would argue, as Mary Dudziak has, that these restrictions harmed her career, "den[ying] her the role she sought for herself as a personal ambassador for equality,"[47] and that under such circumstances, Baker turned to the family as an avenue for expressing her politics. Indeed, in Baker's self-conscious creation of the "Rainbow Tribe," the personal has never been more political.

In 1954, Baker and her husband, Jo Bouillon, began consciously conducting a pseudoscientific social experiment in multicultural harmony by adopting twelve children of different races and religions. Through the serial adoption of children of different races, Baker invented what she conceived as an antiracist vision of the multiethnic family, calling her adopted children the Rainbow Tribe. Their very existence as a family on the global stage, she imagined, would level racial differences, rendering such hierarchies meaningless. Baker and Bouillon wanted to demonstrate that their Rainbow Tribe could grow and thrive together and become a family, a collective retort to white supremacy. Baker's rainbow vision of domesticity stands in marked contrast to the domesticating marble house designed for her by Loos. Together Baker, Bouillon, and their twelve children inhabited an experimental community at Les Milandes, where Baker made her private life open to the public through official tours and visiting hours. It was also home to Jorama, a wax museum featuring tableaux of Baker's life.

Not only did family, as multiracial spectacle, become a way of producing politics through the public performance of domesticity; it also functioned as a new frame for La Baker, the diva. Family, romantic coupling, and the domestic

represent exactly those ends persistently thwarted in the narrative trajectory of Baker's films, in which she costarred with white male leads: she may have been the first globally successful black film star, but she was also the leading lady that never got her man. These celluloid limits, remarkably similar to the theatrical ones decried by Aida Overton Walker decades earlier, reflect the persistence of cultural fears of miscegenation as well as cultural anxieties around the expression of black female sexuality. These compounded projections around race and sexuality created a confined narrative and representational repertoire for Baker as a leading lady who represented both the New Woman and the New Negro— and they were exactly those racist cultural anxieties that Baker defied all her life offstage and negotiated constantly onstage. When these limits were further cemented by the curtailing of her public speech by the state, the (re)production of family by the diva became essential to reinvigorating Baker's star status and to providing a platform for public political speech. As it turns out, the family also became indispensable to the production and endurance of her legacy. She immortalized their story through her multiple autobiographies, the touristic site of Les Milandes, with its wax museum, and other self-archiving practices.[48] Her child Jean-Claude Baker took up active guardianship of this legacy (buoyed by his own performance as male diva) through his own biography of Baker, his restaurant Chez Josephine, and his foundation.[49]

This kind of public dissemination of the staged "private" self emerges as an obligatory and defining element of twentieth-century female stardom. And particularly, transnational adoption as the public performance of motherhood-as-philanthropy has evolved into a recurring contemporary motif of female stardom. Notable examples include Mia Farrow, who in 1973 began serially adopting children of different racial, ethnic, and national origins (and with a variety of difficult health needs), and Angelina Jolie, who, shortly after joining the UN High Commission for Refugees, adopted a son from Cambodia, then went on to adopt two more children, from Ethiopia and Vietnam (and give birth to three), and who, echoing Baker, famously shared her vision of adopting multiple children from different cultures. By invoking these actresses, I do not intend to conflate their intentions, desires, or politics as celebrity adoptive parents. I do want, however, to point to an area that remains to be fully explored by feminist criticism, that is, the public production of idealized nonnormative families and the figure of the celebrity mother engaged in cross-cultural and international adoptions. Celebrity performances of this version of queered motherhood, of which Baker was an innovator, could be productively read in complex terms through feminist critiques about the global north/south traffic in children and the commodification of "disposable" bodies in transnational economies. Tied to twentieth-century conceptions of who "inhabits the modern" and read in concert with the production of excess capital in the twenty-first century, these

exchanges have generated the emergence of strange markets, in which, I would argue, the diva plays a significant role. Such flows tend to reflect "established routes of capital from south to north, from poorer to more affluent bodies, from black and brown bodies to white ones, and from females to males."[50]

Baker, unlike the diva-mothers whose transnational adoptions are now the "afterlife" of her Rainbow Tribe, reversed this flow in several respects. She was well aware that her public performances of altruistic motherhood also inverted several important racialized tropes: that of the black woman as a bad mother, made axiomatic by the 1965 publication of the Moynihan Report; that of the white woman as morally superior and "naturally" fit to adopt; and, finally, that of the black child as universally needy or neglected. Baker as a black mother, and a wealthy one, to poor white children, as well as to children of other nationalities and races, produced an important rescripting of public discourses on race and motherhood. Ironically, as a political critique of racial prejudice, the Rainbow Tribe reasserts a problematic racial essentialism: Baker expressed stereotypical ideas about the "predispositions" of her children toward certain skills and talents associated with their respective racial and ethnic heritage or national origin. Nevertheless, Baker performed motherhood through disidentification, understood as the incorporation of "a moment, object, or subject that is not culturally coded to 'connect' with the disidentifying subject."[51] Baker undermined categories into which her body was not seen to fit: female stardom, successful motherhood, and the nuclear unit seen as a preserve of the white family. In this respect, Baker's offstage or social performances as mother, wife, and activist are as integral to understanding her work as her performances on stage and screen are. Baker's staging of the Rainbow Tribe turns out to be one of her most significant performances, and a foundational element of that performance is the collapse of the public-private divide.

BAKER'S DISCIPLES

Despite the multiple ways in which Baker's politics were domesticated by others—symbolically in the form of modernist architecture, more literally by state-sponsored surveillance during the McCarthy era—her performances and her iconic diva status (whether on display in her stage shows, her films, or her role as the mother of the Rainbow Tribe) open up reception spaces with more progressive critical possibilities. I turn now to a queer appropriation of Baker's oeuvre as a method for retroactively comprehending the politics of her iconicity in her moment. Baker's late-stage career might easily be read as another tragic ending to the career of a sex symbol threatened by the decay of her beauty. Here it is important to note that the term *diva* is attached, often with negative connotations, to the body of older women, and especially to black female stars of any

age, in a way that relegates them to the past or codes them dismissively as "unrea-sonable, unpredictable, and likely unhinged. When a woman is called a diva or accused of exhibiting diva behavior, that woman is usually a woman of color."[52] In defiance of such negative raced and gendered scripts of denigrated or decaying female stardom, Baker continued to perform onstage until the week of her death, remaining primarily in the mode of high glamour, wearing costumes that evoked her most provocative and revealing early performances. Her costumes suggested nudity with the use of flesh-colored body stockings and form-fitting evening dresses that flattered her svelte body and enhanced her larger-than-life image, which was literally augmented by the use of huge cabaret-style feather head-dresses. Unabashedly exhibiting her prowess as a performer defiantly never past her prime, whose indomitable spirit refuses to conform to the limits of the body, time, or social strictures, Baker's performances neatly lent themselves to camp appreciations of the diva's audacity. In fact, for her 1973 return to Carnegie Hall in New York, she was marketed explicitly to an American gay audience.[53] A fore-mother of the "bioqueen" or "faux queen" Baker had a humorous appreciation for the femme technologies that made her stardom radiate, and she approached the construction of glamorous femme-ininity on the stage with the same disrup-tive humor that characterized her representation of raced and gendered primi-tivism in her early career.

But Baker's own queer appropriations of the constructedness of gender and race went beyond the production of a high-camp sensibility as "expressing what's basically serious to you in terms of fun and artifice and elegance," to cite Christopher Isherwood's 1954 definition.[54] It was Baker's ability to cannibalize oppressive forms that gave political salience to performances that otherwise might appear retrograde. Here I am borrowing Maryse Condé's formulation for the anticolonialist tactics of Caribbean authors: "'Cannibalism is what you do to what you love. You eat what you worship but also make fun of it.'"[55] While Baker unabashedly sought the fame and fortune of a diva, she simultaneously under-stood all the ways in which she was not, as a black woman, meant to inhabit the space of glamour, wealth, or high art. She recognized her own uncanny posi-tion and cannibalized the tropes of stardom and negrophobia: she incorporated them, digested them, and recycled them to her own ends. Hence Baker's own iconicity comes to lend itself to cannibalization, to a reworking of nostalgia for potentially liberatory redeployments. These redeployments are the afterlives of Baker's performances, but more than echoing or merely citing the past, they serve to retroactivate Baker, making visible her own complex engagements of diva iconicity.

Karim Aïnouz's *Madame Satã* is a film based on the memoirs of João Fran-cisco dos Santos (1900–1976), son of slaves, gay street fighter, criminal, and drag performer, who spent twenty-seven of his seventy-six years in prison, becoming

a legendary figure in the streets of Rio de Janeiro. The title of the film references dos Santos's real-life stage name, which he took from the 1930 Cecil B. DeMille film *Madam Satan*. The establishing shot of *Madame Satā* shows a badly beaten dos Santos (Lázaro Ramos) staring at the camera while a voice-over recounts his numerous social and criminal offenses, including (according to the subtitle translation) the charge that he is a "passive pederast, who shaves his eyebrows and imitates women, even changing his own voice." He is introduced to us in a long take that mimics a police mug shot or interrogation video. For dos Santos, who makes a living as a petty criminal and pimp, almost every space is impossible to inhabit—to which his bruised and bloody face testifies. Through the character of dos Santos, the film considers the legacy of slavery in the aftermath of abolition (1888) and explores Afro-Brazilian diasporic cultures of resistance and survival.

Even the alleys of prostitution and gambling in the Lapa district in 1930s Rio de Janeiro, portrayed as utopic netherworlds, erupt in a violence that threatens to bring dos Santos either death or imprisonment. His shared apartment in a decaying urban building is portrayed as an idyllic rooftop escape, the site of his own staging of an ideal queer family: he is protector and pimp for Laurita (Marcélia Cartaxo) and Tabu (Flávio Bauraqui); they work the streets to support dos Santos's household, and in return he cares for, organizes, and protects them. Laurita is lover, wife, and mother of a child for whom he also cares. The effeminate Tabu is working off a debt as his housekeeper and, as his buddy and partner, teams up with him to pull off petty criminal acts. Yet even this space of familial tenderness and safety is not sanctuary from police raids, domestic violence, and cruelty.

We see the film's first evocation of Baker as the camera pans across dos Santos's apartment and we glimpse newspaper clippings of Baker tacked to the wall by his vanity table. Asked by a stranger if he is a fan of Baker, he responds, "Of La Baker, I am a disciple." Dos Santos sees himself not as a fan but as an initiate and student of La Baker. For dos Santos, Baker has something divine to teach him. Through Baker he can gain a measure of freedom through manifesting her performance of glamour, celebrity, and female stardom. In short, he is given license to inhabit spaces that have excluded his body, spaces that would otherwise prove toxic for him. While he is punished for impersonating the white cabaret star he works for as a dresser, dos Santos can inhabit La Baker's esprit and vestments with impunity and free from the antiblackness of the workplace.

Early in the film, the cabaret where he works appears to offer some respite and opportunities for creative fantasy, as well as a paycheck within the formal economy. But this potential is shattered by the realization that his employers have no intention of paying him for his work, and that the performer he works for as a dresser is filled with hatred for black people. She is especially contemptuous of

his admiration of, and his aspirations to, her line of work. When she comes into her dressing room to find dos Santos wearing her costumes and queering the words to her performance, she is livid.[56] He apologizes and effusively praises her, trying to explain his admiration for her art by revealing that he has learned all the words to the number. She is disgusted and cruelly rejects his praise. He gives her his word that it will not happen again, and when in return she verbally abuses him and dishonors "his word," he refuses to be subjected to her abuse and, in an act of angry rebellion, rips her costume, begins to destroy her dressing room, and then attacks her.

The cabaret first appears in the second scene of the film, following the opening image of dos Santos's arrest. The initial shot is of a blue beaded curtain; we hear the soft and gravelly voice of a cabaret performer singing the story of "The 1001 Nights" as glasses clink in the background. At a musical cue from the piano, the curtain is pulled back to reveal a close-up of dos Santos's face emerging from the beads. Suddenly, the film cuts to two well-dressed men watching the act from a café table, then back to dos Santos lip-syncing, then to another man standing and watching, then back to dos Santos, creating circuits of visual exchange between men within a venue that is coded as male-only—until we see a shot of breasts clad in a glittering costume. The film cuts ambiguously between this female body and dos Santos, suturing their cabaret performances. When the camera finally pulls back to a space behind dos Santos, we can see that, in fact, he stands behind a beaded curtain at the back of the nightclub singing to himself and watching the woman, his employer, perform onstage (see figure 2). We realize that while the film's editing has momentarily allowed dos Santos to realize his dream of being center stage as diva and object of queer desire and adoration, he is not the one onstage singing and being watched by the male customers; a female performer is.[57] Later in the film, however, we discover that it is not the role of the white star dos Santos longingly wants to inhabit, but that of La Baker.

The second occasion on which the film explicitly evokes Josephine Baker is when we see dos Santos in a movie theater watching *Princess Tam Tam* (figure 25). What interests me most about *Madam Satã* is how it represents dos Santos's disidentification with the primitive Baker. Disidentification in this scene suggests identifications across gender and nation that are less about performing a new identity or inhabiting an old one than the possibility of performing against fixed identity altogether—performing conflicting identities in order to explode each, or performing a space of contradiction that enables space for new social formations. José Muñoz argues that rejections of toxic notions of the self by minoritarian subjects are not simply individual rebellions but part of the process of creating "counterpublics—communities and relational chains of resistance that contest the dominant public sphere."[58] And it is this potential dos Santos sees unfolding—and then enacts.

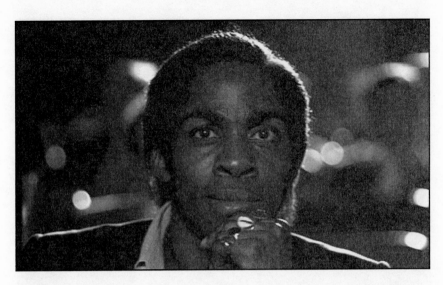

FIGURE 25. Lázaro Ramo as dos Santos in a movie theater watching Josephine Baker in *Princess Tam Tam* (dir. Karim Aïnouz, Brazil, 2002).

Through such practices of disidentification, Baker as colonial exotic in *Princess Tam Tam* can be reworked by dos Santos as a liberatory figure. Elizabeth Coffman has argued persuasively that "in *Princess Tam Tam*, the gaze or camera perspective is white, masculine, and . . . ambivalently 'colonial.'"[59] The narrative of *Princess Tam Tam* is driven by a familiar Pygmalion plot within which Baker plays a "universalized" colonial subject, Alwina (blackness in the film being represented through a conflation of nonwhite ethnicities, from African American to African to Arab). As an anachronistic primitive living in the modern moment, she is seen as in need of civilizing influences but also serves as a "muse" whose primitivism becomes a conduit for the white colonial subject, here a French author, to regain access to his creative unconscious. For the French author and his agent, Alwina is a theater of opportunity for conducting a social-uplift experiment while exercising their colonial fantasies of the "civilizing mission" on an intimate register. They school her in manners, and then Alwina is brought to Paris to test her skills at passing as "civilized." The scene we see dos Santos watch is the final dance number and the moment when Alwina fails this test. Interestingly, *Madam Satã* edits out a key narrative element in *Princess Tam Tam*—the fact that Alwina's failure is in part the result of a plot by the jealous wife of the writer, who hopes to undermine her husband's experiment by encouraging Alwina to drink too much. When her guard is down, the wife hopes her "civilized" appearance will be exposed as a façade that can be quickly undone by her irrepressible "nature." But in the moment the character Alwina fails the test, the film allows the diva La Baker to break through the character and appear

FIGURE 26. Josephine Baker in *Princess Tam Tam* (dir. Edmond T. Gréville, France, 1935) as the film is shown screened within Karim Aïnouz's *Madame Satã* (Brazil, 2002).

"as herself" in the film. Alwina, dressed in a satin gown, has been brought to an upscale Parisian nightclub to watch a Busby Berkeley–style dance number. In *Madam Satã*, we see dos Santos watching this scene intently, and as a flicker of a smile appears on his face, the camera cuts to Alwina at her table, furiously drinking champagne while she passionately watches the stage, barely resisting the urge to dance. As the sound of maracas and African drums grows more intense, an intoxicated Alwina takes to the stage, kicking off her shoes—one landing in an ice bucket and the other hitting an old man in the head at his dinner table. After a cut back to dos Santos, we (and he) watch the famous sequence in *Princess Tam Tam* that cuts rapidly between Alwina-as-La Baker—who has torn off her restrictive formal gown to gain the physical freedom to perform her own unique diasporic vernacular dance—and the image of an African male drummer who seems completely external to the black-tie dinner-club scene, perhaps because the footage appears to have been spliced in from an ethnographic film. The sound of the drumbeat soon overtakes the scene, signifying Alwina/La Baker's "return to Africa" and the failure of the protagonists' colonial *My Fair Lady* experiment.

In *Madam Satã* we, the audience, watch along with dos Santos as the editing, the camerawork, and Baker's dance in *Princess Tam Tam* become increasingly energetic. The film then cuts away from the movie screen to dos Santos in

the theater, as he sinks into his seat, displaying an expression of intense pleasure as though hatching a plan. His sinking gesture marks a moment of private communion between diva and devotee. The nightclub audience turns out to love the performance, and Alwina emerges as a star, triumphing in a variation on Baker's original *succès de scandale* at the Théâtre des Champs-Elysées (see figure 26). She succeeds in society, albeit as spectacle. But in *Madam Satā*, that shot of dos Santos tucked into his seat and smiling directly gives way to images of the Alwina/La Baker dance sequence. At the climax of this number, the film cuts directly to dos Santos, now standing before a mirror, fully made up, practicing his lines and getting into character, after which he triumphantly takes the stage of a Lapa neighborhood bar as the diva Jamacy.

Despite his initial expulsion from the cabaret, and later in the film from an upscale nightclub, it is at the moment of modeling himself after La Baker that dos Santos realizes his dream of becoming what he calls "an artiste," engaged in queer public performance before an audience of admirers. After his first drag performance, he confides to the owner of the bar, "When I was on stage, I was filled with ecstatic joy." Looking at the bar owner's pictures of himself as a young boxing champ, dos Santos tries to make the bar owner understand his own sense of triumph, implicitly juxtaposing the two realms of public performance of gender, boxing and drag. Previously, we have seen dos Santos perform only privately in his shared apartment in a decaying urban building that, nonetheless, is portrayed as an idyllic rooftop escape. The apartment, and later the Lapa bar, form the key sites for dos Santos's own staging of diva resistance to state, class, and social violence through the production of queer family and community, brought together by his own performances of agency. Taking center stage, so to speak, in the domestic sphere, even during long absences in prison, dos Santos acts as a parental figure. Within complexly gendered power dynamics of matriarchal and patriarchal domestic violence, butch/femme control, and queer affiliations, dos Santos cares for and protects the family, managing their survival in an underground economy.

When he finally talks the bar owner into allowing him further performances, he does so under the sign of heterosexual love: he will perform in celebration of Laurita's birthday. The performance he choreographs is also an act of mourning for the loss of his gay lover, Renatinho, who was killed in a hate crime. The realized performance, where dos Santos dramatically emerges onstage as the diva Jamacy, is not, I would argue, drag as female impersonation. Rather, it is a transnational drag performance of queer male cross-identification with black female stardom. I want to suggest that La Baker's mobile diasporic diva iconicity grounds this performance as an act of freedom. Invoking both La Baker of *Princess Tam Tam* and Josephine the matriarch of the Rainbow Tribe, Jamacy performs for a queer multiracial family of friends, lovers, and children, including

prostitutes and strangers who come together at the local bar in Lapa. Like Baker's, dos Santos's performance of the diva is framed by his own staging of family.

For both divas, "imagined family" offers an idyllic space in which the domestic functions as a political imaginary that exceeds the limitations of nation-state, especially as the nation-state is imagined through racial hierarchy, social violence, and class immobility. And it is realized by the complicated diasporic transnational circulations of culture that bring Josephine Baker, an American expatriate in a French film, to a Brazilian audience. Dos Santos's Baker-inspired diva performance becomes the centripetal force for the formation and survival of a queer counterpublic imagined as a space of radical freedom for new formations of family, class, sexuality, race, nationality, and gender. All this is a result of what Brett Farmer calls the "fabulous sublimity of diva worship," understood as "a practice of resistant queer utopianism" and "of queer authorization and becoming," with its "disorganizational impulses," that significantly move "toward both subjective fracture *and* subjective restoration."[60]

Paying attention to Baker at multiple sites of reception—like those evoked in *Les Triplettes de Belleville*, the Rainbow Tribe/Les Milandes eviction photo, and *Madam Satã*—allows room for Baker to break free from the captivity narratives of nostalgia, colonialism, and Black Venus spectacle that fix her in reductive and often reactionary frames. These sites of retroactivation reveal both Baker's ability to move through and cannibalize paradoxical class, race, national, and gender identities, and the ways that Baker's performances and diva iconicity have marked out potentially resistant and liberatory psychic and cultural spaces for many a twentieth- and twenty-first-century other.

Situated in the realm of transatlantic and transnational mobilities, the figures I examine in this book took to the global popular stage at a time when women and other minoritarian subjects were accessing publicity in new and unprecedented ways. These divas challenged the proper boundaries of gender, race, national, and sexual identity by seizing the chance offerings of mobility and publicity. The figures I look at might be considered exemplars of modern cosmopolitanism, situated as they are between iconic modern cities such as Paris, New York, Chicago, and London, but here, in this chapter as in the rest of this project, "mobility" evokes more than cosmopolitanism; it points to geographic mobility (escaping race riots, urbanization and migration, intercontinental travel, movement within cities and public spheres); the body in motion (dance, performance, moving pictures); social mobility (class, race, nation, and so on); discursive mobility (shifting significations and meanings, or how the subject is produced and redefined through discourse); and finally, importantly, temporal flows (how meanings shift across time and how performances are remembered and archived in dynamic

and retroactive ways). These queered temporal and spatial mobilities can be modes of survival, acts of necessity rather than the products of choice and privilege that a term such as "modern cosmopolitanism" sometimes associated with a figure like Baker or a place like Paris might signal. Baker's circulations, while they offer images of cosmopolitan worldliness, are equally circumscribed, as her movements onstage and offstage are curtailed by racist legacies and nationalist and colonialist discourses.

Josephine Baker and the other figures I examine are examples of modern subjects that produced self-authored spectacles, whose diva iconicity was an object of their own invention but also subject to the distortions of reception and the control of state and national projects. They negotiated queer and/or racialized identities through performance tactics that worked against cultural ideologies premised on fixed binaries, whether black and white, heterosexual and gay, or object and subject. I argue that these popular performers were also cultural critics who theorized race and sexuality through performances of mobility and publicity, and even when their critique was subsumed in glamour, trivialized, or lost to dominant narratives, their work persists in the ephemeral archive of the afterlives of diva iconicity. While Baker's performances do not strictly "succeed" in either creating what might be considered a "utopic" space outside binary logics or in heroically deconstructing dominant narratives, examining Baker's performances and the various citations and afterlives of her oeuvre together can succeed, I argue, in opening up new spaces of possibility for imagining the politics of the modern stage and its rich afterlives.

CONCLUSION
Diva Remains

The public does not appreciate our limitations, or, rather, the limitations
other persons have made for us.
> —Aida Overton Walker, "Color Line in Musical Comedy," 1906

When Aida Overton Walker died at age thirty-four in 1914, she was
hailed in the *Chicago Defender* as the "premier danseuse of the colored race."[1] But
as Dan Burley, the theatrical editor of the New York *Amsterdam News*, reflected
in a newspaper article almost thirty years later in 1940, analyzing the passing of a
rich era of black theatrical innovation and political development of which Over-
ton Walker was a part: "Stars are built from situations supplied them." In his anal-
ysis, "What's Wrong with Negro in Showlife? For First Time, Answer Is Given in
Searching Analysis of Its Ills," the answer to the waning of gains made by Over-
ton Walker's generation lay firmly situated in the racialized political economy of
the stage, a "fault that can accurately be placed at the door of the theatre opera-
tors and producers who fail to intelligently use the talents of these performers."[2]
With a somewhat different emphasis, I have argued that operators and produc-
ers, along with critics and audiences, failed to consider the intelligence of these
performers. They failed to recognize their intelligence as cultural producers,
but more particularly as cultural critics—a failure that Overton Walker herself
identified and addressed in the 1906 editorial from which the epigraph above is
taken. Taking up the pen as a public political commentator, she considered how
such limitations have been "made for us." As the previous chapters have dem-
onstrated, such miscalculations had their counterpart in the public and critical
misreceptions that met this generation of stage performers.

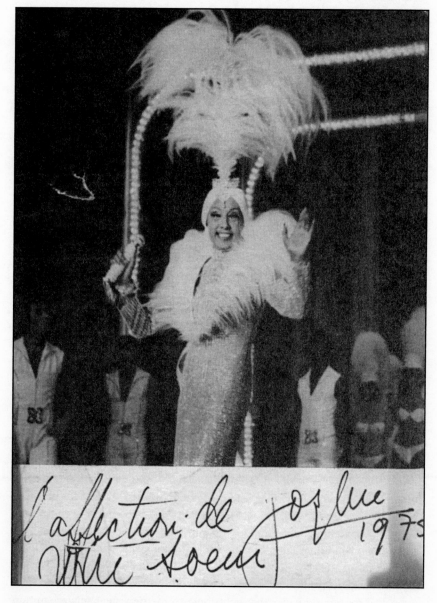

FIGURE 27. Josephine Baker postcard, autographed for the author's grandmother, 1975. Collection of the author.

The stages upon which Aida Overton Walker, Loïe Fuller, Libby Holman, and Josephine Baker performed were thus spaces of profound dissonance, in whose cacophonies we can also identify outcry and resistance. For instance, Aida Overton Walker's cultural critique is made legible in the archive most discernibly through these newspaper editorials. Reading her explicitly political commentaries as themselves public performances that are entwined with her overall artistic output, as I do in chapter 1, throws her participation in an orientalist cultural craze like Salomania into a different light, as much more than capitalizing on one dance's popularity. Similarly, locating these performances in a social and political context, I have extended the analysis of diva iconicity beyond the arena of representation to the performance politics of reception and recitation practices. And I have argued that it is necessary to consider both those audiences who were contemporary with their divas *and* those whose attention radiates across a temporal distance, to recognize that diva devotees perform cultural work themselves. Thus, I allow for the ways that affective investments can retroactivate the meaning of past performances. What emerges in looking at these very different figures together is an examination of the various political grammars at work in the production of this past-tense future of diva iconicity.

This temporally queered methodology makes visible the ways in which this early twentieth-century modern matrix deeply informs our present-day ways of seeing and desiring bodies, social identities, and histories. Haunted by the afterlives of empire, slavery, and minstrelsy, the modern stage was then, and continues to be now, a space constructed through reception practices whose genealogies are steeped in the pedagogies of racial spectacle that Saidiya Hartman's work in *Scenes of Subjection* cautioned against. Beware the attribution of agency at the site of performance, Hartman cautions, given "the thorny status of pleasure" that has been put to instrumental uses, where "pleasure is inseparable from subjection, will indistinguishable from submission, and bodily integrity bound to violence."[3] Mindful of this entanglement, the queered temporal reading, or retroactivation, stems from a different but related ethical imperative, one committed to resisting the powerful epistemological refusals to know in the presence of literal and manufactured absences. Working within the limiting constraints of the representational economies of primitivism, orientalism, and exoticism, these performers nonetheless contributed to the making of a raced and gendered modernity that overflowed those limits. To reiterate the point, audiences, then and now, received these performers and performances within learned and entrenched retrograde logics that contribute to the persistent misrecognition of their work. For some, that misrecognition (sometimes in combination with other factors) translated into loss, into absence in the archive of either the actual performances or their significance. These misrecognitions, which I've also discussed as processes of legibility and illegibility, in turn shape performance and

reception practices of the present day, as well as the meanings carried through those practices.

The reconfigurations of meaning produced by the movements of performances across geographic space and through time mean that diva iconicity is accompanied by shifting as well as sedimented racial logics. Recognizing the play between movement and the accretion of tropes that informs spectacle has shaped how this book understands the critical intellectual interrogations of race, class, gender, and nation that are produced through various popular performances and their afterlives. These "moving performances" are mobile signifiers as well as poignant and evocative markers whose political significance, I argue, can be retroactively accessed by attending to the diva's afterlives.

DIVA ARCHIVES

Libby Holman, torch-singer-become-philanthropist, whose career stretched across several decades and genres, exemplifies the diva concerned with scripting the legibility of her own racialized iconicity over time. She herself revisited and revised the shifting frameworks that structured the ways of seeing her performances, hoping to unmoor herself from the toxic past and attach herself to the forward-moving currents of social justice. Perhaps the most of all these figures, she gave attention to self-archiving practices, crafting the public memory of her legacy in the form of an official archive. As I show in chapter 3, she considered how her early torch songbook and oeuvre would be assessed retrospectively. And she was invested in how her later involvement in the civil rights movement would be remembered—or might be misrecognized or forgotten. Therefore, she even sought to transmute her own legacy by literally producing a named archive, contributing her recordings, papers, and memorabilia to the Libby Holman Collection of the Boston University archives. Through this collection, she hoped to foreground her own work as a civil rights benefactor and a friend of the King family, in part with the hope of deflecting the negative connotations that might adhere to her earlier career, from its tabloid sensationalism to participation in the appropriative and racist marketing of the torch song genre.

Yet, as the chapter on Holman explored, it is strikingly ironic that Libby Holman appears destined to repeatedly show up, despite all these efforts, in an entirely different location: as the alternately charming and moody queer camp femme fatale torch singer in contemporary repertory theater productions. In this sense, then, she became, as we saw in chapter 3, a primary example of the extent to which retroactivation remains outside the diva's control. In this case retroactivation can constitute another limiting factor or work against processes of sedimentation, allowing unlikely or disruptive citational practices, where the diva's iconicity haunts the present in ways that potentially illuminate the politics of the

past. It is imperative to resist cultural epistemologies that refuse to know raced and gendered histories in the presence of material and manufactured absences. One way of addressing this refusal, I have suggested, is to examine the political meaning and social effects of performances as *retroactivated*.

Josephine Baker, the subject of chapter 4, similarly sought to craft her own legacy as more than La Baker, the dazzling expatriate revue performer. In Baker's case, shaping a public persona as an outspoken critic of US race relations from abroad was an important component of how she hoped to be remembered and understood, despite being seen as perhaps absenting herself from civil rights struggles in the United States until her return to speak at the 1963 March on Washington. In the second half of her life, producing a vision of the Rainbow Tribe and amplifying the publicity surrounding her production of this multiracial family through Les Milandes, Baker, as Jules-Rosette Bennetta describes it, "molded herself into a folk icon, a virtual edifice, and a social movement."[4] Les Milandes, and the mythic narrative it molded into the form of a wax museum, formed a new, touristic archive of Baker. Yet Baker, despite these efforts at reframing her legacy, continues to emerge in the popular imagination as a cultural fetish, repeatedly attached to glamorous but primitivist renderings of her banana-skirted performances, whether as in the animated cartoon in *Les Triplettes of Belleville* or as in the staged reincarnation for Beyoncé's persona at the Fashion Rocks show. But other iterations of her afterlives, such as the nuanced invocation in the film *Madame Satã*, offer up a different kind of glimpse of the work that Baker's iconicity has afforded—and *can* afford—in this case, of black queer diasporic identifications with the diva.

Diva iconicity can be subjected to a narrow and repetitive frame, a GIF-like capture of one facet of the diva's performance repertoire on the modern stage played out in effect as a cultural meme. This state of repetitive capture reflects the constrained and persistent modes of reception that can narrowly circumscribe ways of celebrating and consuming the iconicity of the diva in her moment—and in future moments. Early twentieth-century audiences were schooled in colonial ways of seeing and consuming spectacular modes of raced and gendered performances in popular culture—and these modes endure today. This persistent set of negative aftereffects is symptomatic of how powerful the legacies of cultural pedagogy around consumption are. These diva aftereffects remain: they are ways of seeing made all the more apparent when contemporary audiences and cultural productions evoke, cite, and recycle past performers and performances through these familiar, narrow, retrograde frameworks. Despite the tenacity and ubiquity of this mode of repetition, there are moments in the archive of afterlives, such as the scenes from *Madame Satã*, where diva iconicity is retroactivated in such a way as to capture a different set of effects and connotations, ones that make legible, for example, the political work of Baker's original

negotiations with the power onstage. *Moving Performances* suggests that without a methodology that incorporates such retroactivating moves, there is danger of allowing sedimented ways of seeing to naturalize. It is an ethical imperative, therefore, especially in working on women of color cultural producers and/or sexual minority subjects, to produce a lens that can work on and against the forgeries of memory and political amnesias.

Understanding the full implications of the temporal effects of genealogies of performance and reception on present-day ways of consuming and looking gestures even beyond the scope of the current project and suggests the importance of this method for future applications. For example, the aftereffects of audience reception practices of early twentieth-century racial spectacle are powerfully reiterated in the current twenty-first-century "fan" cultures of neominstrelsy and orientalist-themed fashions and styles. They are seen, for example, in the persistent taste for racial masquerades like blackface Halloween costumes, "ghetto fabulous" parties, or the ritualistic antiblack performance practices of racist fraternity songs and other so-called traditions that persist on college campuses and social media as a theater of opportunity for nonblack sexual and gender expression through expression of white racial hostility and racial entrenchment. The aftereffects are also seen in orientalist Western popular cultural appropriations such as belly dancing crazes; or the consumer orientalist practices of yoga as a style craze; or the veil as ambivalent popular symbol of racialized sexualized subservience and/or as feminine agency and sexual expression, or as a threatening duplicity and sign of terror.

Repetitions of past performances are produced through reiterative representations (retrograde acts of masquerading the past), but more importantly are enacted through performative modes of consumption. The latter is of particular interest to me, as these consumption modes enact desires to inhabit imagined past pleasures of racist consumption; in other words, they are in part contiguous practices and in part fantasied projections. Each—representation and consumption and reception; continuation and projection—lends itself to reproducing anew the kinds of "limitations" that Overton Walker identifies in the epigraph, or the "situations supplied" that Burley identifies in the opening of this chapter. Such incarnations are the stuff of retrograde, rather than retroactivated, diva afterlives.

Significantly, foregrounding the contours of the persistence of such negative limits also invites a heightened critical recognition of the intelligence actually required of these performers in the past (as cultural producers and as critics) to navigate and produce spaces of survival and resistance within those limits placed upon them. Retroactivation as a method of interpretation, then, can offer a crucial window into the political labor required of performers to challenge and to negotiate (even while sometimes, or in some ways, remaining complicitous in)

racialized masquerades, toxic repertoires, and tired tropes. This book sees this labor as indispensable to thinking through diva iconicity and recognizes it as a labor that is often obscured or missing from the archive. This work remains invisible, especially, I suggest, in the absence of a methodology that insists on taking up the later uses to which such icons have been put as a window into the past. Further, the ability to recognize this past labor makes visible the larger consolidation of whiteness, which these performers confronted, a force that staked claims both on the making of the modern through the exclusion and incorporation of racial and sexual others and on the invention of an archive of the modern. The performers I examine faced the difficult and Sisyphean labor of unfixing society's ideological moorings to envision a different modern futurity, or at least to expose the reliance of such futurities on imagined pasts. What we do with those pasts now has something to teach us, retrospectively, about the diva's labor and its meaning, which otherwise might be lost in the ephemeral archives of performance.

AFTEREFFECTS: RETROGRADE PERSISTENCE

Within their lifetimes Overton Walker, Fuller, Holman, and Baker built repertoires out of necessity and contradiction. Aida Overton Walker, an internationally celebrated African American singer and dancer, was known as the "dancer that dignified the profession" even as she took up the Salomania dance, one of the most scandalous dances of the era. She is remembered as the "Queen of the Cakewalk" and the wife of George Walker, Bert Williams's comic partner. But, as we saw in chapter 1, her more significant contributions are generally effaced from mainstream histories of modernism, American dance, and theatrical social change. Loïe Fuller, a modern dance pioneer, left the United States when she was not able to protect her choreography as intellectual property and became the muse of art nouveau in Europe, an early innovator of stage technologies and electricity. Fuller produced modern visions of futurism through juxtaposition onstage with Japanese performers she framed implicitly as her orientalist, atavistic other. Libby Holman, an openly bisexual heiress-millionaire Jewish torch singer who was the frequent subject of tabloid scandal, relished rumors that she could pass as black and crafted two very different careers singing blues-based material. And finally, Josephine Baker, an African American US expatriate, became one of the first transnational stars of the twentieth century and at the same time, as an outspoken critic of US racism, was the subject of state surveillance.

Given the contradictions and ironies these performers inhabited in their lifetimes, it is perhaps not surprising that they are also unevenly archived and remembered after their passing, both in the popular imagination and in scholarly

literature. They have come to be iconic in disjointed ways within our contemporary popular landscape, and this refracted iconicity both bespeaks and belies the significance of these performers, their work, and its meaning. Beyoncé cites Baker's famous banana skirt when dancing at a Fashion Rocks performance, while Overton Walker is frozen in time as the embodiment of the history of the cakewalk, her Salome dance leaving no easily traceable mark on contemporary performances. Loïe Fuller, however, can be found in blockbuster museum exhibitions, as well as being recently reincarnated through the contemporary Time Lapse Dance Company founded by Jody Sperling, which aims to present "visually arresting kinetic theater fusing dance with mesmerizing fabric-and-light spectacles after the style of modern-dance pioneer Loïe Fuller,"[5] and is embodied in restaurant form at Loïe Fuller's in Providence, Rhode Island, a charming jewel-box invocation of Fuller's status as art-nouveau muse. Josephine Baker is a perennial subject of film and stage, with the most recent adaptation of her life forthcoming as a musical starring Deborah Cox, scheduled to premiere in April 2016. She is also the namesake for Chez Josephine in New York, a creative West Forty-second Street French bistro tribute founded by one of her children as a living legacy of the aura of the diva's iconicity as well as a repository for memorabilia. Libby Holman was the celebrated subject of an episode of the television show *Mysteries & Scandals* and of late appears to be inspiration for campy femme fatale characters in ensemble theater productions based on her scandalous personal life. Meanwhile, Holman has been largely overlooked in academic literature on the torch singer or on US folk and blues traditions. These celebrity-infused afterlives are one of the distorting lenses that obfuscate the past in the name of preserving it.

Retrograde tropes are another. Tropes powerfully, and perhaps ultimately, operate as technologies of strategic forgetting or fixing—political amnesias and forgeries of memory that distort the archive of the diva. When the divas I explore take to the stage, they perform within a repertoire of images, movements, and cultural scripts that precede their appearance. For instance, Baker plays a childlike primitive subject in movies with a *My Fair Lady* plot, cast for her box-office status as a diva, and while she is ever the leading lady, she never gets the (always white) man, because as a black film star she cannot achieve full status as subject. While Overton Walker and Fuller take up the apparently obligatory orientalist stylings of modern dance, it is to very different effects. And when Holman and Fuller each deploy technologies of racial masquerade, it is with greater and lesser self-consciousness about the politics of appropriation and imitation. I have referred to their repertoires as ones composed of preexisting tropes. Primitivism, orientalism, and exoticism are not new, nor merely products of the modern, but rather they both go into its making and remain as its powerful aftereffects. Diana Taylor calls such structures "scenarios," or "meaning-making paradigms

that structure social environments, behaviors, and potential outcomes."[6] When divas enter the stage, their personae exceed the immediate roles they are cast in, but they are just as often limited and framed by the tropes and scenarios that haunt the scene and within whose silhouettes they perform.

Thus this set of diva aftereffects reveals the connections between the material violence of past and present and the workings of genealogical processes of representation and performance on the bodies of performers and their audiences. Audiences are as likely to reproduce such effects as to become inured to them. Writing about the "afterlife of slavery," Saidiya Hartman identifies specific "scenes of subjection," and she enumerates how the repetition of images of brutality under slavery, images of torture and the tortured slave body, constitute a spectacle that works to obscure and to naturalize the material terror of slavery. Connecting the antiblackness of the present to the past, she writes, "Black lives are still imperiled and devalued by a racial calculus and a political arithmetic that were entrenched centuries ago. This is the afterlife of slavery." Thinking about the work of the slave narrative, she writes, "Rather than inciting indignation," she argues, "too often they immure us to pain by virtue of their familiarity . . . and especially because they reinforce the spectacular character of black suffering."[7] That neutralizing, hardening, and imprisoning effect is at the heart of the danger of the familiarity of tropes, as they emerge from the institutions such as slavery, with its manufacture of pleasure vis-à-vis black suffering. And, it could be argued, the effects are in fact heightened over time, as the alibi of naturalization gains force with repetition.

"The story of 'otherness,'" José Muñoz argues, is "one tainted by a mandate to perform for the amusement of a dominant power bloc."[8] This mandate "to perform" is a demand of power that he identifies as "the story of 'otherness.'" For Muñoz, disidentification, critical recycling, and the reappropriation of toxic forms for liberatory purposes are ways, foremost, to identify the mere possibility of survival for minoritarian subjects within this "story of 'otherness'" and its naturalized repertoires. This has made his work foundational as a departure point for queer of color studies, performance studies, and, initially, this project. This recognition of and investment in the survival of marginalized subjects is one ethical imperative underlying tactics related to "critical recycling." It is a pitch for performer and audience to keep breathing in the claustrophobic accumulation of social violence and the scenes, tropes, and mandates to perform of which such violence is comprised. Processes and practices such as critical recycling and disidentification offer the mere (not even necessarily hopeful) possibility of performing in and against existing structures of power. In the most quotidian sense, recycling means to take waste and convert it into the useful. It is a tool that sometimes produces the desired conversion, reclamation, or undoing.

Yet this must be a cautionary tale: if recycling means to reuse, it can mean to return to and to remain instrumental. Divas enter a stage filled with toxic tropes or scenarios ("meaning-making paradigms that structure social environments, behaviors, and potential outcomes"[9]), which are made up of particular roles, stock characters, and ways of moving and presenting bodies. They perform within and against these powerful forces of reiteration. They incorporate an eye roll like Josephine Baker; slip in a bit of serious choreography or write an editorial like Aida Overton Walker; perform across the color line; inhabit something considered impossible. However, any hoped-for conversion or resistance to the toxic requires adding the force of critique to performance, a recognition, as Overton Walker puts it in the epigraph, of the "limitations, or, rather, the limitations other persons have made for us."

There have been two main avenues of critiquing disidentification as a term of agency: that disidentification is a third term, but not one that finally undoes power or systemic oppression, and that disidentification is simply not de facto liberatory—that it can work in the interests of power. Cultural studies perennially returns to such questions: What do such entrenched tropes, rooted in long histories of perverse pleasures of consumption and mandates to perform, require acts of resistance to look like? For some audiences, critics, or pessimistic scholars, the absence of a total break is a sign of failure or even a willing concession to the totalizing operations of power. If these performances or divas are viewed therefore as failures, it is often because they are seen not only to exist within but to contribute to the sedimentation of retrograde repertoires. Within the new, within the force of innovation and resistance, there is, yet, a "remain." The question that haunts the diva archive is: What remains?

AFTERLIVES: RETROACTIVATING THE DIVA ARCHIVE

Moving Performances attends to the then and the now, or what can be understood as the heterogeneous temporalities, as well as geographies, of performance. Using affective connections with the past as a method for analysis, I draw, on the one hand, from material archives, a physical but ephemeral pastiche of past histories—playbills and newspaper clippings, postcards, found film footage, and photographs—and, on the other hand, from a kaleidoscope of later and contemporary citations and allusions. The persistent affective traces of the past—in filmic and popular citations, reiterative consumption patterns, and even archival absences—comprise the afterlives of these earlier performances. The method that emerges is one of *retroactivating*, where residual effects that persist into the present and become new iterations of the diva's iconicity are themselves an interpretive window that reveals some meaning about the original political effects of these performances, effects that otherwise tend to disappear and be effaced in

the ways the modern stage is remembered. Even as the impact and critique of these performers and performances have been obscured, distorted, effaced, or forgotten over time, examining their afterlives in contemporary citations and reuses, or becoming aware of their absence from the present moment, acknowledges the performative possibilities of doing something more with these performers and performances than consigning them to the status of retrograde reenactments—or forgetting them altogether.

These performers grappled with entanglements in modernism's tropes and repertoires, entanglements that created the conditions for the very forgeries of memory that obscured acts of resistance and subsumed such figures in a sea of complicity or triviality. *Moving Performances* engages the past and the political effects (efficacious or otherwise) that have been thus obscured by using the diva's afterlives as a retroactivating framework. These were aesthetic innovators profoundly interrupting the colonizing gazes of their audiences, producing what Daphne Brooks has called "bodies in dissent" that would "forge discursive as well as embodied insurgency."[10] Overton Walker and Baker specifically drew on a black diasporic consciousness in the theatrical and dance performances they wrote, produced, and performed. They also notably mounted resistance through outspoken political work that included organizing around labor conditions, writing newspaper editorials, and participating in racial uplift work and education for girls, or speaking out internationally against US racism. Given the constraints within which they worked, these artists continued to challenge the social violence of existing prescriptions, prevailing racial and gender tropes, and discourses of normalization through their dances, songs, and films, and as they staged their work and lives as modern divas. But this is not necessarily how they are remembered.

The individual innovators of the popular stage I have considered here—Aida Overton Walker, Loïe Fuller, Libby Holman, and Josephine Baker—were famous in their own moment and milieu; each was a star at a time when the figure of the "female star" was emerging as a global commodity on stage and screen, and each accrued in her own era the status of diva. Their performances, onstage and off, produced an iconicity that troubled easy categories and existing tropes, and exceeded the space and time of proper inhabitation. It is also apparent how elusive agency can be, and certainly how tenuous its legibility becomes in the ways the modern stage is remembered. Yet it is equally important to name and describe those limits placed upon those desired agencies. The performance and reception practices that circumscribed them in their moment continue to haunt the present. One way to recognize and remember the politics of diva iconicity, as well as its limits, is to widen the frame of the archive, not just by widening what counts as performance, beyond the stage to other modes of publicity and outspoken public discourses, but by looking at the ways in which a diva's iconicity

does or does not persist and how it is remembered and invoked in the ensuing decades. Examining the aftereffects of diva iconicity, I have argued, provides retrospective insight both into the politics of the labor they performed as cultural producers and critics in their moment and into the persistence of the limiting constraints they faced, and how those constraints continue to persist in present-day consumption practices.

The most iconic and frequently cited figure I examine is Josephine Baker, the subject of the final chapter. Her career as a dancer, singer, and performer remarkably spanned almost seven decades. As an expatriate who was an outspoken critic of racism and segregation in the United States, she found herself, like many other prominent African Americans at home and abroad, the subject of state surveillance. The state's production of a permanent and lasting condition of suspicion, produced, ironically, by an avowed lack of evidence, speaks to the conditions of the diva archive. Like the graphic redactions to the materials in the Baker FBI files discussed in the previous chapter, censorship creates competing grounds of positive and negative space against which the diva's iconicity retroactivates: a lack of evidence meets iconic presence, and ephemera mark the space of loss and mourning while iconicity ensures persistence. The diva's iconicity becomes the site of figure-ground struggle: a semiotic prison-house, each mode is a way of exercising power and resistance (see figure 2). Such dialectics and contradictions become the space in which the diva's iconicity is activated and diva afterlives take shape.

As the subjects of material feminist performance histories, these icons then become repositories that hold important implications for thinking about the present moment and the consumption of gendered and raced bodies in contemporary popular cultural practices: whether reiterated in new forms of tabloid sensationalism and the commodification of "diva" celebrities; whether echoed in social media technologies that make everyone a diva, or in the persistence of and capitalization on reception practices that desire to inhabit past practices, or retro-racisms. The proliferation of divas intensified by mass markets and the disposability of contemporary forms of female celebrity, as well as the replicability and scalability of social media technologies, all mark another kind of absence of the diva. For some, the subsuming of the diva in the politics of consumer mass markets may even suggest the death of the diva. Or has a shift occurred in the diva archive from locating the power of divas in their iconicity and the star's own aura to locating it in fandom, moving the locus of meaning from cultural production to cultural consumption and capital?

Looking to diva afterlives additionally illuminates how contemporary consumption practices and ways of seeing are chained to racial, gender, and sexual configurations of the past. Contemporary practices ranging from ballroom culture and drag competitions to mainstream commodified Halloween costumes

continue to seek out ways of reproducing spaces for the consumption of an imagined and romanticized past, whether these take the forms of the utopian radical queer sociality of the cabaret or of nostalgia for the vaudeville stage, including iterations of neoblackface racist performance practices. Extending my analysis of critical recycling to what I call the production of the nostalgic grotesque, I offer this term as a way of demarcating a whole spectrum of practices in the present that variously invoke and desire to reproduce racist, sexist, classist, and homophobic tropes of reception—and performance. This attention to the persistence and sedimentation of retrograde practices opens up and allows for an intersectional analysis that examines in more elucidating, critical, and historical ways the contemporary uses of cross-racial performance practices, which occur not only in mainstream spaces but also within queer and ostensibly feminist spaces.

We are nonetheless left with the diva remains, one of which is the love and devotion of divas past. An integral part of the manufacture of Josephine Baker's star persona was the staging of her "primitive" iconicity, with its themes of savagery and exoticism staged for the music hall and revue, against another Baker: a New Woman fashionista wearing Paul Poiret gowns who circulated as part of a cosmopolitan smart set. Baker's ironic deployments (such as traveling with her pet snake, Kiki, and her leopard, Chiquita) and wittily sarcastic domesticating gestures (at Les Milandes) were performed on and against the primitivist constraints within which audiences, artists, and managers located her. And it was surely this ability to perform through and against such limiting frameworks and retrograde tropes that produced the powerful affective afterlives of Baker's queer iconicity. That iconicity itself began as a "moving performance": a poignant stage presence and public persona. As Baker pushed beyond reproducing the constraints within which she was cast, her diva persona became a mobile, transportable (across space and time) iconicity, inspiring and generating afterlives that produced a space for thinking critically, along with Baker, about the limits and possibilities of her own legibility and legacy.

Baker's iconic longevity became another weapon to deploy, as the postcard that opens this chapter testifies, bearing the inscription: "L'affection de une soeur, Josephine" (see figure 27). As it happens, the postcard was autographed for my grandmother, who attended one of Baker's final appearances onstage in France, just a day before Baker died. The image on the card is atypical when compared to Baker's earlier repertoire of highly sexualized, partially clad Folies-Bergère images popularized by Paul Colin. In the photograph used for this postcard, Baker is sheathed in a white evening gown, effortlessly balancing the large feathered fountain-top of a chorus girl headdress. She appears as a dazzling stately column, poised in a timeless fashion—or a fashion that dares time—staking a claim on the pinnacle of success, a survivor: a true diva. She flashes a regal wave but a generous smile, mic poised at the ready.

The glimpse of three of her young male backup dancers in matching white outfits signals the staying power of her own virility and sexual appeal, as well as her gay iconicity. As it happens, the postcard, too, is a survivor, as testified by the smoke stains from a Thanksgiving Day fire in my grandmother's house. Out of the complete destruction of a household electrical fire, it is Baker's postcard that remains, becoming an unlikely gift across two generations. My grandmother was the eldest daughter of thirteen children in a poor Irish Catholic family, the mother of nine, a rather proper Chicago public school teacher, who happened to make her first trip abroad to Paris in a trip sponsored by a civic organization. It's utterly uncanny to imagine her attending a glamorous Baker performance in *la ville lumière*. Yet this ephemeral card seems like a clue from the touristic circulation of Baker's iconicity, about how moving performances function and survive in a complex, transnational, racially segregated, and queer world.[11]

Critical retroactivation best describes the work these performances can do. In addition to the diva's initial stage performance, there is a corresponding set of reception practices by which fans, artists, critics, and audiences reuse, reinterpret, and remember the work of these performers over time. This set of practices can offer a productive retroactivating lens, one that can potentially excavate and activate the meaning of the work performances do, making visible their political aftereffects, even as these meanings have been obfuscated as performances navigate the retrograde hauntings of racial tropes. This critical retroactivation is all the more urgent to explore because of the presence of another set of aftereffects, those that are lost and redacted, like Josephine Baker's FBI files referenced in chapter 4, the pages of which become a distorted archive of state-sponsored reception as erasure. This image, impenetrable black and white stripes that produce a stark study in modern aesthetics, is another kind of remain.

NOTES

INTRODUCTION

1 "Salome Dinner Dance," *New York Times*, August 23, 1908.

2 The *New York Times* provided the cure for the infectious Salomania in an article entitled "The Call of Salome: Rumors That Salomania Will Have a Free Hand This Season," August 16, 1908.

3 "Two Dusky Salomes," Chicago news clipping, January 1909, Locke Collection Envelope 2461, "Williams and Walker," Billy Rose Theatre Division, New York Public Library.

4 December 12, 1906, unidentified news clipping, Billy Rose Theatre Division, New York Public Library.

5 "The act that one does," Judith Butler argues, "the act that one performs, is, in a sense, an act that has been going on before one arrived on the scene." "Performative Acts and Gender Constitution: An Essay in Phenomenology and Feminist Theory," in *Performing Feminisms: Feminist Critical Theory and Theatre*, ed. Sue-Ellen Case (Baltimore: Johns Hopkins University Press, 1990), 272.

6 J. L. Austin, *How to Do Things with Words*, ed. J. O. Urmson and Marina Sbisà, 2nd ed. (Cambridge, MA: Harvard University Press, 1975).

7 According to the *Oxford English Dictionary*, *trope* refers to "the use of a word or phrase in a sense other than that which is proper to it" or a "particular manner or mode."

8 Diana Taylor, *The Archive and the Repertoire: Performing Cultural Memory in the Americas* (Durham, NC: Duke University Press, 2003).

9 Marcia B. Siegel, *At the Vanishing Point: A Critic Looks at Dance* (New York: Saturday Review Press, 1972), 1.

10 Peggy Phelan, "The Ontology of Performance," in *Unmarked: The Politics of Performance* (New York: Routledge, 1993), 146–166.

11 Cedric Robinson, *Forgeries of Memory and Meaning: Blacks and the Regimes of Race in American Theater and Film before World War II* (Chapel Hill: University of North Carolina Press, 2007), 150–151.

12 *E! Mysteries and Scandals*, season 3, episode 1, March 6, 2000.

13 Films based on this episode in Holman's life include *Sing, Sinner, Sing* (dir. Howard Christie, 1933); *Reckless* (dir. Victor Fleming, 1935), with Jean Harlow; and *Written on the Wind* (dir. Douglas Sirk, 1956), with Lauren Bacall and Rock Hudson.

14 José Muñoz, "Ephemera as Evidence: Introductory Notes to Queer Acts," *Women and Performance* 16 (1996): 6.

15 Philip Brian Harper, "The Evidence of Felt Intuition: Minority Experience, Everyday Life, and Critical Speculative Knowledge," in *Black Queer Studies: A Critical Anthology*, ed. E. Patrick Johnson and Mae G. Henderson (Durham, NC: Duke University Press, 2005), 115.

16 Muñoz, "Ephemera as Evidence," 10.

17 Ibid., 7; Harper, "The Evidence of Felt Intuition."

18 "Archive of feelings," Ann Cvetkovich, *An Archive of Feelings: Trauma, Sexuality and Lesbian Public Cultures* (Durham, NC: Duke University Press, 2003); "residues," Muñoz, "Ephemera as Evidence," 10.

19 See Phelan, "The Ontology of Performance." In an argument that resonates with Siegel, Phelan articulates her influential conception of the ontology of performance as a process of loss/disappearance and nonreproductivity.

20 Joseph Roach, *Cities of the Dead: Circum-Atlantic Performance* (New York: Columbia University Press, 1996), 45.

21 On forgeries of memory, see Robinson, *Forgeries of Memory and Meaning.*

22 Diana Taylor, *Disappearing Acts: Spectacles of Gender and Nationalism in Argentina's "Dirty War"* (Durham, NC: Duke University Press, 1997).

23 Roach writes, "To perform in this sense means to bring forth, to make manifest, and to transmit. To perform also means, though often more secretly, to reinvent." Roach, *Cities of the Dead*, xi.

24 Joseph Roach, "Deep Skin: Reconstructing Congo Square," in *African American Performance and Theater History: A Critical Reader*, ed. Harry J. Elam Jr. and David Krasner (New York: Oxford University Press, 2001), 102.

25 Robinson, *Forgeries of Memory and Meaning.*

26 Alexander Doty, "Introduction: There's Something about Mary," *Camera Obscura* 65 (2007): 2.

27 Mae G. Henderson, "About Face, or What Is This 'Back' in B(l)ack Popular Culture? From Venus Hottentot to Video Hottie," in *Understanding Blackness through Performance: Contemporary Arts and the Representation of Identity*, ed. Anne Crémieux, Xavier Lemoine, and Jean-Paul Rocchi (New York: Palgrave Macmillan, 2013), 174–175.

CHAPTER 1 THE COLOR LINE IS ALWAYS MOVING

1 James Weldon Johnson, *Black Manhattan* (1930; Boston: Da Capo Press, 1991), 93.

2 "Musical and Dramatic: Aida Overton Walker at the Pekin Theatre," *Chicago Defender*, November 1, 1913.

3 "Aida Overton-Walker Laid to Rest," *Chicago Defender*, October 24, 1914; N. H. Jefferson, "Aida Overton-Walker Is Dead," *Chicago Defender*, October 17, 1914.

4 Rebelling against the "spectacle" of ballet, Duncan and St. Denis developed new kinesthetic approaches by drawing inspiration from the imagined pasts of ancient Greece (Duncan) and a fusion of orientalisms (St. Denis).

5 Jo A. Tanner, *Dusky Maidens: The Odyssey of the Early Black Dramatic Actress* (Westport, CT: Greenwood Press, 1992), 40.

6 See David Krasner, "Black Salome: Exoticism, Dance, and Racial Myths," in *African American Performance and Theater History: A Critical Reader*, ed. Harry J. Elam Jr. and David Krasner (New York: Oxford University Press, 2001); David Krasner, *A Beautiful Pageant: African American Theatre, Drama, and Performance in the Harlem Renaissance, 1910–1927* (New York: Palgrave Macmillan, 2002); Susan Curtis, *The First Black Actors on the Great White Way* (Columbia: University of Missouri Press, 1998); Susan A. Glenn, *Female Spectacle: The Theatrical Roots of Modern Feminism* (Cambridge, MA: Harvard University Press, 2000); Cedric Robinson, *Forgeries of Memory and Meaning: Blacks and the Regimes of Race in American Theater and Film before World War II* (Chapel Hill: University of North Carolina Press, 2007); and Tanner, *Dusky Maidens.*

7 Daphne Brooks, *Bodies in Dissent: Spectacular Performances of Race and Freedom, 1850–1910* (Durham, NC: Duke University Press, 2006); Jayna Brown, *Babylon Girls: Black Women Performers and the Shaping of the Modern* (Durham, NC: Duke University Press, 2008).

8 See Kathy Peiss, *Cheap Amusements: Working Women and Leisure in Turn-of-the-Century New York* (Philadelphia: Temple University Press, 1986). Middle-class reformers felt that "cheap amusements threatened to inundate New York, appealing to the 'low' instincts of the masses, debasing womanly virtues, segregating youth from the family, and fostering a dangerously expressive culture" (163).

9 See David Krasner, "Rewriting the Body: Aida Overton Walker and the Social Formation of Cakewalking," *Theatre Survey* 37, no. 2 (November 1996): 67.

10 Carl Van Vechten, "Terpsichorean Souvenirs," *Dance Magazine* 31, no. 1 (1957): 16–18.

11 Hammerstein's Victoria press release as quoted in a newspaper review dated 8/5, year unknown, "The Dance of Salome," Locke Collection Envelope 2461, "Williams and Walker," Billy Rose Theatre Division, New York Public Library (hereafter abbreviated as Locke 2461).

12 W. E. B. Du Bois, *The Souls of Black Folk* (New York: Dover, 1994), 2, v.

13 Siobhan B. Somerville, *Queering the Color Line: Race and the Invention of Homosexuality in American Culture* (Durham, NC: Duke University Press, 2000), 11.

14 Harriet E. Coffin, "All Sorts and Kinds of Salomes," *Theatre Magazine*, April 1909, 130.

15 Gospel accounts in Matthew 14:1–12 and Mark 6:14–29 describe a feast honoring King Herod's birthday. A young princess dances before the king, and when he offers her anything she wants in return, up to half his kingdom, she demands the head of John the Baptist on a platter. John's public condemnation of the king's marriage to his brother's wife, Herodias, the young woman's mother, is the implied motive. The name Salome is recorded in Flavius Josephus's genealogical history *Jewish Antiquities*, volume 28, book 4; see www.gutenberg.org/files/2848/2848-h/2848-h.htm#link162HCH0001.

16 See Bram Dijkstra's *Idols of Perversity: Fantasies of Feminine Evil in Fin-de-siècle Culture* (New York: Oxford University Press, 1986).

17 *Salomé* was produced by Aurélien-François Lugné-Poë (who also played Herod) at the Théâtre de l'Oeuvre, Paris, February 11, 1896. Wilde would never see his play performed.

18 Strauss saw a private production of *Salomé* directed by Max Reinhardt in 1902 at the Kleines Theatre in Berlin and used a German translation by Hedwig Lachman as the basis for his opera.

19 Gaylyn Studlar, "'Out-Salomeing Salome': Dance, the New Woman, and Fan Orientalism," in *Visions of the East: Orientalism in Film*, ed. Matthew Bernstein and Gaylyn Studlar (New Brunswick, NJ: Rutgers University Press, 1997).

20 *Theatre Magazine*, January 1908. Page 29 featured a picture of "Mlle. Dazie as Salome in Follies of 1907."

21 Donna Carlton, *Looking for Little Egypt* (Bloomington, IN: IDD Books, 1994), xi.

22 On the World's Columbian Exhibition, or Chicago World's Fair, see "Revisiting the World's Fairs and International Expositions: A Selected Bibliography, 1992–2004," published online by the Smithsonian Institution Libraries, www.sil.si.edu/silpublications/Worlds-Fairs/introduction.htm. One thing the Chicago World's Fair did *not* feature was the contributions of African Americans. Ida B. Wells and Frederick Douglass protested this exclusion and circulated a pamphlet entitled *The Reason Why the Colored American Is Not in the World's Columbian Exposition* to publicize and educate a national and international audience about the atrocities of lynching and the convict lease system, urging the audience to "recogniz[e] that the spirit and purpose of the local management of the Exposition were inimical to the interests of the colored people." Black Americans were literally excluded from the

fair, with the eventual compromise being the creation of a "Negro Day." Otherwise, the Haiti pavilion became the de facto black pavilion and the space from which Wells and Douglass distributed their pamphlet. See Ida B. Wells, Frederick Douglass, Irvine Garland Penn, and Ferdinand L. Barnett, *The Reason Why the Colored American Is Not in the World's Columbian Exposition* [1893], ed. Robert W. Rydell (Urbana: University of Illinois Press, 1999).

23 The Salomania dance was influenced by African American and African diasporic forms, while African Americans were explicitly excluded from the planning of the fair. See Anna R. Paddon and Sally Turner, "African Americans and the World's Columbian Exposition," *Illinois Historical Journal* 88, no. 1 (1995): 19–36.

24 Donna Carlton provides this translation of the term: "Hoochy coochy is from the French compound *hochequeue* (*hocher* 'to shake' and *queue* 'tail'). A *hochequeue* is a wagtail, a type of bird that, while standing, continually flutters its tail feathers." Carlton, *Looking for Little Egypt*, 57.

25 Among those going by the name "Little Egypt" were Saida DeKreko, Catherine Devine, Fahreda Mahzar Spyropoulos, Gertrude Warnick, and Ashea Wabe. See Carlton, *Looking for Little Egypt*, 65; and Lucinda Jarrett, *Stripping in Time: A History of Erotic Dancing* (London: HarperCollins, 1997). On Fahreda Mahzar, see Shirley J. Burton, "Obscene, Lewd, and Lascivious: Ida Craddock and the Criminally Obscene Women of Chicago, 1873–1913," *Michigan Historical Review* 19, no. 1 (1993): 1–16.

26 See Susan Gubar, *Racechanges: White Skin, Black Face in American Culture* (New York: Oxford University Press, 2000); and Eric Lott, *Love and Theft: Blackface Minstrelsy and the American Working Class* (New York: Oxford University Press, 1995).

27 See also the museum exhibition catalog: William Rubin, ed., *"Primitivism" in 20th Century Art: Affinity of the Tribal and the Modern, in Two Volumes* (New York: Museum of Modern Art, 1984). On the ensuing controversy, see Thomas McEvilley, "Doctor Lawyer Indian Chief: 'Primitivism' in 20th Century Art at the Museum of Modern Art in 1984," *Artforum* 23 (November 1984): 54–61 and the curators' response.

28 Hazel V. Carby, "Policing the Black Woman's Body in an Urban Context," *Critical Inquiry* 18 (1992): 752.

29 Nadine George-Graves, *The Royalty of Negro Vaudeville: The Whitman Sisters and the Negotiation of Race, Gender, and Class in African American Theater, 1900–1940* (New York: St. Martin's Press, 2000), 104–105.

30 See Shane Vogel, *The Scene of Harlem Cabaret: Race, Sexuality, Performance* (Chicago: University of Chicago Press, 2009); and Ann Douglas, *Terrible Honesty: Mongrel Manhattan in the 1920s* (New York: Farrar, Straus & Giroux, 1995).

31 Johnson, *Black Manhattan*, 95, 97.

32 See George-Graves, *The Royalty of Negro Vaudeville*, on the Whitman Sisters.

33 Tanner, *Dusky Maidens*, 132.

34 As part of the professionalization of the African American theater and concerted efforts to create viable professional opportunities for black performers, a number of management circuits were created in this period. The most notable were S. H. Dudley's Theatrical Circuit, the Elite Amusement Corporation, and the Theater Owners Booking Association. See Curtis, *The First Black Actors*, 43–44.

35 On the use of *normal* and *queer* and other terms from the turn-of-the-century gay lexicon, as well as a history of "slumming" practices, especially straight attendance at gay events, including massive drag balls in the 1920s and 1930s, see George Chauncey, *Gay New York: Gender, Urban Culture, and the Making of the Gay Male World, 1890–1940* (New York: Basic Books, 1995).

36 Carby, "Policing the Black Woman's Body," 739, 750.

37 The exhibition *100 Years in Post-Production: Resurrecting a Lost Landmark of Black Film History*, held at New York's Museum of Modern Art in 2014–2015, featured recently discovered silent film footage, including footage of Bert Williams, and added significantly to our understanding of the technologies of performance used by African American performers constructing blackface performance.

38 See Gubar, *Racechanges*; Lott, *Love and Theft*; and Michael Rogin, *Blackface, White Noise: Jewish Immigrants in the Hollywood Melting Pot* (Berkeley: University of California Press, 1996).

39 Marlon Riggs's filmic archive of racist images in popular culture, *Ethnic Notions* (Berkeley: California Newsreel, 1987), includes a powerful attempt at critical re-citation as he evokes Bert Williams in blackface at the end of the film.

40 Linda Mizejewski, *Ziegfeld Girl: Image and Icon in Culture and Cinema* (Durham, NC: Duke University Press, 1999), 122.

41 *Lift Every Voice: 1900–1924*, dir. Sam Pollard (Alexandria, VA: PBS Video, 1999).

42 Tanner, *Dusky Maidens*, 85.

43 Sylvester Russell, "Williams and Walker's *In Dahomey* Company," *Indianapolis Freeman*, September 26, 1902, in *The Ghost Walks: A Chronological History of Blacks in Show Business, 1865–1910*, ed. Henry T. Sampson (Metuchen, NJ: Scarecrow Press, 1988), 268–269.

44 Other numbers include "My Little Zulu Babe." These materials require more extended analysis on the function of diasporic forms, desires, and fantasies in African American vaudeville productions, which is beyond the scope of this chapter.

45 Russell, "Williams and Walker's *In Dahomey* Company."

46 Undated review, Locke 2461.

47 Review quoting George Walker, "Colored Actor Tells Story of His Life from Kansas to Abyssinia," January 29, ca. 1906, Locke 2461.

48 *Bandanna Land*, music by Will Marion Cook and Bert Williams; book and lyrics by Jesse A. Shipp and Alex Rogers, who wrote a series of "African" musicals. Cook also wrote *In Darkeydom* (1914), creating lyrics from Paul Lawrence Dunbar's poetry.

49 *Bandanna Land* program, Schomburg Center for Research in Black Culture, New York Public Library. In other programs her character is listed as "Dinah Simmons."

50 Quoted in Tanner, *Dusky Maidens*, 46.

51 "Aida Overton Walker at Webers," *Chicago Defender*, March 4, 1911.

52 William Jelani Cobb, *The Devil and Dave Chappelle* (New York: Thunder's Mouth Press, 2007).

53 Lisa Guerrero and David J. Leonard, "Playing Dead: The Trayvoning Meme and the Mocking of Black Death," May 29, 2012, *NewBlackMan (in Exile)*, http://www .newblackmaninexile.net/2012/05/playing-dead-trayvoning-meme-mocking-of.html.

54 Cedric Robinson, *Forgeries of Memory and Meaning: Blacks and the Regimes of Race in American Theater and Film before World War II* (Chapel Hill: University of North Carolina Press, 2007); Michael Rogin, "'Make My Day!': Spectacle as Amnesia in Imperial Politics," *Representations* 29 (Winter 1990): 103.

55 Brooks, *Bodies in Dissent*. Brooks describes her use of the term "Afro-alienation" to refer to "a tactic that the marginalized seized on and reordered in the self-making process" (4).

56 Here I am borrowing Maryse Condé's formulation for the anticolonialist tactics of Caribbean authors, presented in her Literary Cannibalism seminar, School of Criticism and Theory, Cornell University, July 2004. See also Louise Yelin, who writes, "As Condé explains, drawing on Oswaldo de Andrade (1928), 'Cannibalism is what you do to what you love. You eat what

you worship but also make fun of it.'" Louise Yelin, "Globalizing Subjects," *Signs: Journal of Women in Culture and Society* 29, no. 2 (2003): 450–451.

57 See Kyla Wazana Tompkins, *Racial Indigestion: Eating Bodies in the 19th Century* (New York: New York University Press, 2012), 95.

58 Curtis, *The First Black Actors*, 28.

59 Annemarie Bean, "Black Minstrelsy and Double Inversion, circa 1890," in *African American Performance and Theater History: A Critical Reader*, ed. Harry J. Elam Jr. and David Krasner (New York: Oxford University Press, 2001), 176.

60 On the Frogs, see Curtis, *The First Black Actors*, 44–45.

61 *Theatre Magazine*, April 1908, 97.

62 Carl Van Vechten, "Negro Theater," in *In the Garret* (New York: Knopf, 1920), 313.

63 "Maud Allan's Barefoot Dancing Stirs London," *Theatre Magazine*, June 1908.

64 Van Vechten, "Terpsichorean Souvenirs," 18. This article is interesting, too, for drawing attention to the lack of a dance archive at the New York Public Library at the time that he was critic. The dance collection opened in 1930.

65 Johnson, *Black Manhattan*, 107, quoted in Tanner, *Dusky Maidens*, 41.

66 Photographer unknown, "Portrait of Aida Overton Walker," Beinecke Rare Book and Manuscript Library, Yale University; reproduced in the online exhibition *Black Acts*, http://blackacts.commons.yale.edu/.

67 Aida Walker Collection, Photograph and Prints Collection, Schomburg Center.

68 *Bandanna Land* (1908), Yorkville Theatre program, Schomburg Center.

69 "Two Dusky Salomes," Chicago news clipping, January 1909, Locke 2461. See also the personal scrapbooks kept by theatergoers of the period in the same collection, especially "Theatre Record and Scrapbook," inscribed "L. H. Mitchell, Bayside, NY," call no. MWEZ + nc 24, 277. This scrapbook almost exclusively records white productions and actors, but notably includes *Bandanna Land* in its inventory.

70 Undated news clipping ca. 1908, "Boston to Have Dance of Salome," Locke 2461.

71 Krasner, *A Beautiful Pageant*, 58.

72 See photographs from news clippings, Locke 2461.

73 Caption for an illustration of Walker, "Even Eighth Avenue Has Its Salome," *New York World*, August 30, 1908, Metropolitan Section, Locke 2461 (reproduced in Krasner, "Black Salome," 202).

74 "Boston to Have Dance of Salome."

75 *Brooklyn Eagle* clipping, Locke 2461.

76 News clipping, September 17, 1907, Locke 2461.

77 Ibid.

78 "Victoria's Show Pleases Crowds," *New Jersey Telegraph*, August 6, 1912, Locke 2461.

79 "Two Dusky Salomes."

80 Ibid.

81 Mizejewski, *Ziegfeld Girl*, 122.

82 "Musical and Dramatic."

83 Review of *Bandanna Land*, n.d., Locke 2461.

84 *Lovie Dear*, cover (New York: Roger Bros. Music Pub. Co., 1911), Schomburg Center.

85 Here Valerie Smith is describing the significance of Julie Dash's film *Illusions* in representing the way in which "the identity of the idealized white female subject relies upon rendering invisible her dependency upon the labor of black women." Valerie Smith, "Reading the Intersection of Race and Gender in Narratives of Passing," *Diacritics* 24, no. 2–3 (Summer–Fall 1994): 54.

86 Mizejewski, *Ziegfeld Girl*, 131.

87 Curtis, *The First Black Actors*, 50.

88 Columbus Bragg, Aida Overton Walker obituary, *Chicago Defender*, October 17, 1914.

89 "Salome Was a Dark Secret," undated news clipping, Locke 2461.

90 Hammerstein's Roof Garden press release quoted in a newspaper review dated 8/5, year unspecified, "The Dance of Salome," Locke 2461.

91 Diana Taylor, *The Archive and the Repertoire: Performing Cultural Memory in the Americas* (Durham, NC: Duke University Press, 2003), 19.

92 Locke 2461.

93 Krasner cites Aida Overton Walker, "Colored Men and Women on the American Stage," *Colored American Magazine* (October 1905): 571, 573, in *A Beautiful Pageant*, 64.

94 "Interlocking" is Barbara Smith's term. See "Toward a Black Feminist Criticism," *Conditions* 2, no. 1 (1977).

95 Bragg, Aida Overton Walker obituary; Jefferson, "Aida Overton Walker Is Dead."

96 See Angela Davis, *Blues Legacies and Black Feminism: Gertrude "Ma" Rainey, Bessie Smith, and Billie Holliday* (New York: Pantheon Books, 1998).

CHAPTER 2 TRANSNATIONAL TECHNOLOGIES OF ORIENTALISM

1 Malek Alloula, *The Colonial Harem*, trans. Myrna Godzich and Wlad Godzich, introduction by Barbara Harlow (Minneapolis: University of Minnesota Press, 1986), 4.

2 Gaylyn Studlar, "'Out-Salomeing Salome': Dance, the New Woman, and Fan Orientalism," in *Visions of the East: Orientalism in Film*, ed. Matthew Bernstein and Gaylyn Studlar (New Brunswick, NJ: Rutgers University Press 1997), 124.

3 Ruth St. Denis attributed her inspiration for orientalist dance forms to seeing a cigarette ad for Egyptian Deities in 1905. St. Denis, *Ruth St. Denis: An Unfinished Life* (1939; New York: Dance Horizons, 1969), 54.

4 Advertisement, *Theatre Magazine*, September 1908, xxi; and November 1908, xxi.

5 Elizabeth Kendall, *Where She Danced* (New York: Knopf, 1979), 78.

6 Ann McClintock, *Imperial Leather: Race, Gender, and Sexuality in the Colonial Conquest* (New York: Routledge, 1995), 33.

7 She was also known by several other names and spellings, including "Sada Yacco" and "Madame Sadayakko."

8 On the sound recordings made during their first tour, see J. Scott Miller, "Dispossessed Melodies: Recordings of the Kawakami Theater Troupe," *Monumenta Nipponica* 53, no. 2 (1998): 225–235.

9 On Fuller at the 1900 fair, see Sally Banes, *Dancing Women: Female Bodies on Stage* (New York: Routledge, 1998), especially chap. 3.

10 See Martin Battersby's introduction to *Loïe Fuller: Magician of Light* (Richmond, VA: Virginia Museum, 1979).

11 F. T. Marinetti, "Manifesto of the Futurist Dance," July 8, 1917, http://antipastimermaids.edublogs.org/2011/03/24/manifesto-of-the-futurist-dance-by-f-t-marinetti-july-8-1917/.

12 Rhonda Garelick, "Electric Salome: Loie Fuller at the Exposition Universelle of 1900," in *Imperialism and Theatre: Essays on World Theatre, Drama and Performance 1795–1995*, ed. J. Ellen Gainor (New York: Routledge, 1995), 85–103.

13 Ibid., 96, 95. She elaborates this argument in later work, for instance, arguing in *Electric Salome* that Fuller "constructs for her spectators a transgressive gaze, an intrusive window into

normally closed worlds" and that "this gaze partakes of the colonial gaze upon which so much imperialist propaganda was based." Garelick, *Electric Salome: Loie Fuller's Performance of Modernism* (Princeton, NJ: Princeton University Press, 2007), 102.

14 The 1629 ban on women acting was rescinded in 1891. Women continued to perform during this ban but were absent from the official stage.

15 "Shakespere on the Tokio Stage," *Minneapolis Journal*, October 8, 1903, *Chronicling America: Historic American Newspapers*, Library of Congress, http://chroniclingamerica.loc.gov/lccn/sn83045366/1903–10–08/ed-1/seq-17/.

16 On Kawakami Sadayakko, see Ayako Kano's *Acting like a Woman in Modern Japan: Theater, Gender, and Nationalism* (New York: Palgrave Macmillan, 2001). Kano does not discuss Sadayakko's relationship to Fuller, but I am indebted to her historical research on Sadayakko throughout this chapter. See also Yoko Chiba, "Sada Yacco and Kawakami: Performers of Japonisme," *Modern Drama* 35, no. 1 (1992): 35–52.

17 Kano, *Acting like a Woman*, 91.

18 Fuller introduced her famous Serpentine Dance on October 20, 1891, at the Columbia Theatre, New York.

19 See Teresa de Lauretis, "The Technology of Gender," in *Technologies of Gender: Essays on Theory, Film, and Fiction* (London: Macmillan, 1989), 1–30. See also Michel Foucault, *The History of Sexuality*, vol. 1, *An Introduction* (New York: Random House, 1980).

20 Donna Haraway, "A Cyborg Manifesto," in *Simians, Cyborgs, and Women* (New York: Routledge, 1991), 149.

21 Ibid., 175, describing the practice of "cyborg writing."

22 Margaret Hale Harris, ed., *Loïe Fuller: Magician of Light*, exhibition catalog (Richmond, VA: Virginia Museum, 1979), 15.

23 See Elizabeth Coffman, "Women in Motion: Loie Fuller and the 'Interpenetration' of Art and Science," *Camera Obscura* 49 (2002).

24 *Danse serpentine (II) (Serpentine Dance [II])*, film by Société Lumière, 1897–1899, cat. Lumière No. 765-I, http://www.moma.org/explore/multimedia/audios/244/2437.

25 Jayna Brown, *Babylon Girls: Black Women Performers and the Shaping of the Modern* (Durham, NC: Duke University Press, 2008), 154.

26 See the 16 mm print entitled *Three Curiosities*, at the Jerome Robbins Dance Division, New York Public Library, call no. MG2HB4–590, http://digitalcollections.nypl.org/items/bd378590-f875–0130–00c1–3c075448cc4b#6:08; and also similar footage on *Dance Program*, call no. MGZHB8–834.

27 Coffman discusses the Fuller film *Fire Dance* (1906) as "more akin to a Méliès magic show than to a physical culture act or vaudeville routine." Coffman, "Women in Motion," 91.

28 See Tom Gunning, "The Cinema of Attraction: Early Film, Its Spectator and the Avant-Garde," *Wide-Angle* 8, no. 3–4 (1986): 63–70.

29 Julio Arce and Yolanda Acker, "The Sound of Silent Film in Spain: Heterogeneity and homeopatía escénica," *Music, Sound, and the Moving Image* 4, no. 2 (Autumn 2010): 145–146.

30 *Post* review of the Serpentine Dance in New York, 1892, quoted in Richard Nelson Current and Margaret Ewing Current, *Loie Fuller: Goddess of Light* (Boston: Northeastern University Press, 1997), 35.

31 Loïe Fuller, *Fifteen Years of a Dancer's Life, with Some Account of Her Distinguished Friends* (Boston: Small, Maynard, 1913), 31.

32 "Reminiscent," quoted in Current and Current, *Loie Fuller*, 85; "spectacle," Hugh Morton, "Loie Fuller and Her Strange Art," *Metropolitan Magazine*, Fuller Clippings File, Jerome Robbins Dance Division, New York Public Library (hereafter cited as Fuller CF).

33 See R. Peter Mooz, foreword to Harris, *Loie Fuller: Magician of Light.*

34 See the exhibition catalogs for *Art Nouveau, 1890–1914*, ed. Paul Grenhaigh (London: Victoria and Albert Museum; Washington, DC: National Gallery of Art, 2000); and Jean Clair, Pierre Théberge, et al., *Lost Paradise: Symbolist Europe* (Montreal: Montreal Museum of Fine Arts, 1995), especially 215–216.

35 See catalogs for *Art Nouveau, 1890–1914* and *Lost Paradise*; Current and Current, *Loie Fuller*; and Fuller, *Fifteen Years.*

36 Marcia B. Siegel, *At the Vanishing Point: A Critic Looks at Dance* (New York: Saturday Review Press, 1972), 1.

37 On female imitators, see Susan Glenn, *Female Spectacle: The Theatrical Roots of Modern Feminism* (Cambridge, MA: Harvard University Press, 2000).

38 See also US Patent 518,347, April 17, 1894, which elaborated on previous patents from Great Britain and France, Fuller CF.

39 *Fuller v. Bemis*, US Circuit Court, Southern District of New York, June 18, 1892, 50 *Federal Reporter* 929, Fuller CF.

40 Caroline Joan S. Picart, *Critical Race Theory and Copyright in American Dance: Whiteness as Status Property* (New York: Palgrave Macmillan, 2013); Anthea Kraut, "White Womanhood, Property Rights, and the Campaign for Choreographic Copyright: Loïe Fuller's Serpentine Dance," *Dance Research Journal* 43, no. 1 (2011): 3–26.

41 Kraut, "White Womanhood," 15–16.

42 Quoted in Current and Current, *Loie Fuller*, 79.

43 See "How I Created the Serpentine Dance," in Fuller, *Fifteen Years.* See also Current and Current, *Loie Fuller*, for a review of these accounts offered by Fuller and recounted in newspapers: *Sketch* interview, quoted on 59; and *New York Herald* and *New York Spirit of the Times* interview, quoted on 60.

44 Quoted in Kano, *Acting like a Woman*, 85.

45 See Amy Sueyoshi, "Mindful Masquerades: Que(e)rying Japanese Immigrant Dress in Turn-of-the-Century San Francisco," *Frontiers: A Journal of Women Studies* 26, no. 3 (2005): 81.

46 See Tara Rodman, "A Modernist Audience: The Kawakami Troupe, Matsuki Bunkio, and Boston Japonisme," *Theater Journal* 65, no. 4 (2013): 490, 500.

47 Shelly Berg, "Sada Yacco in London and Paris: Le Reve Realise," *Dance Chronicle* 18, no. 3 (1995): 346; Rodman, "A Modernist Audience," 500–501.

48 See Miller, "Dispossessed Melodies."

49 Shelley Berg, "Sada Yacco: The American Tour, 1899–1900," *Dance Chronicle* 16, no. 2 (1993): 148.

50 Berg, "Sada Yacco in London and Paris," 359, 382, 348.

51 See Chiba, "Sada Yacco and Kawakami," 40–41.

52 See Kano, *Acting like a Woman*, and Chiba, "Sada Yacco and Kawakami."

53 Current and Current, *Loie Fuller*, 178.

54 Kano, *Acting like a Woman*, 219, 230.

55 Berg, "Sada Yacco: The American Tour," 152.

56 Rebecca Schneider, *The Explicit Body in Performance* (New York: Routledge, 1997), 3.

57 José Muñoz, *Disidentifications: Queers of Color and the Performance of Politics* (Minneapolis: University of Minnesota Press, 1999), 187.

CHAPTER 3 "VOICES WITHIN THE VOICE"

1 See Darby Perry, *Libby Holman: Body and Soul* (Boston: Little, Brown, 1983); Jon Brad-shaw, *Dreams That Money Can Buy: The Tragic Life of Libby Holman* (New York: William Mor-row, 1985); and Milt Machlin, *Libby* (New York: Dorchester Publishing, 1990), which was advertised as being about "the Murder Case That Shocked the Nation."

2 In a 1954 concert flyer, Claudia Cassidy described her voice as "husky, wavering, sudden deep velvet magic"; a *Newsweek* review, titled "Re-racinated," described her voice as a "mix-ture of sugar, graphite and raw whiskey" (September 14, 1964); and a *New York Times* review describes "the black-haired, well-rounded girl who growled out laments" ("Libby Holman Sings at UN Next Week," October 30, 1965), Box 15, Libby Holman Collection, Howard Gotlieb Archival Research Center, Boston University Special Collections (hereafter cited as LHC). The phrase "bottled blue smoke" is from "Libby Holman to Return to the Stage," *Chicago Defender*, August 1, 1964.

3 Roland Barthes, "The Grain of the Voice," in *Image, Music, Text*, ed. and trans. Stephen Heath (New York: Hill & Wang, 1977), 179–189.

4 "Libby Holman Returns to Stage to Aid Star," *Chicago Defender*, November 8, 1941.

5 Angela Davis, *Blues Legacies and Black Feminism: Gertrude "Ma" Rainey, Bessie Smith, and Billie Holliday* (New York: Pantheon Books, 1998), 88–89. On the torch song as "manufac-tured commodity" for "white, urban, literate, middle- and upper-class Americans," see also John Moore, "'The Hieroglyphics of Love': The Torch Singers and Interpretation," *Popular Music* 8, no. 1 (January 1989): 32, 41.

6 Davis, *Blues Legacies*, 88–89, 166, 165.

7 Moore, "The Hieroglyphics of Love," 39.

8 Here Valerie Smith is describing the significance of passing through Julie Dash's film *Illu-sions*. The film is significant for expanding the understanding of passing from a visual to an aural phenomenon as it describes the story of Mignon Dupree, a black Hollywood studio executive during World War II who passes at work and is able to negotiate work and better working conditions for a young black woman, Esther Jeeter, hired to do voice-overs for white stars. In Smith's words, *Illusions* represents the way in which "the identity of the idealized white female subject relies upon rendering invisible her dependency upon the labor of black women." Smith, "Reading the Intersection of Race and Gender in Narratives of Passing," *Dia-critics* 24, no. 2–3 (Summer–Fall 1994): 54.

9 Radio interview by Arlene Francis, WOR, New York, January 26, 1966, audiotape in LHC; hereafter "Francis interview."

10 Austin quoted in Andrew Parker and Eve Kosofsky Sedgwick, "Introduction to *Performa-tivity and Performance*," in *The Performance Studies Reader*, ed. Henry Bial (New York: Rout-ledge, 2004), 167; originally published as J. L. Austin, *How to Do Things with Words*, ed. J. O. Urmson and Marina Sbisà, 2nd ed. (Cambridge, MA: Harvard University Press, 1975). See also Jacques Derrida, "Signature Event Context," in *Margins of Philosophy*, trans. Alan Bass (Chicago: Chicago University Press, 1982), 307–330; Judith Butler, *Gender Trouble: Feminism and the Subversion of Identity* (New York: Routledge, 1990); and Judith Butler, *Bodies That Matter: On the Discursive Limits of "Sex"* (New York: Routledge, 1993).

11 This is suggested by incidents such as the spectacular 2015 case of Rachel Dolezal, the president of a local NAACP chapter who was exposed as white-passing-as-black. In addition to unpacking the stereotypical and harmful meanings that circulate in these supposedly por-table (aural and visual) representational grammars, there is an urgency to understanding their repetition and mere doggedness. And in the cases of Holman and Dolezal (although this may

be as far as the comparison should be taken), there is a shared appeal to an "ethical" performative, a becoming other/becoming black through performance in the service of civil rights.

12 Adrian Piper, "Passing for White, Passing for Black," in *Passing and the Fictions of Identity*, ed. Elaine Ginsberg (Durham, NC: Duke University Press, 1996), 253.

13 J. L. Austin, "How to Do Things with Words: Lecture II," in *The Performance Studies Reader*, ed. Henry Bial (New York: Routledge, 2004), 147–153.

14 "Re-racinated" is the title of a *Newsweek* review of an East Hampton show, September 14, 1964, Box 15, LHC.

15 Michael Rogin, "Blackface, White Noise: The Jewish Jazz Singer Finds His Voice," *Critical Inquiry* 18, no. 3 (Spring 1992): 434.

16 Diana Negra, *Off-White Hollywood: American Culture and Ethnic Female Stardom* (New York: Routledge, 2001).

17 See chapter 2, "An Erotics of Race," in Carla Kaplan, *Miss Anne in Harlem: The White Women of the Black Renaissance* (New York: HarperCollins, 2013); and John Szwed. *Billie Holiday: The Musician and the Myth* (New York: Viking Press, 2015).

18 Moore, "The Hieroglyphics of Love," 38.

19 "Whatever Became of . . . Libby Holman," interview by Richard Lamparski, WBAI Radio, January 31, 1966, audiotape in LHC; hereafter "Lamparski interview." This incident is also retold in Darby Perry's *Libby Holman*, 47.

20 *Rang Tang* (1927), Royale Theatre Playbill, Programs and Playbills, Schomburg Center for Research in Black Culture, New York Public Library. There is an undated review clipping that indicates the show was noteworthy as a black revue staged on white Broadway. See "Opened July 12, 1927, Royale Theatre, reviewed July 23, 1927," Locke Collection Envelope 2583, 1883–1919, Billy Rose Theatre Division, New York Public Library.

21 Lamparski interview.

22 Elaine Ginsberg, ed., *Passing and the Fictions of Identity* (Durham, NC: Duke University Press, 1996), 2; my italics.

23 Betty Boop was based on the white performer Helen Kane's appropriation of the African American performer Esther Jones's "Baby Esther" persona.

24 Lamparski interview.

25 In 1931, Ruth Millard attributed Holman's sound to a congenital difference: "A palate, an eighth of an inch askew, produced that strangely voluptuous, haunting voice that gave the town a new thrill." Holman concurred: "I call it my vomit." See "One Great Love, a Salon and a Smart Old Age," *New York Times*, January 4, 1931, Box 15, LHC.

26 Davis, *Blues Legacies*, 88–89.

27 Francis interview.

28 Ibid.

29 Lamparski interview.

30 Ira Jeffries, "My Mother's Daughter," in *The Persistent Desire: A Femme-Butch Reader*, ed. Joan Nestle (New York: Alyson Publications, 1992), 59, quoted in Patricia White, *Uninvited: Classical Hollywood Cinema and Lesbian Representability* (Bloomington: Indiana University Press, 1999), 159. See also Eric Garber, "A Spectacle in Color: The Lesbian and Gay Subculture of Jazz Age Harlem," in *Hidden From History: Reclaiming the Gay and Lesbian Past*, ed. Martin Duberman, Martha Vicnus, and George Chauncey (New York: Meridian, 1990); and James Wilson, *Bulldaggers, Pansies, and Chocolate Babies: Performance, Race, and Sexuality* (Ann Arbor: University of Michigan Press, 2010).

31 See Hazel V. Carby, "Policing the Black Woman's Body in an Urban Context," *Critical Inquiry* 18 (1992): 755.

32 Hazel V. Carby, *Cultures in Babylon: Black Britain and African America* (New York: Verso, 1999), 36.

33 James Baldwin, *The Devil Finds Work* (New York: Knopf, 2013), 105.

34 Ibid., 103–104.

35 White, *Uninvited*, 159.

36 Davis, *Blues Legacies*, 141–142.

37 Ann Douglas, *Terrible Honesty: Mongrel Manhattan in the 1920s* (New York: Farrar, Straus & Giroux, 1995), 336–338.

38 Carl Van Vechten, quoted in Davis, *Blues Legacies*, 153.

39 Davis, *Blues Legacies*, 153.

40 Douglas, *Terrible Honesty*, 76.

41 Andrew Ross, *No Respect: Intellectuals and Popular Culture* (New York: Routledge, 1989), 68.

42 Ethel Waters, *To Me It's Wonderful* (New York: Harper & Row, 1972), 11.

43 Deborah R. Vargas, *Dissonant Divas in Chicana Music: The Limits of La Onda* (Minneapolis: University of Minnesota Press, 2012), 1.

44 Barthes, "The Grain of the Voice," 181, 185, 188.

45 Phelan, "The Ontology of Performance," in *Unmarked: The Politics of Performance* (New York: Routledge, 1993).

46 Fred Moten, *In the Break: The Aesthetics of the Black Radical Tradition* (Minneapolis: University of Minnesota Press, 2003), 5.

47 Josephine Lee, "Bodies, Revolutions, and Magic: Cultural Nationalism and Racial Fetishism," *Modern Drama* 44, no. 1 (Spring 2001): 81.

48 See Mary W. Anderson, "Libby Holman: A Woman Who Made a Difference," *Negro History Bulletin* 48, no. 4 (1985): 62.

49 "New 'Blues' Team to Concertize," unidentified news clipping, Libby Holman Clippings File, Billy Rose Theatre Division, New York Public Library (hereafter cited as LHCF).

50 *New York Herald Tribune*, October 3, 1954, LHCF.

51 Elijah Wald, *Josh White: Free and Equal Blues Rare Performances*, Liner notes essay for Vestapol Release, 2001, 14–15.

52 Libby Holman, handwritten note on an envelope, LHC.

53 *Standard-Times* [New Bedford, MA], July 30, 1954, Box 15, LHC.

54 "Libby Holman Relights Her Torch," *New York Herald Tribune*, n.d., LHCF (my italics).

55 Langston Hughes, "Note on Commercial Theater," in *The Collected Poems of Langston Hughes*, ed. Arnold Rampersad (New York: Knopf, 1994), 215; first published in *Crisis*, March 1940.

56 Libby Holman, interview by Duncan McDonald, audiotape of radio interview broadcast on WQXR, November 10, 1965, LHC.

57 Francis interview.

58 Ibid.

59 Malcolm Johnson review, *New York Sun*, n.d., Box 15, LHC.

60 Russell MacLaughlin review, *Detroit News*, n.d., Box 15, LHC.

61 *Earth Songs* Playbill, Box 9, LHC.

62 "Libby Holman Relights Her Torch," *New York Herald Tribune* n.d., LHCF.

63 "Backfire," in the column titled "Adventures in Race Relations," *Chicago Defender*, July 5, 1947.

64 Sky Gilbert also directed a controversial staging of Oscar Wilde's *Salomé* in 1987 for the "Risks" series at the Court House Theatre in Canada; "postmodern sexual thriller" is from

Susan Walker, "A Walk on the Wild Side" (review of *Play Murder*), *Toronto Star*, September 25, 2003.

65 Eva-Marie Kröller, *The Cambridge Companion to Canadian Literature* (Cambridge: Cambridge University Press, 2004), 126.

66 Holman also appears as a character in recent contemporary theater productions, including *Swell Party* (premiered January 2013) and *The Only Light in Reno* (premiered January 2014), both written by Topher Payne and commissioned by Georgia Ensemble Theatre and Conservatory (Robert J. Farley, producing artistic director).

67 Trey Graham, "Women's Work," review of *In Good Company*, *Washington City Paper*, December 5, 1997, www.washingtoncitypaper.com/articles/14011/womens-work. *Scandal* fans will appreciate the positive review of Kerry Washington, then a college senior at George Washington University, playing Loraine Hansberry in this production.

68 Ibid.

69 Ibid.

70 Buddies in Bad Times Artistic Mission, http://buddiesinbadtimes.com/about/.

71 Sky Gilbert, *Ejaculations from the Charm Factory: A Memoir* (Toronto: ECW Press, 2000), 217.

72 Al-Solaylee, "Too Old for Camping," *Toronto Globe and Mail*, September 29, 2003, http://www.theglobeandmail.com/arts/too-old-for-camping/article772703/; Robert Ormsby, "Mainstream Murder," blog post, October 4, 2003, www.drama.ca/blog/?p=53.

73 Sky Gilbert, *Play Murder* (Winnipeg: Blizzard Publications, 1995), 17.

74 For "pointlessness," see Al-Solaylee, "Too Old for Camping"; Hans Kellner, review of *Play Murder*, *Philadelphia City Paper*, October 31–November 7, 1996.

75 Gilbert, *Ejaculations*, 74.

76 "Blues, Ballads, Sin-Songs," *New York Times* review, n.d., LHCF.

77 "Libby Holman Relights Her Torch," *New York Herald*, October 3, 1954, LHCF.

CHAPTER 4 MUCH TOO BUSY TO DIE"

1 My reading of *It's Time* was enriched, on this point and others, by e-mail communication with the artist, November 20, 2015.

2 Fields also uses the double entendre of "captivating" to describe Loos's design. Darell Wayne Fields, "House for Josephine Baker (Parody Series)," in *harlemworld: Metropolis as Metaphor*, comp. Thelma Golden (New York: Studio Museum in Harlem, 2003), 92.

3 Ollie Stewart, "'Too Busy to Die,' Jo Baker Tells AFRO," *Baltimore Afro-American*, January 23, 1943.

4 Patricia Hill Collins, *Black Sexual Politics: African Americans, Gender, and the New Racism* (New York: Routledge, 2005), 27–28.

5 Paul Colin, *Josephine Baker and La Revue Nègre: Paul Colin's Lithographs of "Le Tumulte Noir" in Paris, 1927* (New York: Harry N. Abrams, 1998), 5.

6 See Bennetta Jules-Rosette, *Josephine Baker in Art and Life: The Icon and the Image* (Urbana: University of Illinois Press, 2007).

7 Baker's performances survive in original archival footage made available by inclusion in commercial films, for example, in *Paris Was a Woman* (dir. Greta Schiller, 1996); *It's Black Entertainment* (dir. Stan Lathan, Showtime, 2001); *Intimate Portrait: Josephine Baker* (dir. Mark Israel, Lifetime, 1998); *The Secret Life of Sergei Eisenstein* (dir. Gian Carlo Bertelli, 1987);

Chasing a Rainbow: The Life of Josephine Baker (dir. Christopher Ralling and Mich Czasky, 1986); and *The Josephine Baker Story* (dir. Brian Gibson, HBO, 1991).

8 Patricia Hill Collins, *Black Feminist Thought: Knowledge, Consciousness, and the Politics of Empowerment* (New York: Routledge, 2000), 76–106.

9 See Mae G. Henderson, "Josephine Baker and La Revue Nègre: From Ethnography to Performance," *Text and Performance Quarterly* 23, no. 2 (2003): 108–133; Jayna Brown, *Babylon Girls: Black Women Performers and the Shaping of the Modern* (Durham, NC: Duke University Press, 2008); Jules-Rosette, *Josephine Baker in Art and Life*; and Daphne Brooks, *Bodies in Dissent: Spectacular Performances of Race and Freedom, 1950–1910* (Durham, NC: Duke University Press, 2006).

10 Henderson, "Josephine Baker and La Revue Nègre," 118.

11 Linda Hutcheon, "Irony, Nostalgia, and the Postmodern," University of Toronto English Library, 1998, www.library.utoronto.ca/utel/criticism/hutchinp.html.

12 "Ownership of the legacy," Lowery Stokes Sims, "Director's Foreword," in *harlemworld*, 7; Mabel O. Wilson, "Black in Harlem: Architects, Racism, and the City," in *harlemworld*, 37.

13 Thelma Golden, "of Harlem: an introduction," in *harlemworld*, 11.

14 Where Freud in 1926 used the metaphor of "the dark continent" in a way that conflated femininity, race, and place, stating that "the sexual life of adult women is a 'dark continent' for psychology," here that conflation is reversed such that colonialism figured as sexual lust is exposed as a desire for natural resources (it's the bananas, not the body, so to speak). Sigmund Freud, "The Question of Lay Analysis," in *The Standard Edition of the Complete Psychological Works*, vol. 20, trans. and ed. James Strachey and Anna Freud (London: Hogarth Press and the Institute of Psycho-Analysis, 1959), 212–213.

15 Henderson, "Josephine Baker and La Revue Nègre," 128.

16 Terri Francis, "Embodied Fictions, Melancholy Migrations: Josephine Baker's Cinematic Celebrity," *Modern Fiction Studies* 51, no. 4 (2005): 829.

17 Cedric J. Robinson, "The Inventions of the Negro," *Social Identities* 7, no. 3 (2001): 339.

18 Ludmilla Jordanova, *Sexual Visions: Images of Gender in Science and Medicine between the Eighteenth and Twentieth Centuries* (Madison: University of Wisconsin Press, 1989), 57–58.

19 José Muñoz uses the term "toxic," following Eve Kosofsky Sedgwick, to mean "retention of the shameful." Muñoz, *Disidentifications: Queers of Color and the Performance of Politics* (Minneapolis: University of Minnesota Press, 1999), 30.

20 See T. Denean Sharpley-Whiting, *Black Venus: Sexualized Savages, Primal Fears, and Primitive Narratives in French* (Durham, NC: Duke University Press, 1999); *The Life and Times of Sara Baartman: "The Hottentot Venus"* (dir. Zola Maseko, South Africa, 1998); and *The Return of Sara Baartman* (dir. Zola Maseko, South Africa, 2003).

21 Sharpley-Whiting, *Black Venus*, 33.

22 See Zine Magubane, "Which Bodies Matter? Feminism, Post-Structuralism, Race, and the Curious Theoretical Odyssey of the 'Hottentot Venus,'" in *Black Venus 2010: They Called Her "Hottentot,"* ed. Deborah Willis (Philadelphia: Temple University Press, 2010), 47–61.

23 See Willis, *Black Venus 2010*.

24 Sharpley-Whiting, *Black Venus*, 106.

25 Shane Vogel, *The Scene of Harlem Cabaret: Race, Sexuality, Performance* (Chicago: University of Chicago Press, 2009), 89.

26 Anne Anlin Cheng, "Ornamentalism, Aesthetic Being: Revolution at the Periphery," keynote lecture, Modernist Studies Association, Boston, November 19, 2015.

27 Phyllis Rose, *Jazz Cleopatra: Josephine Baker in Her Time* (New York: Doubleday, 1989), 109; Anthea Kraut, "Between Primitivism and Diaspora: The Dance Performances of

Josephine Baker, Zora Neale Hurston, and Katherine Dunham," *Theatre Journal* 55 (October 2003): 437; Wendy Martin, "'Remembering the Jungle': Josephine Baker and Modernist Parody," in *Prehistories of the Future: The Primitivist Project and the Culture of Modernism*, ed. Elazar Barkan and Ronald Bush (Stanford, CA: Stanford University Press, 1995), 313; Sharpley-Whiting, *Black Venus*.

28 Rose, *Jazz Cleopatra*, 109.

29 Fields, "House for Josephine Baker," 90.

30 Loos's "Ornament and Crime," first published in Germany in 1930, was written and delivered as a lecture in 1908. Adolf Loos, *Ornament and Crime and Other Essays*, trans. Michael Mitchell, introduction by Adolf Opel (Riverside, CA: Ariadne Press, 1998).

31 Ibid., 100; italics in the original.

32 Beatriz Colomina also draws attention to the fetishization and tattooed surface of the house, writing, "The exterior of this house cannot be read as a silent mask designed to conceal its interior; it is a tattooed surface which does not refer to the interior. . . . In the passages, the visitors consume Baker's body as a surface adhering to the windows." Colomina, "The Split Wall: Domestic Voyeurism," in *Sexuality and Space*, ed. Beatriz Colomina (Princeton, NJ: Princeton Architectural Press, 1992), 98.

33 Fields, "House for Josephine Baker," 92.

34 Letter from Kurt Ungers to Ludwig Münz, quoted in Ludwig Münz and Gustav Künstler, *Adolf Loos: Pioneer of Modern Architecture*, trans. Harold Meek (London: Thames & Hudson, 1966), 195.

35 Metz quoted in Colomina, "The Split Wall," 90.

36 Darell Wayne Fields, *Black DNA* (semiotic adaptation of the Totemic Operator by Claude Lévi-Strauss, ca. 1962), 2003. From "House for Josephine Baker," originally published in *harlemworld*.

37 Saidiya Hartman, *Scenes of Subjection: Terror, Slavery, and Self-Making in Nineteenth-Century America* (New York: Oxford University Press, 1997), 22.

38 Henry Louis Gates Jr., "An Interview with Josephine Baker and James Baldwin," *Southern Review* 21, no. 3 (1985): 597.

39 Fields, "House for Josephine Baker," 93.

40 Federal Bureau of Investigation, "Josephine Baker," *FBI Records: The Vault*, vault.fbi.gov/josephine-baker.

41 See William J. Maxwell, *F. B. Eyes: How J. Edgar Hoover's Ghostreaders Framed African American Literature* (Princeton, NJ: Princeton University Press, 2015).

42 See memo dated November 5, 1951, FBI, "Josephine Baker," BUFILE #62–95834, 6.

43 FBI, "Josephine Baker."

44 See Mary L. Dudziak, "Josephine Baker, Racial Protest, and the Cold War," *Journal of American History* 81, no. 2 (September 1994): 543–570.

45 Federal Bureau of Investigation, Freedom of Information Act Files, "Josephine Baker," accessed in August 2006 at http://foia.fbi.gov/foiaindex/jbaker.htm. The FOIA website has since been reorganized (as of this writing, Baker's files are at http://vault.fbi.gov/josephine-baker), and the preamble or abstract amended multiple times. In 2014 the published "Disclaimer," which is still used, stated: "Some of these records are no longer in the physical possession of the FBI, eliminating the FBI's capability to re-review and/or re-process this material. Please note, that the information found in these files may no longer reflect the current beliefs, positions, opinions, or policies currently held by the FBI." The 2015 abstract is an updated version that reads: "Freda Josephine McDonald (1906–1975), who went professionally by the name Josephine Baker, was a singer, dancer, actress, and civil rights advocate.

This release contains FBI documents from 1951 to 1966, largely concerning immigration and security issues related to Baker's association with communist proponents and related groups." http://vault.fbi.gov/josephine-baker.

46 FBI, "Josephine Baker," letter dated June 25, 1952, BUFILE #62–95834, 26; and letter dated July 31, 1952, BUFILE #62–95834, 37.

47 Dudziak, "Josephine Baker, Racial Protest, and the Cold War," 569.

48 Baker authored (and coauthored) a number of autobiographies, including Marcel Sauvage, *Les Mémoires de Joséphine Baker* (Paris: Èditions KRA, 1927); and Josephine Baker and Jo Bouillon, *Josephine*, trans. Mariana Fitzpatrick (New York: Harper & Row, 1977; 1st ed. published in France by Éditions Robert Laffont, 1976).

49 Jean-Claude Baker gives an unflattering composite sketch of Les Milandes as a poorly managed profit-making scheme in his cleverly titled chapter "Life Is a Cabaret at Les Milandes" in his celebrity biography of Baker, *Josephine: The Hungry Heart* (New York: Random House, 1993). Jean-Claude Baker managed the restaurant Chez Josephine in New York, opened in 1986, until his death in 2015. And although he declares in *The Hungry Heart*, "I've never even been her fan" (xvii), he remained devoted to the public preservation and promotion of her legacy throughout his life. See http://www.chezjosephine.com.

50 Nancy Scheper-Hughes, "Parts Unknown: Undercover Ethnography of the Organs-Trafficking Underworld," *Ethnography* 5, no. 1 (2004): 37.

51 Muñoz, *Disidentifications*, 12.

52 Kimberly Springer, "Divas, Evil Black Bitches, and Bitter Black Women: African American Women in Post–Civil Rights Popular Culture," in *Feminist Television Criticism: A Reader*, ed. Charlotte Brunsdon and Lynn Spigel, 2nd ed. (Maidenhead, Berkshire, England: Open University Press/McGraw-Hill, 2008), 78; Nicole R. Fleetwood, *On Racial Icons: Blackness and the Public Imagination* (New Brunswick, NJ: Rutgers University Press, 2015).

53 See Rose, *Jazz Cleopatra*, 250–253.

54 Christopher Isherwood, *The World in the Evening* (New York: Noonday Press, 1954), 110, quoted in Pamela Robertson, *Guilty Pleasures, Feminist Camp from Mae West to Madonna* (Durham, NC: Duke University Press, 1996), 1.

55 Maryse Condé's formulation as explicated in her Literary Cannibalism seminar, School of Criticism and Theory, Cornell University, July 2004. The concept is also cited in Louise Yelin, "Globalizing Subjects," *Signs: Journal of Women in Culture and Society* 29, no. 2 (2003): 450–451.

56 His small slips have words such as *sultry* becoming *salty*, and after the scene where he watches Baker perform in *Princess Tam Tam*, these changes become complete rewritings. Dos Santos creates his own pantheon of performance personae including Jamacy, the Queen of the Forest; the Shark; and the Wild Pussycat. In his elaborate mythology, he defines himself as "son of Iansã and Ogum" (West African Orisha worshipped by slaves).

57 Here the film reverses another trope, that of the black voice appropriated by the white singer, so powerfully evoked in Julie Dash's film *Illusions* (US, 1982), the story of a black woman hired to do voice-overs for white starlets in the 1940s. While Baker's body has been the site of much critical attention, her voice has not.

58 Muñoz, *Disidentifications*, 146. Rita Felski develops the idea of a "feminist counterpublic sphere" in "Politics, Aesthetics, and the Feminist Public Sphere," in *Beyond Feminist Aesthetics: Feminist Literature and Social Change* (Cambridge, MA: Harvard University Press, 1989), 155. Lauren Berlant discusses "the collapsing of the political and the personal into a world of public intimacy" (1) while also stating that "there is no public sphere in the contemporary United States." Berlant, *The Queen of America Goes to Washington City: Essays on Sex and*

Citizenship (Durham, NC: Duke University Press, 1997), 1, 3. See also Michael Warner, *Publics and Counterpublics* (New York: Zone Books, 2002); and the "Public Sentiments" special issue of *Scholar and Feminist Online* guest-edited by Ann Cvetkovich and Ann Pelligrini (2003), available at barnard.columbia.edu/ sfonline/ps/index.htm.

59 Elizabeth Coffman, "Uncanny Performances in Colonial Narratives: Josephine Baker in *Princess Tam Tam*," *Paradoxa* 3, no. 3–4 (1997): 381.

60 Brett Farmer, "The Fabulous Sublimity of Gay Diva Worship," *Camera Obscura* 59 (2005): 170, 173, 177, 183.

CONCLUSION

1 N. H. Jefferson, "Aida Overton Walker: Foremost Woman in Theatrical Life Dies," *Chicago Defender*, October 17, 1914.

2 Dan Burley, "What's Wrong with Negro in Showlife? For First Time, Answer Is Given in Searching Analysis of Its Ills," *Amsterdam News* (New York), October 26, 1940, 20.

3 Saidiya Hartman, *Scenes of Subjection: Terror, Slavery, and Self-Making in Nineteenth-Century America* (New York: Oxford University Press, 1997), 33.

4 Bennetta Jules-Rosette, Josephine Baker in Art and Life: The Icon and the Image (Urbana: University of Illinois Press, 2007), 42.

5 See the Time Lapse Dance Company website, http://timelapsedance.com/.

6 Diana Taylor, *The Archive and the Repertoire: Performing Cultural Memory in the Americas* (Durham, NC: Duke University Press, 2003), 28.

7 Hartman, *Scenes of Subjection*, 6, 15.

8 José Muñoz, *Disidentifications: Queers of Color and the Performance of Politics* (Minneapolis: University of Minnesota Press, 1999), 187.

9 See Taylor, *The Archive and the Repertoire.*

10 Daphne Brooks, *Bodies in Dissent: Spectacular Performances of Race and Freedom, 1850–1910* (Durham, NC: Duke University Press, 2006), 3.

11 See Bennetta Jules-Rosette on the ways Baker crafted herself as a "touristic landmark" and on the significance of a related postcard of Baker from 1970, popular, Jules-Rosette notes, with older women visiting Les Milandes. Jules-Rosette, *Josephine Baker in Art and Life,* 255, 27.

BIBLIOGRAPHY

BOOKS AND ARTICLES

"Aida Overton Walker at Webers." *Chicago Defender,* March 4, 1911.

"Aida Overton-Walker Laid to Rest." *Chicago Defender,* October 24, 1914.

Alloula, Malek. *The Colonial Harem.* Translated by Myrna Godzich and Wlad Godzich. Introduction by Barbara Harlow. Minneapolis: University of Minnesota Press, 1986.

Al-Solaylee, Kamal. "Too Old for Camping." *Toronto Globe and Mail,* September 29, 2003. http://www.theglobeandmail.com/arts/too-old-for-camping/article772703/.

Anderson, Mary W. "Libby Holman: A Woman Who Made a Difference." *Negro History Bulletin* 48, no. 4 (1985): 62.

Andy Warhol. Berlin: New National Gallery, 1969. Exhibition catalog.

Arce, Julio, and Yolanda Acker. "The Sound of Silent Film in Spain: Heterogeneity and homeopatía escénica." *Music, Sound, and the Moving Image* 4, no. 2 (Autumn 2010): 139–160.

Austin, J. L. *How to Do Things with Words.* Edited by J. O. Urmson and Marina Sbisà. 2nd ed. Cambridge, MA: Harvard University Press, 1975.

———. "How to Do Things with Words: Lecture II." In *The Performance Studies Reader,* edited by Henry Bial, 147–153. New York: Routledge, 2004.

"Backfire." *Chicago Defender,* July 5, 1947.

Baker, Jean-Claude, and Chris Chase. *Josephine: The Hungry Heart.* New York: Random House, 1993.

Baker, Josephine, and Jo Bouillon. *Josephine.* Translated by Mariana Fitzpatrick. New York: Harper & Row, 1977.

Baldwin, James. *The Devil Finds Work.* New York: Knopf, 2013.

Banes, Sally. *Dancing Women: Female Bodies on Stage.* New York: Routledge, 1998.

Barthes, Roland. "The Grain of the Voice." In *Image, Music, Text,* edited and translated by Stephen Heath, 179–189. New York: Hill & Wang, 1977.

Bean, Annemarie. "Black Minstrelsy and Double Inversion, circa 1890." In *African American Performance and Theater History: A Critical Reader,* edited by Harry J. Elam Jr. and David Krasner, 171–191. New York: Oxford University Press, 2001.

Berg, Shelley. "Sada Yacco in London and Paris: Le Reve Realise." *Dance Chronicle* 18, no. 3 (1995): 343–404.

———. "Sada Yacco: The American Tour, 1899–1900." *Dance Chronicle* 16, no. 2 (1993): 147–196.

Berlant, Lauren. *The Queen of America Goes to Washington City: Essays on Sex and Citizenship.* Durham, NC: Duke University Press, 1997.

Bernstein, Matthew, and Gaylyn Studlar, eds. *Visions of the East: Orientalism in Film.* New Brunswick, NJ: Rutgers University Press, 1997.

Bial, Henry, ed. *The Performance Studies Reader.* New York: Routledge, 2004.

Bradshaw, Jon. *Dreams That Money Can Buy: The Tragic Life of Libby Holman.* New York: William Morrow, 1985.

Bragg, Columbus. Aida Overton Walker obituary. *Chicago Defender,* October 17, 1914.

Brooks, Daphne. *Bodies in Dissent: Spectacular Performances of Race and Freedom, 1850–1910.* Durham, NC: Duke University Press, 2006.

Brown, Jayna. *Babylon Girls: Black Women Performers and the Shaping of the Modern.* Durham, NC: Duke University Press, 2008.

Burley, Dan. "What's Wrong with Negro in Showlife? For First Time, Answer Is Given in Searching Analysis of Its Ills." *Amsterdam News* (New York), October 26, 1940.

Burton, Shirley J. "Obscene, Lewd, and Lascivious: Ida Craddock and the Criminally Obscene Women of Chicago, 1873–1913." *Michigan Historical Review* 19, no. 1 (1993): 1–16.

Butler, Judith. *Bodies That Matter: On the Discursive Limits of "Sex."* New York: Routledge, 1993.

———. *Gender Trouble: Feminism and the Subversion of Identity.* New York: Routledge, 1990.

———. "Performative Acts and Gender Constitution: An Essay in Phenomenology and Feminist Theory." In *Performing Feminisms: Feminist Critical Theory and Theatre,* edited by Sue-Ellen Case, 270–282. Baltimore: Johns Hopkins University Press, 1990.

"The Call of Salome: Rumors That Salomania Will Have a Free Hand This Season." *New York Times,* August 16, 1908.

Carby, Hazel V. *Cultures in Babylon: Black Britain and African America.* New York: Verso, 1999.

———. "Policing the Black Woman's Body in an Urban Context." *Critical Inquiry* 18, no. 4 (1992): 738–755.

Carlton, Donna. *Looking for Little Egypt.* Bloomington, IN: IDD Books, 1994.

Chauncey, George. *Gay New York: Gender, Urban Culture, and the Making of the Gay Male World, 1890–1940.* New York: Basic Books, 1995.

Cheng, Anne Anlin. "Ornamentalism, Aesthetic Being: Revolution at the Periphery." Keynote lecture, Modernist Studies Association, Boston, MA, November 2015.

Cherry, Deborah. *Beyond the Frame: Feminism and Visual Culture, Britain, 1850–1900.* New York: Routledge, 2000.

Chiba, Yoko. "Sada Yacco and Kawakami: Performers of Japonisme." *Modern Drama* 35, no. 1 (1992): 35–52.

Clair, Jean, Pierre Theberge, et al. *Lost Paradise: Symbolist Europe.* Montreal: Montreal Museum of Fine Arts, 1995. Exhibition catalog.

Cobb, William Jelani. *The Devil and Dave Chappelle.* New York: Thunder's Mouth Press, 2007.

Coffin, Harriet E. "All Sorts and Kinds of Salomes." *Theatre Magazine,* April 1909, 130.

Coffman, Elizabeth. "Uncanny Performances in Colonial Narratives: Josephine Baker in *Princess Tam Tam.*" *Paradoxa* 3, no. 3–4 (1997): 379–394.

———. "Women in Motion: Loie Fuller and the 'Interpenetration' of Art and Science." *Camera Obscura* 49 (2002): 73–104.

Colin, Paul. *Josephine Baker and La Revue Nègre: Paul Colin's Lithographs of "Le Tumulte Noir" in Paris, 1927.* New York: Harry N. Abrams, 1998.

Collins, Patricia Hill. *Black Feminist Thought: Knowledge, Consciousness, and the Politics of Empowerment.* New York: Routledge, 2000.

———. *Black Sexual Politics: African Americans, Gender, and the New Racism.* New York: Routledge, 2005.

Colomina, Beatriz. "The Split Wall: Domestic Voyeurism." In *Sexuality and Space,* edited by Beatriz Colomina, 73–98. Princeton, NJ: Princeton Architectural Press, 1992.

Current, Richard Nelson, and Marcia Ewing Current. *Loie Fuller: Goddess of Light.* Boston: Northeastern University Press, 1997.

Curtis, Susan. *The First Black Actors on the Great White Way.* Columbia: University of Missouri Press, 1998.

Cvetkovich, Ann, *An Archive of Feelings: Trauma, Sexuality and Lesbian Public Cultures.* Durham, NC: Duke University Press, 2003.

Cvetkovich, Ann, and Ann Pellegrini, eds. "Public Sentiments." Special issue, *Scholar and Feminist Online* 2 (2003). http://sfonline.barnard.edu/ps/.

Davis, Angela. *Blues Legacies and Black Feminism: Gertrude "Ma" Rainey, Bessie Smith, and Billie Holliday.* New York: Pantheon Books, 1998.

de Lauretis, Teresa. "The Technology of Gender." In *Technologies of Gender: Essays on Theory, Film, and Fiction,* 1–30. London: Macmillan, 1989.

Derrida, Jacques. "Signature Event Context." In *Margins of Philosophy,* translated by Alan Bass, 307–330. Chicago: University of Chicago Press, 1982.

Dijkstra, Bram. *Idols of Perversity: Fantasies of Feminine Evil in Fin-de-siècle Culture.* New York: Oxford University Press, 1986.

Doty, Alexander. "Introduction: There's Something about Mary." *Camera Obscura* 65 (2007): 1–9.

Douglas, Ann. *Terrible Honesty: Mongrel Manhattan in the 1920s.* New York: Farrar, Straus & Giroux, 1995.

Du Bois, W. E. B. *The Souls of Black Folk.* 1903; New York: Dover, 1994.

Dudziak, Mary L. "Josephine Baker, Racial Protest, and the Cold War." *Journal of American History* 81, no. 2 (September 1994): 543–570.

Farmer, Brett. "The Fabulous Sublimity of Gay Diva Worship." *Camera Obscura* 59 (2005): 165–195.

Felski, Rita. "Politics, Aesthetics, and the Feminist Public Sphere." In *Beyond Feminist Aesthetics: Feminist Literature and Social Change,* 154–180. Cambridge, MA: Harvard University Press, 1989.

Fields, Darell Wayne. "House for Josephine Baker (Parody Series)." In *harlemworld: Metropolis as Metaphor,* compiled by Thelma Golden, 89–94. New York: Studio Museum of Harlem, 2003.

Fleetwood, Nicole R. *On Racial Icons: Blackness and the Public Imagination.* New Brunswick, NJ: Rutgers University Press, 2015.

Foucault, Michel. *The History of Sexuality,* vol. 1, *An Introduction.* New York: Random House, 1980.

Francis, Terri. "Embodied Fictions, Melancholy Migrations: Josephine Baker's Cinematic Celebrity." *Modern Fiction Studies* 51, no. 4 (2005): 824–845.

Freud, Sigmund. "The Question of Lay Analysis." In *The Standard Edition of the Complete Psychological Works,* vol. 20, translated and edited by James Strachey and Anna Freud, 177–250. London: Hogarth Press and the Institute of Psycho-Analysis, 1959.

Fuller, Loïe. *Fifteen Years of a Dancer's Life, with Some Account of Her Distinguished Friends.* Boston: Small, Maynard, 1913.

Garber, Eric. "A Spectacle in Color: The Lesbian and Gay Subculture of Jazz Age Harlem." In *Hidden from History: Reclaiming the Gay and Lesbian Past,* edited by Martin Duberman, Martha Vicinus, and George Chauncey Jr., 318–331. New York: Meridian, 1990.

Garelick, Rhonda K. "Electric Salome: Loie Fuller at the Exposition Universelle of 1900." In *Imperialism and Theatre: Essays on World Theatre, Drama, and Performance, 1795–1995,* edited by J. Ellen Gainor, 85–103. New York: Routledge, 1995.

———. *Electric Salome: Loie Fuller's Performance of Modernism* (Princeton, NJ: Princeton University Press, 2007).

———. "The Political Salomé: Colonialism and the Dance of the Seven Veils." Paper presented at the annual meeting of the Modern Language Association, Chicago, IL, 1990.

Gates, Henry Louis, Jr. "An Interview with Josephine Baker and James Baldwin." *Southern Review* 21, no. 3 (1985): 594–602.

George-Graves, Nadine. *The Royalty of Negro Vaudeville: The Whitman Sisters and the Negotiation of Race, Gender, and Class in African American Theater, 1900–1940.* New York: St. Martin's Press, 2000.

Gilbert, Sky. *Ejaculations from the Charm Factory: A Memoir.* Toronto: ECW Press, 2000.

———. *Play Murder.* Winnipeg: Blizzard Publications, 1995.

Ginsberg, Elaine, ed. *Passing and the Fictions of Identity.* Durham, NC: Duke University Press, 1996.

Glenn, Susan. A. *Female Spectacle: The Theatrical Roots of Modern Feminism.* Cambridge, MA: Harvard University Press, 2000.

Golden, Thelma. "Of Harlem: An Introduction." In *harlemworld: Metropolis as Metaphor,* compiled by Thelma Golden, 9–11. New York: Studio Museum of Harlem, 2003.

Graham, Trey. "Women's Work." Review of *In Good Company. Washington City Paper,* December 5, 1997. www.washingtoncitypaper.com/articles/14011/womens-work.

Greenhalgh, Paul. *Art Nouveau, 1890–1914.* London: Victoria and Albert Museum and the National Gallery of Art, 2000.

Gubar, Susan. *Racechanges: White Skin, Black Face in American Culture.* New York: Oxford University Press, 2000.

Guerrero, Lisa, and David J. Leonard. "Playing Dead: The Trayvoning Meme and the Mocking of Black Death." *NewBlackMan (in Exile),* May 29, 2012. http://www.newblackmaninexile .net/2012/05/playing-dead-trayvoning-meme-mocking-of.html.

Gunning, Tom. "The Cinema of Attraction: Early Film, Its Spectator and the Avant-Garde." *Wide Angle* 8, no. 3–4 (1986): 63–70.

Haraway, Donna. "A Cyborg Manifesto: Science, Technology, and Socialist-Feminism in the Late Twentieth Century." In *Simians, Cyborgs, and Women: The Reinvention of Nature,* 149–181. New York; Routledge, 1991.

harlemworld: Metropolis as Metaphor. Compiled by Thelma Golden. New York: Studio Museum of Harlem, 2004. Published in conjunction with the exhibition *harlemworld: Metropolis as Metaphor,* organized by Thelma Golden and shown at the Studio Museum of Harlem, New York, January 28–April 4, 2004.

Harper, Philip Brian. "The Evidence of Felt Intuition: Minority Experience, Everyday Life, and Critical Speculative Knowledge." In *Black Queer Studies: A Critical Anthology,* edited by E. Patrick Johnson and Mae G. Henderson, 106–123. Durham, NC: Duke University Press, 2005.

Harris, Margaret Haile, ed. *Loïe Fuller: Magician of Light.* Richmond, VA: Virginia Museum, 1979. Exhibition catalog.

Hartman, Saidiya. *Scenes of Subjection: Terror, Slavery, and Self-Making in Nineteenth-Century America.* New York: Oxford University Press, 1997.

Henderson, Mae G. "About Face, or What Is This 'Back' in B(l)ack Popular Culture? From Venus Hottentot to Video Hottie." In *Understanding Blackness through Performance,* edited by Anne Crémieux, Xavier Lemoine, and Jean-Paul Rocchi, 159–179. New York: Palgrave Macmillan, 2013.

———. "Josephine Baker and La Revue Nègre: From Ethnography to Performance." *Text and Performance Quarterly* 23, no. 2 (2003): 108–133.

Hughes, Langston. "Note on Commercial Theatre." In *The Collected Poems of Langston Hughes*, edited by Arnold Rampersad, 215. New York: Knopf, 1994. First published in *Crisis*, March 1940.

Hutcheon, Linda. "Irony, Nostalgia, and the Postmodern." University of Toronto English Library, 1998. www.library.utoronto.ca/utel/criticism/hutchinp.html.

Jarrett, Lucinda. *Stripping in Time: A History of Erotic Dancing*. London: HarperCollins, 1997.

Jeffries, Ira. "My Mother's Daughter." In *The Persistent Desire: A Femme-Butch Reader*, edited by Joan Nestle, 59–61. New York: Alyson Publications, 1992.

Jefferson, N. H. "Aida Overton Walker Is Dead." *Chicago Defender*, October 17, 1914.

Johnson, James Weldon. *Black Manhattan*. 1930; Boston: Da Capo Press, 1991.

Jordanova, Ludmilla. *Sexual Visions: Images of Gender in Science and Medicine between the Eighteenth and Twentieth Centuries*. Madison: University of Wisconsin Press, 1989.

Jules-Rosette, Bennetta. *Josephine Baker in Art and Life: The Icon and the Image*. Urbana: University of Illinois Press, 2007.

Kano, Ayako. *Acting like a Woman in Modern Japan: Theater, Gender, and Nationalism*. New York: Palgrave Macmillan, 2001.

Kaplan, Carla. *Miss Anne in Harlem: The White Women of the Black Renaissance*. New York: HarperCollins, 2013.

Kellner, Hans. Review of *Play Murder*. *Philadelphia City Paper*, October 31–November 7, 1996.

Kendall, Elizabeth. *Where She Danced*. New York: Knopf, 1979.

Krasner, David. *A Beautiful Pageant: African American Theatre, Drama, and Performance in the Harlem Renaissance, 1910–1927*. New York: Palgrave Macmillan, 2002.

———. "Black Salome: Exoticism, Dance, and Racial Myths." In *African American Performance and Theater History: A Critical Reader*, edited by Harry J. Elam Jr. and David Krasner, 192–211. New York: Oxford University Press, 2001.

———. "Rewriting the Body: Aida Overton Walker and the Social Formation of Cakewalking." *Theatre Survey* 37, no. 2 (November 1996): 67–92.

Kraut, Anthea. "Between Primitivism and Diaspora: The Dance Performances of Josephine Baker, Zora Neale Hurston, and Katherine Dunham." *Theatre Journal* 55 (October 2003): 433–450.

———. "White Womanhood, Property Rights, and the Campaign for Choreographic Copyright: Loïe Fuller's Serpentine Dance." *Dance Research Journal* 43, no. 1 (2011): 3–26.

Kröller, Eva-Marie, ed. *The Cambridge Companion to Canadian Literature*. Cambridge: Cambridge University Press, 2004.

Lee, Josephine. "Bodies, Revolutions, and Magic: Cultural Nationalism and Racial Fetishism." *Modern Drama* 44, no. 1 (Spring 2001): 72–90.

"Libby Holman." *E! Mysteries and Scandals*. Season 3, Episode 1, March 6, 2000.

"Libby Holman Returns to Stage to Aid Star." *Chicago Defender*, November 8, 1941.

Loos, Adolf. *Ornament and Crime: Selected Essays*. Translated by Michael Mitchell. Introduction by Adolf Opel. Riverside, CA: Ariadne Press, 1998.

Lott, Eric. *Love and Theft: Blackface Minstrelsy and the American Working Class*. New York: Oxford University Press, 1995.

Machlin, Milt. *Libby*. New York: Dorchester Publishing, 1990.

Magubane, Zine. "Which Bodies Matter? Feminism, Post-Structuralism, Race, and the Curious Theoretical Odyssey of the 'Hottentot Venus.'" In *Black Venus 2010: They Called Her "Hottentot,"* edited by Deborah Willis, 47–61. Philadelphia: Temple University Press, 2010.

Marinetti, F. T. "Manifesto of the Futurist Dance." July 8, 1917. http://antipastimermaids
.edublogs.org/2011/03/24/manifesto-of-the-futurist-dance-by-f-t-marinetti-july-8-1917/.

Martin, Wendy. "'Remembering the Jungle': Josephine Baker and Modernist Parody." In *Prehistories of the Future: The Primitivist Project and the Culture of Modernism*, edited by Elazar Barkan and Ronald Bush, 310–325. Stanford, CA: Stanford University Press, 1995.

"Maud Allan's Barefoot Dancing Stirs London." *Theatre Magazine*, June 1908, 164–166.

Maxwell, William J. *F. B. Eyes: How J. Edgar Hoover's Ghostreaders Framed African American Literature*. Princeton, NJ: Princeton University Press, 2015.

McClintock, Anne. *Imperial Leather: Race, Gender, and Sexuality in the Colonial Conquest*. New York: Routledge, 1995.

McEvilley, Thomas. "Doctor Lawyer Indian Chief: 'Primitivism' in 20th Century Art at the Museum of Modern Art in New York." *Artforum* 23 (November 1984): 54–61.

Miller, J. Scott. "Dispossessed Melodies: Recordings of the Kawakami Theater Troupe." *Monumenta Nipponica* 53, no. 2 (1998): 225–235.

Mizejewski, Linda. *Ziegfeld Girl: Image and Icon in Culture and Cinema*. Durham, NC: Duke University Press, 1999.

Moore, John. "'The Hieroglyphics of Love': The Torch Singers and Interpretation." *Popular Music* 8, no. 1 (January 1989): 31–58.

Moten, Fred. *In the Break: The Aesthetics of the Black Radical Tradition*. Minneapolis: University of Minnesota Press, 2003.

Muñoz, José. *Disidentifications: Queers of Color and the Performance of Politics*. Minneapolis: University of Minnesota Press, 1999.

———. "Ephemera as Evidence: Introductory Notes to Queer Acts." *Women and Performance* 16 (1996): 5–18.

Münz, Ludwig, and Gustav Künstler. *Adolf Loos: Pioneer of Modern Architecture*. Translated by Harold Meek. London: Thames & Hudson, 1966.

"Musical and Dramatic: Aida Overton Walker at the Pekin Theatre." *Chicago Defender*, November 1, 1913.

Negra, Diane. *Off-White Hollywood: American Culture and Ethnic Female Stardom*. New York: Routledge, 2001.

"A Negro Salome." *Vanity Fair*, June 1923, 26.

Newman, Richard. "The Brightest Star: Aida Overton Walker in the Age of Ragtime and Cakewalk." *Prospects* 18 (October 1993): 465–481.

Ormsby, Robert. "Mainstream Murder." *drama.ca* (blog), October 4, 2003. www.drama.ca/blog/?p=53.

Overton Walker, Aida. "Colored Men and Women on the American Stage." *Colored American Magazine* 9 (October 1905): 571, 575.

Paddon, Anna R., and Sally Turner. "African Americans and the World's Columbian Exposition." *Illinois Historical Journal* 88, no. 1 (1995): 19–36.

Parker, Andrew, and Eve Kosofsky Sedgwick. "Introduction to *Performativity and Performance*." In *The Performance Studies Reader*, edited by Henry Bial, 167–174. New York: Routledge, 2004.

Peiss, Kathy. *Cheap Amusements: Working Women and Leisure in Turn-of-the-Century New York*. Philadelphia: Temple University Press, 1986.

Perry, Darby. *Libby Holman: Body and Soul*. Boston: Little, Brown, 1983.

Phelan, Peggy. "The Ontology of Performance." In *Unmarked: The Politics of Performance*, 146–166. New York: Routledge, 1993.

Picart, Caroline Joan S. *Critical Race Theory and Copyright in American Dance: Whiteness as Status Property*. New York: Palgrave Macmillan, 2013.

Piper, Adrian. "Passing for White, Passing for Black." In *Passing and the Fictions of Identity*, edited by Elaine Ginsberg, 234–269. Durham, NC: Duke University Press, 1996.

"Re-racinated." *Newsweek*, September 14, 1964.

Roach, Joseph. *Cities of the Dead: Circum-Atlantic Performance*. New York: Columbia University Press, 1996.

———. "Deep Skin: Reconstructing Congo Square." In *African American Performance and Theater History: A Critical Reader*, edited by Harry J. Elam Jr. and David Krasner, 101–113. New York: Oxford University Press, 2001.

Robertson, Pamela. *Guilty Pleasures: Feminist Camp from Mae West to Madonna*. Durham, NC: Duke University Press, 1996.

Robinson, Cedric. *Forgeries of Memory and Meaning: Blacks and the Regimes of Race in American Theater and Film before World War II*. Chapel Hill: University of North Carolina Press, 2007.

———. "The Inventions of the Negro." *Social Identities* 7, no. 3 (2001): 329–361.

Rodman, Tara. "A Modernist Audience: The Kawakami Troupe, Matsuki Bunkio, and Boston Japonisme." *Theater Journal* 65, no. 4 (2013): 489–505.

Rogin, Michael. *Blackface, White Noise: Jewish Immigrants in the Hollywood Melting Pot*. Berkeley: University of California Press, 1996.

———. "Blackface, White Noise: The Jewish Jazz Singer Finds His Voice." *Critical Inquiry* 18, no. 3 (Spring 1992): 417–453.

———. "'Make My Day!': Spectacle as Amnesia in Imperial Politics." *Representations* 29 (Winter 1990): 99–123.

Rose, Phyllis. *Jazz Cleopatra: Josephine Baker in Her Time*. New York: Doubleday, 1989.

Ross, Andrew. *No Respect: Intellectuals and Popular Culture*. New York: Routledge, 1989.

Rubin, William, ed. *"Primitivism" in 20th Century Art: Affinity of the Tribal and the Modern, in Two Volumes*. New York: Museum of Modern Art, 1984.

Russell, Sylvester. "Williams and Walker's In Dahomey Company." *Indianapolis Freeman*, September 26, 1902. In *The Ghost Walks: A Chronological History of Blacks in Show Business, 1865–1910*, edited by Henry T. Sampson, 269–269. Metuchen, NJ: Scarecrow Press, 1988.

Said, Edward. *Orientalism*. New York: Vintage Books, 1979.

"Salome Dinner Dance." *New York Times*, August 23, 1908.

Sauvage, Marcel. *Les mémoires de Joséphine Baker*. Paris: Èditions Kra, 1927.

Scheper-Hughes, Nancy. "Parts Unknown: Undercover Ethnography of the Organs-Trafficking Underworld." *Ethnography* 5, no. 1 (2004): 29–73.

Schneider, Rebecca. *The Explicit Body in Performance*. New York: Routledge, 1997.

"Shakespere on the Tokio Stage." *Minneapolis Journal*, October 8, 1903. *Chronicling America: Historic American Newspapers*, Library of Congress. http://chroniclingamerica.loc.gov/lccn/sn83045366/1903–10–08/ed-1/seq-17/.

Sharpley-Whiting, T. Denean. *Black Venus: Sexualized Savages, Primal Fears, and Primitive Narratives in French*. Durham, NC: Duke University Press, 1999.

Siegel, Marcia B. *At the Vanishing Point: A Critic Looks at Dance*. New York: Saturday Review Press, 1972.

Sims, Lowery Stokes. "Director's Foreword." In *harlemworld: Metropolis as Metaphor*, compiled by Thelma Golden, 7. New York: Studio Museum of Harlem, 2003.

Smith, Barbara. "Toward a Black Feminist Criticism." *Conditions* 2, no. 1 (1977): 26–43.

Smith, Valerie. "Reading the Intersection of Race and Gender in Narratives of Passing." *Diacritics* 24, no. 2–3 (Summer–Fall 1994): 43–57.

Smithsonian Institution Libraries. "Revisiting the World's Fairs and International Expositions: A Selected Bibliography, 1992–2004." April 2005. www.sil.si.edu/silpublications/Worlds-Fairs/introduction.htm.

Somerville, Siobhan B. *Queering the Color Line: Race and the Invention of Homosexuality in American Culture.* Durham, NC: Duke University Press, 2000.

Springer, Kimberly. "Divas, Evil Black Bitches, and Bitter Black Women: African-American Women in Postfeminist and Post–Civil Rights Popular Culture." In *Feminist Television Criticism: A Reader,* edited by Charlotte Brunsdon and Lynn Spigel, 72–91. 2nd ed. Maidenhead, Berkshire, England: Open University Press/McGraw-Hill, 2008.

St. Denis, Ruth. *Ruth St. Denis: An Unfinished Life.* 1939; New York: Dance Horizons, 1969.

Stewart, Ollie. "'Too Busy to Die,' Jo Baker Tells AFRO." *Baltimore Afro-American,* January 23, 1943.

Studlar, Gaylyn. "'Out-Salomeing Salome': Dance, the New Woman, and Fan Orientalism." In *Visions of the East: Orientalism in Film,* edited by Matthew Bernstein and Gaylyn Studlar, 486–510. New Brunswick, NJ: Rutgers University Press.

Sueyoshi, Amy. "Mindful Masquerades: Que(e)rying Japanese Immigrant Dress in Turn-of-the-Century San Francisco." *Frontiers: A Journal of Women Studies* 26, no. 3 (2005): 67–100.

Szwed, John. *Billie Holiday: The Musician and the Myth.* New York: Viking Press, 2015.

Tanner, Jo A. *Dusky Maidens: The Odyssey of the Early Black Dramatic Actress.* Westport, CT: Greenwood Press, 1992.

Taylor, Diana. *The Archive and the Repertoire: Performing Cultural Memory in the Americas.* Durham, NC: Duke University Press, 2003.

———. *Disappearing Acts: Spectacles of Gender and Nationalism in Argentina's "Dirty War."* Durham, NC: Duke University Press, 1997.

Tompkins, Kyla Wazana. *Racial Indigestion: Eating Bodies in the 19th Century.* New York: New York University Press, 2012.

Van Vechten, Carl. "Negro Theater." In *In the Garret,* 312–324. New York: Knopf, 1920.

———. "Terpsichorean Souvenirs." *Dance Magazine* 31, no. 1 (1957): 16–18, 92.

Vargas, Deborah R. *Dissonant Divas in Chicana Music: The Limits of La Onda.* Minneapolis: University of Minnesota Press, 2012.

Vogel, Shane. *The Scene of Harlem Cabaret: Race, Sexuality, Performance.* Chicago: University of Chicago Press, 2009.

Wald, Elijah. DVD liner notes essay. In *Josh White: Free and Equal Blues Rare Performances.* Vestapol, 2001.

Walker, Susan. "A Walk on the Wild Side" (review of *Play Murder*). *Toronto Star,* September 25, 2003.

Warner, Michael. *Publics and Counterpublics.* New York: Zone Books, 2002.

Waters, Ethel, with Charles Samuels. *His Eye Is on the Sparrow: An Autobiography.* New York: Doubleday, 1951.

———. *To Me It's Wonderful.* New York: Harper & Row, 1972.

Wells, Ida B., Frederick Douglass, Irvine Garland Penn, and Ferdinand L. Barnett. *The Reason Why the Colored American Is Not in the World's Columbian Exposition* [1893], ed. Robert W. Rydell (Urbana: University of Illinois Press, 1999).

White, Patricia. *Uninvited: Classical Hollywood Cinema and Lesbian Representability.* Bloomington: Indiana University Press, 1999.

Wilde, Oscar. *Salomé: A Tragedy in One Act.* Translated from the French by Lord Alfred Douglas. Illustrated by Aubrey Beardsley. 1894; New York: Dover Publications, 1967.

Willis, Deborah, ed. *Black Venus 2010: They Called Her "Hottentot."* Philadelphia: Temple University Press, 2010.

Wilson, James F. *Bulldaggers, Pansies, and Chocolate Babies: Performance, Race, and Sexuality.* Ann Arbor: University of Michigan Press, 2010.

Wilson, Mabel O. "Black in Harlem: Architects, Racism, and the City." In *harlemworld: Metropolis as Metaphor,* compiled by Thelma Golden, 27–37. New York: Studio Museum of Harlem, 2003.

Yelin, Louise. "Globalizing Subjects." *Signs: Journal of Women in Culture and Society* 29, no. 2 (2003): 439–464.

FILM, VIDEO, AND AUDIO RECORDINGS

Chasing a Rainbow: The Life of Josephine Baker. Directed by Christopher Ralling and Mich Czasky. United Kingdom, 1986.

Danse Serpentine (II) (Serpentine Dance [II]). Film by Société Lumière. 1897–1899. Cat. Lumière No. 765-I. http://www.moma.org/explore/multimedia/audios/244/2437.

Ethnic Notions. Directed by Marlon Riggs. Berkeley, CA: California Newsreel, 1987. VHS.

Illusions. Directed by Julie Dash. United States, 1982.

Intimate Portrait: Josephine Baker. Directed by Mark Israel. Lifetime, 1998.

It's Black Entertainment. Directed by Stan Lathan. Showtime, 2001.

The Josephine Baker Story. Directed by Brian Gibson. HBO, 1991.

Libby Holman: Moanin' Low (Early Recordings, 1927–1934). Los Angeles: Take Two Records, 1995.

The Life and Times of Sara Baartman: "The Hottentot Venus." Directed by Zola Maseko. South Africa, 1998.

Lift Every Voice: 1900–1924. Directed by Sam Pollard. Alexandria, VA: PBS Video, 1999. VHS.

Madame Satã. Directed by Karim Ainouz. Brazil/France, 2002.

Paris Was a Woman. Directed by Greta Schiller. New York: Zeitgeist Video, 1996. DVD.

Princess Tam Tam. With Josephine Baker. Directed by Edmond T. Gréville. France, 1935.

Reckless. Directed by Victor Fleming. United States, 1935.

The Return of Sara Baartman. Directed by Zola Maseko. South Africa, 2003.

The Secret Life of Sergei Eisenstein. Directed by Gian Carlo Bertelli. 1987; New York: Resolution/Mystic Fire Video, 1987. VHS.

Sing, Sinner, Sing. Directed by Howard Christie. United States, 1933.

La sirène des tropiques (Siren of the Tropics). Directed by Mario Nalpas and Henri Étiévant. France, 1927.

Three Curiosities. 16 mm print. New York Public Performing Arts Library. http://digitalcollections.nypl.org/items/bd378590-f875-0130-00c1-3c075448cc4b#6:08.

Les Triplettes de Belleville. Directed by Sylvain Chomet. France/Belgium/ Canada/UK, 2003.

Written on the Wind. Directed by Douglas Sirk. United States, 1956.

Zou Zou. With Josephine Baker. Directed by Marc Allégret. France, 1934.

INDEX

Abyssinia (stage musical), 37
Acker, Yolanda, 137
adoption, transnational, 147–149
Africa, in vaudeville productions, 35, 38
African Americans: classical forms and, 60; critics, 35, 37; employment opportunities for, 32; labor union for, 41; migration of, 32; and NAACP, 102; New Negro movement, 32; overseas engagements of, 33; press, 35, 158; race records, 108; theater, 176n34; World's Fair contributions of, 29, 175n22. *See also* blackness; race and racism
aftereffects. *See* archives and afterlives
agency. *See* politics and resistance of performance
Aïnouz, Karim, 20, 150–151
Allan, Maud, 28, 42
Alloula, Malek, 61, 63; *The Colonial Harem*, 63
All Star Stock Company, 33
appearance/disappearance effect, 77
appropriation, cultural: in American music, 111; of Baker, 149–150; Betty Boop as, 183n23; of the blues, 99–100; Holman on, 125; vs. imitation, 54, 114; Schneider on, 92; of sound, 113
Arce, Julio and Yolanda, 77
architecture and blackness, 139–140
archives and afterlives: black feminist thought in, 25; of dance, 178n64; of divas, 164–165; exhibitions, 80, 131, 133, 143; FBI files as, 146; Fuller's, 65, 79–80, 164–165; Holman's, 9, 95, 119–124, 125–126, 161; nature of, 13–14; Overton Walker's, 55–56, 164–165; of performance, 8; remains of, 167; retroactivating, 167–171; of slavery, 166. *See also* Baker, Josephine, archives and afterlives; diva iconicity; retroactivation

art nouveau, 68–69, 70, 79–80
Atkinson, Brooks, 105, 117
audiences: aftereffects of, 163; Baker's, 131, 134–135; Holman's, 106; response to Overton Walker, 25; of torch singers, 105–106; Waters and, 111; white middle-class, 5
aural passing, 95, 113, 125
Austin, J. L., 4–5
authenticity narrative, of Holman, 98, 117, 118
avant-garde artists and primitivism, 132

Baartman, Sarah, 135, 137
"back to Africa"–themed productions, 35, 37, 38
Baker, Jean-Claude, 148, 188n49; *Josephine: The Hungry Heart*, 188n49
Baker, Josephine: autobiographies of, 188n48; background and career of, 130; banana dance, 134–135; communists and, 188n45; death of, 6, 170; diva iconicity of, 127–129; domestication of, 139–141, 144; evictions of, 142–143; feminists on, 131, 138; Knowles tribute to, 130; late-stage career of, 149–157; in *Les Triplettes de Belleville*, 134–136; in *Madame Satā*, 151–155; mobility of, 156; performances of, 185n7; politics and resistance of, 131–132, 137–138, 162; postcard, 159, 170–171; primitivism in relation to, 132–133; primitivism of, 130–131; in *Princess Tam Tam*, 152, 153–155; Rainbow Tribe of, 147–148, 149; scholarship on, 131; significance of, 20–21; songs of, 131; voice of, 188n57; in *Zou Zou*, 137
Baker, Josephine, archives and afterlives, 185n7; contradictions in, 164–165; FBI

201

Hottentot, 137; "My Little Zulu Baby," 177n44; nature of, 33–34; Rang Tang revue, 103; Salomania in relation to, 176n34; scholarship on, 177n44; TOBA, 32–33, 108, 176n34. *See also* Williams & Walker Company

Victorian patriarchy, 66

violence, racial, 31–33

"The Vision of Salomé" dance (Allan), 28

Vogel, Shane, 138

Walker, Aida Overton. *See* Overton Walker, Aida

Walker, George, 23, 34, 38, 42, 56–57

Walton, Lester A., 37, 54

Waters, Ethel, 108–112, 120–121; *His Eye Is on the Sparrow*, 109; *To Me It's Wonderful*, 109, 112

Wells, Ida B., 175n22

White, Josh, 97, 114–116; *Blues Till Dawn* (with Holman), 116

White, Patty, 109

White, Walter, 102, 144

white audiences: of Baker, 131, 134–135; Holman and, 98–99; middle-class, 5; response to Overton Walker, 25; of torch song singers, 105–106

whiteness: bad girl, 52, 54; characteristics of, 30–31; as a commodity, 49; ethnic European claims to, 102; femininity and, 92; as freedom, 146; impact of, 164; in *Les Triplettes de Belleville*, 136; linked

to orientalism, 65; the production, 10. *See also* blackness; orientalism; Overton Walker, Aida, performing Salome; race and racism

Whitman Sisters, 33–34

Wilde, Oscar, 27–28, 73, 89

Williams, Bert (Egbert) Austin: career of, 38; in *100 Years in Post-Production*, 177n37; Riggs's use of, 177n39; as Salome, 43–44, 52; Van Vechten on, 42; in Williams & Walker, 34

Williams & Walker Company: *Abyssinia*, 35–38; *Bandanna Land*, 38; *In Dahomey*, 35–37; early work of, 34–35; end of, 38; Overton Walker in relation to, 1; political organizing of, 41; recycling of racist forms, 40–42. *See also* vaudeville

Winchell, Walter, 144

women: ban on acting of, 180n14; celebrity and stardom, 17, 148–149; employment of, 32; ethnic European, 102; female stardom, 148; femininity, 86, 92; femme fatales, 52, 69; motion and, 81; New Womanhood, 61–63. *See also* the black female body; black feminists; diva iconicity; feminism and feminists

World's Columbian Exposition (Chicago, 1893), 29, 30, 175n22

Wynn, Ed, 50, *51*

Ziegfeld Follies, 23, 28, 52

Zou Zou (film), 131, 137

ABOUT THE AUTHOR

JEANNE SCHEPER is an associate professor of gender and sexuality studies at the University of California, Irvine. She researches and teaches feminist performance studies and visual culture; cultural studies; theories of race, gender, and sexuality; and transatlantic modernism. She has published on Nella Larsen's novel *Quicksand* in *African American Review*, on the "diva politics" of reception and Josephine Baker's iconicity in *Camera Obscura*, on activist archives and academic labor in *Feminist Studies*, and on the role of television in public policy debates on the military's "don't ask, don't tell" policy.